*Writing Past Colonialism* is the signature book series of the Institute of Postcolonial Studies, based in Melbourne, Australia. By postcolonialism we understand modes of writing and artistic production that critically engage with and contest the legacy and continuing mindset and practices of colonialism, and inform debate about the processes of globalization. This perspective manifests itself in a concern with difference from the Euro-American, the global, and the norm. The series is also committed to publishing works that seek "to make a difference," both in the academy and outside it.

OUR HOPE IS THAT BOOKS IN THE SERIES WILL

- engage with contemporary issues and problems relating to colonialism and postcolonialism
- attempt to reach a broad constituency of readers
- address the relation between theory and practice
- be interdisciplinary in approach as well as subject matter
- experiment with new modes of writing and methodology

## ipcs

**INSTITUTE OF POSTCOLONIAL STUDIES** | WRITING PAST COLONIALISM

*Selves in Question: Interviews on Southern African Auto/biography*
   Edited by Judith Lütge Coullie, Stephan Meyer, Thengani Ngwenya, and Thomas Olver

*Boundary Writing: An Exploration of Race, Culture, and Gender Binaries in Contemporary Australia*
   Edited by Lynette Russell

*Postcolonizing the International: Working to Change the Way We Are*
   Edited by Phillip Darby

*Dark Writing: geography, performance, design*
   by Paul Carter

*Hidden Hands and Divided Landscapes: A Penal History of Singapore's Plural Society*
   by Anoma Pieris

# dark writing

**GEOGRAPHY, PERFORMANCE, DESIGN**

Paul Carter

 University of Hawai'i Press   Honolulu

© 2009 University of Hawai'i Press
All rights reserved
Printed in the United States of America
14 13 12 11 10 09     6 5 4 3 2 1

**Library of Congress Cataloging-in-Publication Data**
Carter, Paul, 1951–
Dark writing : geography, performance, design / Paul Carter.
   p. cm.—(Writing past colonialism)
Includes bibliographical references and index.
ISBN 978-0-8248-3246-9 (hard cover : alk. paper)
ISBN 978-0-8248-3312-1 (pbk. : alk. paper)
   1. Cartography—Philosophy.   2. Geography—Philosophy.
3. Environmental geography.   I. Title.
GA102.3.C367   2009
526.01—dc22          2008022936

University of Hawai'i Press books are printed on
acid-free paper and meet the guidelines for permanence
and durability of the Council on Library Resources

Designed by Leslie Fitch
Printed by The Maple-Vail Book Manufacturing Group

*In memory of Denis Cosgrove (1948–2008)*

**CONTENTS**

*Figures*     ix
*Plates*     xi
*Preface: The Great Divide*     xiii
*Acknowledgments*     xvii

Introduction: Outlines     1

Chapter 1: Step-by-Step: Geography's Myth     16

Chapter 2: Dark with Excess of Bright: Mapping the Coastlines of Knowledge     49

Chapter 3: Drawing the Line: Putting Spatial History into Practice     79

Chapter 4: The Interpretation of Dreams: Mobilizing the Papunya Tula Painting Movement, 1971–1972     103

Chapter 5: Making Tracks: Interpreting a Ground Plan     140

Chapter 6: Solutions: Storyboarding a Humid Zone     173

Chapter 7: Trace: A Running Commentary on *Relay*     203

Chapter 8: Dark Writing: The Body's Inscription in History's Light     228

Conclusion: Linings     260

*Bibliography*     283
*Index*     301

*Color plates follow page 78*

**FIGURES**

1. *Petitions of the Aboriginal People of Yirrkala, 14 August 1963.*   18
2. Matthew Flinders, "Chart of Spencer's Gulf," detail, 1814.   26
3. William Whewell, "Inductive Chart," detail, 1867.   31
4. "Map of Lake Eyre South and Environs," detail, 1869.   34
5. William Dawes, "Map of New South Wales," detail, 1792.   37
6. "Siccar Point: Hutton's Unconformity," January 2006.   40
7. James Hutton, "Junction at Siccar point of primary and secondary sandstone."   41
8. Sir James Hall, "Siccar Point," probably 1788.   42
9. James Grant, "Chart of the Australian Coast: The North and West Parts of Bass's Straits."   52
10. Phillip Parker King, "Collated Chart of Bass Strait."   53
11. W. Hamilton, "The View of the Island of Ouby from Freshwater Bay on Batchian," 1779.   60
12. L. R. Fitzmaurice, "Messrs Fitzmaurice & Keys Dancing for their Lives," 1846.   64
13. Jean Houel, "Plan de la Barrière de la Santé, à Malte," 1782.   66
14. "Drawing of a Snake Story," by Toba.   111
15. Pintupi pencil drawings, 1971.   114
16. Geoffrey Bardon, "Signs and symbols basic to Western Desert imagery."   115
17. Geoffrey Bardon, comic strip, "Taffy and Shipwreck, No. 4."   117
18. "Old Mick Tjakamarra and Old Walter Tjampitjinpa making and touching a ground sand mosaic."   119
19. Johnny Warrangkula Tjupurrula, "Water Dreaming with Man in Cave," April–May 1972.   121
20. William Light, *Plan of the City of Adelaide in South Australia*, 1836.   141
21. Four Views of North Terrace, Adelaide, South Australia, 1860s, c.1915, 1930s, 2001.   142
22. Eugene von Guerard, "Torrens River, 31 July 1855."   144
23. "Barton's 1853 Map of Adelaide."   145
24. G. S. Kingston, "Distribution of Houses in Adelaide, 1842."   148
25. Paul Carter, *Tracks,* Four "Variable Grids."   153

26. Paul Carter, *Tracks,* ground plan, sketch showing "random ashlar" motif.   154
27. Paul Carter, *Tracks,* ground plan, showing location of four stelae.   155
28. Paul Carter, *Tracks,* iconographs, four stages of development.   158
29. Charles Lapicque, "Figures Entrelacées," 1946–1947.   163
30. Paul Carter, *Solution,* site location.   176
31. Paul Carter, *Solution,* "Forest in the Harbo*r, Timber Pilings, North Wharf."   188
32. Paul Carter, *Solution,* "Utopian Projections, Victoria Harbo*r."   190
33. Paul Carter, *Solution,* "Humid Edge Forms."   193
34. Paul Carter and Ruark Lewis, *Relay,* site location. (i) Aerial View of Fig Grove; (ii) Fig Grove & Central Water Feature Grading Plan, May 1998.   205
35. Paul Carter and Ruark Lewis, *Relay,* monograms.   211
36. William Henry Fox Talbot, "Wings of an Insect," 1839.   239
37. William Henry Fox Talbot, "Spade and Broom," c.1840.   240
38. William Henry Fox Talbot, "Entrance, University College, Oxford," 1843.   243
39. William Henry Fox Talbot, "Imitation of Printing" (reversed), c.1844.   244
40. Julia Cameron, "Sir John Frederick William Herschel," April 1869.   247
41. William Henry Fox Talbot, "Soliloquy of the Broom," 21 January 1841.   249
42. William Henry Fox Talbot, "Hand," c.1841.   250

**PLATES**

1. François Boucher, *The Arts and Sciences: Architecture and Chemistry* (1750–1753).
2. "Version 1 of the Honey Ant Mural," June–August 1971.
3. Old Walter Tjampitjinpa, "Stars at Night," pre-1971.
4. Johnny Warrangkula Tjupurrula, "Water Dreaming," August–September 1973.
5. Yala Yala Gibbs Tjungarrayi, "Man ['Wati'] Ceremony," March–April 1972.
6. "Version 2 of the Honey Ant Mural," June–August 1971.
7. "Version 3 of the Honey Ant Mural," June–August 1971.
8. Paul Carter/Trampoline, *Tracks*, "Iconographs/Alphabets."
9. Paul Carter/BuroPlus, *Tracks*, photomontage of appearance by night.
10. D'Oyley Aplin and Alfred Selwyn, "Lagoon," detail of Geological Survey of Victoria, 1858.
11. Paul Carter, *Solution*, mythform.
12. Paul Carter and Ruark Lewis, Fig Grove and *Relay*, progress of work.
13. Paul Carter and Ruark Lewis, *Relay*, concept sketches and text treatments.
14. Ruark Lewis, *Relay*, Graffiti Cluster 1, drawing.
15. Ruark Lewis, Graffiti Cluster 6, development drawing.
16. Paul Carter and Ruark Lewis, *Relay*, detail of red tier.
17. Paul Carter and Ruark Lewis, *Relay*, detail of yellow tier.
18. Paul Carter and Ruark Lewis, *Relay*, detail of green tier.
19. Paul Carter and Ruark Lewis, *Relay*, detail of blue tier.
20. Paul Carter and Ruark Lewis, *Relay*, "The Diver" (detail).
21. Tomb painting, Paestum, Andriuolo.
22. "The Diver," tomb painting, Paestum, Tempa del Prete.
23. Paul Carter, "Fissure 5."

## PREFACE: THE GREAT DIVIDE

A GREAT DIVIDE exists between those who believe in ideas and those who believe in pictures. Readers who believe in ideas think that understanding the world we have made means getting to the bottom of the notions that have shaped our conceptions of things. If they pick up a book like *Dark Writing*, they look forward to an investigation of the origins of things. Isn't that what the title implies —a revelation of the underlying principles that structure our thinking, our institutions, and environmental practices? These readers like stories. Even if they are not particularly interested in history, they like books that are organized historically, with a narrative like a path leading clearly from one idea to another. You are the readers I see in bookstores, immobilized with a volume in your hand, oblivious to the canned music, to the swirl of faces; through the portal of print, you are immersed in the invisible world of ideas.

In contrast, people who believe in pictures are reading books backwards. You can see them in a different section of the same bookstore. They are flicking through illustrated books, beginning at the back cover and flipping the pages over. The title page and the introduction are the last things they look at. If they come across a striking image, they pause; and you can tell they wish they could extract this picture from its printerly matrix and take it home. These readers have been educated in the same institution as the others—they are engineers, architects, planners, designers, and *visualizers* of every trade—but they are impatient with words. Verbal concepts convey nothing concrete to them. They want models of the world, diagrams that show how systems work. They are fascinated by processes rather than structures. They do not want to know the world and to reflect on it; they want to invent it, manipulate it.

Picture people are not interested in lengthy explanations; they equate knowledge with showing rather than telling. They will scrutinize the illustrations in *Dark Writing* first; it may be some while before they come to read this preface, even though it is also addressed to them. W. J. T. Mitchell thinks we inhabit a world increasingly dominated by images.[1] He may be right, but the shift from a primarily print culture to one where authority is vested in pictures has not been reflected in our disciplinary categories or pedagogical practices. Students, teachers, and an educated general reader passionate about promoting environments that sustain us physically and spiritually will, I hope, find the journey of *Dark Writing* rewarding. But it is almost certain that because of their training, some

will feel more at home drawing out an idea, while others will be more in their comfort zone with a discussion of drawing in practice.

This is the great divide: drawing is something ideas people and picture people both do. Some do it with chains of argument, others do it with geometrical figures. Both are trying to figure out how the world is made. Both want to change what is as well as understand it. But they speak different languages. Mitchell has argued that images are texts—that they can be *read* in some way—and the same, I have found, is true in the other direction: considered as calligraphy, as marks placed in public spaces, printed texts also picture the way the world is structured. But no one teaches this hybrid discourse of the imagetext.[2] Historians do not look at maps very much. Philosophers may *draw on* paintings, but they continue writing about invisible concepts. Engineers may make a hobby of ancient dock design, but what counts practically are the representational capacities of the latest digital drawing program. Planners distinctly don't care for the historical evidence, while those on the other side of the fence, the heritage lobby, has little or no competence in reading the architectural drawings that will determine the future of their past.

This is the great divide, and it explains why this preface is a plea for trust, a request to readers to suspend their doubts and go on the journey, even though this means almost certainly traversing some territories you may feel lie outside your usual domain. *Dark Writing* is a landscape rather than a straight road leading from a problem to its solution. There *is* a problem. It is: Why are our representations of the world so poor? Why is the language in which we describe our designs on the world so wasteful of the world's beauty? These questions have as their corollary: How did this reduction of the world's dark writing to bare lines come about? And how can we recover a richer technique of drawing our world, designing the places where we want to be? There are solutions. A richer drawing practice is needed. But so is a richer, poetic way of drawing ideas together. We need new ways of reconnecting the present to the past, and new bridgeheads between disciplines.

This is what *Dark Writing* does, the journey it performs. But to arrive where it wants to go, it takes a zigzag course, back and forth across the divide. This is no excuse for a lack of clarity, but it explains why some passages in the book may seem dark at first (and to different readers); they are passages that lie in the gap between the two great readerly domains I have described. They occupy a place inside the line of the great divide, where drawing means two things, simultaneously different and alike. By this means an argument about ways in which artists, designers, and landscape architects—and all environmentally concerned citizens—can represent their worlds better, and more sustainably, is placed in a dialectical relationship with the history of thought in the past; the drawing of lines in the future is related to a history of linear thinking in the past.

# ACKNOWLEDGMENTS

PARTS OF *Dark Writing* were originally written as "Gaps in Knowledge: The Geography of Human Reason" in *Geography and Enlightenment*, edited by David N. Livingstone and Charles W. J. Withers, University of Chicago Press, 1999 (chapter 1); "Dark with Excess of Bright: Mapping the Coastlines of Knowledge" in *Mappings*, edited by Denis Cosgrove, Reaktion Books, 1999 (chapter 2); "Federating Forms, the Place of Cultural Theory in Design," *Etudes Litteraires* (chapter 3, commissioned but unpublished); "Ground Designs, and the New Ichnology" in *Disputed Territories*, edited by David Trigger, University of Hong Kong Press, 2003 (chapter 4); "Introduction: The Interpretation of Dreams" in *Papunya, A Place Made After the Story, The Beginnings of the Western Desert Painting Movement*, Miegunyah Press, 2004 (chapter 5); "Dark Writing: Memory's Bodily Inscription in the Light of History" was published in *Value Added Goods: Essays on Contemporary Photography, Art & Ideas*, edited by Stuart Koop, Centre for Contemporary Photography, Melbourne, 2002 (chapter 6); "Mythforms: Techniques of Migrant Place-Making" was originally written for *Building Dwelling Drifting: Architecture and Migrancy*, edited by Stephen Cairns, Routledge, 2003 (chapter 8). My thanks to all mentioned here, editors and publishers, for their expertise in many departments, and for their generosity in sharing it with an intruder on their disciplinary shores.

Additionally, I would like to thank Jonathan Bordo for his support of the argument developed in chapter 3; the late Geoffrey Bardon, for his generosity and trust as well as his expert information; Kevin Taylor, principal of Taylor, Cullity & Lethlean, landscape architects (Melbourne and Adelaide), for the invitation to work on the North Terrace (Adelaide) redevelopment project; Christine Adams of the Centre for Contemporary Photography for image preparation; Dr. Judith Buckridge, Allom Lovell & Associates (particularly Ann Gibson), and Jim Webber (Docklands Authority) for information used in *Solution*; Hugh Martin, Ross Bonnithorne, James Basham, Geoff Croker, Mark Damant, and Robyn Merrick (all of Lend Lease) for commissioning and oversighting *Solution*. Edmund Carter created the digital collages for *Solution*; BuroPlus (Melbourne) assisted with CAD renderings for *Solution* and *Tracks*; Trampoline (Melbourne) designed the *Solution* report, as well as the LED arrays used in *Tracks*.

The NSW government's Olympic Co-Ordination Authority commissioned

*Relay* at Fig Grove in October 1998. My thanks to my fellow artist, Ruark Lewis, whose marathon design and drawing effort illuminated a concept and text beyond the everyday; our digital designer, Kate Luckraft; Glenn Allen (Hargreaves Associates); Bridget Smyth, Ann Loxley, and Katie Perry (Olympic Co-Ordination Authority); and Harry Gordon, author of *Australia and the Olympic Games*. Lee Bradbury (McMurtrie & Co. Stonemasons, Orange) brilliantly transformed our digital instructions into lettering. The on-site installation owed much to the dedication of Roy Furtado (Abigroup).

The Australian Centre, University of Melbourne, and latterly the Faculty of Architecture, Building and Planning, University of Melbourne, have accommodated and supported my research—which is also indebted to the Australian Research Council (Senior Research Fellowship, 1994–1998; Professorial Research Fellowship, 1999–2003). Publication of *Dark Writing* was assisted by grants from the Australian Academy of the Humanities and the independent creative research studio Material Thinking (Melbourne).

## INTRODUCTION
## Outlines

*All my world is scaffolding.*
   —GERARD MANLEY HOPKINS, *Spiritual Exercises*

**The Dapple of Things**

When the dark writing that informs our environments is perceived, it can be discerned in everything. The pied beauty of clouds, foliage, and limestone walls comes into view not as a background to important events but offering an alternative focus of its own. The mackerel shimmer of offshore waves, transposed downtown, is crystalized in a hive of windows, while down below the crowds flow cinematically to and fro. Dark writing indicates the swarm of possibilities that had to be left out when this line was taken. It notates reflections, warping the grids of harborside façades into tremulous concentricities. The assembly of shadows, the organization of optical phenomena that resist the light, the look of things that suggests a face, the depth of bodies that cannot be unconcealed—all of these fall under dark writing's jurisdiction. Like the ground, the meaning of dark writing cannot be excavated; it resides in the footstep, the leap and the instant between two strides. It is the dappled history of those marks; its blotches are the signature of time, its litter the resistance of slovenly nature to every attempt to clean it up. Dark writing is complexity's hieroglyph, pointing to what the medievals called the *thisness* of things. It alludes to distance and the difficulty of meeting.

It may be wondered, then, whether the perception of dark writing's abiding presence can have any practical consequence. It changes the way we see things, but can it change the way we *design* them? Writing this book, I have begun to see the straight edges of our constructed environment as narrow pencils of shadow, as dark mortar joining the parts of the world together. But how can the

doubling of appearances, which dark writing transcribes, enter the language of place making? Always gesturing toward other presences, the marks dark writing makes outline other places inside the one we agree to inhabit; written within the enclosures we set aside for public life, they signify forms of communication that resist the self-same logic of linear reason. They suggest patterns of meeting that cannot be represented or prescribed. Transposed to the auditory realm, their scatter and drift, their oceanic ebb and flow, has the effect of many voices speaking at once. Because it always exceeds what can be conventionally represented, dark writing is the discourse of the sublime. But of what use is *that* to planners, architects, and even journalists—all of whom, in the society of the spectacle, are employed to quantify phenomena in a way that dissociates them from the matrix of multiplicity where they belong and excel?

Yet even if designers are complicit in phasing out dapple, in eliminating the background noise of the environment but for which our linear constructions would not stand out, it is with designers that we must begin. Artists, all agents of symbolic transformation, may have signed up to the cult of smoothness, from which every wrinkle of time has been airbrushed, but they remain able to see the supplement of dapple that has been left out. They may not be able to represent the aging of their environment, or the cosmic chiaroscuro—night and day and now the ineffable change of the climate—but they can register these sublimities as blind spots in the present representational regime. Immanuel Kant anticipated this when he hypothesized the "saturated phenomenon" which "refuses to let itself be regarded as an [abject] object . . . precisely because it appears with a multiple and indescribable excess that annuls all effort at constitution [assimilation to an abstract concept]."[1] Confronted with the exceptional, Jean-Luc Marion explains, "the gaze can no longer discern the 'poor or common phenomenality of objects' . . . hence, there arrives 'counter-experience of a non-object.'"[2] The non-object is not invisible. It is what cannot be focused. It is the content of peripheral vision. It is an experience of looking up into a cathedral of tremulous leaves or trying to make sense of the heaven of stars endlessly expanding through the telescope.

It is blinding and, although instrumental reason—the kind of bureaucratized logic that traverses the turbulence of the world like a trapeze artist suspended over the void—cannot countenance it, the creative imagination *can*: "For intuition, supposedly 'blind' in the realm of poor or common phenomena, turns out, in a radical phenomenology, to be blinding.[3] . . . Bedazzlement begins when perception crosses its tolerable maximum."[4] This awareness doesn't have to be the domain of one philosophy. It touches every one of us if we dare to listen to the senses and allow their take on the world to touch us. It is this proprioceptive capacity that artists, and all designers when they permit themselves to be conscious of what they do, put to good use. Even if the dark writing of the world cannot be

represented, its absence can be registered. Traces of what is missing can shine through. There is, as I say, nothing arcane about this fact. Everyone who draws or writes knows that they retrace lines of thought that have already been taken, that their lines if good are wiser than the wit that produced them. Whoever does mathematics, Ernst Mach reflected, "will occasionally have the uncanny sense that his science and even his pencil are more clever than he."[5] The same is true of artists. They often paint more than they intend.

François Boucher's charming personification of Architecture is an example (Plate 1). It is one of sixteen personifications of the arts and sciences, which Boucher painted for his patron, Louis XIV, between 1750 and 1752. Arranging them in eight panels, Boucher presented his allegorical portraits as pairs. It's hard to know whether much should be read into the pairings. Some exploit likeness and difference (Painting and Sculpture), others simply yoke like and like (Fishing and Hunting). Yet others, though, join fields of endeavor that, on the face of it, have no connection. Among these are Astronomy and Hydraulics, and Architecture and Chemistry. Still, even if too much shouldn't be read into the arrangement, the painting sweetly captures the double bind of the designer—who, on the one hand, both designs the world *and* sees how much this design leaves out. The question that the infant architect seems to pose is also the question posed by the painting itself. How, the figure seems to ask, can a drawing represent an object? How does a two-dimensional design drawn on a page become the basis of a building? What flight of the material imagination gives this design its purchase on the world?

This is one question. But to answer it, another, a negative one, has to be asked: How does this act of translation occur *in the absence of a mediating body?* Because one thing is clear in Boucher's design: The little architect is nowhere to be found in either the ideal form of the drawing or the Euclidean abstraction of the column base underneath his foot. An artist there must be who carries out this act of translation, but the shadow of his presence does not fall across the transaction. The architect whom Boucher depicts is left out of the environment he constructs. But this does not mean that his absence cannot be represented. *Boucher shows him there amid the scaffolding of the new temple*—where he can only appear as the personification of an abstraction, where his pudgy milk-smooth flesh signifies paradoxically only the phantom of an idea. This paradox of the unrepresentable body situated at the heart of our designs on the world extends to the composition at large. Because even if Architecture's drawings conspicuously leave it out, Boucher can represent the dapple of an environment that surrounds the architect's endeavor. Rearing behind the rude scaffolding of the portico are the turbulent clouds of a world whose structures, while ephemeral because constantly changing, embody principles of vitality that the lines of the building rule out. Equally, the illumination of the scene, the chiaroscuro that highlights the

little realm of reason within which linear thinking operates, is due to the unseen hand of nature that has, fortuitously, opened up a gap in the clouds where the sun can come through. And all of this natural-seeming composition is, of course, at the disposal of the artist, Boucher.

Boucher's charming design effortlessly captures the enigma of dark writing. Mediating ideal forms and their design on the world are bodies—human bodies, atmospheric bodies and the movement forms they constantly assume and leave behind. Yet the maps, the plans—and the future history they inaugurate, of colonization, territorialization, and the authorization of new political and social orders—entirely discounts them. It is as if Cartesian thinking is afraid of descending into the world of "Hair and Mud and Dirt or any different thing that's very worthless and lowly," as Parmenides puts it in Plato's dialogue. But this cuts both ways. If linear thinking fears the unbraiding of its line of command as it descends into complexity, so it is also anxious to tether the copy to its original—in Boucher's painting, for example, it's unclear whether the child is confidently demonstrating the power of architecture to exercise an influence on the design of the world or nervously comparing the mason's unfinished block of stone with its ideal form. That great poet of "dappled things," Gerard Manley Hopkins, understood this anxiety profoundly: the deeper he went into the thisness of phenomena—"All things counter, original, spare, strange"—the more intensely he felt the need to sheet them back to the unifying creativity of God, "whose beauty is past change."[6]

To recuperate the dark writing of the world is to go both above and below the line of disembodied reasoning that currently mediates our design on the world. It is to put the figure of the architect back into the picture. But in what way? You see that there is a child mediating the passage of lines into the world. But there is also Boucher, the artist, depicting that figure. The architectural drawing in the picture may look like an ideal form, but it is the offspring of the artist's hand and eye. It materializes a yet earlier idealization. In other words, there is inside the outline a history of drawing. The lines on the map, the outlines on the urban plan, may pose as the minimalist representations of pure ideas, but they contain within them a history of earlier passages. Nothing is more repetitive than a straight line, as any railway commuter will tell you, but it nevertheless possesses movement. It traces the intention of the one who made it, and anyone who travels that line again retraces the track of the tracker. It's in this sense that *Dark Writing* brings bodies back into our designs on the world: not to insist on a neglected interiority but to recover instead a movement that occurs in-between the makers of marks and the marks they make. This is the realm between Boucher the painter and the child Architecture. It is simultaneously a movement of mind and body, of idea and gesture.

### Stepping Stones

To look for the last time at Boucher's vignette, you can see the movement I am talking about inscribed there. It is in the mid-stride of the child as he extends his left leg experimentally, as if about to take his first step in the world. In that instant, he contemplates the heuristic value of the drawing he holds up: will it, can it, yield solid ground on which to advance? And yet, of course, the medium of painting demands that this seeming movement prove illusory. Eternally poised, Boucher's child gestures toward a movement form that cannot be represented. Our world is composed of the traces of movement, but our representations conceal this. Our thinking is a movement of the mind, but our forms of thought are static. Whether it is the outside world or the inner world, we write about it and draw it as if it were motionless. Look at geography's maps; you would never guess they were the cumulative trace of many journeys. Or look at the drawings architects make; where are the performances of everyday life that their diagrams are meant to foster? Thinking about the places we make for ourselves is similarly inhibited. In fact, we seem to think much as we draw, in straight lines and flat planes. To get from one place to another involves a leap of the imagination. Even those who believe that rational thought advances step by step cannot deny that thinking begins in an orientation to one's human surroundings. But nothing of this provenance survives in what is counted as knowledge. We think as we draw, creating self-enclosed figures, cut off from one another and from the history of their coming into being.

Like photographers taking care their shadow does not get into the picture, we absent ourselves from the scene of discovery. A description of the world is accounted most authoritative when it contains no trace of the knower. Invention means to come across something, to fall in with it, but our inventions are presented as ruptures with the past. They spring out of nothing to offer us new choices—new landscapes to command. Maps do this with their alluringly complete coastlines and calligraphically consistent ranges and rivers. But so do the designed places of urban planning with their suddenly complete patterns of paths, squares, bridges, and roads. Nothing moves in these ideal representations. They are theaters from which the possibility of anything happening has been removed. To walk in them is to be an actor in someone else's dream. How remarkably silent our graphic descriptions of the world are: no breaking surf is heard in them, no animated conversation, no reports of gunfire or anguished whale song.

Could a richer animation be possible? Could we read—and write—our environment in a way that did not mummify its dynamic character? As it is, animation is a preoccupation of our science, for the odd thing is that the line drawings in which we display our design on the world demand a commentary that will

belie appearances. The journals of the colonial surveyor are an early example of this. They contain a record of encounters that are nowhere to be found in the completed chart—or so it is said, although in *Dark Writing* the traces of a movement history embedded in the map *are* recovered. A contemporary case is the drawing practice of architects, landscape architects, and planners; because they depict dead cities and untenanted places, they have to be animated with words. But while it tries to conjure up images of people meeting—women walking strollers, men purposefully clasping briefcases—the rhetoric of designed place making cannot conceal its death wish. It presents all forms of dynamic interaction as in some way exceptional—as if the general condition of places is to be empty, without memory, bare of desire.

*Dark Writing* is about a double movement that shapes our being in the world but which our representations oddly bracket off. It is about the way in which we figure forth the places we inhabit. This involves two operations: a way of thinking and a way of drawing. To figure something out means to think figuratively. It is to associate formerly distant things on the basis of some imagined likeness. It is to draw together things formerly remote from one another. The line of such thought represents a movement, a dynamic contraction that cannot be adequately represented by the dimensionless line of cartography. To think figuratively is to inhabit a different country of thought. In this, the ground cannot be taken for granted as a uniform and flat plane in which the ideal figures of thought are incised. The environment of figurative thinking possesses topological properties: it has points that lie far apart but belong together; it also has surfaces that look close together but in fact never meet. It is a world where the laws governing relationships count, and where the value of passages is recognized.

The world I am describing is not hidden. It is all about us in full view. It is the plenitude of other bodies in motion, and the traces these leave. It is the ordinary experience of a public place where an intuition of incalculable opportunities for meeting sustains a peaceable to and fro. It is the discourse of places when they are recognized as dynamic compositions. This recognition dissolves the glass between observer and observed. It does not reduce the distance between people. On the contrary, it was the illusion of science to pretend that distance no longer counted. What it does is open up a choreographic intuition of the organization of parts. Social philosophers argue that Western thought has disparaged the body. The body has been left out of theorizing about the nature of the world; linear maps and unpeopled plans represented a tradition of disembodied thinking. But while *Dark Writing* agrees with this, its emphasis is on the spaces in-between people. Its interest is the mobile body, the body—at once ideal and real—that throws itself into space, and in this way draws the world together.

To draw this world, to represent it and make it available for a richer dis-

course about place making, involves a different engagement with the materials of writing. It entails, for example, recovering the origins of writing in drawing, and drawing in writing. Before they became conventionalized as the vehicles of concepts, letters were the material traces of a mental movement. In Enlightenment thought this idea is transposed to the world of nature, which is imagined as composed of hieroglyphs awaiting decipherment. The character of nature is written in the face of the rocks, in the morphology of embryos, in the fractal formulae of ferns and snowflakes. And it becomes the task of the natural scientist to extract the through line, the graphic algorithm, that holds the key to the history, evolution, and present appearance of natural things.

But this determination to linearize the enigmatic gestalts of the external world depended on extracting them from the matrix of encounter—and, again, absenting the detective-observer from the scene of discovery. In this way the dark writing of the environment was rendered light, transparent, and a double movement was repressed—that of the observer and that of the observed. Fossils, cloud forms, even the faces of people shocked by the sudden appearance of men with guns, they are all forms of impression, all bear witness to something that impressed itself upon them but which is not (and never was) there. It could be the mold of an ancient shell, it could be a blast of wind shaving off edges of cloud, or it could be the deposited trauma of an unprecedented violence expressed in a running footprint. These kinds of evidence cannot be treated as images or representations. They do not represent anything but themselves, a fleeting relationship with the environment, a trace of passage.

To read traces it is necessary to be a tracker—to let the shadow of one's intention fall across the track; it is to become part of the movement. This logic extends to the language of description and the conventions of drawing. There is no outside place anymore. Of course, it has been increasingly accepted that maps are cultural constructions expressing ideological programs. But our point is different: that it does not matter how maps are redrawn unless they are drawn differently. Unless they incorporate the movement forms that characterize the primary experiences of meeting and parting, they continue to territorialize desire even when they seek to establish common boundaries. How can this different writing happen? Is it through a naïve copying of the blotches, smears, and stains that constitute the language of traces? Or is it through a different attitude toward the drawing of lines? In this latter case, the new drawing does not dispense with lines but recognizes their drawing as a movement simultaneously of hand and eye. It is a new reading practice that is advocated, one that preserves what is currently dark in writing and drawing, its style.

And the same logic applies to thinking about the formation of places. Places are made after their stories. They emerge from discourse, from acts of naming.

Nowhere emerges silently. Every act of place design has its double in a spoken or unspoken invocation of place. Even the meanest design figures forth a kinesthetic impulse. Within every line there is a braid of other lines. The one line that emerges from this quiver of intentions is the reduction of a multiplicity of orientations, invocations, and prayers. To be conscious of this is a start. By refiguring the line as a meeting place of ambiguous expectations, as the trace of a mental journey—so that drawing the line is not an act of cutting off and conclusion but a process of directed movement—the discourse of place making would be practically reoriented. The stories told about these lines would not be the animation of the dead but the accompaniment of dynamic forms, and it would be a dialogue with builders, and with the rest of us, the performers of a life in which meanings are not fixed but, like the to and fro of discourse, constantly appear and fade away. Such a world is composed of impressionable surfaces; it retains impressions that when imaginatively recollected allow readers to become the writers of the places where they will be.

**First Pass**

How did our representations of the world become hard and dry? One place to look is in the field of Enlightenment geography. The maps that furnished the spatial authority of empire emerged from a history of journeys. But the collectivity of movement forms they distill is accorded no value. It can be shown that what happened in the process of surveying the world *did* make it to the map—in the form of place names, for example—but these particulars are treated as poetic and of no scientific value. Chapter 1 reverses this perspective and suggests that modern geography's foundations are poetic—and it is geography's myth to suppose otherwise. The inductive sciences—of which geography is one—make use of spatial figures of speech in order to describe the nature of reality. But for geography—which, after all, is the science of describing physical space—these figures of speech are indispensable. The maps we inhabit represent mental geographies—ways of thinking and drawing that idealize the appearances of the world in the interest of saving the appearance of reason. But the ironic result of this determination to reduce the world to an algebra of points and lines is that it opens up abysses both in thought and nature. Only the creative imagination can bridge these gaps in reason.

Chapter 2 stays with the history of geographical thinking, taking a practical example of linear logic found in the map. Perhaps the most prominent—and from the point of view of imperial ambitions the most significant—feature found on maps of new places is the coastline. The continuous line that differentiates a mass of land from water is the indispensable prerequisite of territorial expansion. It is also the geographical generalization—the extrapolation from particular calculations of position—that justifies geography in calling itself a science. But the

coastline is an artifact of linear thinking, a binary abstraction that corresponds to nothing in nature. This would not matter except that the construction of the coast as ideally thin and oppositional has real-world consequences. As a cut in nature, the coastline becomes the favored site of scientific enquiry, but it is also the place where Western and non-Western people are suddenly exposed to one another. As an imaginary place, quarantined off from the normal comings and goings of social life, it incubates strange, and often fatal, performances. The unreason of the antics that cluster along its edge points to the madness inherent in thinking and drawing the world digitally.

At the same time, the reductionism of linear thinking continually produces rebellion. To get on—whether in scientific or human terms—means finding a way to manage change. It is the experience of movement, interaction, exchange, that the idealism of Western reason leaves out. This is paradoxical because the same reason prides itself on invention, the inauguration into the world of new concepts, places, and things. The bodies—agents of those movements that give the world its shape and coherence—are always left out of the calculations. The same is true mentally; in theories of creativity, thinking is treated as an ideal point or line. The fact that thought is a coming together of recollection, imagination, and invention, and that ideas emerge as positions within a larger dance of ideas—this is ignored. Chapter 3 discusses two theories of creativity that wrestle with the incapacity of logical thinking to think change. Toward the end of his life, the philosopher of phenomenology, Edmund Husserl, realized that his theory of ideal forms could not explain how these forms were transmitted. In his *Origin of Geometry* he imagined the interaction of ideas and history occurring through "an act of concomitant production." This idea turns out to be a variation on the much older, Platonic concept of participation or *methexis*. The discussion of these ideas is useful here because it shows how a new thinking (and drawing) practice does not abandon the line but goes inside it. The line is always the trace of earlier lines. However perfectly it copies what went before, the very act of retracing it represents a new departure.

To think the line differently is not only to read—and draw—maps and plans in a new way. It is to think differently about history. To materialize the act of representation is to appreciate that the performances of everyday life can themselves produce historical change. The beginnings of the Western Desert Painting movement at Papunya in central Australia in 1971–1972 illustrate this. The paintings that came out of that place and time, as well as a number of the artists, are world-famous now, but the role played by Geoffrey Bardon, the white teacher who facilitated this extraordinary event, is little known. Bardon's engagement with the schoolchildren, with the adult painters, and with the white authorities was non-linear in every sense. Far from standing outside the creative situation, Bardon cast himself in the role of instigator, play-actor, provocateur, and collector.

He realized that the so-called dot-and-circle style of painting embodied a profoundly non-linearist conception of the environment and of human obligations to it, and that these were rooted in a conviction that the human and non-human worlds were unified through movement forms that were at once mythological, participatory, creative, and recreative.

The key point about the Papunya drawings was that they were both plans, or maps of place, *and* traces of passage. They established the Indigenous deeds of title to the lands from which they had been exiled. They were proclamations of the Law, made manifest through the descent upon the painters of the rights and obligations to preserve the stories of these places that had brought them into being and which underwrote their eternity. Legitimate access to this country was bestowed by knowledge of these stories, and the artist's place there was embodied in his competence to reproduce (to recreate) the constitution of the place through his story. Unlike our maps, though, these symbolic representations were not written in lines. They were transformations of tracks. As Bardon wrote, "[t]he Western Desert viewer seemed to me to understand the paintings as being not unlike imprints on the surface of the sand, which like a person walking could look forwards or backwards, these visual words looking over their shoulder as it were, the orderings of the graphic signs, not following a line as in cursive writing script, but read comprehensibly from any direction in interrelationships seemingly understood as a cluster, or patterning, or aggregation of written forms."[7]

As forms of dark writing that notated a design on the environment, the Western Desert paintings are a challenge to European ways of documenting relationships with place. The story of their recognition and the beginnings of their circulation in a non-Indigenous and uneducated white community is one of reconceptualizing the foundations of Western representation. To retrace what happened at Papunya is to have in one's hands a worked example of how linearism can yield to non-linearist grammars of place making and marking. For this reason the details of Bardon's thought and action in that period are not simply of historical interest but provide a manual to how, in general, we will have to rethink our assumptions about place making. The way we draw and the way we think (drawing one point out to the next) will have to be replaced by a faith in the gap between dots. When this happens, the intervals will turn out not to be empty but embodying instead a rhythm. The passage from one position to the next—and the passes themselves—will acquire interest and meaning. The composition of their intervals presupposes the existence of a rhythmic geography, one that manifests itself as the movement form of a place when it is understood affectively as the trace of belonging. For all of these reasons, chapter 4 occupies a pivotal position in the development of *Dark Writing*'s argument.

The dark writing of change—that experiential manifold of movements and its traces in the environment that our non-figurative linearism is blind to, and

whose meaning it therefore discounts—represents a design on the world quite as powerful as that promoted by the light writing of the scientist and the orthodox designer. But how can it gain recognition in the practical world of place making? Husserl may have theorized a way in which recollection can morph into invention, but in practice our positivistic mindset means that public authorities commissioning new public spaces assume that they spring out of nothing. Chapters 5, 6, and 7 describe three case studies—and three different ways—of combating this attitude. In the first, an opportunity to revisit William Light's canonical foundational plan for Adelaide is described. Light's grid was not an ideal form but a complex synthesis of movement forms both local and foreign. It was dynamic, deliberately incomplete—and when this origin is recollected and the creative intention it embodied acknowledged, the redevelopment of North Terrace can, or should, proceed differently. It becomes possible to incorporate and articulate a hidden ground history of tracks, to choreograph a myriad of informal meeting places, and to reconnect the grid with the folded topography of the hinterland. The formal outcome of this is practical—a new kind of public artwork—and theoretical, a new ichnography or science of reading the dark writing of tracks.

*Solution* is the name of a public spaces strategy developed for a site in Melbourne's Docklands. Victoria Harbour is the result of draining a swamp and redirecting the course of a river. Postcontainerization, it has been redeveloped as a leisure boating, residential, and commercial zone. A swamp is a humid zone without sharp edges. Enlightenment maps, and their contemporary descendants, the urban designer's master plan, have no use for them. They represent the world as ideally dry or wet and allot no value to amphibious environments. However, when such environments are recognized as colloidal systems, this changes. The "World of Neglected Dimensions" in which colloids lie provides a figurative way of thinking about history, architecture, and programming. Colloids are movement forms that model the Brownian motion of people meeting in public spaces. Tending to form tracks and junctions of irregularly stepped surfaces, they suggest the characteristic architecture of lagoons and shallow seas. Above all, they place transformation at the heart of the place-making process. The discovery of this case study is that drawings of public spaces need not represent objects to be built but quite the opposite: their lines can indicate passages that must be kept open. These correspond to the omitted or neglected dimensions of movement that constitute the place historically, performatively, and by design as a place of constant exchange.

The third case study goes back to a question posed at the beginning of chapter 1 and considers it in the context of making a public artwork celebrating sporting achievement. What would a rhythmic geography look like—one that annotated the journeys that underwrite the map? It would be a history as much as a

geography. But then there is a second question: What kind of history can be written about the instants—those fleeting moments of supreme movement—that form the content of sport? Franz Kafka imagined the history of mankind as "the instant between two strides taken by a traveller," but it might as well be a runner. A history of timing and spacing would have to imitate its subject matter, materialize reading as traveler, and make an athlete of the eye. This at least was the program of *Relay*, a text-based artwork created for the Sydney Olympics. The composition of *Relay* and the distribution of its elements across a large terraced site put back into a landscape design the performative potential that its linearist conception had eliminated. It created the conditions of an informal choreography. Secreted inside what the poetic texts said, though, was another cryptic communication—a dark writing inside the light. In this way, remembering and forgetting were intertwined, the immortal and the ephemeral. A way was found to inscribe jointly a movement of limbs and a movement of mind.

The three case studies respond to the challenges of the earlier chapters. They propose different techniques for drawing and thinking movement back into the design of places. They also respond to the practical precedent Indigenous cultures set, in which geography, performance, and design are different expressions of one constantly renewed act of self-becoming at that place. But it is clear that profound cultural differences cannot be dissolved, and thinking and drawing practices peculiar to one relationship to country cannot be directly transposed to the circumstances of postindustrial place making. Such advances as we make in reintegrating theory and practice, rehabilitating the movement forms buried in our habits of thinking and drawing, will depend on looking for precedents within our own cultural background. The discovery of the figurative basis of geographical thought is one step in the right direction, but the more general challenge is to resurrect the mobile body that our ideal forms of thought and design have hitherto largely banished from consideration.

The next chapter of *Dark Writing* begins this process. It takes three instances in which the absence of the body is noted. These are interesting because in each case the remedy is not to represent the body but to trace its absence. An image of what is not there is not formed; instead, its passage is retraced. Paradoxically, this means that the body—or the bodies of all others—are not imprisoned in the grid of representation but allowed to exist apart from what can be visualized and fixed. In the first case the novelist Charles Morgan meditates on the handwriting of an unknown girl. In the second, the trace of the environment is found in the early photographs of Henry Fox Talbot. Finally, the paradox of tomb paintings is considered: What does it mean to paint images of the living and to bury them out of sight (in the dark) with the departed? In all three cases, the absent body is conjured up through a concomitant act of production. The observers are implicated in what they discern. They participate in acts that try to conjure up what is

missing without destroying it by reducing it to the light writing of classificatory reason. From this it emerges that the dark writing of the body must remain on the edge of sight. It is the mobile and the immersed who write and read it, those who are prepared to take passage (even into death) seriously.

**Blurring the Line**

Some of the material in the first half of *Dark Writing* is a development of ideas first put forward in *The Road to Botany Bay* (1987) and *The Lie of the Land* (1996). The notion of *spatial history* set out in the earlier book rationalized the discovery that the making of colonial Australia (and perhaps all Enlightenment colonies) was a poetic adventure. Frontiers were invented, and then advanced, figuratively. It was one of the ironies of what I called imperial history that it repressed this collective act of bringing space into being. Imagining colonial space like a theater, it was blind to the creative heritage of place-making acts—including physical acts of displacement as well as metaphorical processes of replacement—that constituted the *difference* of colonial history.

In *The Lie of the Land* the poetic constitution of place was lifted from its historical matrix and used as the basis of a new politics, one in which human relations were detheatricalized and their performative nature reactivated—"our footsteps are also footprints, our wanderings are also designs." Walking in the steps of the ancestors is not only to repeat what happened but to participate in making something new. The key terms in chapter 3—Husserl's theory of "concurrent actual production" and the Platonic concept of *methexis*—are also key terms in *The Road to Botany Bay* and *The Lie of the Land* respectively, but this is the first time that they are considered together and their practical implications teased out. The performative view of history, the recognition that making history and writing history are (at least under the aegis of spatial history) one and the same, provides the theoretical framework for a reconsideration of the beginnings of the Western Desert Painting movement in chapter 4.

The first two terms of *Dark Writing*'s subtitle, geography and performance, emerge from this provenance. Their connection with the third term, design, was the result of the way those books were received, for their early readers were not only geographers, historians, or students of culture in general; their poetic logic appealed to artists, composers, dancers, and architects. I was drawn into conversations with a variety of practical place makers who had in common a desire to think our relationship to place differently. They wanted in their various ways to resuscitate a prehistory of movement. They were interested in the ways country and people write back. Above all, they were committed to finding the points of coincidence that might operate as pivot points of a new exchange. These fictions of place, as Arakawa and Gins would call them,[8] could be ephemeral or lasting, unique or repeated, solitary or grouped, but they were places where the graphi-

cality of geography and choreography coincided, where place making and place marking met. The result of this interest was a number of chapters published in different, specialist collections. There, though, the broader poetic thesis underlying these forays into different fields was necessarily obscured. Parts of *Dark Writing* are descended from those earlier publications, but in recasting them, either in part or wholly, the disciplinary lines that separated them have been blurred again.

In the last chapter of *Dark Writing*, geography, performance, and design are brought together through a discussion of a history of the line. Throughout the book the argument is made that an expanded design language will be found inside, not outside, the line. It occurs when the line is reconceptualized rhythmically. The modern line of drawing and thinking has at least two genealogies, a Cartesian-deductive one and an inductive one associated with the rise of the empirical sciences. The Modernists spiritualized or dematerialized the line in an attempt to represent essential forces, but the movement attributed to their lines remained linear, as it were, progressive and ruthless. There was little sense that the line had a history, or, as we might say, a lining, that it was the formalization of a field of traces rather than the outline of a past, present, or future object.

The lining, which is simultaneously the rhythmic geography underwriting the map and the vernacular choreography of other bodies that secures the Brownian motion of the public coming together in public space, is stitched into the garment of representation, but it does not adhere to it completely; there are gaps between the stitches, the hem of the lining is puckered, and the body of it may billow out like a shadow. In other words, the line that surfaces in representations is rhythmically underpinned. This becomes important in discussions about the relationship between representations and the world they seemingly represent. Bruno Latour feels that all the modern attempts to resolve this conundrum philosophically have failed. Instead of thinking of the relationship between Society and Nature (and, in our terms, between thinking/drawing and the environment) as abyssal, instead of seeing philosophy's task as bridge building, he calls us to attend to the "pass" itself.[9] In our terms, he is saying: recognize that you are stitched into the lining of the world, aligned with its field of operations.

But Latour's "transcendence," which privileges passage, or Nigel Thrift's overarching concept of "movement space"—the claim that the contemporary world is entirely a "flow world"—encounter this problem[10]: that the movement they promote as the new ontological ground of thinking lacks rhythm, the counterpointing of motion that would make it discernible and susceptible to manipulation. Geography, performance, and design share this desideratum: that the terrain they recollect, imagine, and invent is dotted, an assembly of survey points, poses, and lines that meet and cross. They deal in movement forms, not pure movement. They notate rhythm. Without this, there would be no content in what

they do. Rhythm is the contraction of movement into physical forms; it makes sense of both movement and stasis. And I suggest that this sense of a rhythmic alignment with the environment has its origins in our earliest projective fantasies. What I christen "the eido-kinetic intuition" refers to a primordial desire to be stitched into the passages of the world. Its explorations supply us with an environmental unconscious, a kinesthetic grasp of the ground in terms of pivot points that prevents the experience of passage from spiraling down into vertigo.

The practical outcome of these reflections on line and rhythm is that our designs on the world need to make room for things to happen. They should be scores that mediate between the abstract and the actual, encouraging improvisation. This is not only a technical challenge. It is a social and ethical one, for the people who come to dwell in these differently designed places will have to take responsibility for arriving and leaving. They will see the cost of the marks they make and leave. They will live constitutionally "in flight." They will have to learn to live in hope and with disappointment. They will have to hope that nothing happens as planned, and learn how to plan for this. This is the serious play democracy might incubate, but to be players it is necessary first that the line be democratized. Learning to read dark writing is part of that process.

## Notes

1. Jean-Luc Marion, *Being Given: Toward a Phenomenology of Givenness*, trans. J. L. Kosky (Stanford, Calif.: Stanford University Press, 2002), 213.

2. Ibid., 215.

3. Ibid., 203.

4. Ibid., 206.

5. Quoted by Paul Feyerabend in *Realism, Rationalism & Scientific Method: Philosophical Papers*, vol. 1 (Cambridge: Cambridge University Press, 1985), 8.

6. Gerard Manley Hopkins, *The Poems of Gerard Manley Hopkins*, ed. W. H. Gardner (Oxford: Oxford University Press, 1970), 69–70.

7. PMS, 127; PAPUNYA, 46. For meaning of abbreviations, see notes to chapter 4.

8. "The fiction of place has no ascertainable dimension. Within and around the body, it can be everywhere at once or localized—inventing, as it goes along, where it is to be next, very much in the manner of fiction-making in general or a nearly wide-open anything goes." (Arakawa Shusaku and Madeline Gins, *Pour Ne Pas Mourir* [*To Not To Die*] [Paris: Editions de la Différence, 1987], 86).

9. Bruno Latour, *We Have Never Been Modern*, trans. C. Porter (Cambridge, Mass.: Harvard University Press, 2002), 129.

10. Nigel Thrift, "Movement-space: The Changing Domain of Thinking Resulting from the Development of New Kinds of Spatial Awareness," *Economy and Society* 33:4 (November 2004): 582–604, 590.

## CHAPTER 1
# Step-by-Step: Geography's Myth

> *It follows that the first science to be learned should be mythology or the interpretation of fables.*
> —Giambattista Vico

> *The history of mankind is the instant between two strides taken by a traveler.*
> —Franz Kafka

### At the Helm

As imperial designs on the world expanded their scope in the latter half of the eighteenth century, and more of the earth's surface was subjected to scientific description, so geographical knowledge also spread. This enlarged field of facts did not, though, exercise any great influence over the way geographers conceived of the foundations of their discipline. Their aim remained much the same: to use the tools of inductive reasoning to reduce the variety of the earth's natural features to certain universal principles. Movement was a prerequisite of geographical knowledge. But it formed no part of geography's representation of the world. Or, if it did, then it was a kind of movement that ultimately brought about its own extinction. As F. S. Marvin, the American geographer and champion of the doctrine of human progress, put it, "the most important general observation we can make" is that "as history goes on, the geographical factor diminishes in importance and the purely human becomes more and more dominant. History as it develops becomes more clearly the evolution of the human spirit. Conditions become modified and unified over the globe, and the mind of man, acting

collectively, more and more determines the circumstances and direction of our lives."[1]

Another geographer, Ellen Semple, has put this point even more strongly, writing that the chief ambition of "the best intellects and energies of expanding peoples" has always been "to annihilate space by improved means of communication."[2] In other words, imperialism, especially in the newly rationalized eighteenth century, involved a spatial sleight of hand. At the same moment as it strove to make space appear—through the occupation of new territories—it also conspired to make space disappear—through the contraction of distance by improved means of communication. This was not only a geographical conjuring trick; it also involved a historical legerdemain, as the annihilation of space also erased from collective memory the history of expansion. Without this spatio-temporal paradox—this operationally convenient but ultimately haunting ability to reduce the world to one great repetition from which the reality of change has been leached out—it would be hard to understand the present-day rhetoric of white settler nations. Their border anxieties obviously reflect a historical bad conscience, but what is more amazing is the stridency with which their pundits insist on autochthonous senses of belonging from which every trace of elsewhere in either time or space is erased.

Maps seem to exemplify this spatio-temporal amnesia. They are, as the late-lamented J. B. Harley showed us, instruments of discourse. The "use of colours, decoration, typography, dedications or written justifications of their method," not to mention "[t]he steps in making a map—selection, omission, simplification, classification, the creation of hierarchies, and 'symbolisation'"—are all inherently rhetorical.[3] But Harley's Foucauldian conclusion—that "all knowledge—and hence cartography—is thoroughly enmeshed with the larger battles which constitute our world. Maps are not external to these struggles to alter power relations. The history of map use suggests that this may be so and that maps embody specific forms of power and authority"—is not the end of the matter. Maps not only enable; they disable. They displace other forms of spatial representation. For example, in 1963, the Yolngu people of North-Eastern Arnhem Land presented the Yirrkala Bark petition to the federal House of Representatives (Figure 1). It used "a repertoire of esoteric signs and symbols . . . articulated according to a pre-existing code or 'underlying template', which is a map of the Dreaming associations of geographical features within clan lands."[4] This, and comparable designs from central Australia (discussed in chapter 4), fold into their designs a spatio-temporal consciousness no Western map can rival. Yet in mainstream white consciousness they exist, if at all, as aesthetic toys, art objects, the mythic residue of collective dreams.

Maps dispossess others but they also—at least as conventionally read—

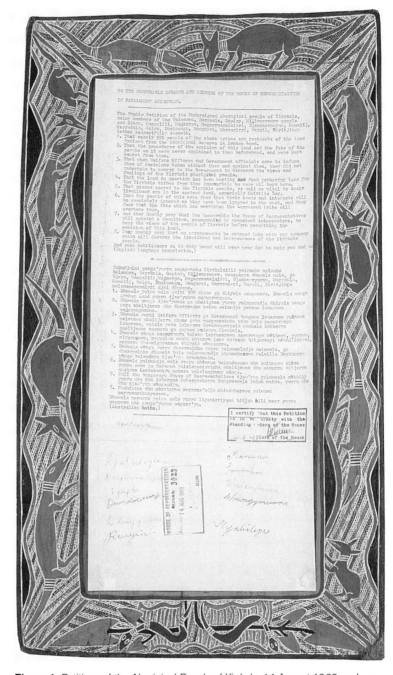

**Figure 1.** *Petitions of the Aboriginal People of Yirrkala, 14 August 1963*, replacement papers glued to stringybark sheets with design painted in pipeclay, charcoal, and ochre, 46.9cm × 21cm, Parliament House, Canberra. Reproduced by courtesy of the House of Representatives, Canberra, and with the permission of the Yirrkala Community.

disable those whose interests they supposedly serve. They disempower us to remember, for example. They wipe out journeys. Their all-seeing panoptic is curiously, and terrifyingly, blind to the history of journeys whose residue is a texture, a ground pattern that identifies the qualitative adventure of a place rather than delineating its quantitive dimensions. Its latitudes and longitudes locate us as stationary observers who, even when we travel—and of what use is a map if it does not let us plan passage?—remain unmoved because the point arrived at and the point left behind are objectively identical. Passage, the subjective amplitude of space, finds no place in these linear scores. Part of *Dark Writing's* aim is to contradict this impression, to show how, read differently, maps *do* preserve the trace of a movement history. But, to begin, the alignment of cartography and Enlightenment geography needs to be acknowledged. For we live in the maps that the colonial surveyors bequeathed us. Inside their cadastral enclosures we have settled down. The roads we drive, the prospects they open up, and the alignment of the walls inside which coming home we agree to reside and sleep are all the linear offspring of those rulers. It is something to reflect that these environs, in which we understand who we are and where we come from, are cultural analgesics dulling history and geography's pain.

Can we live with our maps differently? Could we inhabit our histories differently? These are questions that might be addressed to modernity generally. To ask about the stultification of space is also to raise questions about the arrest of temporal consciousness. To move in space, and to move in mind, both presuppose a dimension prior to cartography's flatland. It is the dimension of passage, which is perhaps a hybrid of our third and fourth dimensions, but which in fact predates their emergence—they are, in reality, geometrical approximations retrospectively thrown over the mobile body and its movement space—to borrow Nigel Thrift's useful expression. Bruno Latour writes that, in ushering in the modern world, the Enlightenment substituted essences for processes. It eliminated as meaningless "passage—literally a pass." "We start from a continuous and hazardous existence—continuous because it is hazardous—and not from an essence."[5] In the same spirit, Celeste Olalquiaga deplores the "spatialization" of knowledge: "Bodies are becoming like cities, their temporal coordinates transformed into spatial ones . . . history has been replaced by geography, stories by maps, memories by scenarios."[6] By "spatialization" she means a theatricalized spatiality drained of process, incapable of incubating change, including its own transformation, a diachronic lifeworld reduced to a two-dimensional diagram in which passage is unthinkable. Events can occur there, but nothing ever happens, and, as T. S. Eliot's character Harry in *The Family Reunion* remarks, "people to whom nothing has ever happened / Cannot understand the unimportance of events."

We talk of geographical *discourse*, but this is perhaps a misnomer, as the explicit object of Enlightenment scholar geographers was to eliminate the discursive trace from their designs on the world. Knowledge would be defined as the removal of the *running hither and thither* that brought it into being. "I have studiously avoided nautical details both at sea and in harbour," Johann Reinhold Forster wrote, explaining the editorial principles informing his recasting of his father Georg's *Resolution* journals. Nor, he continued, "[have I] ventured to determine how often we reefed, or split a sail in a storm, how many times we tacked to weather a point, and how often our refractory bark disobeyed her Palinurus, and missed stays. The bearings and distances of projecting capes, of peaks, hills, and hummocks, of bays, harbours, ports, and coves, at different hours of the day, have likewise been omitted."[7] Forster's removal of "instructive particulars," as he puts it, exemplifies the way in which a record of traveling was turned into geographical knowledge. Applying the principles of inductive reasoning, according to which the acquisition of "distinct Facts" needed to be allied to "the establishment of general principles," the movement history of the voyage is eliminated. So the recovery of a distinctive geographical discourse is the first step if we are to emancipate ourselves from its Platonic forms.

A new geography, one adequate to the task of tracking passage, does not simply restore the passages Forster edited out. It accords them epistemological significance, showing how they were *the way* that new things were found in a double sense. They determined what came into view but also how it was viewed—a point that becomes clear in the next chapter when the relationship between the colonizer's preoccupation with coastlines and the distinctively *coastal* nature of Enlightenment knowledge is explored. The *Resolution* and its helmsman were not drifters; they scored the surface of the ocean. Theirs was a material hydrography, or water writing. The keel was like the pen in cursive or running writing which never leaves the page. Transposed to land, Michel Serres articulates the corollary of this when he reflects on the discretion of his father's agriculture, whose plowshare grooved the land but always allowed for something to be left over, "a margin, a surplus, a swerve."[8] Without this surplus "residual unculture,"[9] Serres insists, there would be no gaps in time or space where things might happen: "We expect to have on hand the swerve, it provides time." It is these gaps in the continuity of space and time that make mobility possible; the swerve "throws us off balance, makes us unsteady. Hence we are on the move."[10] The swerve, like Latour's passage, is a movement trace. It is *geo-graphy*, where geography merges into performance to produce a different design in the surface.

But Michel Serres wrote nostalgically after visiting China and witnessing a bureaucratically controlled agriculture that had remorselessly expanded to occupy every available space. This, he foresaw, was the future everywhere and it

frightened him: "We are destined to the same law, condemned to reason. We are rushing eastwards where fields have no lacunas. Because we will be hungry, and no one can speak out against reason, we are moving lucidly toward a swarm of positivities."[11] We are moving at the same time, he thought, toward the desiccation of thinking, in which signs replace symbols, a process he likened to industrialized agriculture. "[T]he exhaustive exhaustion goes from loam to loess to numbers and codes. In the realm of signs everything is made with a minimum help of ciphering, without cost or waste, loss or shortage, omission or repetition. Without exception the entire flow of numerals uses two markers: a point and a line, the simple difference of zero and one."[12] So one step toward a reinvigorated geography is to materialize its process, to reconnect mapping to drawing, and drawing to running—the primary act of moving across ground.

And the next step is—while accepting the argument that geographical discourse is inherently rhetorical—*not* to discount geography's symbolizations. Instead of regarding the symbolic language of geographical knowledge and its maps negatively, it should be interpreted positively as the last preserve of meanings that cannot be reduced to reason. The realm of the symbol is, in Serres' language, the realm of the swerve. It is where analogues of movement that have not been digitized out of existence can still be found. But these two steps—which the rest of this chapter attempts to map—are really one and the same—or, more precisely, two aspects of the same stride. For, if you materialize the process of the voyage—drawing out the arabesque that Forster attempted to excise—you find that it is made up of successive poses. And every pose, like every footstep, cannot be read in isolation from every other. So with symbols; they are inherently multivalent, on the move, if you like, between one meaning and another. This discovery not only applies to the character of the map, it extends to mental geography as well. For the question of how to represent movement graphically has its counterpart in how to understand the movement of mind. Enlightenment geography tried to rule out passage and Enlightenment reason did the same in the sphere of logic. Consequently, in a period of unprecedented discovery, the possibility of invention—a term etymologically connected with discovery—was in theory at least rendered impossible.

### Leaping Bounds

Palinurus, to whom Johann Reinhold Forster refers, is the name of the helmsman in Virgil's great poem of empire, the *Aeneid*. In his father's journal, on which Johann Reinhold's narrative is closely based, quotations from the *Aeneid* appear, glossing weather conditions and the progress of the voyage. These are culled from different parts of the poem, and sometimes set together to fit the context; occasionally words of the original are even rewritten, as a rhapsode might stitch

together old materials differently to fit the present theme. As if Forster senior were rehearsing epigraphs for a publication that was never completed, Virgil's epic of empire founding is invoked as a kind of self-fulfilling oracle, as a way of lending the first impressions of the voyage the retrospective unity of a survey. In any case, the point is that the literary reference is not mere rhetorical padding, and, in eliminating it, Johann Reinhold is faithfully following the advice of the father of inductive reasoning, Francis Bacon, to subordinate "the skirmishes and slight attacks and desultory movements of the intellect" to "Tables of Discovery."[13] The poetic, associated with the movement of the mind, is to yield to the scientific, represented by the grid or the "Table."

In this case a double reversal is needed in order to recover the movement history that underwrites geography. The excised poetic content must be restored, but then its creative role in communicating the *spatiality* of the journey needs to be identified. In deploying Virgil to lend his narrative a retrospective unity of purpose, Forster senior was already downplaying the poetic basis of his own story, the sense in which the narrative had to construct the passages that would plausibly carry the reader from one place to another. In suggesting that the voyage is bound to succeed in its goals, both Forsters render the role of Palinurus redundant; it is as if the *Resolution* sails by itself. But this is a mistake—one which, oddly enough, the fate of Palinurus in the *Aeneid* alerts us to. There, falling asleep at the helm, the navigator-steersman falls overboard and is lost, his washed-up body later being attacked by the natives of the place. Focusing on the fact that Capo Palinuro on the southwest Italian coast commemorates this mythological event, the twentieth-century poet Giuseppe Ungaretti suggests that Palinurus' fate is an allegory about inflexibility of purpose. In his poetic meditation, Palinurus fails because he identifies himself too completely with Aeneas' imperial *pietas*. His too-linear outlook is linked to his "desire for an absurd, rock-like immortality."[14] By contrast, the helmsman-geographer overseeing our enquiry needs to be alert to desultory movements of the mind as well as to missed moorings.

To identify the poetic substrate of geography's discourse, a way of reading is needed that can resist science's flattening out of language, its rejection of the figurative way in which concepts are framed. This is the force of the first epigraph, the eighteenth-century Neapolitan philosopher Giambattista Vico's dictum that "the first science to be learned should be mythology or the interpretation of fables." The contradiction at the heart of geography—that its tables of discovery lead to the annihilation of the very thing it proposes to discover, i.e. space—shows that the space invoked is mythical. It is not the temporally and spatially grooved manifold of human and non-human topographies that constitute the operational space of encounter, the space where things happen. It is a mental geography, a

reduction of spatial spread to the "laws" of inductive reasoning. Its ideal space is the blank page of the chart, empty and ready for inscription. To understand geography's myth, a mythology or method for interpreting fables is needed. This is what Vico supplied in his *La Scienza Nuova* (1725), whose fundamental premise was that knowledge was mythopoeic; that is, the world any science described was inseparable from the poetic techniques (the figures of speech) used in its description.[15] The methods human *ingegno* (ingenuity, wit, or inventiveness) used to constitute the different fields of human knowledge were profoundly metaphorical —a metaphor, for example, was operationally a technique for bringing two ideas or *topoi* together.[16]

*Verum ipsum factum*, Vico's methodological assumption that he amplified as "the truth beyond all question: that the world of civil society has certainly been made by men, and that it is in our ability to retrieve its principles from within the modifications of our human mind," was hardly original. Most Enlightenment philosophers would have subscribed to it, while "social and political theorists since antiquity have commonly predicated their notions of homo sapiens on a particular image of man as homo faber."[17] Nor was Vico's fascination with myth eccentric. Men like Bayle, Hume, Montesquieu, and Fontenelle, responding to the rapidly enlarged geographic and ethnographic knowledge flowing into Europe from her American, Indian, and Far Eastern commercial and colonial interests, were confronted with an array of mythic systems that inevitably recalled their own Greco-Roman heritage, and the challenge was clear—to differentiate the logical workings of their own minds from those of the myth-bound primitive.

For Enlightenment thinkers, as Peter Gay has remarked in a telling image, "myth could be sympathetically understood only after it had been fully conquered, but in the course of its conquest it had to be faced as the enemy."[18] In this context Vico's oddity was to regard the poetic logic of myth not as an enemy to reason but as its foundation. Rejecting the Enlightenment idea—itself, of course, a Euclidean figure of speech—of a unilinear progress from *mythos* to *logos*, Vico maintained—and this was the original inflection he lent his *verum-factum* principle—"the essentially mythopoeic constitution of humanity." All cultural creations, including Descartes' much-vaunted geometrical method of reasoning, including even *La Scienza Nuova*, "are recreations of myths."[19]

Vico's philological method of recovering the "poetic wisdom" of the ancients employed three interrelated mental faculties: *memoria, fantasia,* and *ingegno*. Donald Verene explains: "[M]emory has 'three different aspects'; memory (*memoria*) when it 'remembers things' (this is parallel to grasping the composition as a whole, i.e. holding the whole work in mind); imagination (*fantasia*) when it 'alters or imitates them' (the reader closely follows, but alters into his own mind the connections and sequence of things in the text); and ingenuity (*ingegno*) when

it 'gives them a new turn into proper arrangement and relationship.'"[20] On the *verum-factum* principle, Vico's imaginative reconstruction of the ancient sources is undertaken in the same spirit that those sources and the events they describe were originally created. Thus, the "poetic geography" of the ancient Greeks, the mythopoeic technique of bringing into being inhabitable land or territory through the metaphorical extension of familiar terms, employed the same three faculties Vico invoked in his own reconstruction. Indeed an exact, philologically attested parallel exists: the rhetorical *topoi* or commonplaces that eloquence under the influence of *ingegno* arranges into the most pleasing form have their counterpart in the physical *topoi,* or places the poetic wisdom of the ancients creates in the wilderness, thus slowly transforming it into a place for the habitation of men.

The access to poetic wisdom, ancient or modern, that Vico's method provides is based on a poetic view of language. In this, language is not composed of literal signs enjoying a one-to-one relationship with the things (people, places, actions, concepts) they signify. It is made up of figures of speech that evoke things metaphorically. A metaphor or any symbolic mode of speaking of speech differentiates one thing from another, but it also suggests a connection between them. It suggests both likeness and unlikeness. As Paul Ricoeur puts it, "[t]he symbol invites thought" because it is ambiguous or multivalent.[21] These qualities differentiate it from the sign: "all symbols have a sign element within them while signs are not symbols. Signs find their primary identification in their one dimensional, conceptually clear identity, being transparencies which strive for univocal meaning with singular intention. In contrast to the sign, the symbol is composed of polar dimensions to be identified not by univocity but by double intentionality."[22] As an example of multivalency, Ricoeur gives the case of religious sky symbolism in which there is both a literal meaning (characteristics given by the sky, transcendence, infinity, etc.) and a symbolic meaning (sky gods, ascensionism).[23]

Multivalency also characterizes geographical symbolism.[24] For instance, the place names bestowed by James Cook (Forster's Palinurus) or any of his professional successors along Australia's coasts and throughout its interior are prominently ambiguous. Referring to one thing, they palpably suggest a connection to something else. Names like "Mount Deception," "Lake Disappointment," or "Cape Catastrophe" contain a sign element—mount, lake, cape—but the epithets that qualify them transform them into symbols inviting thought. This is because the epithets cross out, as it were, the authority of the sign; a mount that deceives is not a mountain, a lake that disappoints is not a lake, and so on. Names like these do not name, or bring into being, places that conform to inductive principles, lying within a continuum between the familiar and the new. They are attempts to name what cannot be classified. They name places that defy their description as places.

They refer to non-places, and, of course, these non-places are not absences in the landscapes, they are holes in the fabric of language. The "double intentionality" of such names resides in this fact, that they both mark a presence and its absence, they both order the chaos and admit it.

In a more elaborate way, Matthew Flinders, the *author* of "Cape Catastrophe" —for such names should be understood as compressed poems or compacted myths—not only figured forth the contradictory qualities of individual encounters in space or time, but organized whole regions along the same principles (Figure 2). According to Vico, the same *ingegno* that rearranges language to create new topics also furnishes the mythopoeic mechanism of imperial expansion and colonization. The Greeks, he pointed out, named the parts of the world they colonized by analogy with the geography of Greece; they transplanted the distribution of *topoi* within their own homeland and, retaining their original spatial relationships with one another, lowered them over the new localities.[25] But this is also how Flinders proceeded in naming islands and headlands in Spencer Gulf, South Australia. If memory recalled the spatial arrangement of the villages of his native Lincolnshire, then fantasy saw an imitation of that arrangement in the layout of islands and coasts; finally, with the aid of his wit Flinders imposed his own geo-poetic logic on the map, creating a new, pleasingly grouped and arranged *topos*, an object of knowledge fit for settlement.[26]

Maps emerging from these processes are mental maps. They employ a poetic geometry to locate and differentiate places. This is clear when the spatiality of Vico's own thought is taken into account. A spatial metaphor is implicit throughout Vico's treatment of memory. If Descartes' geometrical or linear mode of reasoning "moves forward by a constant and gradual series of small steps," *ingegno*, Vico explains, "is the faculty that connects disparate and diverse things. The Latins called it acute or obtuse, both terms being derived from geometry. An acute wit penetrates more quickly and unites diverse things, just as two lines are conjoined at the point of an angle below 90 degrees. A wit is obtuse because it penetrates simple things more slowly and leaves diverse things far apart, just as two lines united at a point lie far apart at the base when their angle is greater than 90 degrees."[27] By contrast, Descartes' thought is single-minded and centred; it divorces knowledge from the faculties of *fantasia, ingegno,* and *memoria*: "We are not really knowing while we are remembering, for knowledge is by definition an immediate intuition. To deduce something, and to know it, 'means to arrive at it by passing from link to link of the whole chain with a continuous and unbroken movement of thought.'"[28] Descartes' method "is apt to smother the student's specifically philosophic faculty, his capacity to perceive analogies existing between matters far apart and, apparently, most dissimilar," and Vico adds disparagingly: "That which is tenuous, delicately refined, may be represented by a single line, 'acute'

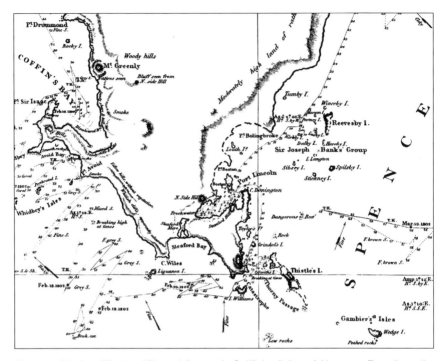

**Figure 2.** Matthew Flinders, "Chart of Spencer's Gulf," detail, from *A Voyage to Terra Australis* (London, 1814). This is a richly "periautographical" chart, representing the life of the Lincolnshire surveyor through his works in the field; thus the spatial relationship of the islands in the Banks' Group roughly reproduces that of the Lincolnshire villages for which they are named (see Carter, *The Road to Botany Bay,* 184–185). Flinders' chart consolidates the coastline by multiplying its iterations—inside the line descriptive words crawl along it and hachured hills shadow it; outside the line the course of the vessel and the concentration of geographical features near the coast reinforce the impression that the subject of the chart is not the objective character of space but the establishment of a geographical feature of singular graphic, cultural, and strategic appeal.

by two. Metaphor, the greatest and brightest ornament of forceful, distinguished speech, undoubtedly plays the first role in acute, figurative expressions."[29]

It is intriguing to imagine what modern maps would look like if they faithfully preserved the trace of Vico's *ingegno*. The most strongly differentiated places would be those that stood at the meeting place of lines that approached at the greatest angle to one another; places that counted would be those that subtended the widest angles to other similarly constituted nodal points. As for the delineation of these knots in the network, they would not be indicated by fine, continuous lines but by an accumulating density of broadly applied brushstrokes drawn with a certain flourish. Maps drawn in this way would bear a surprising resemblance to older Renaissance charts with their lacework of rhomb lines, or, for that matter, to the provisional sketch maps drawn onboard ship during the course

of the survey. In any case, what these differently drawn maps preserve, which post-Enlightenment cartography exquisitely lacks, is *memory*. "Mythic-Symbolic Language," according to Ricoeur, stages man's subjective consciousness of his being in the world. Ricoeur focuses in this connection on the symbolism of evil. Man has a primary sense of the Fall, a sense of inadequacy, call it mortality or fate: "Myth, on the existential level, may be understood as the product of unhappy consciousness,"[30] and its language carries forward the memory of that primary reflection on the human condition. Vico championed mythopoeic logic in the same spirit. If memory with the aid of imagination is essential to invention, then whatever is produced preserves a movement of mind. But, evidently, in the case of geography's provisional markings on the blank page of the map, or its equally circumstantial place names, it is also the history of a *physical* passage that is traced.

Understanding the mythic-symbolic language these products of *ingegno* represent, we are in a position to measure the cost of what modern maps leave out. In annihilating space, rendering it everywhere the same—continuous, unbroken—they repress the movement history, the heritage of passages, and all their hazards, that went into its production. But this is not simply the unfortunate side effect of a technology that for most operational purposes is a decisive advance on older systems of spatial representation. Ricoeur explains that the "reflective knowledge" associated with mythic-symbolic language, or what Vico calls "the interpretation of fables," is essentially different from the "linearity of symbolic logic" associated with the dimensionless lines of the modern map: "Reflective philosophy is a philosophy of the concrete" because "[t]he symbol and the myth are the result of an occasion or occasions, distinguished by the particularities of time and space."[31] By editing out the occasions of knowledge, the contingency of coming across things is forgotten, and with it all the history of things not found, or found and lost. As Michel Serres puts it, "[r]eason does not introduce evil, but excludes it. Western science is born of this exclusion. It emerges from the tragic. Its fundamental categories come from it: purity, abstraction, rigour."[32] The price of abstraction, the option of a formal logic, is the loss of concrete human expression. It is this concrete expression, the sense of an existence poised between expectation and limitation, that the explorers' oxymoronic names poetically figure forth.

When the movement form darkly embedded in geographical discourse is forgotten, so is our capacity to change the maps of the places where we live. In the introduction, I referred to spatial history's double readership. On the one hand, it speaks to geographers, spatial historians of different kinds. On the other, it resonates with choreographers and performers of many kinds, as well as those designers who produce more lasting marks on the ground. But this split readership is a post-Enlightenment disciplinary artifact. It offends against common

sense and disperses the obvious common interest of the parties. And it may be said to spring from the repression of geography's *ingegno*. The notion that geography's representation of the earth's surface possesses (or approaches) an absolute correctness—and even the most radical postcolonial revisionists do not contest the practical correctness of maps—means that they appear immune to further change. They are timeless and placeless, or, which amounts to the same thing, they belong to the unchangeable past. We can use maps to locate new things. We can design new places using the same cartographic conventions to draw our plans, but we cannot intervene in them and radically undraw them or undo their lines.

And what this means is hinted at by Donald Verene, who, with Vico's association of invention with memory in mind, writes, "What the moderns lack, what Descartes did not give us, is memory."[33] Memory is what our mythic-symbolic language preserves, and, as Ricoeur indicates, it is specifically a memory of our desire for freedom, of our perennial longing to make a place for ourselves in the world. It is because this primordial reality is forgotten, according to Verene, that our society fetishizes free choice. If we cannot remember the struggle to be free, poetically embedded in the institutions of thought, then we have no choice but to believe that we can freely choose. But evidently this freedom is illusory, a kind of collectively self-willed amnesia brought about by our unquestioning submission to the authority of abstract reason. "Memory is forgotten by the modern world as our attempt to release hope points us toward the future. The future for the modern world is the present become more extreme. There is no basis for the preparations for the future except the perfection of the method and the talk of choice." So, Verene concludes, "[t]he constant talk of choice becomes applied ethics, which masquerades as civil wisdom in the age of anxiety."[34]

### Geography's Myth

Now that we have to hand a way of reading the "logically inferior" language of metaphor and image, we are in a position to characterize geography's myth. This manifests itself at two levels. At one level geography, together with the other emergent Enlightenment sciences, embraces the *myth* of scientific description. "The grammarian-analyst," Michel Serres writes, "willingly banishes myth, poetry or literature because of their confused or obscure or, at the very least, shrouded contents, because he seeks the clear and distinct."[35] But, as we have just seen, it is *not* scientific to dismiss the mythic-symbolic memories of passage embedded in geographical discourse, because if we do we tend to destroy the very domain that we sought to understand. This is why Ricoeur emphasizes the importance of a "heuristic structure to interpret this distinctive kind of language *without destroying it*."[36] Our reading of place names—and, in the next chapter, our interpretation of the cartographer's graphic marks—are intended

to have this heuristic structure, as they certainly serve to discover something about these human artifacts, and do so without banishing them from further consideration.

A recognition of this first level enables us to understand Forster the younger's stratagem in interpreting and editing his father's *Resolution* journal. He is seeking to eliminate all those parts of the text that figure forth the experience of passage, the process of coming across things, for these experiences display *ingegno*, and it is precisely the play of the imagination that the step-by-step progress of inductive reasoning is meant to supersede. A paradox produced by this editorial process is that the process of discovery is curiously disowned; that distinctive environment of darkness when preliminary impressions are forming and being constantly revised and discarded is excluded as, presumably, irrational. Trying to imagine how the chains of association that characterize dreams are triggered off, Freud imagined the preconscious "aroused, experiencing no doubt a simultaneous exploring of one path and another, a swinging of the excitation now this way and that, until at last [the dream wish] accumulates in the direction that is most opportune."[37] Without much modification, that could be applied to the state of mind of Forster's Palinurus as he finds himself at the mercy of his "refractory bark," having to follow its inclinations until at last a providential path is opened up.

Freud is trying to represent a constitutionally confused and confusing process, but this, as Serres suggests, is exactly what the new science of reason wants to eliminate. It is the dark inscription of these simultaneous explorings of one path or another that the discourse of facts and events wants to repress. It wants to give the impression that it writes over a blank surface, rather than one that is corrugated, hollowed out, tilted, here rough, there tender. But Freud's spatial figure of speech—and he emphasized that his representations of mental processes were only metaphors—also delivers us to the second level at which geography's myth operates. What passes for physical geography is, as our interpretation suggests, mental geography. The universal projections used to represent the spherical globe two-dimensionally are geometrical figures; they create an ideally uniform and continuous surface where the surface of the world can be displayed and all its parts simultaneously reviewed and brought into communication with one another. But this is not the end of the construction. The content of the maps also represents a mental geography, an ideal ordering of spatial phenomena. And what is true of maps is true of geographical discourse in general: it is an idea of space that drives it and not the willingness of the naïve observer to take whatever she finds as it comes.

*Geography, like its fellow sciences, thinks spatially.* That is, it uses spatial figures of speech to communicate its ideas. Unlike the other sciences, though, geography, as a science of space, is not in a position to treat the spatiality of its own

thinking as purely figurative. For the question arises: If geography could think non-spatially, how could it think space? The corollary of this is that geography has no choice but to think figuratively, spatially; how otherwise could its distinctive domain exist? Its mythic-symbolic substrate is not an archaeological relic of an earlier state of development but permeates the foundations of the discourse, even when it has been rigorously refounded.

Spatial metaphors run throughout the expository writings of late eighteenth-century and early Victorian philosophers and scientists. And, as soon emerges, these metaphors have a distinctive landscape. For example, when Jeremy Bentham describes "the affection of sympathy . . . advancing with experience and mental culture into a widening field of action. Its links become multifarious, and capable of great extension. They spread into divers circles—domestic, social, professional, civic, provincial, national"[38]—we understand that the geographical figure of speech is metaphorical. It is not *entirely* metaphorical; the radiance of reference—Bentham's test of civilization—is certainly spatial, but primarily Bentham refers to an enlargement of the affective, intellectual, and cultural horizon. Or, to take another deliberately complex passage—Darwin's meditation on a "tangled bank." The arrangement of "plants of many kinds, with birds singing on the bushes, with various insects flitting about, and with worms crawling through the damp earth" is not simply a figure of speech designed to help us grasp the laws of growth with reproduction, inheritance, and variability. Their spatial arrangement—"so different from each other, and dependent upon each other"—*is* a literal outcome of evolution.[39] At the same time, though, the main object of the image is to figure forth invisible principles, and it is the science of these that we are meant to grasp.

These spatial figures of speech pose as purely illustrative, but obviously an idea of order is written into them. The physical environment conjured up is one in which lines may be traced outwards from a point, where unity expands step by step to embrace diversity. A logical landscape is being invoked, one that offers an analogy to reason. The organization of this landscape becomes explicit in William Whewell's *History of the Inductive Sciences*, which, in order to show the progress of each science as particular facts are combined to form general truths, features "Inductive Charts" (Figure 3). As Whewell explained, "[t]he Table of the progress of any science would thus resemble the Map of a River, in which the waters from separate sources unite and make rivulets, which again meet with rivulets from other fountains, and thus go on forming by their junction trunks of a higher and higher order." Whewell suggests that these periods when the mental landscape wears a progressive appearance might be contrasted with those other epochs where a protracted wandering has occurred without advance. In these periods, speculative ideas flourished, deductive reasoning dominated,

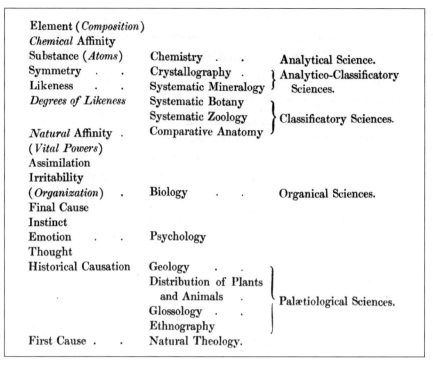

**Figure 3.** William Whewell, "Inductive Chart," detail from *The Philosophy of the Inductive Sciences*, vol. 2 (London: John W. Parker, 1867), 117. Through the "consilience of inductions," the "collection of particulars" is meant to converge on a few simple generalizations. But, as Whewell's "table" shows, this rarely happens. What happens instead is that a few fundamental observations generate a growing number of "sciences." In fact, inductive reasoning encounters the same problem Plato did when he tried to understand the relationship between the One and the Many. Thus, Whewell says that his "tables" may look like "the genealogical tables by which the derivation of descendants from a common ancestor is exhibited; except that it is proper in this case to invert the form of the Table, and to make it converge to unity downwards instead of upwards, since it has for its purpose to express not the derivation of many from one, but the collection of one truth from many things" (William Whewell, *The Philosophy of the Inductive Sciences*, vol. 2, 76).

detached from a "conjunction" with "distinct Facts." Notions emerging in this way might be internally consistent but they could have no scientific value. They "are like waters naturally stagnant; however much we urge and agitate them, they only revolve in stationary whirlpools. [Only] when our speculations are duly fed from the spring-heads of Observation, and frequently drawn off into the region of Applied Science, we may have a living stream of consistent and progressive knowledge."[40]

In each of these writers, the Utilitarian moralist Bentham, the natural scientist Darwin, and the historian of science Whewell, the structure of inductive reasoning resembles the spatial organization of a part or a whole north European

landscape. Would Whewell have said the comparison was purely illustrative? Then Michèle Le Doeuff, who has studied the persistence of figurative language in scientific discourse, would certainly disagree. Whewell's figure of speech may pose as a teaching device useful, as Le Doeuff puts it, because of a fortuitous congruity with a concept but "extrinsic to the theoretical work,"[41] but in fact it is hard not to feel that the congruity *precedes* the comparison and that generally the mental geography informing Enlightenment science was so embedded in everyday expression as to be unconscious. When, for example, Leibniz explained that "he who advances without reason is immediately lost," plunging "into morasses and shifting sands of doubts without end, wherein is nothing solid nor firm," adding that the philosopher's responsibility was "to make known the roads and to repair them: and finally to travel slowly, but with a firm unwavering tread, by the side of that pure and living stream of clear and simple knowledge, which has its source among us, which can serve as a comfort on our painful march, and as a thread in the labyrinth of these vast overgrown territories"[42]—he perhaps thought he was using a geographical figure of speech so intuitively recognizable as to have no methodological significance. But that, as Le Doeuff argues, is the point: philosophy's status depended on "a break with myth, fable, the poetic, the domain of the image," yet the study of knowledge continued to rely on "a whole pictorial world."[43]

But—to return to our topic—even if, in most fields of study where inductive reasoning is used to advance knowledge, we disregard what Le Doeuff calls the "shameful face of philosophy,"[44] this discretion can hardly be extended to geography. In that domain the facts and the method used to organize them repeatedly turn out to employ the same language—concepts and figures of speech fuse, *mental* geography and the goals of physical geography embodying the same cultural, ethical, and economic values. In *The Road to Botany Bay* I documented the confusion early white explorers, surveyors, and miscellaneous travelers and settlers felt when the Australian landscape failed to match their topographical preconceptions. These were not naïvely experiential preconceptions—as if the ground somehow continually tricked them; they were logical or conceptual. The delirium—etymologically, the sense of being out of the furrow and therefore, with Serres' plowing meditation in mind, with no reason to be on the move—was mental. The morasses, shifting sands, and stationary whirlpools (or at least billabongs) were not organized in the manner of Whewell's river. Not going anywhere, they could not be conceived in terms of linear progress. They could not be narrated; resisting the step-by-step advance of orderly reasoning, they could not be *thought*. This is why explorer narratives repeatedly turned into moral and intellectual dramas. Explorers did not simply encounter baffling environmental conditions. The grounds of their reason were attacked. In passing a moral

judgment on the country they traversed, they were defending the integrity of the mental landscape they carried with them.

Environments that had not been subjected to centuries of European cultivation, and whose climatic regimes also differentiated them in other ways, were not simply "unthinkable" and "indescribable" because they offended European taste. They challenged the ideally logical mental geography that the explorers carried with them, one which the unconscious spatiality of their discourse had profoundly embedded in their modes of thought, their chains of association, and their systems of assigning value. What I find interesting about this ontological unbalancing is not that it produced the well-documented, and humanly as well as environmentally destructive, mismatch between colonizers and the colonized. The negative history of the incapacity to conceive of environments and cultures logically arranged according to different principles has been the tragedy of colonized peoples from the earliest times, and the burden of postcolonial writers in our time. More to our purpose is that the encounter with terrains, cultures, and languages that did not stand to reason forced some amongst those charged with widening the field of reason to reflect on the flimsiness of inductive reasoning's foundations (Figure 4). They rediscovered the truth that even Francis Bacon could not ignore, that when it came down to it, inductive reasoning advanced poetically by way of the collection of analogies.[45] For, *"whatsoever science is not consonant to presuppositions, must pray in aid of similitudes."*[46]

Geography's myth, which it shared with other domains of scientific enquiry, was that it could advance without similitudes. But what further curtailed its claim to give a dispassionate picture of the field it covered was that the great majority of its figures of speech were spatial, and indeed often explicitly topographical. To think about "instructive particulars," which in inductive reasoning meant putting together enough of them to permit generalization, was, in effect, already to imagine the physical landscape in terms of a mental landscape characterized by linearity. In this sense nineteenth-century Australian explorers did not steer a course through trackless wildernesses; insofar as they made progress, they retraced a line that was already there, and every rhetorical and picturesque device employed to persuade readers that the passage had indeed fulfilled expectations and reached a decisive destination was intended to show that they had advanced step by step. The linearization of the landscape had the object of discovering a decisive direction, a horizon point toward which the landscape features seemed oriented or likely to converge. In looking for a way through, one ideally aligned with the natural lie of the land, explorers were like Florentine artists organizing the milieux and the objects they depicted around an ideal vanishing point. But this alignment of observer and world also worked in the opposite direction, as it immediately gave the impression of a world organized with the viewer in mind.

**Figure 4.** "Map of Lake Eyre South and Environs," detail from *Gazeteer, Map of South Australia* (Adelaide, 1869). It is interesting how in reality the "indistinct" did make its way into maps that purported to deal with the "clear." In this map of characteristically "featureless" land north of Spencer Gulf in South Australia, the effect of collating various earlier surveys is to produce a mythopoeic landscape that would not be out of place in a work of utopian fiction. Names like Illusion Plains, Lake Hope, Mount Attraction, Decoy Hill, Mirage Creek, Mount Delusion, and Welcome Springs attest to the same existential discovery of the ambiguity of appearances that is also manifest in such cartographic graffiti as "Numerous Natives," "Conspicuous Sand Banks," and the like. These are symbolic terms, dark writing preserving not so much a prehistory of settlement as its necessary and abiding shadow.

When the environment seemed to turn away, one felt correspondingly lost. This explains why, in colonial travel writing, fertile prospects always *smile,* and *welcoming* country generally is anthropomorphized as wearing a face.[47]

But the evidence of the journals, particularly of unpublished drafts, and of the provisional maps appended to them, is that no line, no gathering swarm of orthogonals all pointing in the same direction, existed. Represented instead is a spatial history composed of gaps. The courses of supposed rivers die out and reappear elsewhere. Necklaces of dots stretch between horseshoe-shaped capes, but their catenaries are cartographers' wish fulfilments, as the vessel has not sailed close enough to the coast to see anything. It is a world of half-things—ranges that, observed from one side only, appear on the map as caterpillar hachures without width or body. The annotations confirm this impression. They are mainly speculations. Like the arrangement of the writing itself, they seem designed to give shape to the intervals, to choreograph spaces whose reason appears to be rhythmic, calligraphic. Nor are the survey lines any more positive; the thickening network of triangulated points beautifully annotates the gymnastic of the expedition, the discursive back-and-forth zigzag essential to plotting the terrain. But its growing collection of instructive particulars does not allow any generalization about what may be beyond the edge of the map or the misty terminus of vision.

### Reason's Abyss

How then to get on? According to John Ruskin, the deity presiding over the nineteenth century was the Goddess of Getting-on.[48] Evidently, then, the stakes were high. Learning to put one foot in front of another was not simply a task for philosophy. Nor was it just a therapeutic technique for people overwhelmed by the flat expansiveness of modern spaces. Had Alexander the Great made the mistake of pausing, Franz Kafka speculated, "he might have remained standing on the bank of the Hellespont, and never have crossed it, and not out of fear, not out of indecision, not out of infirmity of will, but because of the mere weight of his body"[49]—the moral of which seems to be: hesitate and an empire is lost. No wonder explorers were keen to fall in with navigable rivers. Whewell's "Map of the River" may have been a geographical figure of speech to describe the concept of scientific progress, but it presupposed the territorial ambition of rivers themselves, their desire to bring all parts into a tributary relationship with the leading power. But here was the rub: Rivers, and even associative trains of thought, might possess an unconscious volition, enabling them to slip snakelike through themselves into other states while logical thought was less cursive, more pedestrian, less fluid, and more staccato. How could one step lead to another unless one knew in advance the direction of one's thought? The choice

of Leibniz's philosophical traveler to walk beside the "pure and living stream of clear and simple knowledge" is quite strategic. Without its natural inclination to flow in one direction, the idea of advancing with a "firm unwavering tread" would be unthinkable.

In practice, of course, the novel landscapes of colonization were not trackless. Almost every part of Australia was crisscrossed with Aboriginal pathways. In the absence of these—or where the explorers or pastoralists could not make them out—Aboriginal "guides" were entrusted with deciphering them. These evidences of previous passage did not necessarily lead anywhere—there was certainly no reason to think that the Indigenous scouts shared the expedition party's keenness to thread the eye of the horizon—but they provided an alibi for taking one direction rather than another.[50] There were many land passages made without these indications, where European travelers steered by compass and sun and star positions as if at sea (Figure 5), but even in these tabula rasa environments the explorers were on the lookout for signs of Indigenous presence, not only for defensive reasons, but because without this even the resolution to continue walking in a straight line rapidly lost any semblance of reasonableness. In short, the Indigenous design on the land provided the unconscious ground of reasonable progress. The collective dream wish, to borrow Freud's phrase, did not simply accumulate until a direction presented itself; in bursting into one region rather than another, it flowed into the runnels and grooves already inscribed in the spread of a different human environment. The movement form, or prehistory, of the experience that formed the survey was not a ruled line; it was more like the process of osmosis, a capillary action throughout a zone of possible connections.

But this dependence on what lay outside reason's capacity to predict had to be denied. Even if the gaps between things constituted geography's distinctive terrain, these had to be repressed. By definition resistant to inductive principles of reasoning, they represented reason's abyss. Every great conundrum in Western philosophy was caught up in the little question of how, logically, to advance one step. To depart from one's ideally stationary position was to wonder how Being entered the world of Becoming. It was also to experience practically the migration of the One into the Many. In *An Investigation of the Principles of Knowledge, and of the Progress of Reason, from Sense to Science and Philosophy* (1794), the theoretical geologist James Hutton explained: "In scientific reasoning, knowledge is produced by steps; in each of these a principle is acquired on which to proceed in reasoning, and thus acquire a further step. It will then appear, that, in science, there is no certainty without seeing every step."[51] But if the image of advancing step by step is not simply chosen for its "congruity" with an idea, but is, in fact, how logical thinking is supposed to work, then it remains to ask: How is the first

**Figure 5.** William Dawes, "Map of New South Wales," detail, 1792, in John Hunter, *An Historical Journal of the Transactions at Port Jackson and Norfolk Island* (London, 1793). Dawes preserves the precartographic period of track making. In his 1792 map, he draws lines that range from the cartographically fixed to the purely ideal ("Track intended"). In between these extremes are delineated actual tracks taken, the zigzag incipient diagonals of the survey, and putative landscape features. It is interesting that the words "track" and "tract" are apparently used interchangeably, suggesting an ambiguous state of settlement, in which the wandering lines of journeys had not yet joined up and turned into boundaries. In any case, "Dawes' zigzag tracks graphically represent discursive spaces. Only when these have been replaced with continuous lines, and territories defined, can the land quieten down" (Carter, *Ground Designs and the New Ichnology*, 277).

step taken — unless it is precisely by imagining thinking as a kind of bipedal motion in which the internal momentum of the body once set in motion carries the thinker-walker forward?

But to think bipedally is inevitably to construe the line in terms of a succession of strides or paces. Bipedal thinking is not a matter of placing one foot in front of another. It depends on a counterpoint of small leaps and small landings, the intervals between steps as well as the imprint of the steps in the sand. If the footprints represent facts, the intervals are born of similitudes. Whether they admitted it or not, inductive thinkers proceeded by way of analogy. Imaginative leaps were the ground of their firm and steady tread from fact to fact

until a direction that could be generalized emerged. Recognizing this, Edouard Von Hartmann, author of *The Philosophy of the Unconscious* (1884), argued that while inductive logic entails what he calls "rational intuition . . . the Pegasus flight of the Unconscious, which carries in a moment from earth to heaven," the "deductive method" associated with Descartes is "only the lame walking on stilts of conscious logic." Von Hartmann explained his own figure of speech in this way: "Each putting of the foot to the ground forms a point of rest, a station . . . which produce[s] a conscious idea. . . . The leaping or stepping itself, on the other hand, is . . . something momentary, timeless, because empirically falling into the Unconscious."[52]

In a comparable way, geography operated with an environmental unconscious, that entire domain of dark writing that constituted the spread of the land. The idea of an environmental unconscious is a projection of colonial distance that leaves out the omnipresence of other peoples and systems of environmental organization. Still, it is a helpful first step. It helps explain how scientists could get on. To reduce the world to reason was to make it a mirror to the rational mind. While inductive thinkers were determined to exclude Vico's triad of faculties (*memoria, immaginazione [fantasia],* and *ingegno*) from the exercise of logical thinking, they could not avoid the fact that the world they described must be a construct of reason itself. So any knowledge of the world involved discretion; one had in a sense to forget the operations of reason, to hold the mind open to the world long enough for perceptions to penetrate it. In other words, to reason consciously, it was necessary to be un-self-conscious as well. James Hutton's biographer, John Playfair, remarked that Hutton held that "there [was] no resemblance between the world without us, and the notions that we form of it."[53] He also allowed that "[t]he world . . . as conceived by us, is the creation of the mind itself, [it is] of the mind acted on from without, and receiving information from some external power."[54] Thus, "our perceptions being consistent, and regulated by uniform and constant laws, are as much realities to us, as if they were the exact copies of things really existing."[55]

What does this mean? Did Hutton espouse a kind of parallel world theory of knowledge? If not, how did "the world without us" communicate with the "world . . . as conceived by us"? What was the medium of translation? Playfair described Hutton's scientific genius in these terms: "with an accurate eye for perceiving the characters of natural objects, he had in equal perfection the power of interpreting their signification, and of decyphering those ancient hieroglyphics which record the revolutions of the globe."[56] Few mineralogists, Playfair declares, "[have] equalled him in reading the characters, which tell not only what a fossil is, but what it has been, and declare the series of changes through which it has passed."[57] Further, "[n]one was more skilful in marking the gradations of nature,

as she passes from one extreme to another; more diligent in observing the *continuity* [italics in original] of her proceedings, or more sagacious in tracing her footsteps, even where they were most lightly impressed."⁵⁸ Hutton could form a notion of the outside world because nature was a book; of course, they wrote differently there—in "ancient hieroglyphics" and cryptic "characters"—but the fact that the traces of intelligence could be tracked there—this was the intuitive hypothesis without which the progress of knowledge was impossible.

In other words, the unconscious—whether it was the Unconscious (pre-Freudian as well as Freudian) or the environmental unconscious of geography—was *prescribed*. The meaning of the phrase *tabula rasa* is loosely invoked to describe the blank ground that modernity invokes to justify its myth of progress, but it refers in fact to a board *scrubbed clean*. "To erase is to destroy by additional covering: they coat the surface of a whitewashed official tablet anew, and, once the lines condemned to disappear are covered up, there is a space ready for a new text."⁵⁹ In this way the light writing of science writes over the dark writing of the world. To judge from Playfair's account, what is lost in this translation is the symbolic richness of the older text. Nature's hieroglyphs—in contrast with the letters of the Roman alphabet—exhibit the three different aspects of Vico's "memory": they bear the trace of the past, they show how it has been altered in the present, and, by making this connection, they enable the scientist to arrange these changes in a sequence that explains their relationship. These polysemous symbols let skilled readers catch change on the wing, trace the footsteps of transformation, and give a positive value to the gaps in reason but for which the hypothesis of an underlying continuity would be unnecessary.

This is the hermeneutic drama played out in Playfair's famous description of the expedition to Siccar Point, on the Scottish coast east of Edinburgh (Figure 6). Hutton argued that the appearance of the earth's surface was due to two great forces acting upon it, one from below, the other from above. Periodically, forces from within the earth thrust up, pushing deep lying rock to the surface. In time, atmospheric erosion wore these new outcrops down; and in further time the alluvium of erosion, forming sediment and being deposited at the bottom of the sea, was compacted into new sedimentary rock—which, in a further period of upthrust, might be lifted up to the surface, whereupon the cycle began again. With this theory in mind, Playfair declared that he could see the more resistant of the older strata tilted on end (Hutton called them "vertical *schistus*") and projecting up into the younger overlying rocks ("sandstone") (Figure 7). With this evidence of upthrust in view, Playfair felt able to extrapolate backwards. Indeed, staring into the "abyss of time," he could see "a time when the *schistus* on which we stood was yet at the bottom of the sea and when the sandstone before us was only beginning to be deposited in the shape of sand or mud"; finally, looking back

**Figure 6.** "Siccar Point: Hutton's Unconformity," January 2006 (photo: Paul Carter). You should be able to see (a) the more resistant of the older strata tilted on end (Hutton called them "vertical *schistus*") and projecting up into (b) the younger overlying rocks ("sandstone").

in his mind's eye to "an epocha [*sic*] still more remote," when "even the most ancient of these rocks, instead of standing upright in vertical beds, lay in horizontal planes at the bottom of the sea."[60]

The significance of the Siccar Point excursion has been much discussed. In a recent article, Keith Montgomery argues that Playfair's account and the many

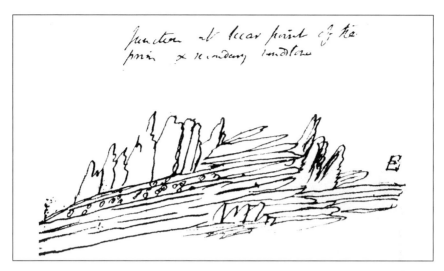

**Figure 7.** James Hutton, "Junction at Siccar point of primary and secondary sandstone" (unsourced). Hutton's field sketch is far less conclusive than Hall's after-image (Figure 8). Made from a different angle, it seems to draw the rocks in perspective. This means that at best its representation of the two features Hutton picked out—sandstone strata partly remaining exposed upon the ends of vertical *schistus*, and points of *schistus* standing "through among" the sandstone—is ambiguous.

physical geology textbooks that have taken their lead from it misrepresent the trip's importance, presenting "an excessively narrow, empirical-deductive view of geological science that diminishes the creative brilliance, depth of preparation and background knowledge, and imaginative insight that leads to the development of Hutton's theory."[61] A further complication arises from Playfair's own dramatization of the event, reflecting his commitment to promoting Hutton's ideas, both through rewriting and clarifying Hutton's original theory and through his biography. Be that as it may, the scientific drama played out at Siccar Point turned on the visualization of the invisible, on the materialization of the instant of change. Here, in the "unconformity" of layers, was palpable evidence of a discontinuity that, paradoxically, confirmed Hutton's theory of the continuity of change. Here, as it were, the hidden surfaced, and, with the application of "rational intuition," the scientist could decipher the ancient hieroglyphic of change (Figure 8). But, if "the world . . . as conceived by us, is the creation of the mind itself," the drama was as much mental as material. The abyss in reason Hutton leapt over with his theory was as much in his mind as in the lie of the land.

The skepticism with which Hutton's theory was initially received was due, Playfair thought, to the fact that it was "proposed too briefly, and with too little detail of facts, for a system which involved so much that was new, and opposite

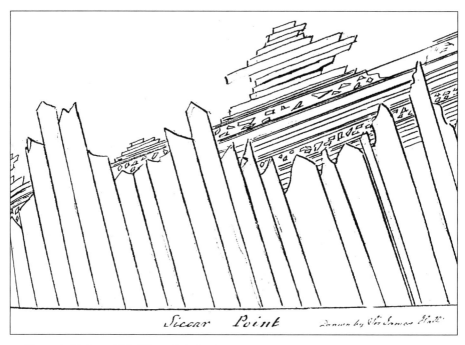

**Figure 8.** Sir James Hall, "Siccar Point," probably 1788, reproduced in Dennis R. Dean, *James Hutton and the History of Geology* (Ithaca, N.Y.: Cornell University Press, 1992), 120. (Copyright: Sir John Clerk of Penicuik.) Hall's ruler-drawn "sketch" beautifully embodies the idea that linearization is explanation. Here every "unconformity" within Hutton's unconformity has been removed to make the diagram absolutely clear.

to the opinions generally received. The descriptions which it contains of the phenomena of geology, suppose in the reader too great a knowledge of the things described. The reasoning is sometimes embarrassed by the care taken to render it strictly logical; and the transitions, from the author's peculiar notions of arrangement, are often unexpected and abrupt."[62] But these "transitions" weren't faults in the author's design. Or, rather, they were "faults" that functioned much as their counterparts in the earth's rocks. Hutton based his gradualist theory of geological change on repeated discontinuities or breaches (hence the Siccar Point excursion). These gaps were voids full of meaning. He drew support for his theory of "some expansive force" responsible for "the immense disturbance . . . of the strata . . . elevating those rocks which it had before consolidated," by appealing: "Among the marks of disturbance in which the mineral kingdom abounds, [to] those great breaches among rocks, which are filled with materials different from the rock on either side . . . veins . . . of whinstone, of porphyry, and of granite, all of them substances more or less crystallized . . . of posterior formation to the strata which they intersect [and which] carry with them the marks of

the violence with which they have come into their place, and of the disturbance which they have produced on the rocks already formed."[63]

Without these breaches or gaps change would be inconceivable—*but so would thinking about change*. The abrupt transitions in Hutton's prose were "instants" in which the Pegasus of the unconscious took wing, delivering consciousness to a place different from this, a transition impossible by consciously putting one foot in front of another. As Playfair wrote, "[t]he mind seemed to grow giddy by looking so far into the abyss of time." What impressed Playfair was the resemblance between the visible evidence and an invisible process. As Hutton's biographer, he was excited by the observable conformity between physical nature (perceptible matter) and metaphysical nature (the theory of matter). Here the visible character of physical objects resembled the invisible character of the geologist's mind. Written into the rock at Siccar Point was the hieroglyph of Hutton's genius. Pursuing his critique of Cartesianism in the modern sciences, Verene maintains that the "falseness of this literal-minded philosophy becomes plain when we consider that it can offer no self-knowledge. It is dedicated to method and has no method by which to know the reality of the knower. For the knower to put himself into words, an autobiography is needed."[64] But Playfair's account of Hutton suggests that inductive reasoning at least *did* allow the "reality of the knower" to form part of what was known. It could do this because, as Hutton suggested, our perceptions are as much realities to us "as if they were the exact copies of things really existing."

### Writing About

As we said at the beginning, the question of how to represent change—passage from one state to another—was not only a practical difficulty for geographers and Enlightenment scientists more generally, it was a theoretical issue. The idea of step-by-step progress, from one well-supported point to the next, did not explain how one foot—both physically and figuratively—was lifted from the ground and placed in front of the other. It repressed the imagination's stepping out of itself, without which no purchase on the world could be gained. Geography's myth was to suppose it could exclude this rhythmic elevation from its account of the earth—to suppose it could advance on stilts and exclude the rise and fall of thought when it is mediated through metaphors. Hutton's story is interesting because it offers a rare insight into the thinking practice of a theoretical geographer. It shows the resemblance between his theory of the earth and his intellectual temperament. Hutton could decipher "ancient hieroglyphics" and cryptic "characters" because he understood them as symbols, not signs. He recognized them as stress points in processes of change, inherently containing the meeting point of past processes of consolidation and future processes of disintegration. He saw them as temporally

acute in Vico's sense, and the wit he brought to their interpretation was similarly acute. Only in this intuitive way could the illusion of continuity be preserved, and with it the authority of the inductive method.

It is not only a history of movement, both conceptual and kinetic, that is recovered when geography's myth is exposed; it is a different kind of intellectual autobiography. In this, as Playfair intuited, the sources of character are not found in the dark backward and abysm of infancy but in the externals of a life. An architectonic history of the self, Freudian or not, is preoccupied with psychological foundations. It presupposes a metaphysical space, an idealized interior, stable, settled—like a territory, which it is the duty of the emergent ego to defend and consolidate. But Hutton's mentality was chemical, devoted to the study of transformations. The work that gave him his identity involved wandering from place to place and making connections between things placed remotely in time and space. He found himself in looking about himself, in the history of his contacts with the environment. The same could be said of all the Enlightenment's active passengers, those practical navigators, travelers, collectors, and other field workers. Insofar as they achieved a reflective relationship with the world they aimed to reduce to order, it was through writing about it—the figurative language they used being the medium through which their own designs on the world came filtering through.

Vico, of course, anticipated the kind of biography I am describing. Responding to a proposal published by Count Gian Antico di Porcia to Italian scholars to write their biographies for the edification of students, he composed his *Vita di Giambattista Vico scritta da se medesimo* between 1725 and 1731. Quite as remarkable as the document itself is the fact that no other Italian intellectual took up the count's invitation. This may have been because the biography Antico di Porcia had in mind was of a very unusual kind—but one perfectly adjusted to Vico's mental character. The essay he was soliciting for the first issue of his *Raccolta d'opusculi scientifici e filologici* was to be a *periautography*. Conspicuously lacking the "bios" of modern autobiography, this word proposed a genre of writing in which the writing of self (*auto*) was identified with the writing of what lies about (*peri*). It may be significant that the term was coined by an architectural theorist, Carlo Lodoli (1690–1761), to whom the doctrine that form follows—or should follow—function is sometimes attributed. A *periautography* would be one in which the form of a mind would follow logically from its functions. It would be through an account of the mind's designs on the world, and the external modifications these produced, that its character would be deciphered. And the reverse would also be true; following Vico's *verum ipsum factum* principle, to narrate the modifications of the mind would also be to understand how the "world of civil society" was made.[65]

As James Goetsch has argued, Vico's theory of knowledge was implicitly spa-

tial or topographical. *Ingegno*, for example, which Vico described as "the faculty that connects disparate and diverse things"—much as figurative language brings together formerly remote concepts—takes the data of memory and *le contorna e pone in acconezza ed assettamento*. The verb *contornare* not only means to give a new turn, but also "to surround; to go round; to outline; to border." A *contorno* can be an "outline" or "ornamental border," and, in the plural, "surroundings" or "environment." *Ingegno* connects disparate and diverse things, then, "by framing one image in its relation to another, outlining in this way a master context of the whole. *Ingegno* 'goes round' the primary sensory topics, creating the human 'surroundings' or 'environment' by 'noting the commonplaces that must all be run over in order to know all there is in a thing that one desires to know well; that is, completely.'" *Ingegno*, Goetsch sums up, "environs the whole world."[66] Vico's *ingegno* can invent because it can draw out connections, but the process of drawing together and drawing apart is very different from the extension of a pure, dimensionless line. It involves a discursive errancy, a willingness to lend the swerve value. As the arabesque of passage, it is a composition of "instructive particulars."

This gives us a clue not only to the character of invention—which etymologically means coming across something, a process of turning toward that gives reality a new turn—but to the movement form secreted in Enlightenment science's inventions. The movement embedded in maps, for example, is not a continuous linear flow. It is rhythmic. It is rhythm that makes the movement form, the figure of passage, conceptually accessible. As Giorgio Agamben says, "in a musical piece, although it is somehow in time, we perceive rhythm as something that escapes the incessant flight of instants and appears almost as the presence of an atemporal dimension in time. In the same way, when we are before a work of art or a landscape bathed in the light of its own presence, we perceive a stop in time, as though we were suddenly thrown into a more original time." It is this sensation, I would argue, that is registered in those strangely disillusioned place names—"Mount Deception," "Lake Disappointment," "Cape Catastrophe," and others. For here the inductive rationalists came up against a rhythm not their own, a presence that could not smoothed away. Here they became conscious of a stop in time. It is the combination of these and their distribution across the map, noting the rhythm of passage, that symbolizes the spatial history geography in due course seeks to annihilate.

### Notes

1. F. S. Marvin in *Geography* 17 (1932): 39–43, in *Historical Geography: A Methodological Portrayal*, ed. D. Brooks Green (Savage, Md., Rowman & Littlefield, 1991), 5.

2. Ellen Semple, *Influences of Geographic Environment* (New York: Henry Holt & Co., 1911), 200.

3. J. B. Harley, "Deconstructing the Map," in *The New Nature of Maps: Essays in the History of Cartography*, ed. Paul Laxton, 149–168, 163 (Baltimore: The Johns Hopkins Press, 2001).

4. Judith Ryan, *Spirit in Land: Bark Paintings from Arnhem Land* (Melbourne: National Gallery of Victoria, 1990), 22–23.

5. Bruno Latour, *We Have Never Been Modern*, trans. C. Porter (Cambridge, Mass.: Harvard University Press, 2002), 129.

6. Celeste Olalquiaga (1992): 93, quoted in Rob Shields, *Lefébvre, Love and Struggle* (London: Routledge, 1999), 176.

7. Georg Forster, *A Voyage Round the World in His Britannic Majesty's Sloop Resolution, Commanded by Capt. James Cook, During the Years 1772, 3, 4 and 5*, ed. Johann Reinhold Forster, J. Robson, P. Elmsby, and G. Robinson, 2 vols. (London: printed for B. White, 1777), vol. 1, ix.

8. Michel Serres, "China Loam," in *Detachment*, trans. G. James and R. Federman (Athens: Ohio University Press, 1989), 3–27, 8.

9. Ibid., 8.

10. Ibid., 9.

11. Ibid., 8.

12. Ibid., 13.

13. Francis Bacon, quoted by Charles Whitney, *Francis Bacon and Modernity* (New Haven, Conn.: Yale University Press, 1986), 68.

14. Frederic J. Jones, *Giuseppe Ungaretti, Poet and Critic* (Edinburgh: Edinburgh University Press, 1977), 165.

15. Giambattista Vico, *The New Science of Giambattista Vico*, trans. M. H. Wallace and T. G. Bergin (Ithaca, N.Y.: Cornell University Press, 1984), 14.

16. See Joseph Mali, *The Rehabilitation of Myth: Vico's New Science* (Cambridge: Cambridge University Press, 1992), 179ff.

17. Ibid., 61.

18. Ibid., 149.

19. Vico, *The New Science of Giambattista Vico*, 127; Mali, *The Rehabilitation of Myth*, 5, 9.

20. Donald Verene, *Philosophy and the Return to Self-Knowledge* (New Haven, Conn.: Yale University Press, 1991), 198.

21. David M. Rasmussen, *Mythic-Symbolic Language and Philosophical Anthropology: A Constructive Interpretation of the Thought of Paul Ricoeur* (The Hague: Martinus Nijhoff, 1971), 42.

22. Ibid., 42–43.

23. Ibid., 43.

24. Even though, as Jacques Bertin points out, "carto-graphics offer a monosemic system in which the meaning of the sign is pre-assigned by the legend."

Because, as he notes, to employ it means that "all the participants come to agree on certain meanings expressed by certain signs, *and agree to discuss them no further*" (Bertin's italics). Whereas the signs we are discussing are precisely sites of disagreement or multivalency. Jacques Bertin, *Semiology of Graphics* (Madison: University of Wisconsin Press, 1983), 2.

25. Vico, *The New Science of Giambattista Vico*, 285–291.

26. Paul Carter, *The Road to Botany Bay* (London: Faber & Faber, 1987), 183–187.

27. Giambattista Vico, *On the Most Ancient Wisdom of the Italians*, trans. L. M. Palmer (Ithaca, N.Y.: Cornell University Press, 1988), 96–97.

28. James Robert Goetsch, *Vico's Axioms: The Geometry of the Human World* (New Haven, Conn.: Yale University Press, 1995), 91–92.

29. Giambattista Vico, *On the Study Methods of Our Time*, trans. Elio Gianturco (Ithaca, N.Y.: Cornell University Press, 1990), 24.

30. Rasmussen, *Mythic-Symbolic Language and Philosophical Anthropology*, 123.

31. Ibid., 123.

32. Michel Serres, *The Troubadour of Knowledge*, trans. S. F. Glaser and W. Pauldon (Ann Arbor: University of Michigan Press, 1997), 69.

33. Verene, *Philosophy and the Return to Self-Knowledge*, 35.

34. Ibid., 35.

35. Serres, *The Troubadour of Knowledge*, 76.

36. Rasmussen, *Mythic-Symbolic Language and Philosophical Anthropology*, 8.

37. Paul Carter, *Repressed Spaces: The Poetics of Agoraphobia* (London: Reaktion Books, 2002), 102.

38. Quoted by Mary Mack, *Jeremy Bentham: An Odyssey of Ideas, 1748–1792* (London: Heinemann, 1962), 207; on Bentham's use of analogy, see Mack, *Jeremy Bentham*, 275ff.

39. Charles Darwin, *The Origin of Species* (London: John Murray, 1859).

40. William Whewell, "History of Inductive Sciences," in *William Whewell: Selected Writings on the History of Science*, ed. Y. Elkana (Chicago: University of Chicago Press, 1984), 10–14.

41. Michèle Le Doeuff, *The Philosophical Imaginary*, trans. C. Gordon (London: Continuum, 2002), 2.

42. G. W. Leibniz, *Philosophical Writings*, trans. M. Morris (London: J. M. Dent, 1961), 237–238.

43. Le Doeuff, *The Philosophical Imaginary*, 1.

44. Ibid., 1ff.

45. Whitney, *Francis Bacon and Modernity*, 73.

46. Ibid., 145.

47. Paul Carter, "Second Sight: Looking Back as Colonial Vision," *Australian Journal of Art* XIII (1996): 9–36, 9–15.

48. John Ruskin, "Traffic," in *The Crown of Wild Olive* (London: George G. Harrap, n.d.), 108.

49. Paul Goodman, *Kafka's Prayer* (New York: Vanguard, 1947), 13; see also Carter, *Repressed Spaces*, 42.

50. See Paul Carter, "Invisible Journeys: Exploration and Photography in Australia, 1839–1889," in *Island in the Stream,* ed. Paul Foss, 47–60, 52 (Sydney: Pluto Press, 1988).

51. James Hutton, *An Investigation of the Principles of Knowledge and of the Progress of Reason,* 3 vols. (Edinburgh: Strahan and Cadell, 1794), vol. 2, 285.

52. Eduard von Hartmann, *Philosophy of the Unconscious,* trans. W. C. Coupland, 3 vols. (London: Trubner & Co., 1884), vol. 1, 316ff.

53. John Playfair, "Life of Dr Hutton," in James Hutton, *Contributions to the History of Geology: Volume 5,* ed. G. W. White, 186 (New York: Hafner Press, 1973).

54. Ibid., 186.

55. Ibid.

56. Ibid., 193.

57. Ibid.

58. Ibid.

59. Nicole Loraux, *Mothers in Mourning, with the Essay "Of Amnesty and Its Opposite,"* trans. Corinne Pache (Ithaca, N.Y.: Cornell University Press, 1998), 89.

60. Playfair, "Life of Dr Hutton," 176–177.

61. Keith Montgomery, "Siccar Point and the Teaching of Geology," *Journal of Geoscience Education* 51: 5 (November 2003), 500–505, 504.

62. Playfair, "Life of Dr Hutton," 176.

63. Ibid., 157.

64. Verene, *Philosophy and the Return to Self-Knowledge,* 213.

65. See Jan Michl, "Form Follows What? The modernist notion of function as a carte blanche," at http://www.geocities.com/Athens/2360/jm-eng.fff-hai.html.

66. Goetsch, *Vico's Axioms: The Geometry of the Human World,* 42–43.

## CHAPTER 2
# Dark with Excess of Bright:
# Mapping the Coastlines of Knowledge

> *behold*
> *The Coast how wonderful. Proportions strange,*
> *And unimaginable forms . . .*
> —Charles Harpur, *A Coast View*

> *Shipwreck has, of itself, opened a wide field of geographical knowledge . . .*
> —J. G. Dalyell

### A Coastal Outline

If you were to tell an oceangoing yachtsman that coastlines were a construction of the mind, he would take you for a madman. The aim may be to keep a safe distance from the shore, but the slow film of low cliffs sliding aft is surely evidence enough of an empirically verifiable boundary between water and land. Common sense tells us that coasts have existed as long as shipwrecks, and to argue otherwise is, one would have thought, perverse. It's true, if amazing, that up until the seventeenth century cartographers regularly depicted islands and continental edges using only symbols for river mouths or purely conventional jewel-like lozenges. It's also true that the discovery that coasts obey the principles of fractal geometry reveals that, in theory, coasts do not have fixed dimensions. But this is all so much landlubber's sophistry to the crew at sea. And besides, without coasts what would be the reason for going to sea? Hasn't the object, and ultimate destination, of every voyage since Homer been to fall in with land? The coast not only harbored harbors, the longed-for object of every colonizing expedition, it paraded the geographical objects—reefs, capes, bays—that made chart

making possible. In a way the coast was an *a priori* of geographical discourse, a word evoking the miscellany of geographical objects that constituted the life of the map. Once differentiated from the haze of spray or the overlay of clouds, it belonged to the class of "distinct Facts" Forster described. It could contract into a harbor, or fold back into an island, but its reality is as palpable as Dr. Johnson's stone.

But our yachtsman was too peremptory; it is not the perception of coasts that is in question but the conception of coast*lines*. The word *coast* has the sense of *side*. It is what most geographical objects present to the eye when they are first seen. Coasts are elevations in the earth's surface whose other sides have yet to be mapped. But coastlines are different. Far from dissolving into rounded or graduated three-dimensional objects, they grow in importance and definition with the advance of the survey. A coastline is a generalization of geographical particulars. As a means of filling in the gaps between the isolated observations of capes, cliffs, and promontories, it represents the traveling cartographer's desire to establish "general principles." The line representing the coastline on the map is the trace of inductive reasoning. As a notion formed of the world, it has, as Hutton said, "no resemblance [to] the world without us." It may pose as a sign representing an empirically verifiable distinct "Fact" but, in reality, it is the graphic counterpart of the "similitudes" scientific geographers used to bring order to the landscape of the world. Joining up unlike things, it is a graphic symbol "inviting thought." The greater the distance between the features whose position on the map has already been fixed, the greater the sharpness of the cartographer's wit. A plausibly drawn line was one that generalized from the known particulars of other coasts. It not only served to relate newly found capes to each other but to the logic of headlands in general (whose intervals had in other parts of the world frequently been found to be composed of catenaries, or bays).

As the points in question usually bore figurative names, the speculative line drawn between them also suggested that the names on the chart were connected in a particular order. In fact, the place names navigators and explorers bestowed were frequently periautographical. They preserved in a cryptic fashion a record of incidents during the voyage, as well as evoking the network of scientific, professional, and political allegiances that had either informed or sponsored the passage or whose patronage protected its interests.[1] As the surveyor and the bestower of place names were usually one and the same person, the putative coastlines drawn on the provisional maps functioned exactly as the metrical markings printed in editions of the poems of Sappho. Their generalized forms indicate particular lines that have gone missing (or which as yet have not been discovered). These intervals have not been sighted (or mapped) yet because, of course, the traveler has limited time and resources. The gaps in knowledge they indicate are

also therefore rhythmic markers, suggesting lengths of time spent in particular waters.

Coastlines could be records of passage in yet another sense. They could be traces of technical errancy, saying more about the navigator's own movement than about the physical relation of things. Matthew Flinders, for instance, who in surveying the coasts of Australia had set himself the task of following the land "so closely, that the washing of the surf upon it should be visible, and no opening, nor anything of interest escape notice,"[2] could not surpass the limitations of his surveying technique. Had he been aware of, and heeded, Dalrymple's and Beautemps-Beaupré's "violent condemnation of surveying the coastline by a series of magnetic bearings, with an azimuth compass—the method used by Flinders—instead of using the sextant to obtain offshore angles, and fixing the ship with a station-pointer,"[3] and had he had reliable timekeepers, he could have avoided "an infinity of trouble"[4] in determining the position of his reference points—mainly capes—both relative to each other and on the face of the globe. As it was, the impossibility of accurately calculating his own vessel's drift meant that tracts of coast could be elongated if the speed of the current was underestimated, and contracted if the rate of passage overestimated.

In any case, not even flawlessly accurate instruments could help Flinders fill in the gaps between. As Ingleton remarks, "the intervening coastline between the 'fixed' navigational features was usually sketched in by eye."[5] In this case, it was the passage of the *hand* as much as the eye that the coastline faithfully reproduced (Figure 9). Sketching by eye meant to reduce to a line, with a handheld pen to assimilate a sweep of land to a continuous curve. Perhaps the symmetrical concavities ascribed to bays are a relic of pre-Enlightenment gesturalism, as the arm, pivoted on its stationary elbow, naturally describes an arc over the page. But as the command of getting from one place to another without any gaps, the extended line was *logically* a form of knowledge (Figure 10). To assist this illusion, in hand-drawing the cartographer did what he could to eliminate any sign of the line's human source. As a recent textbook still remarks, "[c]oastlines may be drawn with a crow quill pen or any other fine nib if care is taken to maintain a uniform thickness of line. It is an aid to have the paper loose on the drafting table so that it may be turned around freely and lines drawn towards the cartographer."[6] Shifted around like this, a seismically sensitive coastline emerges, the trace of a repeated hand-eye passage, and it's not going too far to suggest that its logical appeal is partly aesthetic, its joined-up arabesques suggesting a sympathetic identification between the manual excursions of the cartographer and the mundane voyage of the explorer.

The coastline, then, was the graphic counterpart of the "mythic-symbolic language" found in colonial place names. It was the calligraphic analogue of those

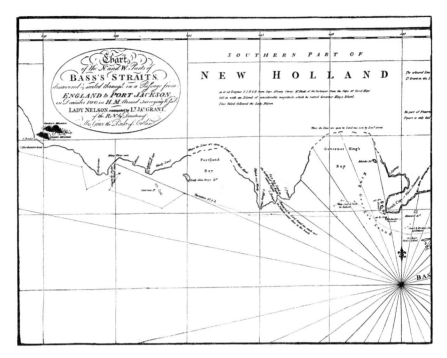

**Figure 9.** James Grant, "Chart of the Australian Coast: The North and West Parts of Bass's Straits," from Ida Lee, *The Logbooks of the "Lady Nelson": With the journal of her first commander, Lieutenant James Grant, R.N.* (London: Grafton, 1915), 32. This chart exhibits at least four kinds of line, each graphically representing a different aspect of the history of the survey: (a) the close dotted, zigzag line of the vessel's course, (b) the single continuous line of the coast ascertained by sight, (c) the double continuous line of the coast ascertained by "accurate survey," and (d) lines that are "open" where "no Land was seen." It is interesting how an expectancy of repetition influences geographical speculation: the name and putative shape of "Governor King's Bay" is formed by analogy with "Portland Bay." However, as the politically more authoritative (and geographically grander) name "King George's Sound" indicates, Grant was hedging his bets.

Pegasus leaps of imagination that formed the figurative or poetic ground of Enlightenment geographical discourse. It was a way of getting on, and the subsequent fossilization of these marks of intellectual movement, as well as historical movement in space, into an authoritative style of earth writing in which the world's surface is reduced to a pattern of continuities—continuous rivers, definite islands, and continental masses—and their negatives—equally gestaltlike seas, lakes, and gulfs—is the graphic triumph of geography's myth. Only by forgetting the movement forms these lines embody, the composite spatial history they aphoristically trace, is it possible to mistake them for facts. They are not analogues of lines in nature; they correspond to a gap in reason. They signify the breach in human knowledge that must open up when memory is forgotten in order to point

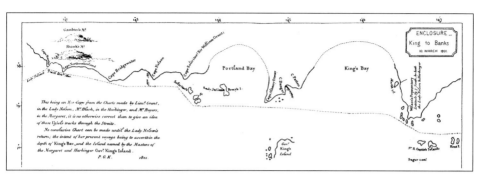

**Figure 10.** Phillip Parker King, "Collated Chart of Bass Strait," from *Historical Records of New South Wales: Hunter & King, 1800–02*, vol. 4, facsimile reprint (Mona Vale, N.S.W.: Landsdown Slattery & Company, 1976), 310–311. Unhappy with Grant's efforts, Governor King collated Grant's partial surveys to produce a presumably more authoritative map. Interestingly, authority in the realm of speculation means the return of geometry—in this map the heads of bays Grant left irregularly dotted have assumed a near regular hemispheric rhythm.

the world to the future. Their elimination of uncertainty does not, though, free us to the future. Rather, it condemns us to redefine a system of closed figures ever more finely. The entire class of the indistinct—not only Whewell's despised "stationary whirlpools" but Leibniz's "shifting sands and morasses," where other ways of getting on obtain—has to be repressed, and with it a different way of reasoning.

### A Running Survey

The aim in this chapter, though, is not to use the graphic conventions of the map to illustrate again the poetic ground of Enlightenment geography's reasoning. It is to explore the practical consequences of repressing this leap of the imagination. No expression of linear reasoning was neutral with regard to its human or natural environment. The advancement of reasoning was always a design on the world. The identification of scientific knowledge with facts that could be joined up to form logical patterns or progressive narratives was an immense reduction of the world's complexity. It was attractive because it simplified but also because it was strategic; as the Spanish equivalent of reduction (*reducción*) makes clear, the elimination of all facets of reality that did not contribute to the steady tread of reason was a formula for the colonization of new territories and the subjugation of its peoples. Maps, for example, did not represent places in a language that non-Western communities could recognize; they were algebraic symbols in which the skilled could read rights of way. Their multiplying jigsaw of interlocked figures was the hieroglyph of imperialism's intent to separate and classify the spread of the earth's surface in order to occupy its territories and command its resources. Until the various marks on the chart were unified into a

single, bounded area, how could the land mass they circumscribed be confidently conquered, claimed, and politically unified?[7]

In this scenario, the coastline is a theoretical construct with practical consequences; it is an idea with real-world effects, and it is some of these effects that we will trace here. To do this is to recover a repressed history of movement—for the coastline was not a thin line but a zone of environmental transformation and unprecedented human encounter; it was a site where inductive reasoning came face to face with the premises of its own scientific pretensions. It was a place, both physically and philosophically, where the myth of abstract linearism was exposed. There is no line, however "dimensionless," however straightforward, that does not conceal an environmental design. There is no sharp line dividing the line in theory from the line in practice; one always bleeds into the other—and, if we accept the figurative basis of geographical reasoning, then there is no line of thought that does not find its precedent in drawing the line. Perhaps the first to be aware of this were practical geographers themselves, the field surveyors charged with organizing the lie of the land into a linear design. They not only found that different environments resisted surveying in different ways, but that the act of surveying demanded its own environment, one with novel human and professional protocols.

The pressure of inductive reasoning on the practical geographer is illustrated in an English treatise on surveying published in 1840, where the apprentice mapmaker is warned that it is an error

> to regard hills as isolated features, as they often appear to the eye; observation, and a knowledge of the outlines of geology, inevitably produce more enlarged ideas respecting their combination; and analogy soon points out where to expect the existence of fords, springs, defiles, and other important features incidental to peculiar formations; and appearances that at one time presented nothing but confusion and irregularity, will, as the eye becomes more experienced, be recognised as the results of general and known laws of nature.[8]

As we have seen, the landscape described here, which conforms to inductive reasoning, is a mental landscape, one in which isolated features share the geographer's desire to transcend themselves, particular facts yielding to general principles. One begins to see why Australian explorers were constitutionally anxious about the progress of their work. Where "the outlines of [north European] geology" did not correspond to the lie of the land, they were not only in danger of wandering aimlessly but of proving themselves mere apprentices in their profession.

Hence the coastal surveyor John Lort Stokes' frustration with the environs of Roebuck Bay, whose mangrove-ridden tidal reaches offered no decisive break,

mappable boundaries, clifftop points of reference—no definite differentiation between near and far, no progressive narrative or drama of telescopic domination. Instead, a truly in-between zone defied the officers, one characterized by fleeting appearances, shifting expressions, deceptive depths, and equally frustrating shallows. "The face of the country [Mr. Usborne] described as exceedingly low, with mud lumps not unlike ant-hills, scattered here and there over the face of it, and several clusters of small trees. Natives also had been seen, though no opportunity of approaching them had occurred, as the moment their restless eyes or quick ears, detected our approach, they most rapidly retreated."[9] To the southwest it was no better: Wickham and the surgeon "visited an inlet near the ship. . . . They proceeded to the south-west for about three miles, through a very tortuous channel, dry in many parts at low water, thickly studded with mangrove bushes, over and through which the tide made its way at high water, giving to that part of the country the appearance of an extensive morass."[10] The only result was to prove "that no opening to the interior would be found in it."[11] In returning, Mr. Usborne managed to shoot himself. "The hoped-for river must be sought elsewhere," Stokes reported disconsolately, christening this zone of non-arrival "Useless Bay."[12]

In practice navigators proceeded by analogy, and even if these were mistaken, there was no other way. An "opening . . . observed in the beach" will bear "every appearance of being the mouth of a rivulet, from the broken and irregular form of the hills behind it"; "a bright appearance on the horizon" will be confidently interpreted as an indication of the existence of islands "that seldom failed in being correct, whenever an opportunity offered of proving it"; and so on. These remarks from Phillip Parker King's *Narrative of a Survey of the Intertropical and Western Coasts of Australia*, undertaken between 1818 and 1822,[13] underline the point that whatever the thin ambitions of the cartographer might be, the coast remained *fat* from the point of view of the coastal surveyor and hydrographer. Dismissing a chart purporting to represent Macquarie Harbour in southwest Tasmania, King explained, "I found it to be merely a delineation of its coast line; without noticing the depth of water, or any of the numerous shoals which crowd the entrance of this extraordinary harbour."[14]

From the land side, too, the route surveyor, in contrast with the triangulating mapmaker, continued to conceive the coast less as a line than as a region, tract, or district—much in the sense used in the King James Bible. The explorer E. J. Eyre, making his way round the cliffs of the Great Australian Bight, regularly describes going down to the "coast" to look for water, where the term implies a distinct transitional zone including sandhills, shore, and shallow water.[15] The elusiveness of the coast's definition might have another cause: "hydrographic charts," we are reminded, "are made with a datum, or plane of reference, of mean

low water, whereas topographic maps are usually made with a datum of mean sea level."[16] Because of the difficulty of calculating longitude in the eighteenth century, north-south coasts in particular could wobble alarmingly on the map; even the extraordinary accuracy achieved by Cook could not overcome this. First Fleet administrators who sited their tents according to the chart were settling in water: perhaps Britain never formally laid claim to *terra australis*.[17]

The 1840 treatise quoted before also illustrates the point, though, that sea and land environments might challenge mapping in different ways. Matthew Edney argues that Foucault was mistaken in identifying the Enlightenment *episteme* with the knowledge of natural history, pointing out that natural historians "consistently employed maps and map-making as the trope of their taxonomic systems."[18] As Edney comments: "Triangulation defines an exact equivalence between the geographic archive and the world. Triangulation makes it possible to conceive of a map constructed at a scale of 1:1. Not only would this be the same size as the territory it represents, it would be the territory. The 'technological fix' offered by triangulation has served to intensify the Enlightenment's 'cartographic illusion' of the 'mimetic map.'"[19] But, except in rare cases, triangulation was not an option for the coastal surveyor. In theory he could use the same techniques as the land surveyor to fix his geographical latitude and longitude, but in reality he was rarely able to remain in one place long enough to make the long run of astronomical and chronometric observations needed to establish his absolute position more or less accurately.

Besides, very few coasts provided the combination of prominent features and long, uninterrupted views needed to establish a baseline. It was not only the mountainous Alaskan shores that failed to "afford any convenient situation,"[20] the indeterminate flats of the Gulf of Carpentaria were equally inconvenient. The coastal surveyor operated there like someone in "flat uncleared country," unable to see ahead and having to rely on astronomical observations to fix the distances between stations. "In surveying any extended line of coast, where the interior is not triangulated, no other method presents itself; and a knowledge of practical astronomy therefore becomes indispensable in this, as in all geodesical operations."[21]

Unable to establish a baseline and to triangulate from it, the coastal surveyor had no sooner sailed out of sight of the positions previously fixed than he had to begin again the process of fixing his own position, and that of the coastal features in relation to it. Bound to fall back on the rough-and-ready technique of dead deductive reckoning, where the ship's position was deduced from its direction of sail and an estimate of distance traveled, he proceeded like the land traveler who confined himself to making a route survey, but here—again—he was at a disadvantage. While the surveyor reconnoitering a new territory could fix the consecutive

points of his march by taking the bearing of prominent objects to either side of his course, the surveyor at sea was always *to one side* of the map he was creating. This helps explain the pivotal significance of improved timekeepers in late eighteenth-century mapping. Yet these, while they facilitated a vastly more accurate calculation of longitude, demanded a new environment of their own if they were to work efficiently. Thus, much as Vancouver wanted to set up an observatory during his first Alaskan survey season "for the purpose of ascertaining the rate and error of our chronometers," he realized that "[t]o take the chronometers ashore would mean moving them to an icy, wet, windy place from the shelter of a warm cabin, with probably disastrous consequences for accuracy of the mechanisms."[22]

### Minding the Gap

Constructing the continuous figure of the coastline presented professional surveyors with conceptual, technical, and even environmental problems. On the other hand, as spatial representations of the principles of inductive reasoning, they were also ideal places to advance the cause of scientific knowledge. As King's comment illustrates, it was the hypothesis of their continuity that made the discovery of gaps possible. Without the consolidation of the amphibious zone between land and water into a decisive barrier, how could interruptions be interpreted as "promising"? It was by establishing the coastline as an obstacle to progress that navigators and marine surveyors proved their worth; locating inlets, openings, deep bays, and the like within the coastline, they discovered the harbors and rivers deemed essential to gaining a foothold and finding a way into new country. These apertures had their counterpoint in the rhythm of points, capes, and coastal islands that, in theory (or else on the principle of analogy), alternated with these gaps. The ideal coastline was like a musical stave or a poetic meter, which, once drawn even in speculative outline, allowed cartographers of colonization to compose the narrative of the journey. The placement of place names and the associative logic governing their choice only put into words what the convention of the coastline had already displayed graphically—that mapping was a movement of the mind, mirroring the "rational intuition" said to underpin the very idea of discovery.

As idealized sites of crossover, the coastlines of empire appealed to the scientific mind vertically as well as laterally. The section of coast that expressed the linear ideal best was one that reared up decisively in the form of cliffs. It was not only an elemental division in nature—water on one side, dry land on the other—but, as post-Huttonian geography became increasingly informed by geology, a temporal exposure. There, in the lifted strata of sandstone, one could see a history of the earth written in lines anyone with a gift for decipherment could read. The coastal setting of Playfair's glimpse into the abyss of time was not

by chance; the coast readied for scientific investigation was one that presented a decisive cross-section through time. And the effect was to telescope the program of science as such, to bring into view, at once as it were, the first and last step in reasoning.

As Cook's artist, Sydney Parkinson rhapsodized on beholding the towering cliffs of Tierra del Fuego:

> How amazingly diversified are the works of the Deity within the narrow limits of this globe we inhabit, which, compared with the vast aggregate of systems that compose the universe, appears but a dark speck in the creation! A curiosity, perhaps, equal to Solomon's, though accompanied with less wisdom than was possessed by the Royal Philosopher, induced some of us to quit our native land, to investigate the heavenly bodies minutely in distant regions, as well as to trace the signatures of the Supreme Power and Intelligence throughout several species of animals, and different genera of plants in the vegetable kingdom, "from the cedar that is in Lebanon, even unto the hyssop that springeth out of the wall": and the more we investigate, the more we ought to admire the power, wisdom, and goodness, of the Great Superintendant of the universe; which attributes are amply displayed throughout all his works; the smallest object, seen through the microscope, declares its origin to be divine, as well as those larger ones which the unassisted eye is capable of contemplating.[23]

"The surface is where most of the action is," writes J. J. Gibson.[24] Geographically, the same could be said of coasts—and the passage just quoted suggests why. Parkinson was a minor artist, not a trained botanist, ethnographer, or collector, but this only makes his evocation of the charms of science the more telling. The voyage to study the transit of Venus focuses attention on the heavens—"the vast aggregate of systems." It also makes Parkinson aware of the infinite variety of the earth's productions—its animals and plants. But the reason these things are revealed is the voyage itself and the scientific spirit in which it is undertaken. The pretension of Enlightenment science is to apply the single scale of reason to both great and small. With the aid of telescope and microscope, it is to show that the stars and the flowers ultimately belong to a single creation. The aim of the expedition is to decipher these connections, and the guiding presupposition is that the universe is a form of writing that *can* be deciphered. Parkinson's notion of a natural language of things goes back to Royal Society speculations from the previous century, but its notion of nature as a book also, as we saw, informed the reasoning of someone as meticulously empirical as Hutton. In any case, the drift of Parkinson's thought makes it clear why Tierra del Fuego's rugged cliffs appealed to him: they were, in effect, a magnificent page on which the diversity

of creation was written. They, and similarly decisive cuts in nature, turned the surface of the earth toward the scientific reader, making it a place where the diversity of things was peculiarly concentrated and exposed. A coast, especially when it was imagined as a linear coastline, was like an illustration in a book: it gave immediate access to another world.

In more sober terms, the British government also recognized the scientific attractions of the coast—as the instructions issued to Phillip Parker King indicate: "You will exercise your own discretion as to landing on the several parts of the coast which you may explore; but on all occasions of landing, you will give every facility to the botanist, and the other scientific persons on board to pursue their inquiries."[25] The coast is here conceived primarily as an arena of intellectual enquiry, a physically linear zone from which inductive reasoning could squeeze out lines of descent, inexorably extracting metaphysical truths or generalizations from the concentration there of physical particulars. The remarkable engraving "The View of the Island of Ouby from Freshwater Bay on Batchian" from Forrest's *A Voyage to New Guinea and the Moluccas* may pose as an ethnographically inflected picturesque view—in reality it assimilates the coast to the exhibition diorama (Figure 11). Type specimens of a multiplicity of exotic objects present themselves to the scientific gaze, washed-up, exposed, already detached from their environmental matrix, already lost it seems unless they can be classified and correctly arranged. The native collectors, examining physically what the English savant examines mentally, pleasantly flatter the latter's sense of intellectual superiority. In this representation, as well as in practice, the decisively linearized coast was a space artificially extracted and differentiated from the uniformity of nature. It was nature disturbed and ruined, a breach that incubated unimaginable productions that even if they existed elsewhere could only be examined here, in this visually privileged nowhere-place. Its very disarray, the mimic resemblance of its productions to the specimens arranged in a *cabinet de curiosités*, could suggest a museum in the making.

These coastal cuts were not natural nor were they environmentally neutral. They were the precondition of an intellectual grasp of the world predicated on the abstraction of things from their places and their reorganization into lines of descent and ascent. Perhaps it is an accident that Aristotle's *De Generatione* and *De Motu Animalium* seem most firmly grounded empirically when describing creatures of the shoreline, but if nothing else it shows how the Stagyrite found walking the beaches of his native Samos was intellectually productive.[26] Combining the ease of walking in a line with the display of many things thrown up from the deep, perhaps shorelines were the natural place of reason. But this logic applied to linear cuts in general. Despite its appearance of providing a general survey of the region's flora and fauna, Wallace's *The Malay Archipelago* turns

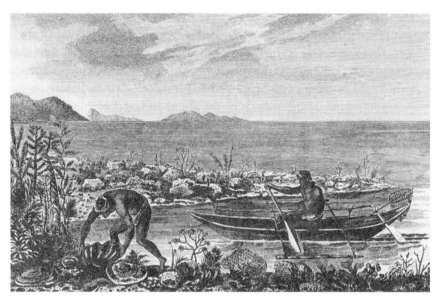

**Figure 11.** W. Hamilton, "The View of the Island of Ouby from Freshwater Bay on Batchian," from *Thomas Forrest, A Voyage to New Guinea and the Moluccas* (London: G. Scott, 1779).

out, when read closely, to be a theoretical zoogeography generalized from collecting trips conducted almost entirely down tracks cut into the jungle by mining companies. It is along these inland corridors that Wallace ambles with his gun and butterfly net; around their slash-and-burn fires that he collects—and where obstructive vegetation gets in the way, or the ground is disagreeably steep, he complains as bitterly as any developer.[27] Needless to say, though, these vestiges of the movement history of his researches do not find their way into the fabric of his theory. The peripateia—Wallace zigzagged from port to port throughout the archipelago, following lines of communication already established by the Dutch, and compiled his observations over a period of years—is entirely erased from his announcement of distinct zoogeographical zones, separated, appropriately enough, by the imaginary "Wallace Line."[28]

Conceptualized as places that maximized the chances of seeing something new, coastlines were a visualist paradise. They were telescopic, bringing things hidden beyond the horizon suddenly near. Because of this promise, their distance, and the atmospheric effects associated them, were easily endowed with romance. Cloud effects, mysterious plumes of smoke, or simply the sound of crashing surf all seemed to lend the prospect of scientific advance a picturesque aura. This narrow fold in the earth/sea's surface not only exposed the hidden but expressed the drama of the hidden itself—a perception that found its English apotheosis later in the nineteenth century when Philip Gosse revealed to the world the wonders of its invertebrate crustacea.[29] Coasts kept alive the dialectic

between the seen and the unseen, whose rationalization was critical to the formulation of Enlightenment epistemology. How did one go from the known to the unknown?—this was the drama the line played out. "Behind the cliffy parts of the coast the land assumed a more fertile appearance; and this seemed an almost invariable law in the natural history of this new world," Stokes observed off the coast adjacent to the Kimberleys in northwest Australia.[30]

In this case the coast stood in for the colonial surveyor. It provided the viewpoint essential to making discoveries. More than this, it seemed to share Stokes' prejudice for classifying and evaluating the earth's surface in terms of sharply differentiated verticals and horizontals; here, from this height, was a level ready for occupation. As names like "Prospect Hill" illustrate, such places fused viewpoint and view into a continuous line of intellectual reasoning and territorial expansion. In this sense the coastal region in the Gulf of Carpentaria that Stokes later denominated "The Plains of Promise" was a continuous coast, an extension made deep. And lo and behold, what is unbroken and uniform begins to differentiate itself. Dark specks seem to emerge in the lens of futurity and before long familiar forms break through the mirage, reasserting beneath the veil of difference the supremacy of sameness. It would not be long, Stokes persuaded himself, before "the now level horizon would be broken by a succession of tapering spires rising from the many Christian hamlets that must ultimately stud this country."[31]

Coastlines licensed a little leap of "rational intuition." They provided a rhetorical solution to the problem of getting on. Although they supplied the zoologist and the botanist with a narrow cut in nature where the diversity of the world was exposed, they appealed to the surveyor primarily as places of mental vision. They provided step-by-step reason with a motivation for taking the next step. They were useful because they permitted a chain of reasoning that, while it appeared to lead to something new, ultimately preserved the sameness of things. Stokes' plains of promise are promising because they enable him to envisage an end that is familiar, in which the conformity of particular facts to general laws is reconfirmed. And, as we saw, when coastal regions failed to deliver this intellectual satisfaction they were, not surprisingly, disparaged. Imagine how the future of cross-cultural encounter would have looked if Stokes had been aware of the way the Yanyuwa, the Indigenous owners of land and sea in the southwest Gulf of Carpentaria, understood their environment. For them, as Dinah Norman Marrngawi puts it, "country is all country," they inhabit a "countryscape" that is seascape and landscape all at once.[32] To enter such a world is to be challenged to reason differently, not simply about questions of ownership but about the foundations of one's place in the world.

Played out in these zones was not only the tragicomedy of imperial mapping, but the practical consequences of a theory of knowledge. As Hutton acknowl-

edged, there was no necessary connection between the world without and the notions we form of it. In the theory of vision put forward by Bishop Berkeley, the divorce of the mind from the senses was championed in an even more radical way. "The qualities we experience visually are entirely other than the qualities we experience tangibly, so that there are no means, except that of habitual experience, of working out connections between the two."[33] The corollary of this argument is that if "sight is a kind of illuminated blindness" and the eye is "in reality not open to the world [and] therefore cannot see," then something else must show the way ahead. "It is undeniably the case," writes Appelbaum, paraphrasing Berkeley, "that as we walk along the road, we are guided by some power, some ability. That power cannot be sensory nor bodily nor organic in origin, since body in itself is mute, dumb, deaf, and mindless." What then? It must be "the mind itself that lights up the way. It must be the mind that sees through blind windows of the eyes. It must be intellect that discloses a world through its radiant vision." The result of this "diabolical development" is that it "reduces the exercise of sight to comparative judgment. Nothing fresh enters into the act of seeing, because seeing consists wholly in comparing a current tableau with past ones. Seeing is seeing sameness. Seeing is the same seeing the same."[34]

Of course marine surveyors were not card-carrying Idealists, but the critiques of empirically founded inductive reasoning advanced by the likes of Berkeley and Hume necessarily haunted their activities. It did not emerge in a philosophical engagement with ideas but in the figurative language they used to describe the challenge of joining up perceptions of novel environments to the conceptions that should enable us to have an idea of them. Stokes' expression "the face of the country" is a commonplace of the exploration literature, but it neatly captures the paradoxical character of Enlightenment reason. In order to be knowable, the novel country must already recognize its would-be knower; it must appear to face his interests. Without this prior hypothesis of an ultimate familiarity or sameness, the difference of the place could not be measured. However, the face of another is always and irreducibly strange, and the gaze of another is even subtler, as it is neither tangible nor strictly visible but resides in some kind of movement or exchange between the parties. In Stokes' little theater of disappointment, the role of animated gaze might have been played by the "natives." With their rapid movements they might have given the "face of the country" a human expression and focus. But instead, they turned away. "Useless Bay" was useless not simply because it refused to be drawn in the form of a decisive coastline, but because it refused to auspice a human encounter. Without this, sight and touch, mind and other minds, remained detached from each other.

## Spirited Performances

Coastlines were among the poetic foundations of empire. They were not only logically necessary places drawn on the map; when it came to encountering other people, they were places for drawing the line. On the beach at Hood Canal in Puget Sound during his first expedition to America's northwest coast, Vancouver found himself approached by a group of native people: "As the Native people drew near, he had a line drawn in the sand between the two groups. He would not allow anyone to cross it without first requesting permission."[35] Just as the continuous line on the map repressed a history of movement, so Vancouver's line drawn in the sand was designed to keep human beings in their place. A kind of mutually immobilizing symmetry was set up in which the others were magically enjoined to imitate Vancouver's group. In this ideologically brittle environment, power manifested itself as the capacity to enforce a mimetic subjugation: the natives will act as we act. The corollary of this belief was an inability to imagine other ways of meeting.

When, during Stokes' intertropical survey, the tables were turned, the sailors did exactly what in other circumstances they would have expected of the Indigenous people. The engraving "Messrs Fitzmaurice and Keys dancing for their lives" alludes to an incident at Melville Island reported in Stokes' narrative, where the ambushed surveyors had the "happy presence of mind" to mimic the people against whom they trespassed:

> immediately beginning to dance and shout, though in momentary expectation of being pierced by a dozen spears. . . . Their lives hung upon a thread, and their escape must be regarded as truly wonderful, and only to be attributed to the happy readiness with which they adapted themselves to the perils of their situation. This was the last we saw of the natives in Adam Bay, and the meeting is likely to be long remembered by some and not without pleasant recollections, for although at the time it was justly looked upon as a serious affair, it afterwards proved a great source of mirth. No one could recall to mind, without laughing, the ludicrous figure necessarily cut by our shipmates, when to amuse the natives they figured on the light fantastic toe; they literally danced for their lives[36] (Figure 12).

As the name "Adam Bay" implies, the Larrakia people who formed the audience of this performance are curiously marginalized in this account. The fact that they possess a sophisticated dance culture, for example, is missing from this story—perhaps they objected to the white presence on aesthetic as much as political grounds! In any case, the mimetic strategy has the effect of effacing

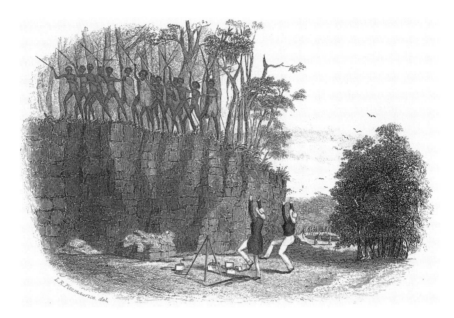

**Figure 12.** L. R. Fitzmaurice, "Messrs Fitzmaurice & Keys Dancing for their Lives," from John Lort Stokes, *Discoveries in Australia,* vol. 2 (London: T. and W. Boone, 1846).

the historical identity and presence of the others, reducing them to a collective Adam, a mirror to the white men's own mythological origins.

It is no wonder that in this linearized and self-reflexive environment cross-cultural meetings (however defined) rarely occurred. Of people met at Rockingham Bay, Queensland, in 1819, King noted, "Everything we said or did was repeated by them with the most exact imitation; and indeed they appeared to think they could not please us better than by mimicking every motion that we made." But their mimicry was clearly a technique for keeping the newcomers at bay: "Some biscuit was given to them, which they pretended to eat, but on our looking aside were observed to spit it out."[37] In this mirror state, where interpersonal communication seemed impossible, a sense of one's own identity was weakened. Mirrored in the antics of the other, your subjectivity became pantomimic or ghostlike. And, following the usual habit of Enlightenment logic, this alarming experience was turned inside-out: A state of mind produced by drawing conceptual lines in the sand was represented as an ethnographic speculation about Indigenous behavior. Alluding to some pistols inadvertently left behind on the shore, Stokes imagines the natives making up a story about them, explaining them as "the motive for the visit of those white men who came flying upon the water, and left some of the secret fire upon the peaceful coast: and when again the white sails of the explorer glisten in the distant horizon, all the imaginary

terrors of the 'Boyl-yas', will be invoked to avert the coming of those who bring with them the unspeakable blessings of Christian civilization."[38]

\* \* \*

So far in this chapter we have looked at the practical effects of drawing coastlines along the coastlines of empire themselves—where geographers employed in the field to enlarge British territories attempted to give the new a sharp definition. But the coastline was a form of reasoning that, in principle, applied to the conception of any place defined in terms of the accumulation of resources and the regulation of access to them. On the same logic, the aberrant forms of human behavior King and Stokes described were not confined to exotic portions of the Australian coast. Produced by the contradictions internal to the logic of inductive reasoning, they manifested themselves just as easily in London or Boston. There, for example, the extraordinary popularity of mesmerism and, slightly later, Spiritualism in middle-class circles might suggest that it was the *tabula rasa* of scientific reason itself that provoked its unruly other, the planchette or turning table of the séance. Cottom, in his appropriately titled book *Abyss of Reason*, writes that "Spiritualists were people seized by the tantalising power that rushes from civilisation's representation of itself. They reached out for and were haunted by an imagined origin of communication glimmering through the intentions of disparate individuals to convey particular meanings."[39] In a sense the discourse of the coastal surveyor, its idiosyncratic mingling of obsessively reported empirical detail and metaphysical surmise, resembled that of the medium, offering, as Spiritualism's advocates Balfour Stewart and P. G. Tait claimed, "a bridge between one portion of the visible universe and another, forming as it were a species of cement, in virtue of which the various orders of the universe are welded together and made one."[40]

These disorders of the imagination were not confined to the dubious milieux of Victorian hand holders. They could be seen wherever contact between two worlds presented a problem of conceptualization. They were as prevalent in Mediterranean ports as in Victorian parlors. The strange rituals associated with quarantine stations, for example, were quite as fanciful as anything recorded along the Gulf of Carpentaria or observed springing from the recesses of the medium's cupboard. Furthermore, the institutions built to digitize passage from one medium to another reflected this logic in their design. A beautiful example of this is the Maltese Barrière de la Santé, where, as Jean Houel's engraving shows, a tripartite process of translation is imposed on anyone seeking to cross over from one medium to another (Figure 13).

Between the fluid turbulence of the sea and the blank and solid terra firma

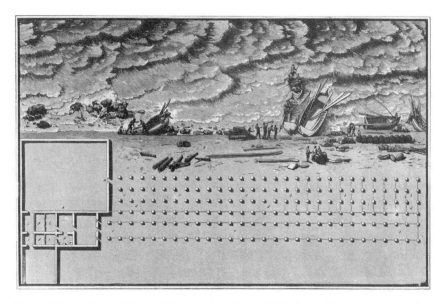

**Figure 13.** Jean Houel, "Plan de la Barrière de la Santé, à Malte," from *Voyage pittoresque des îles de Sicile, de Malte et de Lipari* (Palermo: Edizione per il Banco di Sicilia realizzata dalla, "Storia di Napoli e della Sicilia", Società Editrice, 1977; orig. pub. Paris, 1782).

has been constructed an interstitial zone consisting of six rows of little pillars or posts laid out parallel to the edge of the shore. These mediate graphically between sea and land. On the land side the plan is a blank, signifying the completion of the land's territorial subjugation; on the sea side, by contrast, the surface is rugged, folded, and promises shipwreck. Mediating between these contrary realms, the barrier digitizes the analog turbulence of the sea, progressively sampling its wave forms until nothing is left of their movement power. And the same applies to the human movement; filtered through this maze of posts, it loses its power to produce change. As Houel explains, the posts were joined by rails so as to form pathways, each of which had its own special destination, depending on whether it was for foreigners or residents of the place. AA indicated the spot where merchandise must be deposited before being carried successively to points BB and CC; in the spare spaces were separately laid out the different kinds of merchandise. Foreign merchants stopped behind the barrier DD, where they could do their bargaining with the merchants of the island—who stood behind the barrier EE (which, being some two hundred paces long, could accommodate 150 people). Between the path marked D and that marked E was a space nine paces wide, so as to prevent infection crossing from one side to the other while at the same time allowing the merchants to view the goods on offer.

This mechanization of movement was designed to create a place of meeting where no one met. Goods passed over while miasmatic vapors were dissipated. In the clipped, rectilinear boustrophedon corridors of the barrier, errancy was eliminated. Every step was taken to defer arrival, to keep the stranger walking backwards and forwards more or less on the spot. It is no accident that check-in counters of every kind use the same barrier system today. The object is the same: to transform the crowd into a linear queue, and to substitute for the protocols of meeting the discipline of waiting. Temporary inmates of these places suffered, as a Parisian architect confined for sixteen days at the quarantine station of Malta in 1833 wrote, "un ennui mortel." He criticized the absurdity of putting quarantined travelers and impounded goods under the same roof, but he might as easily have ridiculed other quarantine procedures—in Malta, letters from infected zones were "dropped in vinegar, and then put into a case, and laid for about a quarter of an hour on wire grates, under which straw and perfumes had been burnt." There were different methods of "expurgation" for different classes of goods. In Venice, wool, flax, feathers, and similar materials were aired for forty days by removing them from their containers and mixing and turning over the heaps twice a day by porters working with hands and arms bared. Woollen and linen cloths were periodically unfolded and refolded and sometimes hung on a cord for better exposure to the air. Furs, considered especially dangerous, were, we learn, "very often waved and shaken." Articles like beeswax, sponges, and candles were purged by immersion in salt water for forty-eight hours. Salted hides, salts, and minerals, however, were considered non-infectable.[41]

As for the involuntary inmates of these places—which were often converted military establishments—they were sailors at sea condemned like Virgil's Palinurus to a lapidary calm. Although nothing could be done to make the frightful prison more comfortable, our architect reports, each of the unwilling guests tried to use the enforced leisure to his or her best advantage—to temper as far as possible the feeling of depression and boredom. Some played marbles, others played violins or the piano, yet others passed the time chatting. Other more solitary souls passed the time sketching—and why not?—the architecture of the average quarantine station, with its four-square window apertures and battlement prospects, made an ideal viewing platform for anyone with a taste for picturesque coasts. Some—in this distinctly French memoir—drowned their sorrows in good food and wine, hiring professional chefs to titillate their palates. Playing cards came bottom of the list of distractions, although some, it seems, could not even stir themselves to a flutter at the tables—"Nos dames, beaucoup plus sédentaires, lisaient, rêvaient ou s'ennuyaient."[42] To be quarantined in this no man's land was not necessarily to withdraw from society. On the contrary, by

regulating behavior, it produced an intensification of social forms that pressed out their artificiality.

The coastline digitized and froze movement. It created a place where, suspended between different media, its inhabitants had no choice but to go through the motion of living and, through writing and drawing, representing themselves to themselves. But wasn't this pretty much how it was anywhere around the coasts of imperial commerce? As Watkin Tench lamented only a few months after the establishment of the British colony in New South Wales, "[i]n Port Jackson all is quiet and stupid as could be wished." The routine of the days, he says, was only to be endured until "night, welcome as a lover, gives us to sleep and dream ourselves transported to happier climes."[43] But why had this feeling of ennui settled on him? Didn't it arise directly from the regime inaugurated when the "Governor marked out the Lines for the Encampment, and to prevent the Convicts straggling into ye Woods . . . appointed a Provost Martial, a Constable and a party of ye Soldiers to take all Men up, that were found out of the Boundaries"?[44] In other words, the installation of linearized territories also digitized human relations. These were negotiated inside a grid, at once administrative and symbolic, that treated meeting and self-impelled movement in general as forms of trespass. The events that took place in this strange parenthesis of space and time were the antithesis of those Kafka associated with the instant between two strides.

In a movement history cartography would be done differently, the closed figures and continuous lines of the conventional map being replaced by indications of tracks and meeting places. A history that took account of space's history, and understood that it formed the poetic preconditions of settlement, would classify the make-believe charades of the lazaretto—and the no less arcane and cruel diversions of the border post, the immigration hall, and the customs house—as failed forms of sociability. But there is no doubt that these zones in which the ordinary ebb and flow of everyday life is artificially cut up and frozen are congenial to reason. Their proliferation of walls, doors, and barred prospects, and the new class of janitors appointed to look after them, find their counterpart in the philosopher's desire to see every step of a logical argument. In fact, the world that Enlightenment thinkers purported to describe was not the "World without," but a building whose design closely resembled that of a prison. If they looked at the world at all, it was through the windows of the soul, and if they saw land, it was from the safe distance of the offing.

As for society, it was best studied from a distance. It is no wonder, then, that when confined to a quarantine of twenty-one days in Genoa, the social philosopher Jean-Jacques Rousseau preferred to perform it in the lazaretto rather than remain on-board ship:

I was therefore conducted to a large building of two stories, quite empty, in which I found neither window, bed, table, nor chair, not so much as even a joint-stool or bundle of straw. My night sack and my two trunks being brought me, I was shut in by great doors with huge locks, and remained at full liberty to walk at my ease from chamber to chamber and story to story, everywhere finding the same solitude and nakedness. This, however, did not induce me to repent that I had preferred the Lazaretto to the felucca; and, like another Robinson Crusoe, I began to arrange myself for my one-and-twenty days, just as I should have done for my whole life.[45]

Here in the solitude of the cell, the author of *Le Contrat Social* could see the origin of society. Here, like Defoe's character, he could build it up step by step, spinning its institutions out of the sensorium of his own brain. The filaments of his argument could radiate and encompass the known world, floating over it and settling where they would. Eventually these new coastlines of knowledge would have the entire globe in their net. But at no point would there be any necessary connection between their designs and the world's own dark writing.

### Shipwrecked

A knowledge of coastlines is inseparable from a fear of shipwreck. Even our oceangoing yachtsman would accept that. It is coasting that creates the danger of running aground. To judge from the stories associated with them, and the place names, some colonial coastlines are scarcely distinguishable from the history of their shipwrecks; capes, promontories, hidden rocks, and reefs belong equally to the mariners' charts and their mythography. You could say that they form one of the more dramatic chapters in any sea traveler's periautography, as navigators of all kinds have always been bound in a fateful relationship to the shore. Thus Dumont D'Urville's companion, Joseph Gaimard, was perversely drawn to the lucid shallows of the northwest Pacific Ocean. Provided no obstacles seriously menaced the ship, he found tacking back and forth among New Hebridean reefs exhilarating, explaining, "Danger has always seemed stimulating to me; I confess it actually appeals to me; I am talking about danger one can counter. It makes my pulses race, makes me think more clearly and faster and my decisions more rapid. In a word it makes me feel so good and so intensely alive that you must pardon this confession."[46] The idea of floating above the shipwreck of La Perouse fills him with a kind of ecstasy: "To be able to contemplate at leisure, after a series of all sorts of accidents, the wreckage of this great and glorious disaster, and to feel deep inside, that one is worthy of this honour, is a reward that mere men cannot bestow, and luckily is not in their power to snatch from us."[47]

Sailors of this kind were not at home at sea. They reasoned drily and in gen-

eral could not swim. The psychoanalyst Michael Balint once wrote a paper in which he distinguished two types of "patient." One, which he called the *philobat*, experiences a thrill the longer his exposure to danger and "the more tenuous his connection with the safety zone which, in the ultimate analysis, is the safe earth." Evidently Gaimard was a *philobat* who found his lack of equipment for coping with danger positively exciting. But this is hardly a balanced attitude toward traveling —any more than the attachment of Balint's other type, the *ocnophil*, to a "firm and protective object" is conducive to navigating the spaces of everyday life.[48]

The pathological character of such seamanship contrasted sharply with the marine techniques English and French voyages encountered in the Pacific. When the Tahitian canoeists steered their light craft in and out of reefs while Cook's *Resolution* foundered on a reef, it was not a display of callousness. Quite possibly they did not appreciate the gravity of the situation. "The Natives," J. R. Forster noted, "who were all gone towards night, fished during night on the reefs, with fires, & came early in the morning again alongside the Ship." And, perhaps grasping the cultural specificity of his nautical crisis, he commented, "Their boats often overset, but this is no harm to them for Men & Women swim most excellently, & I saw several dive for a single bead, & bring it up from a great distance under Water."[49]

The fragility of canoes was taken as a sign of primitiveness when, in reality, it reflected a different understanding of the coast as an amphibious and inherently turbulent, mobile environment. We are told that "[b]ecause of the ever-present problem of depth of water and because the flux and reflux of the tides cause powerful tidal streams of ever varying speed and direction whenever they flow, tidal lore loomed large in the Atlantic seaman's life."[50] Still, this shouldn't disguise the incompetence and ineptitude inherent in the project of *getting ashore*, embodied in the design, construction, and navigation of vessels fitted only to float far out to sea (like wooden *philobats*) and whose steering inshore and mooring always posed a logistical nightmare. Naturally, though, the European navigators, proud of their copper-bottomed "coffins," leaking water at the rate of an inch an hour, could not see this. In Tasmania, "The only vehicle, by which these savages transport their families and chattels across the water, is a log of wood," King noted. "[It] may be called a *marine-velocipede* . . . the extreme case of the poverty of savage boat-building all round the world." King attributed its poverty to a paucity of suitable canoe-building timber and concluded, sanguinely enough, that it was nevertheless proof "that man is naturally a navigating animal."[51]

The destruction of Virgil's Palinurus can stand in for many; the mobility of sailors is always shadowed by a giant continent intent on hunting them to their grave. J. G. Dalyell's comment, that "[s]hipwreck has, of itself, opened a wide field of geographical knowledge," is of little consolation to the conscientious captain.

Without the means of communicating with the outside world, what is the use of the knowledge gained by living on a desert island? But, in a profounder sense, all imperial knowledge was predicated on shipwreck of one kind or another. Even if the mapping of coastlines occurred without human loss, it presupposed the difficulty of getting ashore. To gain a firm foothold on the world was equally the task of philosophers and colonizers, and because of the way they thought about this problem—creating mental abysses where others saw only negotiable gaps—they were both fascinated by the coast and afraid of it. To get ashore was always to be in danger of drowning, to be momentarily out of your depth both physically and intellectually.

This moment of crossing over involved the shipwreck of reason; only by giving oneself up to the elements could one make a translation that was often felt to be as much emotional or spiritual as physical. Corbin reports of the early nineteenth-century practice of therapeutically dunking young ladies in the waves: "The female bathers held in the arms of powerful men and awaiting penetration into the liquid element, the feeling of suffocation, and the little cries that accompanied it all so obviously suggested copulation that Dr Le Coeur was afraid the similarity would render bathing indecent."[52] To the evangelical mind immersion suggested a different kind of intercourse—with the divine. The author of *Missionary to the New Hebrides*, the Reverend John Paton, described a memorable shipwreck on the island of Tanna: "I sprang for the reef, and ran for a man half-wading, half-swimming to reach us; and God so ordered it, that just as the next wave broke against the silvery rock of coral, the man caught me and partly swam with me through its surf, partly carried me till I was safely set on shore."[53] Once ashore, it is the impossibility of following the coastline that brings him self-knowledge, for, coming to a mighty rock he cannot climb, the shipwrecked man of God has no choice but to let himself over the edge of the cliff and seek to continue his journey on the shore below: "I lay down at the top on my back, feet foremost, holding my head downwards on my breast to keep it from striking on the rock; then, after one cry to my Saviour, having let myself down as far as possible by a branch, I at last let go, throwing my arms forward and trying to keep my feet well up. A giddy swirl, as if flying through air, took possession of me."[54]

In these circumstances it is understandable that the coast became a site of regulation. If coastal visitors were vulnerable to all kinds of fall—intellectual, spiritual, and moral—then, in the interests of public well-being and civil order, passage across that debatable land needed to be stabilized. Unreliable waves, shifting sands, unpredictable natives, and enigmatic interiors needed to be policed. This was the function of the coastline, to cordon off an in-between zone and to bring its labyrinth of possibilities within the prisonhouse of reason. Surviving his fall, Paton naturally gave thanks to God, besides invoking the New

Testament's master of shipwrecks, St. Paul. But the "giddy swirl"—which recalls Playfair's giddiness on looking so far into the abyss of time—is also the gap in reason, that necessary difference that cannot be reduced to sameness, which haunted the Enlightenment mind. It describes the shipwreck of the mind that imagines it can illuminate the way ahead by the power of its own reason, but it also evokes the birthplace of *ingenium*, the speculative genius that connects disparate things. Paton attributes his salvation to spiritual grace, yet the descent into darkness that renews his faith depends on re-entering his body, against Cartesian or Berkeleyan mentalism allowing back into the metaphysical picture an eido-kinetic intuition inseparable from a knowledge of the lie of the land and its movement forms.[55]

\* \* \*

Captain Forrest prefaced his account of his *Voyage to New Guinea and the Moluccas* with a passage from Ovid's *Metamorphoses*—"he delighted to wander in unknown lands and to see strange coasts, his eagerness making light of toil."[56] After considering the figurative role played by coastlines in the discourse of empire, this seemingly innocent delight assumes a darker hue. For one thing it suggests that coast dwellers are constitutionally disposed to travel; for another it suggests that their traveling will have far-reaching human consequences. There was nothing particularly new about this. Thucydides had identified two conditions essential to the creation of a marine empire, both of them associated with the prevalence of coasts and coastal dwellers: first, the fact of coast dwelling, which meant that as communication by sea became more common, Hellenes and the barbarians of the coast and islands were tempted to turn pirates; second, the necessity of reacting to this, which led Minos of Crete to establish a navy with which he "made himself master of what is now called the Hellenic sea, and ruled over the Cyclades, into most of which he sent the first colonies, expelling the Carians and appointing his sons governors; and thus did his best to put down piracy in those waters."[57]

But to return to Forrest's poetic summary of his reasons for embarking on a voyage of coastal exploration. Two questions suggest themselves. First, why did Forrest alter Ovid, substituting "littora" (coasts) for the original's "flumina" (rivers)? Second, what is the significance of the fact that the wanderer in Ovid's poem is Hermaphroditus? Adapting classical texts to one's own situation was not uncommon. As we pointed out, J. R. Forster's narrative of Cook's Second Voyage is punctuated with quotations (and misquotations) from Virgil's *Aeneid*, used to establish the narrative's poetic logic. Forrest's substitution of "coasts" for "rivers" made Ovid's text an accurate commentary on his voyage, a prolonged coasting of

the Moluccas and the group of islands to the northwest of New Guinea. But what of the hidden identification with Hermaphroditus?

Leaving his native hills and his foster mother Ida, Hermaphroditus "for the sheer joy of travelling visited remote places, and saw strange rivers." In Lycia he came upon a clear pool of water where, it so happened, the nymph Salmacis dwelt. She, catching sight of him, at once fell in love with him, but he repelled her and then, thinking she had gone, disrobed and lowered himself into the water. But she was watching him from behind the bushes. "At the sight Salmacis was spell-bound. She was on fire with passion to possess him, and her very eyes flamed with a brilliance like that of the dazzling sun, when his bright disc is reflected in a mirror. She could scarcely bear to wait, or to defer the joys which she anticipated. She longed to embrace him then, and with difficulty restrained her frenzy. Clapping his hollow palms against his body, Hermaphroditus, dived quickly into the stream." Salmacis plunged after him, "clinging to him, her whole body pressed against his." Then her prayer that they might never be separated was answered: "for, as they lay together, their bodies were united and from being two persons they became one . . . a single form, possessed of a dual nature, which could not be called male or female, but seemed to be at once both and neither."

Wasn't the fate of Hermaphroditus exactly what the coastal surveyors both desired and desired to avoid? In this case, the substitution of "coasts" for "rivers" had a psychological aptness. Keeping to the coasts, the avant-garde of imperialism avoided entanglement with the other. They were narcissistic enough to want to be seen and desired by the other. Stokes again: "Our intercourse with the natives had been necessarily of the most limited character, hardly amounting to anything beyond indulging them with the sight of a new people, whose very existence, notwithstanding the apathetic indifference with which they regarded us, must have appeared a prodigy."[58] But they also wanted at all costs to avoid seeing turning into touching. Theirs was a rationalistic culture afraid of taking the plunge and finding itself out of its depth and unable to swim. To elude the humid Salmacis and take the eros out of exploration, they constructed dimensionless coastlines from which every sign of depth, ambiguous chiaroscuro, or mimetic desire was excised. But the effect of this shallow salvation was not to make a place safe for civilization, only to set the stage for a future of disastrous shipwreck.

The Enlightenment coastline not only represented a technical challenge to late eighteenth-century mapmakers. A necessary construction of Enlightenment reason, it dramatized the limitations and contradictions inherent in the Enlightenment project. As a surface where most of the cultural action was—cartographically but to an increasing degree, psychologically, performatively, and politically—the coastline suggested that the optimistic anticipation of mapping the world, classifying its products and ordering their relations, was founded on a myth. Experienced as a

radical discontinuity, as a breach in time and space, the coast could be construed as the necessary other of reason—without its prospect of stripped-bare nature the mind would lack the raw material whose recollection constituted its *raison d'être*. Yet even when its products had been threaded along taxonomic lines, the coast remained obstinately discontinuous, abyssal, antirational, impossible to fix. To represent it as a line was to paper over a crack—and the image is suggestive, as the nightmare represented by the coast consisted in the fact that it resembled reason so closely.

Writing of the "deceptious appearances that are frequently observed at sea, such as the reflection of the sun, ripplings occasioned by the meetings of two opposite currents, whales asleep upon the surface of the water, shoals of fish, fogbanks, and the extraordinary effect of mirage [which] have given birth to many . . . non-existing islands and shoals," King commented that if all these were laid down in charts, "the navigator would be in a constant fever of anxiety and alarm for the safety of his vessel."[59] But along the coast this was normal; where the known and unknown resembled each other, and might so easily collapse into the blindness of the same, no wonder dark and light, anxiety and boredom, land and sea, seemed distinguished by only the narrowest of lines. Where the sun shone most brightly "in the direction of our course," there the greatest danger was in "running thus 'dark with excess of bright' upon any rocks or shoals that might be in our way."[60] No wonder that "crossing the line" was, as Kant observed, a euphemism for insanity, the shipwreck of reason.[61]

## Notes

1. See Paul Carter, *The Road to Botany Bay* (London: Faber & Faber, 1987).

2. Matthew Flinders, *A Voyage to Terra Australis*, 2 vols. (Adelaide: Australian Facsimile Edition, Libraries Board of South Australia, 1974; orig. pub. 1814), vol. 2, 145.

3. Geoffrey C. Ingleton, *Matthew Flinders, Navigator and Chartmaker* (Surrey: Guildford, 1986), 388.

4. Matthew Flinders, *Private Journal*, 14 September 1811; cited in Ingleton, *Matthew Flinders*, 403.

5. Ingleton, *Matthew Flinders*, 130.

6. A. H. Robinson, *Elements of Cartography* (New York: John Wiley and Sons, 1960), 129.

7. This outline history of the line might seem unduly deterministic—after all, "in both the maps of the Caribou and coastal Eskimo . . . an unbroken line is used to represent coastline or riverbank," and most cultures seem able at the anthropologist's behest to represent where they live lineally. But while this shows a capacity to map, it does not, as Denis Wood emphasizes, "result in maps." Denis Wood, *The Power*

*of Maps* (New York: Guilford, 1992), 146–147. Or, to put it another way, an ability to inscribe a peripatetically inhabited environment in the form of spatio-mimetic marks is quite different from a cultural propensity to read the line as a sign of space conceived as a bounded blank, uniformly ready for civilizing inscription. The Eskimo line represents a passage, a rate of progress, even a seasonal calendar, and is fat, palpable, and regional; the cartographer's line signifies the conquest of environmental memories, the translation of pathfinding and performative renewals of place into the blank of a territory metaphysically brought into being by a bounding line that does not belong to it and, being nowhere, cannot be refuted or easily superseded.

8. E. C. Frome, *Outline of the Method of Conducting a Trigonometrical Survey, for the Formation of Topographical Plans* (London: J. Weale: Architectural Library, 1840), 59.

9. John Lort Stokes, *Discoveries in Australia, with an Account of the Coasts and Rivers Explored and Surveyed etc.*, 2 vols. (Adelaide: Australian Facsimile Editions, Libraries Board of South Australia, No. 33, 1969; orig. pub. 1846), vol. 1, 76.

10. Ibid., 76.

11. Ibid.

12. Ibid.

13. Phillip P. King, *Narrative of a Survey of the Intertropical and Western Coasts of Australia*, 2 vols. (Adelaide: Libraries Board of South Australia, 1969; orig. pub. London: John Murray, 1827). See vol. 1, 191 and 363 respectively.

14. Ibid., 152.

15. Edward J. Eyre, *Journals of Expeditions of Discovery into Central Australia*, 2 vols. (Adelaide: Libraries Board of South Australia, 1964; orig. pub. London: T. and W. Boone, 1845). Along the Great Australian Bight, Eyre frequently uses such phrases as "sand-drifts of the coast" (vol. 1, 236), "hummocks of the coast" (vol. 1, 276), and the like.

16. Robinson, *Elements of Cartography*, 128.

17. The calculation of latitude using Mercator's orthomorphic projection was also approximate. Different surveyors working in the same vessel might use tables for calculating the size of the intervals between different meridians at different latitudes that slightly differed from one another. See J. Ballard, *Mercator's Projection and Marine Cartography in H.M.S Endeavour* (Duntroon, N.S.W.: Royal Military College, Faculty of Geography, occasional paper No. 34, 1983), 4–5.

18. Matthew H. Edney, *Mapping an Empire: The Geographical Construction of British India, 1765–1843* (Chicago: University of Chicago Press, 1997), 19.

19. Ibid., 21.

20. Vancouver's problem near Port Chalmers in May 1794 was but a recurrent issue, as Alun C. Davies points out in "Testing a New Technology: Captain George Vancouver's Survey and Navigation in Alaskan Waters, 1794," in *Enlightenment and*

*Exploration*, ed. Stephen W. Haycox, James K. Barnett, and Caedmon A. Liburd, 106–108 (Seattle, Wash.: Cook Inlet Historical Society, 1997).

21. Frome, *Outline of the Method of Conducting a Trigonometrical Survey*, 2.

22. Davies, *Enlightenment and Exploration*, 106.

23. Sydney Parkinson, *A Journal of a Voyage to the South Seas* (London: Stanford Parkinson, 1773), 10–11.

24. J. J. Gibson, *The Ecological Approach to Visual Perception* (Boston: Houghton Mifflin, 1979), 23.

25. King, *Narrative of a Survey*, vol. 1, xxxi.

26. Gary Shapiro, *Alcyone: Nietzsche on Gifts, Noise, and Women* (Albany: State University of New York Press, 1991), 116–118, shows that Aristotle's acquaintance with the shoreline doesn't necessarily make him less superstitious about other kinds of bi-elemental fauna.

27. For instance: "At Batchian there are only two tolerable collecting-places—the road to the coal-mines, and the new clearings made by the Tomoré people." Alfred Russel Wallace, *The Malay Archipelago*, introduction by John Bastin (Kuala Lumpur: Oxford University Press, 1986; orig. pub. 1896), 346.

28. The term was coined by T. H. Huxley: Wallace "proposed a long continued separation between an Indo-Malayan and Austro-Malayan region . . . divided by a line running east of the Philippines between Sulawesi and Borneo and between Bali and Lombok." John Bastin, "Introduction," in Wallace, *The Malay Archipelago*, vii–xxxvii, xxii.

29. The sequel was dismal. Revealing what had formerly lain hidden, Gosse brought about the destruction of what he most cared for. As his son reported, "[t]he fairy paradise has been violated, the exquisite product of centuries of natural selection has been crushed under the rough paw of well-meaning, idle-minded curiosity . . . my Father . . . had by the popularity of his books acquired direct responsibility for a calamity that he never anticipated." Edmund Gosse, *Father and Son* (Harmondsworth: Penguin, 1982), 97.

30. Stokes, *Discoveries in Australia*, vol. 1, 86.

31. Ibid., vol. 2, 319. See Paul Carter, *The Lie of the Land* (London: Faber & Faber, 1996), 82ff, for a discussion of this passage.

32. Quoted by Amanda Kearney and John J. Bradley, "Landscapes with Shadows of Once-living People: The *Kundawira* Challenge," in *The Social Archaeology of Australian Indigenous Societies*, ed. B. David, B. Barker, and I. J. McNiven, 182–203, 202 n.2 (Canberra, Aboriginal Studies Press, 2006).

33. Margaret Atherton, *Berkeley's Revolution in Vision* (Ithaca, N.Y.: Cornell University Press, 1990), 224.

34. David Appelbaum, *The Stop* (Albany: State University of New York Press, 1995), 24–25.

35. Robin Fisher, "George Vancouver and the Native Peoples of the Northwest Coast," in *Enlightenment and Exploration*, ed. Stephen W. Haycox, James K. Barnett, and Caedmon A. Liburd, 200 (Seattle, Wash.: Cook Inlet Historical Society, 1997); as Fisher comments, "Vancouver's own boundary lines were both physical and mental."

36. Stokes, *Discoveries in Australia*, vol. 1, 414.

37. King, *Narrative of a Survey*, vol. 1, 169.

38. Stokes, *Discoveries in Australia*, vol. 1, 81.

39. Daniel Cottom, *Abyss of Reason: Cultural Movements, Revelations, and Betrayals* (Oxford: Oxford University Press, 1991), 84.

40. Writing in 1875; quoted in Cottom, *Abyss of Reason*, 80.

41. C. E. A. Winslow, *The Conquest of Epidemic Disease* (Princeton, N.J.: Princeton University Press, 1943), 237–238; Winslow bases his remark on John Howard's report published in 1789, "The Principal Lazarettos in Europe with various papers relative to the Plague."

42. Daniel Panzac, *Quarantaines et Lazarets: l'Europe et la peste d'Orient, XVIIe–XXe siècles* (Aix-en-Provence: Edisud, 1986), 50–51.

43. Watkin Tench, *Sydney's First Four Years: Being a Reprint of a Narrative of the Expedition to Botany Bay*, with an introduction and annotations by L. F. Fitzhardinge (Sydney: Library of Australian History/Royal Australian Historical Society, 1979; orig. pub. 1798), vol. 1, 5.

44. George Worgan, *Journal of a First Fleet Surgeon* (Sydney: Library Council of New South Wales and the Library of Australian History, 1978), 33.

45. Jean-Jacques Rousseau, *The Confessions*, trans. W. Conyngham Mallory (New York: Tudor, 1935), 447.

46. Quoted in Helen Rosenman, ed., *Two Voyages to the South Seas*, vol. 1, Astrolabe 1826–1829 (Carlton, Vic.: Melbourne University Press, 1987), 249.

47. Ibid., 243.

48. Michael Balint, "Friendly Expanses—Horrid Empty Spaces," in *The International Journal of Psycho-Analysis* XXVI (1955): 228.

49. M. E. Hoare, ed., *The Resolution Journal of Johann Reinhold Forster, 1772–1775*, 4 vols. (Cambridge: Cambridge University Press, 1982), vol. 2, 325.

50. D. W. Waters, *Science and the Techniques of Navigation in the Renaissance* (London: Trustees of the National Maritime Museum, Maritime Monographs and Reports, No. 19, 1976), 2.

51. King, *Narrative of a Survey*, vol. 1, 44.

52. Alain Corbin, *The Lure of the Sea: The Discovery of the Seaside in the Western World, 1750–1840*, trans. Jocelyn Phelps (Cambridge: Polity Press, 1994), 74.

53. John G. Paton, *Missionary to the New Hebrides* (London: Hodder & Stoughton, 1919), 146.

54. Ibid., 147–148.

55. On eido-kinesis, see this volume, 267–271.

56. Ovid, *Metamorphoses*, trans. F. J. Miller, 2 vols. (London: William Heinemann, 1925), Book IV, ll. 288–379 for this and subsequent quotations.

57. Thucydides, *History of the Peloponnesian War*, trans. R. Crawley (London: Dent, 1910), 3–4.

58. Stokes, *Discoveries in Australia*, vol. 1, 81.

59. King, *Narrative of a Survey*, vol. 1, 445.

60. Ibid., vol. 1, 196.

61. Immanuel Kant, *Anthropology from a Pragmatic Point of View*, trans. M. J. Gregor (The Hague: Martinus Nijhoff, 1974), 88. This significance of Kant's nosology in a colonial context is touched on in Carter, *The Lie of the Land*, 257–258.

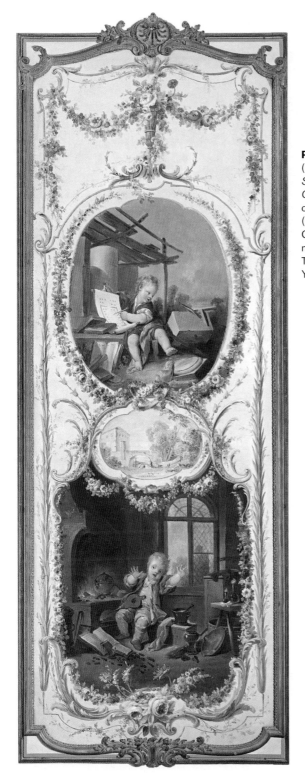

**Plate 1.** François Boucher (1703–1770), *The Arts and Sciences: Architecture and Chemistry* (1750–1753), oil on canvas, 85.5 × 30.5 in. (217.17 × 77.47cm), Henry Clay Frick Bequest. Accession number: 1916.1.07. Copyright The Frick Collection, New York, reproduced by courtesy.

**Plate 2.** "Version 1 of the Honey Ant Mural," June–August 1971 (Geoffrey Bardon and James Bardon, *Papunya, A Place Made After the Story* [Carlton, Vic.: Miegunyah Press, 2004]). Reproduced by courtesy of Dorn Bardon. "Obed Raggett, Long Jack Phillipus Tjakamarra and Bill Stockman Tjapaltjarri stand in front of a circular arabesque system linked by a horizontal bar or journey line with hooks and double hooks" (Geoffrey Bardon and James Bardon, *Papunya, A Place Made After the Story*, 17).

**Plate 3.** Old Walter Tjampitjinpa, "Stars at Night," house paint on cardboard, pre-1971, irregular 35 × 30cm (Geoffrey Bardon and James Bardon, *Papunya, A Place Made After the Story* [Carlton, Vic.: Miegunyah Press, 2004], 105). Reproduced by courtesy of Dorn Bardon. "Recognised as significant June 1971 . . . It was this work depicting stars at night that first interested me in the pensioners' work: to me it was a valid simplification of a perceived object, an image for a star, in fact, an observed twinkling star" (Geoffrey Bardon and James Bardon, *Papunya, A Place Made After the Story*, 105).

**Plate 4.** Johnny Warrangkula Tjupurrula, "Water Dreaming," poster paint with PVA, bondcrete glue on hardboard, August–September 1973, 120 × 90cm approximately (Geoffrey Bardon and James Bardon, *Papunya, A Place Made After the Story* [Carlton, Vic.: Miegunyah Press, 2004], 160). Reproduced by courtesy of Dorn Bardon.

**Plate 5.** Yala Yala Gibbs Tjungurrayi, "Man ['Wati'] Ceremony," poster paint with PVA, bondcrete glue on hardboard, March–April 1972, 55 × 45cm (Geoffrey Bardon and James Bardon, *Papunya, A Place Made After the Story* [Carlton, Vic.: Miegunyah Press, 2004], 389). Reproduced by courtesy of Dorn Bardon. "The hieroglyphs were a composite, a coming-together of the archetypal forms, whereas the archetypes were for the most part the first representations given to me. . . . The artists wrote and painted a landscape as an interaction of stories and totemic ideas, incorporating the archetypes within the hieroglyphic composites" (Geoffrey Bardon and James Bardon, *Papunya, A Place Made After the Story*, 114).

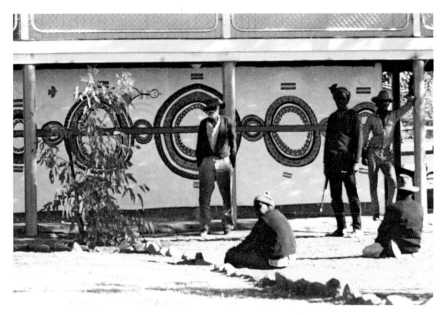

**Plate 6.** "Version 2 of the Honey Ant Mural," June–August 1971 (Geoffrey Bardon and James Bardon, *Papunya, A Place Made After the Story* [Carlton, Vic.: Miegunyah Press, 2004], 17). Reproduced by courtesy of Dorn Bardon. "The Ceremonial Men or Women did not think that the mural was safe and were not happy with it; it was reorganised showing a European ant, quite clearly, and the profile of a European bird" (Geoffrey Bardon and James Bardon, *Papunya, A Place Made After the Story*, 17).

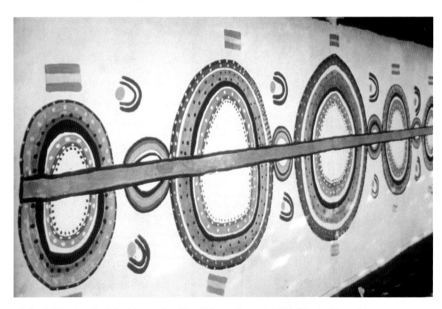

**Plate 7.** "Version 3 of the Honey Ant Mural," June–August 1971 (Photo: Harry Munro, reproduced in Geoffrey Bardon and James Bardon, *Papunya, A Place Made After the Story* [Carlton, Vic.: Miegunyah Press, 2004], 12). Reproduced by courtesy of Dorn Bardon. "The completed Honey Ant mural showing the modified Aboriginal forms, the flashes, the linking of the journey lines in skilful freehand" (Geoffrey Bardon and James Bardon, *Papunya, A Place Made After the Story*, 12).

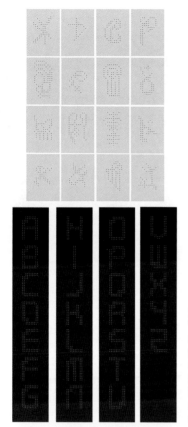

**Plate 8.** Paul Carter/Trampoline, "Iconographs/Alphabets." (top) Figure 28a movement forms digitized to fit a ten-pixel-wide LED array; (bottom) Dedicated "terrace" electronic font (*Tracks*, LED component, PowerPoint presentation, courtesy of Trampoline graphic design studio, 9 July 2001).

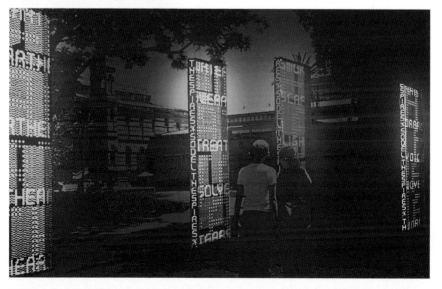

**Plate 9.** Paul Carter/BuroPlus, *Tracks*, photomontage of appearance by night ("*Tracks* Montage," PowerPoint presentation, 29 October 2003). The lateral walls of the "stelae" are perforated with a "random ashlar" pattern. Different scales of perforation are used to create lettering. Each screen is dedicated to a different element, this being reflected in the color of the LED.

**Plate 10.** D'Oyley Aplin and Alfred Selwyn, "Lagoon," detail of Geological Survey of Victoria, 1858. In this early map of the "Lagoon," at various times called Batman's, West Melbourne, and Melbourne Swamp, the pink zones signify basalt outcrops.

**Plate 11.** Paul Carter, *Solution*, mythform (Paul Carter, *Solution, a public spaces strategy*, Victoria Harbo*r, July 2002, figure 31). *Solution* consists of two interlocking patterns. One is derived from a history of ground markings. These markings interpret the history of spatial designs on the site. The second pattern used in *Solution* is derived from a study of the constellation Argo Navis as it rotates annually through the southern sky.

**Plate 12.** Paul Carter and Ruark Lewis, Fig Grove and *Relay*, progress of work. Photo copyright Sydney Olympic Park Authority, reproduced by courtesy.

**Plate 13.** Paul Carter and Ruark Lewis, *Relay*, concept sketches and text treatments. (top) Paul Carter, "Starting Block," concept sketch for *Relay* (September 1998); (bottom) Ruark Lewis, *Relay* design, color text treatment and collage, November 1998. 50 × 400cm (detail) (Photo: Paul Carter).

**Plate 14.** (Above) Ruark Lewis, *Relay* Graffiti Cluster 1, "Peter Montgomery," green tier. 300 × 420mm, watercolor ink on paper.

**Plate 15.** Paul Carter and Ruark Lewis, *Relay* Graffiti Cluster 6: (top left) Paul Carter, sketch design based on the phrase "History helps create history," contributed by "The Oarsome Foursome" to Harry Gordon's personal copy of *Australia and the Olympic Games*; (top right) Paul Carter, revised design sketch incorporating phrase evoking Dawn Fraser's swimming achievement (green tier, row 4); (bottom left) Ruark Lewis, final design; (bottom right) Paul Carter and Ruark Lewis, work in situ (photo: Paul Carter).

**Plate 16.** Paul Carter and Ruark Lewis, *Relay*, detail of red tier (Photo: Paul Carter).
SHAPETHESE**BURIEDSOUNDS**TOSING
RAC**INGWELESS**THANZERO

**Plate 17.** Paul Carter and Ruark Lewis, *Relay*, detail of yellow tier (Photo: Babette Griep).
YOUSURF**ACESING**GOLDENLABOUR
CAN**TSTOPT**OSHUTITNOW
RUNNI**NGONE**SONYARRA
LIELONG**GRASS**TORYSHAPE

**Plate 18.** Paul Carter and Ruark Lewis, *Relay*, detail of green tier (Photo: Paul Carter).
FLOWERINWO**RDSTRUEAN**DFAITHFUL
KIS**SPARTAND**DRIVETIME
WA**ITODAY**

**Plate 19.** Paul Carter and Ruark Lewis, *Relay*, detail of blue tier (Photo: Paul Carter).
**HOPENOWTHEO**RERACOMESROUND
**HUMANORACLES**SHOWAWAY
SUNONOUR**LIP**S

**Plate 20.** Paul Carter and Ruark Lewis, *Relay*, "The Diver" (detail) (Photo: Paul Carter).

**Plate 21.** Tomb painting, Paestum, Andrioulo, Tomb 114, South Wall. Inv. 24817. Reproduced by courtesy of the Museo di Paestum and La Sopraintendenza alle Antichità e Belle Arti di Salerno. The tomb is of an adult male. Other paintings on the inner walls of the tomb show a helmeted warrior standing in front of a horse, reins in hand, another warrior riding home in triumph, and a third warrior advancing between two rows of well-shielded warriors. Presumably this is the cinematic representation of the defunct's life as a soldier. The painted pomegranates may symbolize any or all of a number of death beliefs. They are like tombs because their exteriors are dry and hard but their insides burst with new life. Pomegranate seeds tied Persephone to Hades, so they are also indirectly connected with resurrection (See M. Cipriani and F. Longo, eds., *I Greci in Occidente, Poseidonia e I Lucani* [Napoli: Electa Napoli, 1996], illustration, 134, catalogue note 183).

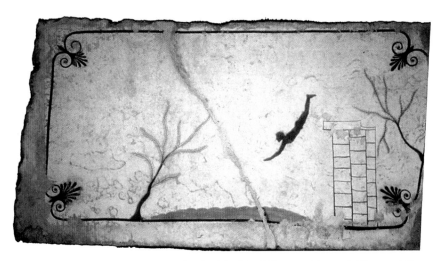

**Plate 22.** "The Diver," underlid of "The Tomb of the Diver," Paestum, Tempa del Prete, c.480–470 BC. Inv. 23104. (Photo: Lorenzo di Masi, reproduced by courtesy of the Museo di Paestum and La Sopraintendenza alle Antichità e Belle Arti di Salerno). Discovered in 1968 (when a pickaxe broke through the roof of the tomb), the iconography of this tomb lid is almost unique in Etruscan-Lucanian painting. The symposium, around the walls of the tomb, whether interpreted as a love feast or a funeral banquet, is a far more typical of this culture's sepulchral art (See M. Cipriani and F. Longo, eds., *I Greci in Occidente*, *Poseidonia e I Lucani* [Napoli: Electa Napoli, 1996], illustration 49, catalogue note 42).

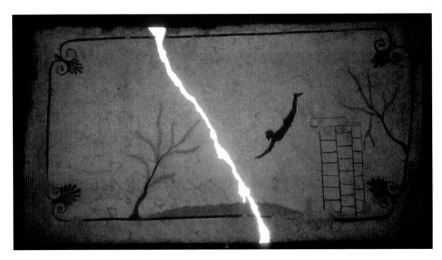

**Plate 23.** Paul Carter, "Fissure 5," digital treatment of image of "The Diver" (Plate 22) (Original photo: Lorenzo di Masi, 1997). This is the final in a series of digitally manipulated images of the diver. Each shifts the fissure to a new position in the field and progressively darkens the background. As the image disappears, the lightning bolt of its discovery becomes all that is left.

CHAPTER 3
# Drawing the Line: Putting Spatial History into Practice

> *How shall I most freely cast a bridge between inside and outside?*
> —PAUL KLEE

### Inside Out

The lines that the artist Paul Klee was drawing in 1906–1907 were "my most personal possession," yet he lamented, "The trouble was that I just couldn't make them come out. And I could not see them around me, the accord between inside and outside was so hard to achieve."[1] As the history of coastlines showed, scientists as well as artists have found it hard to connect the ideal lines they carry around in their heads with the actual appearance of the world. In geography this discrepancy has practical, real-world consequences: in the gap opened up by reason's detachment from the environment of perceptions arises a culture of miscommunication, human and environmental reductionism. By contrast, an artist's inability to harmonize inside and outside might seem to be a private matter. Drawing a line on the map can cost lives—because whether or not the line is drawn in the right place, it constitutes activities along the line oppositionally. A poorly executed line left on a page presumably hurts no one and nothing (except the artist's pride). In at least one area of graphic activity, though, this distinction is far less clear-cut. Klee hints at it when he compares the problem of creating an accord between inside and outside to building a *bridge*.

Architects may think of themselves as designers; like artists, they are experts in a kind of drawing. But architects, unlike artists, evidently have designs on the world. Further, they share their graphic language with cartographers and surveyors. Architectural plans are usually drawn onto plans previously prepared by

site surveyors. These in turn derive their chief features from earlier surveys of the locality where the new development is to be placed. Thus, nested within local, regional, and ultimately global parameters, the plans that architects, landscape architects, and indeed any kind of space designer prepare are directly descended from, and related to, the ideal lines of maps. In countries whose colonization coincided with the rise of modern survey techniques, the relationship between architectural plans, town plans, and the divisions of the cadastral survey are formal. The same rectilinear reductionism is common to all of them. Drawing right-angled buildings or carparks onto the grid of the colonial town—both of which are aligned to the ideal east-west, north-south grid of global latitude and longitude—architects and planners do not apply *ex nihilo* an abstract and conventional sign. They reinscribe a symbolic design on the world that has a long history.

Still, this history is rarely acknowledged. In practice, most designers assume that their plans exist in an unproblematic relationship to the outside world. It is obvious that their lines do not correspond to anything in the world of mobile perceptions, but they proceed as if they do—and, miraculously, builders, the public, and ultimately the inhabitants of these linearly conceived and constructed environments come to share their view, willingly punctuating their lines of flight with arbitrarily fixed walls, doorways, and the entire theater of everyday life that these digitized environments orchestrate and regulate. In *theory* it is acknowledged that the grasp of these continuous lines on the world is tenuous because it fails to notate the movement forms that dominate our intersubjective experience, but in practice this lack of accord between inside and outside is ignored. Architectural theorist Catherine Ingraham notes that "[a]rchitecture has maintained its dedication to linearity in the face of what seems like astounding counter-evidence, the drift and turbulence of forces that can barely be resolved ... the tenuousness of graphite on paper or ink on mylar; the loss of resolution in repetition and reproduction; the interior mess of the wall."[2]

Perhaps this dedication reflects the realization that, in reality, architectural plans represent *nothing at all* except a notion or creation of the mind. In this case, to link the ideal lines of the architectural drawing to the inductively constructed coastlines of Enlightenment geography is a mistake. The squares and rectangles of the architectural plan can be compared to the rectilinear grid imposed on the earth's surface by the imperial survey. But they have no connection to the lie of the land—and, in a sense, no interest in it. Drawn out of itself, deduced from an ideally continuous line, perhaps the architectural drawing has a different derivation. According to Claudia Brodsky Lacour, the post-Cartesian "language of architectonics" is not symbolic. The "dimensionless line" characteristic of the architectural drawing does not represent anything: "Descartes' architectonic line

... is a specifically one-dimensional construct without plastic reality. It does not illustrate the forms of nature, but, like Socrates seeking to read the inscrutable 'letters' of the soul, it translates thought onto an empty surface. It reiterates nothing and represents no preexisting process, but commits an unprecedented form to being. Rather than develop inevitably from a given material core, it is drawn."[3]

The problem of relating what is inside the mind to the "World without" can be suspended in this case. "Architecture, defined by the Cartesian architectural theorist as the 'practice' of 'executing plans' (*desseins*) and the 'theory' of 'appropriate proportions', would be a single activity in which drawing manifests thought and nothing else ... [it] would be as Descartes imaged it in 'thought': a materialization of method, thinking ordered by thought itself, not imperceptibly, but in lines."[4] Would designers today subscribe to the more radical implications of Descartes' argument—that the "line of thought" is not only non-representational but, more accurately, an abstraction of the demonstrable self, drawn out *"for as long as thinking lasts"*?[5] I doubt it. But even in its weaker form, as a theory of drawing, it is counterintuitive. If an architectural drawing represents nothing, how does a builder materialize it? How, firstly, is an ideal form transmitted from mind to mind—and how, secondly and more importantly, is it translated from mind into matter? Goodman circumvents the problem of referentiality in this kind of drawing by describing plans and elevations as "scores." He makes the same claim about maps. They are instructions for constructing a place.[6] They enable the builder—or the traveler—to impose order on the world. But scores notate movement; they seek to represent rhythmic arrangements in time and space. Plans, like completed maps, are remarkable for expunging traces of the "drift and turbulence" of being in place. They pose as signs of things already built, as unilateral designs on environments already assimilated to geometrical reason.

There is another possibility. Perhaps there is no essential architectural line. Plans for buildings and public spaces may be drawn deductively or inductively according to the taste and disposition of the designer. The meaning of the line is not inherent in the diagram but depends on the architect's interpretation of it. In this case the deductive temper discloses itself in an obsessive insistence that every formal instruction is followed to the letter. The object is to produce a machine for living. In contrast, the inductively minded designer is willing to let the design materialize incrementally. It is the property of incrementality, Jean-Gabriel Ganascia argues, that limits the application of inductive mechanisms to the design of artificial intelligence machines. Machine learning "build[s] efficient procedures so as to be able to infer plausible results that comply with a set of formalised examples coming from a more or less complete series of experiences."[7]

By contrast, induction assumes that the set of experiences is always incomplete; as "the mechanism whereby the successive accumulation of experiences leads to certainty,"[8] its operation can never be entirely detached from the human subject and their situation. It is *ductive*, a process of drawing out and guiding toward and by its nature is receptive to changing circumstances and directions in the world without.[9]

In design practice, though, deductive and inductive lines look pretty much the same and operate in the same way to exclude the material flux of being in place. Conspicuously left out of geography's line—as it is left out of Descartes' construction of the "I"—is, of course, the body that writes, and which, in writing, is also being written. Justine Clark explains:

> the surface of the drawing is the site of involuntary traces, just as the surface of the body is the scene of involuntary muscular motions—blushing, tics, twitches—the play of internal effects across the surface of the body. If we follow Elizabeth Grosz's contention that "all effects of depth and interiority can be explained in terms of the inscriptions and transformations of the subject's corporeal surface . . . that the body can be understood as the very *stuff* of subjectivity," then this surface of bruises and blushes, tingles and scars is crucial.[10]

It is not that the inductive line of design has ignored the surface of the body. It is simply, and crucially, that it has always immobilized the bodily movement it has found, erased its preinscriptions, and dematerialized its corporeality—just as cartography has systematically leached the map of its calligraphic and kinesthetic underlay.

The theory of "the line of beauty," espoused by the eighteenth-century cartoonist William Hogarth illustrates this point. Commenting on a story told by Pliny in which the Greek artists Protogenes and Apelles displayed their virtuosity by drawing inside each other's lines, Hogarth asked how a technical facility in drawing fine lines could demonstrate artistic skill. To make sense of this, he concluded, we must "suppose it to be a line of some extraordinary quality, such as the serpentine line will appear to be."[11] By drawing a finer line, Pliny must have meant not a thinner but a *"rather more expressive line."*[12] A serpentine line was more expressive because it seemed to embody movement. It did not outline an ideal form but embodied in an artistic form the body's own movement. The suggestiveness lay *inside* rather than outside—"the serpentine line, by its waving and winding at the same time different ways . . . may be said to inclose (tho' but a single line) varied contents."[13]

But this commitment to deriving the line of beauty inductively from nature did not prevent Hogarth from jettisoning the bodies from which these movement

forms derived. His object in championing "the variety of lines" may be to construct *bodies* more accurately, but only on condition that "the *stuff* of subjectivity" is subtracted. Hence his curious thought experiment: "let every object under our consideration, be imagined to have its inward contents scoop'd out so nicely, as to have nothing of it left but a thin shell, exactly corresponding both in its inner and outer surface, to the shape of the object of itself: and let us likewise suppose this thin shell to be made up of very fine threads."[14] The value of conceiving objects as three-dimensional string figures, as "shells composed of lines," is that "we obtain the true and full idea of what is call'd the outlines of a figure."[15]

What, then, would a drawing practice look like that did *not* leave out the body? As I said in the introduction, spatial history interested not only cultural historians and theorists, architects and landscape designers found it useful. Spatial history put bodies back into the historical picture by asserting that space—the operational domain of white settler societies—is the discursive residue of a collectivity of movement forms, histories, and experiences. What distinguishes this claim from similar critiques of Enlightenment geography is the prominence it gives to the choreographic, poetic, and graphic creativity underpinning colonialism or any expansionist design on the world. The idea was not to mitigate a violent history but to show that within it there always lay another possibility, a potentiality for meeting differently. This creative substrate appealed to designers, who recognized that their graphic tools were irremediably embedded in a history of human and environmental erasure and who wanted to make room for a different possibility of meeting and reconciling. In time I found myself also participating in projects that sought to give the poetic insights of *The Road to Botany Bay* and *The Lie of the Land* a practical application in the realm of public space design. But the effect of this growing experience of turning inside out was only to deepen my awareness of the intractable nature of the relationship between inside and outside, between a theory of spatial production and the practice derived from it.

It might be a museum design that incorporated the traces of journeys. It might be a landscape design that sought to notate the movements of people in a more sophisticated way. It might be the design of a museum interior that aimed to integrate Vico's triad of remembering, imagining, and inventing. But in every one of these projects, the design language remained linear. The rhetoric of a history conceived as the instant between two strides taken by a traveler might be invoked to differentiate the design approach, but the drawings used to support the new spaces where walking was to regain its significance as a mode of knowing continued to be composed exclusively of geometrically abstract lines. Here were design practitioners who *wanted* to accommodate the "drift and turbulence" of bodies in motion, but who remained committed to a philosophy of drawing that prevented this experience from being registered in the design. It seemed to

confirm Ingraham's point that "even in epistemological and representational accounts of its own artistic practice, architecture relies on a kind of orthogonality, a linear movement from drawing to building, architect to drawing."[16]

The question for me became: Is there another way of drawing (and thinking) that allows the movement forms characteristic of spatial history to find a place in the design of places? Can the relationship between inside and outside be negotiated in a way that does not take the form of a bridge in which the difference between theory and practice is pre-emptively equalized and in this way canceled out? Can the difference between thinking and walking be notated, and what kind of line would do justice to this difference?

### Withdrawing

As a matter of fact, the problem of putting a spatial historical consciousness into practice had already been broached *theoretically* at the end of *The Road to Botany Bay*. If the spaces we occupy are not theatrical artifacts but unfinished processes in whose production we participate, how are we to become aware of this? This is an important question because without this spatial historical consciousness it is impossible to understand the interconnectedness of past, present, and future actions. We proceed without memory as if the spaces we inhabit are a *tabula rasa* that we can choose to inscribe as we wish. The human, environmental, and spiritual costs of this collective forgetfulness are everywhere to be seen, in the reckless destruction of cultures, in the overexploitation of the earth's gifts, and in the delirium that passes for free choice in our consumerist society. It is an urgent ethical responsibility to learn that we walk in the tracks of others and, having learned this, to regroove these traces creatively and differently. Without this power of creative recollection, we are doomed to repeat the same steps, with the same destructive consequences. As Verene observes, where the power of remembering is forgotten the future becomes a more extreme version of the present.

To evoke the creative nature of spatial historical consciousness—the sense in which we were immersed in a creative process and had a responsibility to ameliorate its destructive consequences—I cited a passage in Edmund Husserl's late work *Origin of Geometry*. Written in the 1930s, when Husserl had come to see that his theory of knowledge was incomplete because it did not take account of the historical origins, transmission, and renewal of forms of knowledge, this text grappled with the question of the historicity of ideal forms. How, for example, were the theorems of Euclidean geometry transmitted from teacher to student and from generation to generation? How, more mysteriously, could a later mathematician build on the inherited knowledge and, while preserving the ideal form, invent something new? In exactly the same way, we could ask:

How can an architect, a landscape designer, or public artist work inside the received forms of the survey—which are also the orthogonals of reason—and create something new? How is it possible to realize the ideal—to make the inside outside in Klee's sense—without destroying its ideality? And, more importantly, how can the provincial, destructive, and myopic character of these ideal forms (which we cannot wholly jettison) be brought to light in a way that changes the future open to us?

To explain the repeatability of ideal forms, Husserl argued that through language a subjective act is rendered objective and transmissable, but ease of transmission of virtual meanings may induce passivity, a forgetfulness of the original meaning, and hence ultimately a crisis of understanding. The craft that makes present again the original meaning, rather than merely recollecting it or representing it, involves an intention to explicate the elements of meaning, "thus bringing the total validity to active performance in a new way.... What was passive meaning-pattern has now become one constructed through active production."[17] Or, to put it another way, "if the originally self-evident production, as the pure fulfilment of its intention, is what is renewed (recollected), there necessarily occurs, accompanying the active recollection [*Wiedererinnerung*] of what is past, an activity of concurrent actual production, and there arises thereby, in original 'coincidence', the self-evidence of identity: what has now been realised in original fashion is the same as what was previously self-evident."[18]

What does this mean in theory? (And, more to the point, what would it mean in practice?) The key terms here are "intention" and "active recollection" because both have a creative sense, referring to the capacity of consciousness to bring sense data to consciousness itself and to hold sensations *and* the environment of sensation simultaneously in mind. Intentionality involves the recognition of "a presumptive, an ideal unity across a flux of data." Lingis explains that it "is not a relating of one real being to another (for example the subject with the object); it is a relating of givenness to identity, of flux to ideality. The 'movement' of intentionality is a movement from the sensible to the ideal; it is this 'movement' or 'tending toward' that synthesises."[19] Husserl's theory of internal time consciousness, for example, is not so much a theory of time as of participation in time. Our temporal universe originates in the consciousness of sensations in their passing: "This inner adhesion to the passing impression is the very tension of the present, the primal tension of intention."[20]

This helps explain Husserl's conception of recollection, which he distinguishes from retention. Recollection singles out something from the past and re-presents it in memory—but does not relive it. By contrast, retention, or primary memory, is "the consciousness of the past as the horizon or background against which the present stands out."[21] Carr invokes the experience of spatial

objects to explain this: "I cannot see an object in space except against a spatial background. Likewise I cannot experience an event except against a temporal background. To experience an event is to be conscious of something *taking place*, that is, its *taking the place* of something else. What is replaced or displaced recedes into the background but is not lost from view; I am still conscious of it but in a different way."[22] Retention is, then, properly called horizon-consciousness, and the horizon of an experience lies not only in the past but in the future, of which we always have some kind of *protention*, however vague.[23] In this case recollection only becomes active when it is accompanied by "an activity of concurrent actual production."

Consciousness, in Husserl's view, is a kind of attraction to, or inclination toward, the world. It conceives of the relationship between inside and outside in terms of tendencies toward things, and of things with tendencies toward one another both in space and time. The emphasis is not on things but on the adherent forces that bring them together and arrange them. This theory not only applies to the organization of sense data but to sensations themselves, as Lingis explains in an exposition of Husserl's theory of sensation or hyletic data: "The course of kinesthetic sensations are free processes, and this freedom in the consciousness of the course of the sensations is an essential part of the constitution of space."[24] This means that the kinesthetic sensations do not reveal the object as simply oriented with regard to a factual zero-point, but rather a freely displaceable zero-point, a freely mobile subject. Conditionality, the "if . . . then" mode, stamps the orientation across kinesthetic sensations.[25] Nor is this emphasis on tending toward as physical movement necessarily anti-architectural; it simply redefines the locus of attention in the space in-between of subject-object relations. The movement of intentionality occurs "in the very space it will constitute by constituting objects"; as such "[d]istance, interval, is continually both opened and traversed by the very enactment of intentionality."[26]

Applied to the passage from *Origin of Geometry*, the explanation of these key terms intentionality and recollection seems to mean that ideal forms are transmitted and renewed when intentionality itself is actively recollected. The part of ideal forms that can be transmitted is that tendency toward the ideal; it is this that is re-enacted when, repeatedly, a form is extracted from the background flux. If this interpretation is right, it suggests that there is a basis in consciousness for Kafka's desire for a history told through the instant between two strides. It is not an idea from the past that is copied but the act of ideation, the very movement of a consciousness *constituted* to extract stable mental forms from the flux of physical sensations.

The drawback of this theory, though, is that it fails to explain why acts of creative renewal and transformation occur at certain times and places. Husserl's

emphasis on the originary nature of intentionality means that the past that lies beyond the horizon (all we might call history) cannot be lived through again except as an infinite series of repetitions that by their nature cancel out the historicity of the experiencing subject.[27] To participate in time is to transcend history: how, then—to return to our original question—to account for the traditions that are the vehicles of ideal forms but are specific to certain cultures and periods? Spatial history, as the phrase suggests, is about a different conception of space and time. It evokes a history of movement, of spacing and timing, and suggests that these experiences constitute a tradition of place making. But the experiences of extracting place from space, or the instant from time in general, cannot be generalized or repeated. They belong to a tradition of place making only on condition that they interpret it in an original fashion.

David Krell makes the same point with regard to architecture, writing that the concept of "recollection as a chain of repetitions" is irreconcilable with the sensation of "the living present" said to characterize internal time-consciousness. As he puts it, "[i]f time is undecidably both a punctuated line and a seamless continuum, then it is neither a chain nor a sprocketed filmstrip. There is no documentary of memory: the mind cannot rewind the chain or reel time back, in order to 'live through' its experiences again. For"—Krell concludes, referring back to the earlier argument of his book that *archeticture*, a spelling that offers etymological support for Krell's contention that architecture once (originally?) signified a labor of love—"its experiences are ecstatic."[28]

How does this critique play out in practice? Here Krell is vague: "If architecture can make do with less continuity, sedimentation, reactivation and recollection as a chain of repetitions, it may be able to do more with interruption and innovation." But isn't this to initiate another series of repetitions, one, what is more, with which we are all too familiar? For in a different form the break with the past is exactly what Descartes sought to initiate with his architectonic line. To reconcile the background and foreground of the world of sensations and the intentionality of consciousness that repeatedly binds them, the Husserl scholar Anna-Teresa Tymieniecka urges us to recognize that the creative act is "a participation in and continuation of the collective effort of humanity which designed this circumambient world and, so, has reached at this point its specific structure."[29] But this attempt to explain how the new both participates in the old and departs from it is also vague.

Perhaps, in fact, "active recollection" and the "activity of concurrent actual production" cannot coexist. This seems to be the view of another interpreter of Husserl, the philosopher Maurice Merleau-Ponty. The artist, aware of a whole past of painting, has still, according to him, to yield to "the unlimited fecundity of each present which, precisely because it is singular and passes, can never stop having been and thus being universally"; he must possess *"the power to forget*

*origins* and to give to the past not a survival, which is the hypocritical form of forgetfulness, but a new life, which is the noble form of it.... The productions of the past, which are the data of our time, themselves once went towards a future which we are, and in this sense called for (among others) the metamorphosis which we impose upon them."[30] It is presumably this power to forget that allows the resemblance between the new "actual production" and "the originally, self-evident production" to appear as a surprising coincidence.

One can become conscious of what went before because in some way it already had us in mind, and it is this intention that we can revive. I can see the force of this argument in the case of the place names that colonizing explorers bestowed on the land. A spatial historical account of these shows that they are poetic figures that attempt to give stable (ideal) form to an orientation toward the flux. They bring ideal places into being and are the candid, poetic record of this intention. Evidently paradoxical, they solicit the attention of the future to make better sense of experience than their authors can. They invite a renewed intention to the problem of kinesthetic sensations and their formalization; properly approached, they invite us to inhabit again the condition of being a "freely mobile subject," the locus of whose attention is the space in-between of subject-object relations. But how would this analysis apply to the graphic conventions of the map? How can the line that the cartographer and the surveyor draw—and which the architect seemingly repeats—be a site of active renewal and transformation in this sense?

\* \* \*

This was the question Hogarth addressed to the lines that Apelles and Protogenes drew in the famous competition recorded by Pliny. This story has a long history, and Hogarth's view that the lines must have been inductively derived reflected the prejudices of his own age. When the Florentine surveyor-turned-architectural-theorist Leon Battista Alberti tried to make sense of Pliny's story, he supposed that the lines the artists drew were like the orthogonals used in the new science of perspective drawings. Alternatively, they were like the horizontal and vertical lines used to draw the "grid" through whose frame the scientific artist could fix the relative positions, sizes, and aspects of things in his field of vision.[31] In this case they were deductive lines, anticipating Descartes' dimensionless line. Alternatively, none of these hypotheses is necessary: Vasari reports that Giotto communicated his unique talent to the pope by drawing a perfect circle.[32] In this case the greatness of an artist seems to have had nothing to do with remembering or forgetting; it was the ability to cut through Husserl's problem (and his elaborate solution) and to present simply a self-evident production. But this, too,

seems counterintuitive: after all, Giotto is esteemed for the Scrovegni Chapel, not for his illustrations of Euclid.

Here is Pliny's account:

> Once, [Apelles] visited Protogenes, only to find that he was not at home. On a large panel in the man's studio, he painted a single fine coloured line. When the artist returned and saw what had been done, he knew his visitor to have been Apelles. He then drew an even finer line in another colour exactly over the first one. When Apelles came again, he drew a third line, this time so exquisitely fine that no other could be drawn. Conceding defeat, Protogenes determined that the panel should remain as it was, to be admired for its artistic virtuosity.[33]

But that was not the end of the story. Protogenes ran down to the port, where he found Apelles and embraced him. The two agreed that the panel should be exhibited as a jointly authored painting—and Pliny reports that centuries later he was still able to see it displayed in the palace of Augustus on the Palatine, describing it as "a seemingly empty panel except for the almost invisible lines ... more esteemed than any of the masterpieces there."[34]

Here, in practice if not in theory, is the exemplification of Husserl's thesis: An originally self-evident ideal form is actively recollected through a concomitant mode of production so as to produce an entirely original "coincidence." The entire drift of the painting—from the real of the physical brushstroke toward the ideal of the pure line (or, as Pliny suggests, from the visible to the invisible)—seems like an illustration of Husserlian intentionality at work. Repeatedly extracting ideal forms from the flux of sensation, Apelles trumps Protogenes when he draws a line that excludes any other line being drawn, a line so fine it rules out further refinement. Transcending a mechanical art of drawing, he produces an ideal line. No longer another line among many, his final line is the One Line to which all others can only aspire. It resembles a Platonic Form.

Perhaps this explains why the "work was for a long time admired by connoisseurs, who contemplated it with as much pleasure as if, instead of some barely visible lines, it had contained representations of gods and goddesses."[35] Apelles had produced a line whose abstraction transcended its human origin. It is not the individually distinctive representation of nature that defines an outstanding artist, but a capacity to express the ideal. It is mastery of the invisible, not the visible, that counts. The master artist, like the surveyor, architect, or cartographer, *withdraws*, rather than draws, when designing. To master the line is to transcend mimesis. Great designers are like gods. They do not make more or less accurate copies of existing things but reproduce ideal forms. They deal in *agalmata*, as

the ancient Greeks called those statues of gods that seemed to communicate directly rather than through a resemblance.[36] No wonder Giotto forwarded a perfect circle to the pope as a sign of his mastery.

### Participation

There is another way to interpret Pliny's story. When Protogenes drew inside Apelles' line, he transformed Apelles' line into the *ground* of his own figure. He revealed that what looked like an ideal (dimensionless) form had, in reality, a physical dimension. It belonged to this world—the world of kinesthetic sensation—and could, accordingly, be modified. When Apelles took up the challenge, drawing a yet finer line inside the one Protogenes had drawn, he did not cancel out the line Protogenes had drawn but divided it in two; his own line—the line that seemed to come as close as possible to the line of all lines (the One)—did this, paradoxically, by producing three incredibly thin lines in parallel, visible because of the different pigments the artists used. The agreement of the two artists to regard the finished work as a joint composition indicated that they regarded the *process* of producing it as part of its value. The artistic merit of the work resided not in the accuracy of the final representation produced—after all, the three bands of color, one inside the other, represented nothing. It stemmed from their playful agreement to explicate the grounds of their art, the sources of its meaning. Taking the ideal line and repeatedly dividing it, they showed that the transmission of the One (the ideal line) meant participating in its active division into many lines.

Perhaps this analysis can be reconciled with Husserl's theory—according to Cobb-Stevens, there is no need to think that the repetition of an ideal object means making it fully present.[37] Rather, the originality of the act consists not in recollecting a truth tradition has obscured but by participating in the original act of creativity it represented, surpassing it. What is made fully present is the movement toward idealization, not an object; hence to assert continuity with the past is also to renew it. Otherwise, how could inventions occur within the field and modern geometers surpass their predecessors? Be that as it may, Husserl's theory still invokes a primary distinction between the knowing subject and the world without, between the production of ideal forms and the flux of sensations. Intentionality may glue them together but it does so *reluctantly*. There is little taste for the *ecstasis* that Krell finds characteristic of creativity, or desire for immersion in the materiality of being. And even Merleau-Ponty's phenomenology of the body has little in common with spatial history's evocation of the kinesthetic space of active place making, of participatory eventfulness.

With Merleau-Ponty, it has been pointed out, "one would never know that the body has a front and a back and can only cope with what is in front of it, that bodies

can move forward more easily than backwards."[38] And yet it is this awareness that is crucial to making tracks and retracing them. It is the hidden spatial context of Pliny's story that explains why a competition calculated to stimulate rivalry produced instead unity—for without the sensation that each artist was painting over the other's shoulder, sharing an orientation toward the discovery of the truth, their subsequent friendship would lack psychological plausibility. Merleau-Ponty's attempt to embody vision, to corporealize perception, brilliantly evokes the situatededness of perception. But the subject remains contemplative, and the subject position static.

In this context, what would it be like to inhabit an environment semantically attuned to the kinetic body, dyadically composed like the left-right of forward walking?

\* \* \*

As a way out of the conundrums presented by Husserl's theory, I invoked, in *The Lie of the Land*, the Platonic term *methexi*s, or participation. How do we walk in the paths of history—a process that inevitably means taking account of the lie of the land and the ways in which it has been produced and reduced? Following tracks of all kinds or movement forms, I argued, was a way of avoiding the infinite regression involved in representing the past as a heritage of presences. Tracks are what is left behind; they bear witness to something that was never there, but always departing, disappearing. They are the supplementary marks that we have had to repress in order to preserve the illusion of theatrical history. They are vestiges of the stride and the instant between strides. To notice them, to retrace them, *to make sense of them*, is to engage with the leftovers of history and to harness their potential to indicate different paths into the future. But I had no authority for my surmise—Aristotle thought Platonic *methexis* no improvement over Pythagorean *mimesis*,[39] while Jacques Derrida's insistence that Husserlian presencing remains rooted in re-presentations suggests *methexis* may simply be a modality of *mimesis*, a magical or shamanistic act of sympathetic identification preliminary to *mimesis* "in its original sense, which always involves a transmutation and an intensification in order to re-present the work in a way never before seen, a way that appropriates the work to the present and makes it 'topical.'"[40]

In this context it was reassuring to find later that the philosopher Hans-Georg Gadamer had anticipated my thought—and explained it clearly. Arguing that Husserl's thesis fails to explain the historical nature of ideal objects, their appearance, transformation, even disappearance, and, invoking the role of tradition in the creative act, Gadamer proposed that explication was never a simple "repetition

of the past, but rather a participation in a present meaning."[41] The text, but it might be any ideal object or design, is simultaneously a unity and a multiplicity, and "brings into play a totality of meaning without being able to say it totally,"[42] a concept explicitly anticipated, Gadamer suggests, in the old Platonic concept of *participation*.[43] This is a term most fully explicated in the *Parmenides*, where the young Socrates finds himself defending the intuition that the One *should* be able to participate in the Many, but unable to explain logically how it can happen without yielding to a relativism that renders ideal forms unnecessary.

Parmenides' solution is to invert Socrates' concern, making it a question of how the Many form part of the One. By way of answer, *methexis,* or participation, it is explained, in the One or the Form is the means by which nature—presented here as entirely passive—acquires its character. Without limit in quantity (*apeiron plethei*), nature displays only negative features, "lack of inner structure, indeterminate multitude and magnitude, and lack of independent existence." In this situation, *methexis* involves two participations. In the first, through "participation in . . . the great and small," it acquires "the various features of size." Hence the *plethos* of a thing "will be that in a thing which *is* through partaking of the great and the small." In this way things find their physical element, their aspect. However, "the nature they have by themselves gives them . . . a lack of *peras*" or boundedness. This, the second participation in the One supplies. Participation in the One gives things their *peras* in relation to one another.[44]

Obviously, this ancient theory of Forms and their descent into matter is only of antiquarian value so far as an understanding of natural systems is concerned —these are recognized as self-organizing, evolutionary, and internally productive of new forms. But it remains relevant to the question of how ideal lines get into the world. This becomes clearer when Parmenides' exposition of *methexis* is juxtaposed with the concept of contraction. The challenge of explaining how the One or the Divine informs the Many or Nature has preoccupied philosophers, logicians, and theologians down the ages, but a particularly useful response for our purposes comes in *The Art of Memory*, a treatise written by the Neoplatonic philosopher Giordano Bruno and published in London in 1583. There, building on the ideas of theologian Nicholas of Cusa (1401–1464), Bruno uses the term in three senses: physiological, psychological, and ontological. Thus bodies, he says, can draw themselves together when exposed to heat; the human mind can "contract into itself" when it "withdraws from the empirical and social world, turns inwardly, and seeks to ascend to higher realms"; finally, the Neoplatonic One "contracts" itself into the universe, "generating and sustaining the existence of particulars."[45]

It is this last sense that is interesting. Bruno emphasizes that the mediation between the One and the Many involves "a double contraction." There is the first

contraction already mentioned through which "the infinite and absolute form" is made "finite in this or that matter."[46] But for this to work, matter has, as it were, to come halfway to meet the absolute form: "The second contraction is that by which inferior nature and multiplicity, through some habit of agreement and obedience, is collected together and by which it is rendered participant, either by a natural or conceptual impulse."[47] This theory of the double contraction recalls Parmenides' notion of a double participation. It also suggests the double movement involved in drawing: drawing is both a putting out or extension into the world, and a withdrawal from it, a contraction toward the ideal. But what would this double contraction look like as a drawing practice? A drawing practice that in some way both collected "multiplicity" together and endowed it with a new formal "existence" would produce a contract between the One and the Many that was ontologically sound as well as graphically imaginable and, who knows, politically progressive.

Perhaps the word *contraction* suggests an answer. The verb *to contract* has a double meaning. On the one hand it means to join up, literally to draw together. On the other hand, it means to shrink back—to draw together in the sense of withdrawing from contact. What kind of mark would meet both these conditions? A clue lies in the figure of traction and in its cognate terms, tract, trait, and track. All these terms refer in one way or another to a practice of tracking. The tracker/artist steps in the footsteps of the past with interest; she pays attention to the spatial disposition of the prints, deriving information from the depth and direction of the marks. The act of tracking also involves a double participation. On the one hand the tracker has to contract her personality into the scale of the pattern on the ground, adjusting her natural rhythm and stride to its demands. On the other, the object of this first contraction is not mere mimicry. It is done with interest—with the intention of joining up the marks, in this way tracking down and coming into the presence of the quarry.

As a matter of fact, the connection between contraction and tracking is already to be found amongst the Italian Neoplatonists. It is all very well to withdraw into oneself in order to come closer to the divine, but this ascent presupposes that some evidence for the divine exists. To locate this means being a kind of metaphysical Hutton, scrutinizing the empirical world for whatever cryptic indications of God it can furnish. Or, as Egidio da Viterbo put it, his "footprints are so hidden" that the philosopher-hunter must bring in the dogs of thought if he is to find his quarry: "These dogs cannot track hidden quarry except by means of footprints, clear traces of the feet, or by odours. Thus in the Forest of Matter divine footprints lie hidden, but when we take notice of them by means of reason, and consider them well, then we hunt out the hiding places of the divine."[48] Interpreted as a graphic or representationalist allegory, rather than as a

theological one, Egidio's story says that the line that illuminates the dark writing of the world (matter, inferior nature, multiplicity), the contracting line, *will be a broken one*. The line that contracts (in the double sense) was never continuous or internally solid or rigid. It was discontinuous, a linear distribution of marks spaced more or less closely together, here stretching out, there gathering.

The line that connects inside and outside—that participates in the production of something new—is bipedal, a construction of stresses and intervals. This throws light on the crisis Paul Klee faced when he could not find a "bridge" between inside and outside. Aware that there was not a "seamless continuum" between the design in his head and the mark on paper, he felt the line withdrawn into a purely ideal realm where it simply repeated itself. It was impossible to mobilize the line in a way that would make it new. Klee's solution was also to break up the line. In his *Pedagogical Notebook* he writes of "the mobility agent . . . a point" that becomes "an active line on a walk, moving freely, without goal. A walk for a walk's sake."[49] But the problem with this conceptualization of the mobile line is that it remains an idealization of walking, as if walking were an originary activity conducted on a surface without memory. In this scenario, when the will to keep going is exhausted, the mobile line stutters to a halt. The "seamless continuum" turns back into a "punctuated line" and, as the next steps will look exactly like those already taken, there is no reason for going on; the future will be a repetition of the past's ideal forms.

The truth is that a single line never goes *walking*: it *skates*. To walk, a line would need to be both discontinuous and multiple—a condition that only the track (and the tracker tracking it) can fulfill. The inertia Klee sensed arose because the interval between two strides had become dead for him. He could not see how to get from one point to the next. He could no longer recognize the traces in the world—"I could not see them around me"—that his own line of thought followed with interest, and as a result he experienced a kind of delirium, a sense of being out of the furrow.[50] It is the quality of interest that the doubly contracted line keeps in play, for interest is the equivalent of Husserl's idea that the concomitant mode of production that accompanies active recollection reflects "an intention to explicate the elements of meaning." Interest is the sense in which the follower goes beyond what lies before her even as she comes behind their tracks.

In fact, in its origin the term "interest" seems to have this double contraction in mind as it means "to be between."[51] This is a condition of movement between things, conceived not as an opposition between the still and the moving but as a rhythmic interplay of elements all of which are vestiges of movement forms and anticipate movement's renewal. Interest is exactly the attraction of Kafka's formulation of history. A history told in terms of instants would successfully notate the double contraction through which inside and outside, the One and the

Many, the dot and the line—and a theory of spatial history and its practice—are reconciled. Always happening in the opening and closing space where following and anticipating are aspects of the same movement, it would be a history of interest.

### Drawing the Line

But to return to Gadamer. The question was how to put spatial history into practice. And the case in point was the challenge of influencing a drawing practice that, even though it evidently had a design on the world, deployed lines as if they were ideal constructions. Husserl's meditation on this problem, and the Platonic notion of participation or *methexis*, have between them produced an answer. They have suggested a graphic practice that understands the line as a field —as a ground or zone—and this field as a dis/continuous track, formed not of ideal "dots" but of marks of various kinds. These marks do not quite meet Grosz's desire for the acknowledgment "of the inscriptions and transformations of the subject's corporeal surface,"[52] because they are derived from the outside world where bodies leave their marks. They are indices of mobility and sociability and annotate intersubjectivity rather than "the very *stuff* of subjectivity." They are not analogues of subjective experience but symbols of them; however, being derived from traces rather than images, they share Grosz's desire to put bodies back into history and, more importantly, back into the discourse of architectural design.

In this sense, the drawing practice described here solves more than a theoretical difficulty. It not only tackles a technical problem inherent to a particular group of design disciplines. It looks outwards toward a reconfiguration of spatial relations. Noting that "[n]o other Platonic dialogue leaves its reader with such a sense of *aporia* or 'being without anywhere to go,'" a recent translator of the *Parmenides*, Albert K. Whitaker, concludes that this is, in a sense, the point; although the relationship between the One and the Many can never be put into so many words, it can at least be approached through what Parmenides calls the "worklike game" of the "gymnastic," that dialectically organized form of conversation in which understanding comes by trying out every argument, rather than by adopting one at the expense of the other.[53] It is interesting, in view of our own earlier argument about the figurative nature of spatial knowledge, that Whitaker links this conclusion to the nature of language itself: "whenever you try to speak about the One or other such things, you necessarily import certain assumed images of the thing you are talking about, imaginations which confound your apprehension of the intelligible."[54] These many imaginings make direct knowledge of the One impossible: "caught between the particularities of visible phenomena and the wholeness of the intelligible forms . . . our speech about these intelligible beings, then, is playful."[55]

In any case, the point Whitaker makes about the *Parmenides*, Gadamer

makes about the Socratic dialogues in general. According to him, they are not only conversations about ideas but conversations about conversation. They give back to discourse its physical meaning of a running hither and thither between different positions. The object is not to produce a logically coherent linear argument but to show that truth resides in the interplay of a multiplicity of positions. But this can only emerge when those taking part contract to participate in the dance of the intellect. Pointing to the ironic character of Plato's deprecation of the very mimesis in which his own dialogues excel,[56] Gadamer emphasizes the ontological, rather than epistemological, aspect of the dialogues, the sense in which they participate playfully in the uncovering of the truth they pursue. Hence, against Aristotle, he can maintain that the separation (*chorismos*) of the noumenal and phenomenal realms does not create an insuperable obstacle to the partaking of the Many in the One, but by creating the conditions of a living dialogue makes possible their communication; attending to the movement of the dialogues themselves, we can say, "all genuine dialogue is dialectical insofar as the interlocutors participate in the conversation in the same way that the phenomenal realm participates in the noumenal . . . interpreting the *chorismos* as an instance of *diairesis* [division, a phase of the dialectic, contrasted with *sunesis* or *sunagoge*, collection]—one can view dialogue ontologically—interpreting verbal engagement as an instance of *methexis*."[57]

Wondering how *chorismos* itself participates in the dialogical rendering of *methexis*, Rod Coltman concludes that it can be seen as "a model for the interdiscursive space between 'I' and 'Thou' that makes this participation possible."[58] But to inhabit this space, which is also to bring it into being, it is necessary, as Parmenides instructs Socrates, to master the gymnastic, the poses of the dialectic that are not merely rhetorical or mimetic but constitutive or choreographic. Then, as for players in the game, who "must know the rules of the game and stick to them. . . . The movement of playing has no goal in which it ceases but constantly renews itself." Thus, Gadamer adds, oddly discovering an act of architectural enclosure in the very securing of openness, "the game has its own place or space (its *Spielraum*), and its movement and aims are cut off from direct involvement in the world stretching beyond it."[59] Translated into design terms, Gadamer's "game" evokes an architectural practice in which figure and ground fuse, and the movement of the line is incorporated into the poses of the buildings that form the place. An art of placing or posing is implied in which the traces that brought the buildings to their present positions are integral to the constitution of the space—in which the *chora* retains the signs of the *chorismos* that brought it into being.

*Chora*, the middle term of the *Timaeus*' account of cosmic creation, is usually translated as "place" and has the sense in Plato of receiver or receptacle. But it

also bears a more active sense, being associated with a verb that has the meaning of "making room for." Hence Robert Turnbull suggests that the place of the *chora* is to make room "for the numbers or, equivalently, the geometric solids . . . when the Receiver is somehow mixed with the intelligible numbers (or shapes), the product is a spatial array of figures."[60] Then, the *chora*, or place of making room, corresponds to Husserl's notion of intentionality as a consciousness of "something *taking place*, that is, its *taking the place* of something else." And this is a formulation that not only applies to the nature of consciousness or the constitution of architectural space, it recognizes the irreducible multiplicity of being in the world and the fact that this being is composed of a myriad of different horizons, in terms of which we are all constantly appearing and disappearing. Evidently it is a matter of conscience, not simply consciousness, to ensure that this movement, this synthesis of appearing and fading, is reinscribed in the design of the *chora*. Otherwise, we are back where we began, with a theoretical observer looking through his theodolite at a mobile world stuttering to a halt in his survey, a world that (on the map and in the architect's concept drawing) is unpeopled, lunar, and supernaturally quiet.

The line not only extends but protends. Unlike Eros' arrows fired at random, it intends something. In this sense the line is also the wandering of the numbers, the elements, or geometric solids to their places. As John Sallis points out in his elucidation of the meaning of the *chora* in the *Timaeus*, the definition of it as a passive receptacle is quite inadequate. As the form of a city in motion, the *chora* comes into being through the differentiation of the four elements, which until then existed merely as traces (*ichnoi*). This happens when a certain distribution of the traces occurs—as a result of which, for example, the "fiery" fleeing to its proper place appears to sight as fire. A complex movement has to be envisaged, "one that involves movements both of the *chora* and of the traces within the *chora*."[61] It seems that the *chora* is a region of regions, and the *topoi* within it "are not merely presupposed by the movement but are determined by it."[62] The city in motion, as opposed to the technical (or theoretical) city, is under the aegis of the feminine—"women will use every means to resist being led out into the light"[63]—and its erotic and procreative character resists definition. In its resistance to patriarchal prescription, the *chora* is the realm of dark writing.

Drawn like this, the new line transforms the meaning of the coastline. For our new line is drawn inside that line. It does not cross it out but divides and doubles it. Through that act of *chorismos*, or separation, it opens up a space where wandering tracks can find room. The authority of the line yields to the pattern created by those participating in its realization. The single course of the linear argument yields to the discourse of the crowd at large, provided they are willing to participate in the retracing of the dark writing inscribed in the aspect of

the forming place. Commenting on the double participation described in the *Parmenides*, Mitchell Miller points out that it requires a doubled boundary, "the property line which first delimits—and so makes definite, determinate—an otherwise indefinite terrain" *and* the boundary that, by defining the terrain on both sides, creates two new regions in relation to each other.[64] So long as the boundary, repeatedly drawn in this way, remains mobile, the unity it describes, the sense of being absolutely related, must be composed of boundlessly multiplying differences. Likewise, a patent for the double-bind or (less negatively) the both/and nature of (self-)consciousness (our mode of participation in Being) exists in the *Parmenides* where the "foundational duality" of the young Socrates' proposition, that "one Is," motivates Parmenides' gymnastic: "With the recognition that *one* and *being* must be *different* from one another, thus adding *difference* and, with it, there is a 'three machine,' replicating in the series of 3, 9, 27, etc."[65]

 This doubling is what is achieved graphically when the line is redrawn in the way described. One line is not canceled out by another. Rather, the line is drawn out, showing what is inside it. The line proves to have an outside, and to be replicable. By not crossing out the line but scoring it or remarking it more deeply, a difference is both created and negated. A dialectical act of differentiation turns out to participate in an act of bringing together. But isn't this an allegory about a differently constituted community? If the sign of division can itself be split in two, this suggests that inside the binary logic signified by the line, a counterlogic of meeting, joining, or sealing can be found. In this understanding of the organization of matter (and of relations generally), differentiation is not oppositional. It is the precondition of discovering likeness. The line within the line marks the distance from which potentially opposed entities run to meet each other. It is the sign of sociality or attraction. Unlike the abyss that opens up between people in individualistic theories of intersubjectivity, it is the gap necessary if meeting is to occur.

 But it is a gap, not a bridge. It is, like the instant between two strides, an interval characterized by a potential or actual movement toward another (another person, the next footstep), that is, a potential relationship rather than an unmarked void. According to the Italian philosopher Giorgio Agamben, Walter Benjamin described the mission of St. Paul in these terms, arguing that the conversion he taught broke down divisions (Jew/Gentile, circumcised/uncircumcised), not effacing them but rendering them politically "inoperative." An event of this kind suspends the dialectic, giving value to the "between," the "interval," the realm of the as if, and the may be. This is not just of theoretical interest. It has immediate implications for the future of social life. Inoperativeness, according to Agamben, is the paradigm of the coming politics, which he evokes as "the open space where formless life and lifeless form meet in a distinct life-form and form of living."[66] In this case we have already made a useful discovery, one of which draftspeople

of every description need to take note: To represent these vital spaces of social and political potentiality, which elude linear thought, a different kind of drawing is needed. One of its techniques, though, will be found inside the line, not outside it, in the division that, in dividing, joins.

## Notes

1. Felix Klee, ed., *The Diaries of Paul Klee, 1891–1918* (Berkeley: University of California Press, 1964), 47–48. Quoted and discussed by Ann C. Colley, *The Search for Synthesis in Literature and Art* (Athens: The University of Georgia Press, 1990), 63.

2. Catherine Ingraham, *Architecture and the Burdens of Linearity* (New Haven, Conn.: Yale University Press, 1998), 52.

3. Claudia Brodsky Lacour, *Lines of Thought: Discourse, Architectonics and the Origin of Modern Philosophy* (Durham, N.C.: Duke University Press, 1996), 7.

4. Ibid., 132–133.

5. Ibid., 144.

6. Nelson Goodman, *Languages of Art: An Approach to the Theory of Symbols* (Indianapolis, Ind.: Hackett, 1976), 170–173.

7. Jean-Gabriel Ganascia, "Logic and Induction: An Old Debate," 1–43 at www-poleia.lip6.fr/~ganascia/Archives_postcript/logique_induction.ps, 39.

8. Ibid., 39.

9. Thomas Ash, "Is It Rational to Believe in Induction?" at www.bigissueground.com/philosophy/ash-induction.shtml.

10. Justine Clark, "Smudges, Smears and Adventitious Marks," *Interstices* 4: 1–8 at www.architecture.auckland.ac.nz/common/library/1995/11/i4/THEHTML/papers/clark/front.htm, 4.

11. William Hogarth, *The Analysis of Beauty* (London, 1753, printed by J. Reeves for the author), xviii.

12. Ibid.

13. Ibid., 39.

14. Ibid., 7.

15. Ibid., 8.

16. Catherine Ingraham, "Initial Properties: Architecture and the Space of the Line," in *Sexuality and Space*, ed. Beatriz Colomia, 264 (New York: Princeton Architectural Press, 1992).

17. Edmund Husserl, "The Origin of Geometry," in *The Crisis of European Sciences and Transcendental Phenomenology*, trans. David Carr (Evanston, Ill.: Northwestern University Press, 1970), 364.

18. Ibid., 360.

19. Alphonso Lingis, "Hyletic Data," *Analecta Husserliana*, Vol. II, ed. Anna-Teresa Tymieniecka, 97–98 (Dordrecht, Holland: D. Reidel, 1972).

20. Ibid., 99.

21. David Carr, *Interpreting Husserl* (Dordrecht, Holland: Martinus Nijhoff, 1987), 251.

22. Ibid., 251.

23. Ibid., 252.

24. Lingis, "Hyletic Data," 98.

25. Ibid., 99.

26. Ibid., 98–99.

27. David Carr reflects most helpfully on these issues in his introduction to his translation of Husserl's *The Crisis of European Sciences and Transcendental Phenomenology*, especially xxxi–xxxviii.

28. David Farrell Krell, *Archeticture, Ecstasies of Space, Time and the Human Body* (Albany: State University of New York Press, 1997), 184.

29. Anna-Teresa Tymieniecka, "Logos and Life: Creative Experience and the Critique of Reason," *Analecta Husserliana*, vol. XXIV (Dordrecht: Kluwer Academic Publishers, c.1986), 136.

30. Maurice Merleau-Ponty, *Signs* (Evanston, Ill.: Northwestern University Press, 1964), 59; quoted by Linge in Hans-Georg Gadamer, *Philosophical Hermeneutics*, trans. D. E. Linge (Berkeley: University of California Press, 1976).

31. Leon Battista Alberti, *On Painting*, trans. J. R. Spencer (New Haven, Conn.: Yale University Press, 1977), 68.

32. Giorgio Vasari, *Lives of the Artists*, trans. G. Bull (Harmondsworth: Penguin, 1965), 65.

33. Pliny the Elder, *The Natural History*, book XXXVI (Cambridge, Mass: Harvard University Press, 1984).

34. Ibid.

35. Ibid.

36. Plotinus understood that the "wise men of old" who "made images (*agalmata*) in the hope of making the gods present to them" sought to cut the Gordian knot of representing the One through the Many. They could do this because " 'the All, too, made every particular thing in imitation of the rational principles (*logous*) it possessed' so that each thing became a 'rational principle in matter (*en hyle logos*) of that which existed before matter.' " James A. Francis, "Living Icons: Tracing a Motif in Verbal and Visual Representation from the Second to the Fourth Centuries C.E.," *American Journal of Philology* 124 (2003): 575–600, 584–585; quoting Plotinus, *Enneads*, 4.3.11.

37. Richard Cobb-Stevens, "Derrida and Husserl on the Status of Retention," *Analecta Husserliana*, Vol. XVII (1985), 375.

38. Maxine Sheets-Johnstone, "On the Significance of Animate Form," in *Analecta Husserliana*, Vol. LV (1998), 226.

39. See Robert G. Turnbull, *The* Parmenides *and Plato's Late Philosophy:*

*Translation of and Commentary on the* Parmenides *with Interpretive Chapters on the Timaeus, the Theaetetus, the Sophist, and the Philebus* (Toronto: University of Toronto Press, 1998), 175; and Rod Coltman, *The Language of Hermeneutics, Gadamer and Heidegger in Dialogue* (Albany: State University of New York Press, 1998), chapter 2 passim.

40. T. Kisiel, "Repetition in Gadamer's Hermeneutics," *Analecta Husserliana*, Vol. II, ed. Anna-Teresa Tymieniecka, 202 (Dordrecht, Holland: D. Reidel, 1972).

41. Ibid., 198.

42. Ibid., 201.

43. Hans-Georg Gadamer, "Discussion," *Analecta Husserliana*, Vol. II, D, ed. Anna-Teresa Tymieniecka (Dordrecht, Holland: D. Reidel, 1972), 241.

44. See Mitchell H. Miller, *Plato's* Parmenides (Princeton, N.J.: Princeton University Press, 1986), 133.

45. Leo Catana, "Meanings of 'Contraction' in Giordano Bruno's *Sigillus Sigillorum*," in *Giordano Bruno: Philosopher of the Renaissance*, ed. H. Gatti, 327–344, 332 (Aldershot, Hants: Ashgate Publishing, 2002).

46. Ibid., 337.

47. Ibid.

48. Ingrid D. Rowland, "Giordano Bruno and Neapolitan Neoplatonism," in *Giordano Bruno: Philosopher of the Renaissance*, ed. H. Gatti, 97–120, 112–113 (Aldershot, Hants: Ashgate Publishing, 2002).

49. Paul Klee, *Pedagogical Notebook*, trans. S. Moholy-Nagy (London: Faber & Faber, 1968), 16.

50. According to the word's Latin derivation.

51. See Paul Carter, "Interest: The Ethics of Invention," at www.speculation2005.qut.edu.au/papers/Carter_keynote.pdf.

52. See note 11 to this chapter.

53. Albert K. Whitaker, *Plato's* Parmenides (Newburyport, Mass.: Focus Publishing, 1996), 2.

54. Ibid., 18.

55. Ibid.

56. Also a central feature of M. H. Miller's reading; see Whitaker, *Plato's* Parmenides, 4ff and chapter 1.

57. Coltman, *The Language of Hermeneutics*, 61.

58. Ibid.

59. See Paul Carter, *Living in a New Country* (London: Faber & Faber, 1992), 178. Gadamer's space somewhat resembles the space in-between I posit as an initial condition of cross-cultural communication under colonialism; his concept remains, however, bracketed off from historical contingency. He ignores the kind of play in earnest I describe in *The Lie of the Land* (313ff).

60. Turnbull, *The* Parmenides *and Plato's Late Philosophy*, 149.

61. John Sallis, *Chorology: On Beginnings in Plato's* Timaeus (Bloomington: Indiana University Press, 1999), 127.

62. Ibid.

63. Ibid., 110.

64. Miller, *Plato's* Parmenides, 133–134.

65. Turnbull, *The* Parmenides *and Plato's Late Philosophy*, 68.

66. See Giorgio Agamben, *Il tempo che resta: Un commento alle Lettera ai Romani* (Torino: Bollati Boringhieri, 2000); and discussion of this passage in Leland de la Durantaye, "The Suspended Substantive: On Animals and Men in Giorgio Agamben's *The Open*," *Diacritics* 33:2 (2005): 3–9, 8.

CHAPTER 4
# The Interpretation of Dreams: Mobilizing the Papunya Tula Painting Movement, 1971–1972

> *Everything in that wondrous time, if I could make it so, was heightened by a feeling of the rightness of the occasion, as in ceremonial dance, and I suppose as the men sang and talked, or I talked, a new kind of dance or song was taking place, although at the time I did not think of it as such.*
> —Geoffrey Bardon

### Inside Story

The art of the Papunya Tula painting movement has stimulated dozens of exhibitions both locally and internationally in the past twenty-five years. It has inspired many catalogue essays and anthropologically inflected studies. TV documentaries and films have been dedicated to it. Thoroughly researched monographs have been devoted to individual artists involved in the movement's beginnings. The exhibition catalogue *Papunya Tula: Genesis and Genius* (2000) revealed many aspects of the movement's complex cultural, social, and political significance.[1] There remains, though, an important gap in our understanding—one the millennial exhibition's name serves to highlight. Much has been written about the Western Desert traditions of landscape representation underlying the iconography of the Papunya Tula painters, and much has been written in appreciation of the visual legacy of Papunya. But little attention has been given to the transactional environment in which this metamorphosis of traditional painting forms into highly prized contemporary art occurred. The creative and interventionist role white schoolteacher Geoffrey Bardon played in facilitating and energizing this transformation has been generally overlooked or downplayed.

In part this reflects the diffidence of Bardon's published accounts. It also stems

from a concern amongst both Indigenous and non-Indigenous writers and scholars not to deflect attention away from the "main game"—the extraordinary act of artistic and cultural self-reaffirmation represented by the painting movement. In a country that places every obstacle in the way of recognizing Indigenous peoples' land rights, to suggest the hybrid character of the movement's beginnings is easily construed as an attack on the artists' cultural autonomy and political agency. But the drawbacks of this ideological purism outweigh its tactical advantages. At an obscure government settlement 200 kilometers (124 miles) west-northwest of Alice Springs between July 1971 and July 1972, up to thirty tribal men of Pintupi, Anmatyerre, Arrernte, Luritja, and Warlpiri backgrounds worked together "crystallising," in Bardon's words, "divergent, contradictory, anonymous, and ancient (yet still shared) beliefs concerning the landscape and the world in which the Aboriginal people lived."[2] They produced more than a thousand paintings, many of exceptional visual appeal. This much is true, but left unmodified, these bare facts of genesis and genius merely hand over the painters from one romanticism to another. The illiterate primitive stocked with dreams yields to the modern *enfant terrible*, chiefly newsworthy for his eccentric lifestyle. It's not an empowering reclassification.

A closer look at the order of events in those early months, and at the interpersonal dynamics shaping them, reveals a different story, one miraculous because it occurred *inside* history, not outside. I made a first attempt to evoke the relationship between Bardon and the painters in *The Lie of the Land*, where I drew attention to Bardon's performance. I suggested (to borrow the terms of the previous chapter) that far from being a passive catalyst in a self-propelled process, he actively participated in a concomitant mode of production—one that did not naïvely reproduce what already existed but invented something new. However, this account was deficient in at least one important respect: Emphasizing Bardon's gift for improvisation, it neglected his own creative investment in what was happening. It also ignored the role that *techne* played—the repertoire of teaching skills that supplied the essential medium of personal and cultural exchange.

The individual and collective creativity of the twenty or so painters who formed the nucleus of the Papunya Tula painting movement in 1971–1972 was remarkable. But so was Bardon's intellectual curiosity, pedagogical commitment, and organizational determination. As an arts and crafts teacher arriving at Papunya in February 1971, Bardon entered a world characterized by systemic racism and interracial mistrust and cynicism. He found himself expected to follow an assimilationist teaching program, in which contempt for Indigenous culture and cultural production was an item of faith. About the horror of the physical conditions, Bardon remains outspoken, describing the "village" where the Pintupi lived in burnt-out cars and improvised lean-to's as "an unsewered, undrained

garbage-strewn death camp in all but name."³ Yet, in next to no time, Bardon managed to gain the interest of his Pintupi charges. He provoked "the first public affirmation of Aboriginal identity in the Western Desert" in the form of the Honey Ant Dreaming murals painted on the school walls. He wooed men from different tribal backgrounds into a cohesive painting group. As a bulwark against the inevitable white paternalism, he helped establish the Papunya School Painters Co-operative.

Even more extraordinarily, Bardon kept abreast *conceptually* with what was happening. As distinguished art historian Bernard Smith notes, his books, *Aboriginal Art of the Western Desert* (1979) and *Papunya Tula: Art of the Western Desert* (1991), marked an epoch in the understanding of Indigenous art. Smith refers to the conceptual vocabulary Bardon devised, whose terms ("hapticity," "archetype," and "hieroglyph") seemed to go the heart of the paintings' aesthetic logic.[4] But these publications also revealed something else: Bardon's conception of the *historical* importance of his role. Conscious of participating vicariously in a collective act of cultural, political, and spiritual self-reaffirmation, he dedicated himself to being its historian. The fruit of his dedication — photographs and annotated sketches of every painting produced between September 1971 and June 1972 at Papunya — underpins his later interpretations. And again, his role as record-keeper was anything but passive. How was the work emerging at Papunya to be catalogued? The conventions Bardon devised now seem unexceptionable, but in their historical context they represent another remarkable conceptual leap.

Bardon's intellectual focus and organizational drive suggest a motivation. Bardon has spoken about this in religious terms. On his trips into the bush with the Papunya painters, he carried in his pocket Henry Drummond's sermon on 1 Corinthians 13.[5] His sense of Pauline mission recalls similar themes in the mythic narrative the author of *Songs of Central Australia*, T. G. H. Strehlow, wove around his and his father's life.[6] Bardon shared with Strehlow another trait: his cultural nationalism. "At all times since the first settlement in 1788 there was a cultural cringe and intimidation from the British Motherland and Europe in general. All cultural matters were basically derivative and imitated examples set in Britain."[7] This was the lesson his education had taught Bardon, and he defined his goal as a teacher in opposition to it. Strehlow had believed that "when the strong web of future Australian verse comes to be woven, probably some of its strands will be found to be poetic threads spun on the Stone Age hair-spindles of central Australia."[8] Bardon felt the same about a future Australian *vision* — it would likely incorporate "a graphic art style" derived from "authentic aboriginal art."[9]

Neither Bardon's missionary zeal nor his cultural nationalism is particularly original. Nor, in the troubled domain of Australian Indigenous–non-Indigenous

relations, do they seem to offer more than another form of paternalism. What distinguished Bardon from his well-meaning ideological contemporaries was his aesthetic activism. Not content to talk about a new Australian vision, he wanted to participate in bringing it about. By February 1971, Bardon recalls,

> I had an abiding interest in the Western Desert graphic designs, yet also I had a purpose for my own art, since with a small grant of $150 from the Interim Film Council, I wished to make an animated film. A graphic art style was something that I very much wished to develop and it was this idea that had brought me, in part, to Papunya and the concept of authentic Aboriginal art, and what it said and might portend and show.[10]

Here, then, is the inside story. Bardon arrived at Papunya armed with cameras, tape recorders, and a shelf of books about modern art and aesthetics. He arrived with a vision, and he went looking for it.

### Child's Play

He also arrived with a training. Bardon was hired to teach social studies to the Aboriginal camp children. Curiously, these products of vicious social engineering weren't interested. After two months Bardon was ready to quit, when Papunya school principal Fred Friis suggested he take over the arts and crafts program. Here, as a trained art teacher, Bardon was more at home. He later claimed that he packed into one year's teaching the entire six-year art curriculum prescribed by the New South Wales Board of Education. He introduced the children to puppet making and puppet theater, ceramics—he constructed and fired a kiln—including the management of glazes and pot decoration, silkscreen printing, clay sculpture, and graphic design. In the context of understanding the emergence of the Papunya Tula art movement, though, the techniques imparted are less important than the techniques used to impart them.

Bardon arrived with certain pedagogical assumptions. He believed with Desiderius Orban that the art teacher's role was not to instill an academic training but to release creativity. Orban had a method for achieving this: "Doodling is a way of eliminating intellectual control."[11] To encourage freer painting gestures, he recommended doodling on a sheet of newspaper with a cheap house painter's brush. The outcome would not be a painting, but it was a beginning: "the transition from doodling to creative painting should be unconscious."[12] Adults should doodle; children scribbled. And, according to educational psychologists, scribbles evidenced a universal creativity. Bardon's basic premise when he entered the Papunya classroom—"Children's love of painting is a universal attitude of all young people and races"[13]—echoed Herbert Read's view that "art-making is as

natural as movement for human beings and hence . . . art has its archetypal or universal aspects."[14] Applying this to what she called the "twenty basic scribbles or diagrams" produced by two- to three-year-old children, nursery school educator Rhoda Kellogg commented that they "are archetypal" and "[t]he potential combinations of them are endless."[15]

Rehabilitating the painting gesture, educators like Orban, Read, Kellogg, and Viktor Lowenfeld inverted the usual connotations of abstraction. Realist art was abstract because it detached seeing from a kinesthetic engagement with one's surroundings. In contrast, "abstract" art put the body back into the picture. On this logic, to see the world with a painterly eye did not mean making a visually accurate copy. It meant spontaneously recreating a subjective sensation—the *feeling* of being in the world. As Orban commented, "[t]he inherently uncontrolled spontaneity of primitive peoples and children—envied by artists—is the foundation of all artistic activity."[16] As "creative painting," it found perhaps its highest form in Chinese calligraphy. Yee Chiang (another art theorist championed by Herbert Read) explained that the "abstract beauty" of the calligrapher's line depends on its embodying a movement: "no Chinese character exactly represents a living thing, yet the main principle of composition is in every case a balance and poise similar to that of a figure standing, walking, dancing, or executing some other lively movement."[17]

Why did creativeness fail? "We force the student into a prefabricated channel," Orban lamented, when "[f]reedom of choice in the field of creativity is a *sine qua non*."[18] As a teacher, Bardon accepted both pieces of advice. He emphasized the importance of "control and understanding of purpose in the classroom." A "class momentum" had to be created if good results were to be achieved, and this aim was best served by a clear "program."[19] But the object was catalytic, not prescriptive; referring to his relationship with the painters in the Great Painting Room between February and August 1972, Bardon emphasized, "Neither side knew what the other possessed or how they thought. The situation developed around the phrase 'not knowing what you are doing.' In creativity the answer is always like this. The creative challenge is not to repeat a solution but to find . . . new solutions that are themselves creative and expressive in originality."[20] And this freedom from "preconceived ideas" was prefigured in his first overtures to the Pintupi children: "With Obed [Raggett] translating we would talk about the weather, the rain, places to travel, to swim, good, earth, fire and water, everything in the universe. I would play games with the children in the sand, drawing tracks. These young people eagerly showed me how to play the game with my knuckles."[21]

In *Creative and Mental Growth* (a standard text with which Bardon was familiar), Viktor Lowenfeld explained creative decline differently. Lowenfeld identified

two "creative types"—"The child who refers mainly to visual experiences, we call the *visual type*; the other, who refers more to subjective feelings as body feelings, muscle sensations, or kinesthetic experiences, we call the *haptic type*."[22] The critical function of the art educator was to identify each student's "type" and to nurture it accordingly. On this classification, Bardon's charges were haptic types. Making patterns in the sand with knuckles and fingers, and telling their stories, they behaved like "haptically minded persons [who] are completely content with the tactile or kinesthetic modality."[23] In the classroom, though, they were being taught to think and see differently; here "the school children also enjoyed working with realism, with Cowboy and Indian illustrations."[24] At Papunya, then, the haptic/visual distinction appeared to be cultural rather than psychological: "my approach . . . was . . . to emphatically discourage all whitefellow art influences and direct the children, and later the men, to their own indigenous patterns and motifs."[25]

This was not necessarily primitivist. Lowenfeld made no value judgment about the differences between the haptic and the visual type. If anything, Bardon's decision to treat the children as haptic types was aesthetic. Like most advanced art educators of his day, Bardon was sympathetic to Modernism. Referring to Picasso's *Guernica*, Lowenfeld commented, "The nature of this [haptic] art expression is at least as deeply rooted, historically and psychologically, as the visual interpretation of the world that surrounds us."[26] Yee Chiang thought the ambition "to present interior reality and exterior reality as two elements in process of unification" was common to Chinese calligraphy and European Surrealism. Orban went further. He associated antirealist art with spirituality, which he identified with "a liberated state of mind in which one's inborn creative ability can flourish."[27] The influence of Kandinsky, who described art as a striving "towards the spiritual," is obvious—"the most important thing in the question of form," he wrote, "is whether or not the form has grown out of inner necessity."[28] Likewise Paul Klee—"Art does not reproduce the visible; rather, it makes visible. A tendency towards the abstract is inherent in linear expression."[29]

When he came to discuss the "concept of simultaneity" in Western Desert paintings, Bardon referred to Kandinsky and Klee as European champions of "the relativism of all perception and the idea that temporality is within ourselves."[30] But even in the Papunya days, he may well have been familiar with Klee's "Creative Credo." There he would have found an extraordinary "trip into the land of deeper insight, following a topographic plan," and conducted entirely in the graphic language of dots and lines—"The dead centre being the point, our first dynamic act will be the line"—and, Klee explained, "When a dot begins to move and becomes a line, this requires time." Crossing his graphic landscape, the artist eventually rests. Before falling asleep he recalls "lines of the most vari-

ous kinds, spots, dabs, smooth planes, dotted planes, lined planes, wavy lines, obstructed and articulated movement, counter-movement, plaitings, weavings, bricklike elements, scalelike elements, simple and polyphonic motifs, lines that fade and lines that gain strength."[31] Has a truer description of the classic *Water Dreamings* of Johnny Warrangkula Tjupurrula ever been written? In the same "Credo" Klee emphasized that these archetypal forms were the "components of the picture," but a visual composition needed more—"a combination of several elements will be required to produce forms or objects or other compounds."[32] Bardon's notion of the "hieroglyph" as a combination of "archetypes" expresses the same idea.

Bardon arrived at Papunya with certain ideas about art and art education. These ideas were practices as well as theories. And, in theory, the practices were not culturally specific. Thus, for example, the first photograph in Kellogg's chapter "The Basic Scribbles" shows an American preschooler "with sand as the art medium," drawing concentric circles measured to the reach of his arm.[33] On this theory, when the Pintupi children "doodled" in the sand, they were simply using a conveniently available medium to express their "inborn creative ability." Teaching in this context meant creating the conditions of creativity. The teacher could be relatively passive (Kellogg) or relatively active (Lowenfeld). In the latter case, children might be steered away from excessively repetitive pattern making. The aim was to explore the kinesthetic interface between inner and outer worlds, copying patterns already made represented a retreat into lazy visualism. But whether active or passive, the task was clear: to avoid stifling the child's innate "spontaneity." Art education concerned the spiritual.

In short, Bardon *could* have encouraged his students to express themselves in paint and crayon with no ulterior motive. Taking Rhoda Kellogg's advice that "teachers should accept everything made with good grace and should not try to evaluate its worth,"[34] he could still have run a responsible "program." The thesis that children were spontaneously creative, given the right conditions, would have seen to that. But while he set about creating the right creative conditions, his acceptance was *conditional*: "A typical art lesson would aim to search out and evolve indigenous patterns with acceptance of any kind of naïve distortions and disciplining student work for skill and clean paints."[35] Or, again: "All the tables were removed and the group up to the ages of 16 years would work on the floor on large paintings. I would talk to the children about patterns at all times. With Obed explaining my points to all classes in the school timetable from 5 years to 16 years, male and female, by talking about patterns I had seen in sacred secret objects and the motifs emerging from the menfolk in archetypal painting, I became known as 'Mr Patterns.'"[36]

Scribbles, doodles, motifs, patterns—call them what you will—were accept-

able when they fulfilled cultural criteria. As Bardon candidly admits, "Working with the children I had searched for the indigenous designs."[37] His motivation for this has already been indicated. It was not pedagogical, but personal and creative. Bardon was in search of an "authentic Aboriginal" style of "graphic design."[38] He wanted to create a vocabulary of recognizably "Australian" graphic motifs, which could be used to create cartoons. Associated with simple narrative elements, these motifs would animate stories for children. It was conceivable that these locally derived "designs" could furnish a universal language. If the language of drawing was "universal," this was perfectly plausible. Then the value of the "indigenous designs" was stylistic rather than iconic. Iconic designs (circles, lines) were found in all children's art—and in the art of most "primitive" cultures. The value of Papunya art would reside in the particular inflection it gave these universal motifs. As recovering these signatures of cultural difference might also help the children, and perhaps their communities, to resist the physical and psychological pressure of assimilation, Bardon's personal ambition might converge on theirs.

Bardon's motivation explains two devices he used to engage the children. The first was to show what he wanted. The second was to relocate the scene of painting. I have referred to the mimetic exuberance that characterized Bardon's conduct of the Great Painting Room.[39] As the epigraph to this chapter suggests, Bardon fancied himself as the leader of a dance. He parodied the painter's behavior, he playfully suggested improvements, he created through his tireless play a sense of "class momentum." Yet throughout these benevolent charades, the painters remained in command of the motif. There was no question of the make-believe extending to the men's designs—these were to be free of "all whitefellow art influences."[40] During the previous autumn with the children, it was different. There Bardon was trying to *initiate* a process, not to oversee it. He not only talked about "patterns" he had seen in "sacred secret objects."[41] He drew them. He drew much else besides: motifs derived from Arnhem land bark paintings, as well as "archetypes" of the kind regularly reproduced in studies of children's art. Then, via Obed Raggett, he tried to communicate a subtle concept: he wanted the children to imitate these motifs but not to copy them.

A kind of eidetic anamnesis was being attempted. The children were being asked to remember something they had, as it were, forgotten—or at least left at the door to the classroom. The results were encouraging on two fronts. They revealed an "indigenous style" and, no less important in the context of Orban's stress on art as a means of "regaining the freedom of our fantasies, our individual ways of thinking, our free personalities"[42]—they disclosed the individuality of the children: "Tracks and spirals became very common and the dotting pattern became evident. Within the framework of traditional patterning there

**Figure 14.** "Drawing of a Snake Story," by Toba, aged sixteen (Geoffrey Bardon and James Bardon, *Papunya, A Place Made After the Story* [Carlton, Vic.: Miegunyah Press, 2004], 141). Reproduced by courtesy of Dorn Bardon. Of what he called "Aboriginal Children's Culture," Bardon commented, "The universal information of all art can be reduced into the elements and principles of design." He encouraged "the children and later the men towards their own rendering of naïve figurations" on the principle (which he attributed Joan Miró) of forcing an art out that "was original and relying only on his personal visual forms, his own inner necessities, compulsions and needs." "As with Vassily Kandinsky, these inner workings would avoid external influences in the same way as the Pintupi painting men were mostly unaware of western influence, and it was my determination not to change them." (Geoffrey Bardon and James Bardon, *Papunya, A Place Made After the Story*, 140).

was wide variation and it was possible that in the groups that came through the classes daily and weekly there were young people from any of four tribes."[43] It became apparent, Bardon commented, "that there was an indigenous style of dots and linear effects, spirals and zigzags."[44] Between June and December 1971, "examples of patterns" (many of them intended for silkscreen printing) were published in the school magazine (Figure 14).[45]

Bardon's second teaching stratagem was to relocate painting activity outside the classroom. As a matter of fact this was a two-way process. Referring to the games the children played in the sand, Bardon recalls how "making friends with the community after school . . . I took part in some of these sand adventures

and later with Obed Raggett succeeded in having these designs evolve in school lessons."⁴⁶ So motifs came in. But they also went out. The children were used to "doodling" outside, so Bardon took his classes underneath the schoolroom (the schoolroom was a first-floor structure erected on gray cement walls supported by steel columns). Here again he set the example he wanted to see followed, spreading paper on the ground and making his own patterns. He also did something else, in retrospect of the greatest significance. In June 1971, he and Obed painted some steel columns and two of the gray cement walls white. Then, along the joins in the cement sheets, they painted a "zigzag pattern" and down one of the columns a red "spiral."⁴⁷ The children seemed to be overwhelmed by the scale of these designs. Their own mural efforts were uninspired. Yet Bardon's strategy of creative induction had an unexpected side effect: seeing Bardon's spiral, Obed Raggett remarked, "Look out for that snake."⁴⁸

### Approaches

In the account of the circumstances leading up to the execution of the Honey Ant Dreaming mural, published in *The Lie of the Land,* Obed Raggett's warning corresponds to "the moment when I began to apply the designs to the wall [and] the yardmen then approached me." In that account, possibly because the focus is on the emergence of the men's painting movement, no mention of the children's role is made. Bardon describes drawing designs on paper—"zigzags, spirals and some of the dotting seen by me on the Tjurungas. The designs were . . . imaginary"—carrying these designs outside, and painting them onto the rough concrete under the school room. And he records how, after several days spent doing this, "it occurred to me to draw the same motifs on the walls." But the intention behind this drawing activity—to encourage the children's creativity —is left out. When Raggett approached Bardon, it may have been less out of curiosity than from a desire to issue a warning against displaying secret designs to uninitiated children.⁴⁹

Or Raggett's approach may have had another explanation. As I mentioned, in April 1971, two months after arriving at Papunya, Bardon resigned—only, the next day, to withdraw his resignation. It was after this that Fred Friis suggested he take on the arts and crafts curriculum. What changed his mind? Bardon had been cultivating the trust and friendship of the men as well as the children. The men liked to go out in the bush kangaroo hunting, but they lacked a decent vehicle; they also lacked powerful guns. That evening, after telling Friis he was leaving, Bardon fulfilled a promise to take the men hunting in his blue Volkswagen Kombi (bus) (and he borrowed a .22 rifle to increase their firepower).

This wasn't the first time he had been hunting, but this time he felt involved in a different way. He went with Johnny Warrangkula Tjupurrula and Mick Nam-

erari Tjapaltjarri, with Bill Stockman Tjapaltjarri and Long Jack Phillipus Tjakamarra—all of them skilled hunters who (and it's presumably no coincidence) became prominent figures in the painting movement. He saw Limpi Tjapangati, to whom he lent his rifle, "in his lightning pursuit of a wounded kangaroo, then tracing roo tracks, vanishing himself into the scrub to complete his kill"; he ate seared kangaroo flesh; he was in some sense initiated. The next day Bardon felt that "I had been part of this drama the previous night and I had decided to stay and see *what I could do for my own creative wish and will*" (my italics).[50]

When Raggett approached Bardon, he not only approached a whitefellow with an interest in local Aboriginal life, but a fellow hunter. Bardon was being watched, his motives scrutinized. In a place where, according to Bardon, everyone play-acted, his play-acting was naturally viewed with suspicion. Publicly, the white administration mouthed the rhetoric of social advancement. Privately, they viewed the Aborigines with contempt. How, then, to interpret Bardon's honest make-believe? Was it a lie or was it a true deception? Did it represent a way of outflanking the endemic cynicism of interracial communication? Critically, it provided a non-verbal, a gestural, mode of expression. It hinted at a language in common. It made "not knowing what you are doing" a source of solidarity rather than weakness. This applied to the children as well as the men: "I was asking the children to understand my language in theirs, I was asking to be understood by them in their own language."[51] In other words, by participating in certain experiences—the children's sand adventures and the men's roo tracking—Bardon felt freed into his own creativity. Initiating the children, he initiated himself. And this, too, the men must have observed and wondered about.

In the published accounts, three overlapping approaches now occurred, which Bardon subsequently identified as three moments in the emergence of the "archetypes." The first "archetypes" Bardon became aware of were those composing the Honey Ant and Widow's Dreaming on the walls of the Papunya School (Plate 2). The second were the line drawings of Tim Payungka Tjapangati and other Pintupi men such as Yala Yala Gibbs Tjungurrayi and Charlie Tarawa Tjungurrayi, as they worked on Bardon's veranda in late 1971 (Figure 15). The third were those evident in the early paintings of Old Mick Tjakamarra, Old Walter Tjampitjinpa, and Long Jack Phillipus Tjakamarra, executed mainly in the schoolroom (between September and Christmas 1971 the men used the artroom, where they were allocated a semiprivate, "barricaded" back section) (Plate 3).[52] But, again, this organic account of a movement's genesis, in which the schoolteacher merely catalyzed Indigenous creativity, needs to be tempered. Just as his interaction with the men and children released his own creativity, so their archetypes were also *his* archetypes. As Bardon has remarked, "[t]he archetypes . . . were *both my archetypal experiences with the Western Desert iconography*, as well

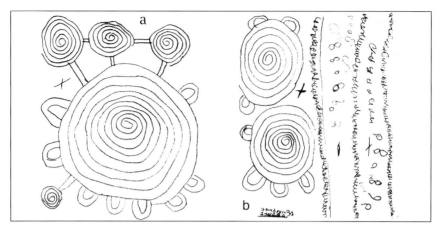

**Figure 15.** Pintupi pencil drawings (Geoffrey Bardon and James Bardon, *Papunya, A Place Made After the Story* [Carlton, Vic.: Miegunyah Press, 2004], 96). Reproduced by courtesy of Dorn Bardon. (a) Unknown Pintupi, "Pintupi pencil drawing," 1971. "This is a complete Dreaming map with a radiating central circle dominating a design with three Dreaming sites and journey lines at the top. Ceremonial Men in ritual position sit around the central form." (Geoffrey Bardon and James Bardon, *Papunya, A Place Made After the Story*, 96). (b) Uta Uta Tjangala, "Pintupi pencil drawing," 1971. "The right hand side of the design uses three columns of sensitive scribble and the looped motif circles of figure [for infinity] motifs, numbering approximately nine or ten examples, had unknown meanings for me at the time and subsequently were never used again." (Geoffrey Bardon and James Bardon, *Papunya, A Place Made After the Story*, 96).

as seemingly primordial and conventionalised cultural terms" (my italics).[53] The motifs used on the walls, on scraps of linoleum, and on boards in the schoolroom were efforts at conversation. They answered Bardon's imitations, *but were different*: "The archetypes were not only responses to me as a result of some request I had made, they were also examples of an artist's willingness to tell me of some natural phenomenon he wished me to share."[54]

In other words, the "archetypes" emerged for Bardon. As he says, his make-believe motifs were copied from what he had seen around the camp. He not only hunted with the hunters, he fraternized with painters. As skilled wood carvers, Clifford Possum Tjapaltjarri and Tim Leura Tjapaltjarri were already represented in public collections. Keith Namatjira, son of Albert and a significant European-style landscape watercolorist, lived at Papunya and knew something about bargaining with commercial art dealers. The white administration paid Kaapa Tjampitjinpa to paint. He produced "painted designs, but often with European influences, for some of the older ceremony men ... using realistic lizards, snakes and kangaroos," besides, on occasion, painting "sacred-secret signs ... set down for ritual men," and he already sold his work.[55] At Kaapa's place Bardon met Johnny Warrangkula Tjupurrula, Charlie Tarawa Tjungurrayi, and two key older men, Old Walter Tjampitjinpa and Old Tutuma Tjapangati. He encouraged them and other men to paint, and in April and May 1971 was observing their "fledgling

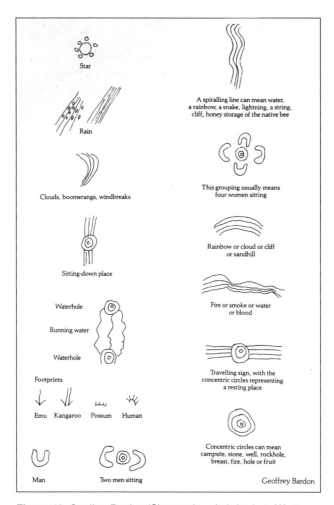

**Figure 16.** Geoffrey Bardon, 'Signs and symbols basic to Western Desert imagery" (Geoffrey Bardon and James Bardon, *Papunya, A Place Made After the Story* [Carlton, Vic.: Miegunyah Press, 2004], 111). Reproduced by courtesy of Dorn Bardon. Bardon explains that these "were revealed to me gradually during 1971 and later expanded. Meanings . . . were based on these compiled signs and symbols and conceptualized as archetypes and hieroglyphs" (Geoffrey Bardon and James Bardon, *Papunya, A Place Made After the Story*, 111).

efforts."[56] But the men may have seen this transaction differently: "They were always interested to try and sell their work and I was a good customer. It was native design that interested me."[57]

But Bardon wasn't interested in zigzags, circles, and half-circles for their own sake. He wanted to develop an animated graphic art style (Figure 16). He was looking for motifs that would tell a story. He sought movement images,

visual forms that might function like narrative units. Stories can be analyzed in two ways. They can be divided up into a succession of static scenes, in the manner of proscenium-arch theater. Or, focusing instead on the transitions from one scene to another, they can be regarded as a continuous sequence of transformations—marking passages from one physical or psychological place to another. Therefore he wasn't interested in decorative or ornamental flourishes, as these suggested the animation of what was static. The quality of animation had to reside in the stroke itself. The useful "native design" communicated a sense of "lively movement." In interpreting motifs as movement images, Bardon was influenced by sand-drawing practice—the coordination he had observed between the drawing of designs and the telling of stories. But he was also influenced by his Modernist art education, with its championing of a dynamic abstraction.

Again, the evidence for these statements is found in Bardon's concomitant activity with the children. For "archetypes" were emerging in his art classes, too. Bardon reproduced a selection of these in his school magazine, *Papunya School News*, a publication that had "the star of Papunya" (a look-alike [?] circle and traveling lines design) emblazoned on its front cover. Perhaps more significant, though, in revealing Bardon's creative agenda was his own contribution to the magazine —"a comic strip series . . . in four episodes that seemed like an enterprising idea for school Aboriginal education."[58] To depict the last episode, Bardon combined the graphic conventions of comic strip storytelling with storytelling motifs used in sand drawing (Figure 17). The seven vignettes (presented on a single page) tell a surprisingly complicated double story. In one, the Papunya football team walks to Haast's Bluff, where "they sleep in camp with relatives," before playing football the next day. In the other, the hero of the tale, a boy called "Shipwreck," meets four men and accompanies them to Glen Helen, where they are gathering "red and yellow ochre for a corroboree [gathering]." (Elsewhere, referring to ochre pits at Haast's Bluff, Bardon notes that they "were local to Papunya and offered a convenience to mix traditional colours with PVA.") The episodes are represented in comic book fashion, and the divisions between the vignettes are drawn as patterns of traveling lines and camping places.

Bardon's unassuming comic strip is significant in another way. It is a visual convention for storytelling that does not tell the whole story. The seven vignettes add up to an "episode." Although the "episode" is complete, it is part of a story "to be continued." An episode is the combination of narrative actions that can be grasped at a glance. The graphic conventions used to depict an episode communicate an idea of simultaneity. This does not mean grasping every story element at once. It is the quality actions have when they are remembered as a narrative unit (an "episode"). A full story is made up of many such episodes, just as each episode is composed of many actions. As a narrative unit, the episode is character-

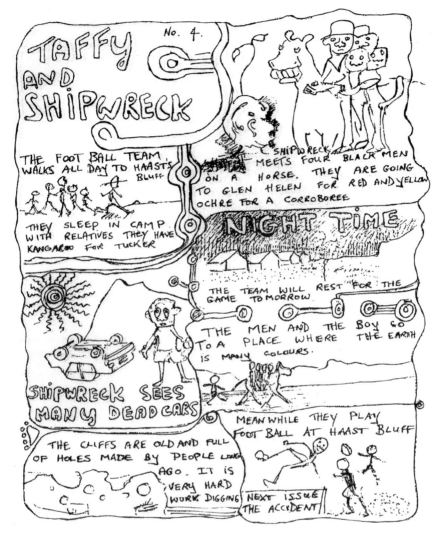

**Figure 17.** Geoffrey Bardon, comic strip, "Taffy and Shipwreck, No. 4" (Geoffrey Bardon and James Bardon, *Papunya, A Place Made After the Story* [Carlton, Vic.: Miegunyah Press, 2004], 146). Reproduced by courtesy of Dorn Bardon. Bardon's design incorporates Pintupi motifs, circles, and journey lines to represent the progress of the story. His purpose was to redirect the children to their own visual culture. This initiative exactly coincided with Bardon's first murals, similarly designed to redirect the men's painting interests. In both initiatives Obed Raggett was central. He was the subject of the cover story of the second issue of *Papunya School News* (18 June 1971) and "his influence led to the goodwill that encompassed the work on the Honey Ant Mural of late July and August 1971" (Geoffrey Bardon and James Bardon, *Papunya, A Place Made After the Story*, 146).

istically ambiguous. On the one hand, it presents completed actions—journeys that lead to places of rest. On the other, it presents all actions as beginning and ending elsewhere "outside the picture frame." A comic strip narrative is only ever provisionally finished. It can always be taken up again.

It's against this background that the "fledgling attempts" of the Western Desert painters need to be seen. The information presented here in no way diminishes Bardon's achievement. It foregrounds its creativity. But it helps explains, perhaps, why, as Fred Myers has argued (writing with Western Desert/Pintupi acrylic painting particularly in mind), "the importance that the larger, predominantly White Australian society has ascribed to Aboriginal painting far outstrips its significance *within* these communities."[59] The emergence of the Papunya Tula painting movement coexisted with a continuing ceremonial tradition. Men like Old Mick Tjakamarra and Old Walter Tjampitjinpa continued to draw archetypal patterns in the sand, infilling the lines with white ochre (Figure 18). Post-1972 photographs don't indicate that exposure to the Great Painting Room altered their style. It was not a linear "evolution" that occurred, but a radiating network of parasitic relationships. So, one day early in 1972, Johnny Warrangkula Tjupurrula is "asking me for cotton wool to help decorate the performers for the forthcoming ceremonies."[60] As for Bardon—"I filmed and taped the performances . . . then I recognised Shorty Lungkata as a solo performer and a beautiful threesome of linked ceremonial men, squatting and linked by hairstring with delicate bird down, a figure later to appear in Anatjari No. III Tjakamarra's cave paintings, 'Wati (Man's) Ceremony in a Cave.'"[61] The image of such episodes, and the story to which they belong, is not a convergence of arrows, but a field of circles all joined to each other by traveling lines.

### Meaning Clusters

In classifying Western Desert practice as "haptic," and in identifying the "symbols" originally used in sand, body, and tjurunga painting as "archetypes," Bardon was drawing on a conceptual vocabulary available to him through his training as an art teacher. The provenance of the term "hieroglyph" is less clear-cut.

In a communication shortly before he died, Bardon suggested that in adopting the term, he had in mind "not so much Egyptian pictograms but Chinese and Japanese script."[62] Distinguishing the paintings produced between September 1971 and June 1972 from the "much simpler" archetypes from which they had sprung, Bardon attributed to them three features that are also characteristic of Chinese calligraphy. They were composed of a "multiplicity of signs"[63]—in the same way a Chinese character is composed of a combination of strokes. The Papunya painters were encouraged to transfer their designs to boards, usually rectilinear in shape. The designs were not designed for a rectilinear presentation,

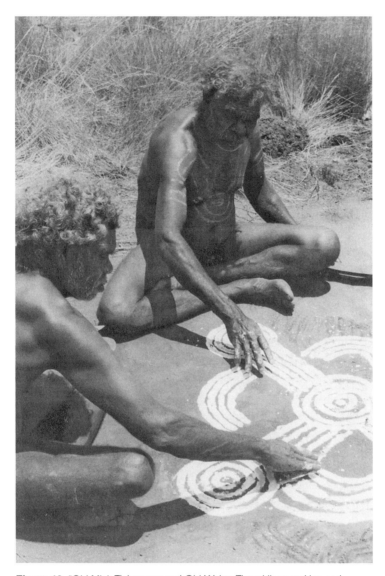

**Figure 18.** "Old Mick Tjakamarra and Old Walter Tjampitjinpa making and touching a ground sand mosaic" (photo: Geoffrey Bardon). Reproduced by courtesy of Dorn Bardon. "The men have on their bodies designs consistent with the meaning of the sand mosaic. The haptic quality of this painting carried over into the paintings on board" (Geoffrey Bardon, *Papunya Tula, Art of the Western Desert* [Ringwood, Vic.: McPhee Gribble, 1991], 8).

yet, in transferring the "painting story" to this new medium, the artist obviously had to be aware of the border which now framed his work. In the same way, as Yee Chiang explains, "The composition of the Chinese characters involves proportioning of the parts, spacing within the imaginary square, poise, posture, adaptation in the interests of pattern."[64]

Thirdly, as Bardon observes, in Chinese calligraphy, "the brush writing or hieroglyph . . . needs a brush held in a particular way, leading to simplification, gesture and a formula that was often copied as an artform in itself."[65] Bardon attributed precisely these virtues to the painters working with him in 1971–1972. Tim Leura Tjapaltjarri, for example, is praised for "a subtle ability in relating tonalities, and using a calligraphic suppleness and delicacy of touch."[66] The "vitality" of Uta Uta Tjangala's style is similarly reflected in the way "he worked intuitive rhythms and pattern without ornamentation, in transition from twig dotting sand painting, and assumed very readily, a mastery of brush method."[67] Traditionally, the men told the stories they were painting by touching the symbols they had painted. Talking to Bardon about the significance of the archetypes, it was logical perhaps that they should touch the paintings *differently*.

Thus, Bardon recalls, "During my 'talkings-out' of [Johnny] Warrangkula's stories the hieroglyphics basic to the Water Dreaming were defined in their many variants and most striking representational forms. . . . I felt that as we talked, and he painted, Johnny was clarifying and giving new life to an archetypal form (Figure 19). Moreover, he was showing, with supreme brilliance, that archetypes were being modified, and changed, sometimes even omitted from a representation. He was making his own rules stylistically and iconographically"[68] (Plate 4). Mastering the hieroglyph, Johnny Warrangkula not only experienced a release of creativity, he necessarily (on Orban's argument) discovered an individual way of thinking and personal freedom. As Bardon observed, "[t]raditionally sand mosaics were group efforts even though one man could own particular topics and so on. The fact that an individual artist could emerge as it happened at Hermannsburg with its differences was an enduring achievement of the early Papunya work."[69]

But what defined mastery in this new art of design? Bardon was clear. A successful hieroglyphic design told a clear story. But a clear story in this new medium had to be measured *visually*, not haptically. The "finished" painting had to have the same visual qualities found in the well-executed Chinese character— "poise, posture, adaptation in the interest of the pattern."[70] A satisfactory hieroglyph eliminated all decoration or ornament. This did not mean paring back the painting to a bare assemblage of archetypes, but ensuring that the painting marks represented emotional accents that communicated the meaning and power of the story in the painter's mind. This explains Bardon's quibble about the use of the word "dotting" to describe the style of the painters in 1971 and 1972.

After 1972, Bardon claims, dotting came to be used purely decoratively. In-

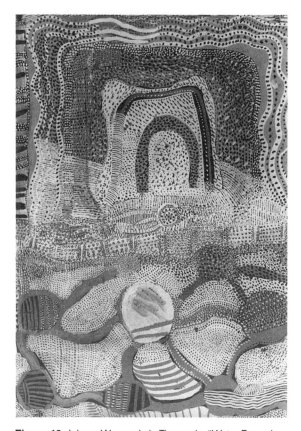

**Figure 19.** Johnny Warrangkula Tjupurrula, "Water Dreaming with Man in Cave" April–May 1972 (photo: Geoffrey Bardon). Reproduced by courtesy of Dorn Bardon. "At least till 1973," the artist "used a cut or stippled 'signature' over the painting, rather than dots; moreover, a part of the stylistic brilliance of this artist is that the cuts or stipples move in different directions and do not overpower the topographical space but rather act and interact with the unmarked surfaces, thereby allowing themselves vitality and an ability to 'breathe.'" Bardon thought this "the finest painting of the Western Desert Painting Movement," adding "it is now lost" (Geoffrey Bardon and James Bardon, *Papunya, A Place Made After the Story* [Carlton, Vic: Miegunyah Press, 2004], 158).

stead of dramatizing and clarifying a story, it often obscured it. But Bardon is committed to the position that in the beginning the painters neither decorated nor concealed their meaning.

> The "dotting" when used by those painters working with me in 1971 and 1972, and later, was not symmetrically formed. The dots were most often of clusters stroked or hatched, and almost always allowed themselves to breathe on the

board or canvas by their having spaces between each other. . . . The dots or strokes at first followed a stroking of the surface by the painter. No one stroke resembled any other and the strokes often seemed to change their direction as clusters, from one section of the painting to the other, and these clusters faced away or toward a hieroglyphic form or forms.[71]

As calligraphic strokes, the "dots" were gestural intermediaries between the idea and form. As movement images, they were microcosms of the meaning of the painting as a whole. If, as Bardon thought, "[a] story would mostly be told as a result of a movement made between a number of places or story situations," a design without movement would also be without meaning.[72] This is the force of his criticism that "in much current Western Desert art . . . the dotting tends to repress or suffocate the surface."[73] For the consequence of this is that "whatever gestures towards movement appear in a painting, seem blocked in and trapped."[74]

Against this background, the particular meaning Bardon ascribed to the term "hieroglyph" emerges. Bardon has often characterized the hieroglyph as a combination of archetypes. But the true distinction lay between signs that were haptic (the archetypes) and those that had successfully made the transition to a form of *visual* writing (the hieroglyph). So, while it was true that "[t]he word [hieroglyph] was an approximation for me of what the painters were attempting to achieve with their culturally received visual language and included archetypes, ideograms and pictograms within its denomination,"[75] the critical point was that the hieroglyphs were "a heightened visual language making figures of sight."[76] Although the painters "sang" their designs into being, the archetypes and their hieroglyphic combination were not phonetic. They did not correspond to spoken syllables or words. They could not be "read" in that way.[77]

On the other hand, they did possess a "spatial" syntax, as the arrangement and interrelationship of elements faithfully represented the idea of a story. Thus, "[t]he use of visual balances or semantic (grammatical and syntactic) equivalents by the artists seemed to me to determine whether there was a linguistic equivalence between spoken and graphic sentences; also, whether the spatiality of the graphics constituted an unmarked or suppressed linguistic meaning able to be understood only by scrutinising the distance between the forms, and their configurative interaction."[78] To the extent that the story was well-known (at least to initiates), different versions of the same story represented different ways of telling it. So, again, "[t]hese meaning-clusters I have called hieroglyphs acted partly as markers allowing meaning to radiate from them; partly as affirmations of story or place. The circle, the half-circle, the cross, the elongated lozenge shape of the ceremonial objects and the irregular line patterns in the paintings could all be conceptual points."[79]

If circular forms suggested the idealization of place, the sense of energy in repose (as a hieroglyph it might signify a waterhole, fire, hill, camp, or vagina, as the context dictated[80]), and traveling lines evidently suggested movement, then most interesting were signs that economically combined both, the half-circles or oval shapes denoting men and women "moving between the principles of stillness and movement,"[81] agents of the design whose country they simultaneously lived in and traveled through, producing it as they went. Concentric duplication implied "the dynamic origins of the circle."[82] In this sense the circle was the completed line of the traveling principle. Finally, most poetically, if the circle could coil up the journey in a campsite, it could also originate traveling; the star sign, a circle surrounded by dots, suggested radiance in more than one sense. "The vortex of this radiating circle was a dynamic out movement of the travelling line from a place of rest."[83]

To "read" the hieroglyph's spatial "language" was not like reading a book. The pattern was not a form of print transparently transcribing a story idea. To read a Western Desert painting was to apprehend the *performance* of that story. This was the success of the painters—to re-present a haptically documented, ceremonial event in a visual form, to find a language that communicated permanently an ephemeral performance. As Bardon explained, "[t]he hieroglyphs . . . were composites of smaller representations or haptic assurances of place; these composites were called by me archetypes and hieroglyphic formings acted *within the interrelationship and self-enactment* of these archetypes; a hieroglyph was a self-evident forming made after the immortal ideality of a story or place and sought to give a physical idea-comprehension of what that place or story was" (my italics).[84] The gesturalism of the dotting, the omnidirectional relatedness of the "haptic assurances of place," conveyed the movement of the story as the artist retold it, and as the retelling was mediated through his hand. As Bardon put it, "[t]hese spatial words acted paratactically as meaning-clusters in the way we see constellations of stars; the vortex of the radiating circle was a dynamic outer movement of the travelling line from a place of rest."[85]

The hieroglyph was the name Bardon gave to the *visual* forms that evolved at Papunya in 1971–1972 (Plate 5). But what was Bardon's investment in them? How was he able to identify them, isolate them, and promote them with such confidence? The answer seems to lie in his original project, the sourcing and development of an authentically Australian graphic art style that could be used to create animated films. The key function of such a style was to tell stories in a recognizably Australian way. As storytelling units—as "visual words"—the graphic units only became legible when they were combined and arranged in relation to each other. Combination was the sign of narrative temporality. Arrangement was the sign of a grouping of actions—an "episode" or even the story from beginning to finish. The "simultaneity" ascribed to the Papunya painter's design

arose because it crowded many moments or actions into a single frame. Far from suggesting arrest, this communicated a sense of heightened animation, as many movements, and their narrative connections, were now presented at once.[86]

The significance of this from Bardon's point of view emerges from his description of traditional sand painting and storytelling. Here Bardon recognized a correspondence between the footsteps of the dance and the marks in the sand — "A reliving of the impress of an animal or totemic ancestor's foot upon the sand."[87] This was another way of assessing the *aesthetic* success of the artist's work, as "any unforthcoming meaning or obscurity seemed often to be a lapsing away by the painter from a ceremonial dance or song's need to communicate what was once meant."[88] But, of course, each sand painting or design could only be part of the dance, a figure or series of poses within the total performance. As Bardon put it, each design had its own horizon of meaning, "coincidental with an incising or hand-marking upon the sand's surface, the story's horizon or forgottenness coinciding with the visuality afforded by the hand or stick marks on the sand."[89]

By "forgottenness" Bardon means to emphasize the design as an act of remembering. The painter did not copy an eternal form. The past only came into being through its becoming present under his hand. As it did not exist anywhere else, it was necessarily forgotten if it lay outside the horizon of the present design. "The changeableness and instability of the soil seemed to me to invite an immediate response in the earth to what was to be put down, by a making of grooves, edges, discernible marks, as the earth was touched and changed, and made understandable by the fingers of a story's proponent. One sensed an unexpectedness in the artists in what they set out, as if meaning did not occur until the forms appeared."[90]

Inside that horizon, "the representations or word-pictures interacted with and replicated each other as the story teller moved his hand omni-directionally so as to create new relationships and meanings."[91] But then "the visual words were wiped away [and] new words were put down, re-transcribing the story-thought and carrying the narrative along."[92] The "interior horizon" of the previous design "vanished as it was covered over and narrationally put aside"[93] — an effect Bardon compared to turning over the pages of a book, where what is represented on one page is replaced by what follows on the next page. The hieroglyph represented a number of pages together. At the very least, it extended the interior horizon. From Bardon's perspective it made possible the telling of a complete story, or at least a complete episode. "Western Desert hieroglyphs of my experience in 1971 sought to write the landscape they enacted, by and through a formalisation of pictograms as hieroglyphic representations. There were no identities in the pictographs of totemic ancestors, only attributes of those parts of the human or animal body sought to be shown as a component of the story's intelligibility."[94]

Later, Bardon came to appreciate that the quality of "finish" he asked for in the paintings was foreign to their inspiration. However satisfying their designs, the Papunya paintings were always stories "to be continued," but this offended the whitefellow canon of good taste—it made them less saleable. Hence the pathos of Bardon's recollection that "Old Walter Tjampitjinpa . . . used the word 'finished' to mean dead when referring to a deceased relative; he also used the word in this same sense, after he had completed a painting."[95] Hence Tim Leura Tjapaltjarri's often cited remark that "the paintings on board were only toys"[96]—for finished designs have ceased to move, and to speak, and are playthings. This is the cause of an irony that cannot be erased. By losing one source of their animation and crossing over to the visual realm, the former marks became signs, furnishing the automata of a different alphabet.

### On the Record

Bardon's own animation in this shaping time remains extraordinary. There were his performances in the schoolroom, not only aimed at stimulating the children but directed with equal exuberance towards the men—"From the beginning I had varied topics to search out desert imagery, of butterflies, grasshoppers and frogs in the way a good teacher has a program to develop understanding."[97] There were his performances outside the classroom: visits to the children's camps, roo hunting with the men, efforts to organize money for painting materials, promotion of a painters' cooperative, his sales efforts. There were his activities *mediating* these different realms. In 1972 he was shuttling daily back and forth between what he called the Great Painting Room in the Town Hall and the New Guinea Shed, a kind of transitional teaching space set up in the Pintupi camp.

> Settlement work began at 7 am with a roll call for all adult men and women. . . . I would begin school duties at 8 am after preparing all the men for their day's work. . . . While the lesson went on in the N.G. shed in the mornings, I would supervise the progress of the painters in the Town Hall in the afternoon (1 hour) and then work with the older children to develop a continuation of Aboriginal traditional art with "nothing whitefella." . . . After school at 3 pm I was back with the adult artists which ended at 4 pm.[98]

No doubt Bardon is right when he reflects, "I feel this absolute availability was necessary to achieving response from the men. Though I did not realise it at the early time my willingness to participate, laid the preparation bit by bit for the wide community acceptance and support I was to be given."[99] But the value of his availability, the effectiveness of his participation, were linked to the

fact that Bardon had something to bring: painting materials, an educational program, and his own "creative wish and will." Even when Bardon served the cause of the painters, he did so with a vision of his own. That vision influenced Bardon's conception of what was happening—and what ought to happen. It also shaped his practical response to the explosion of creativity in which he was participating. This emerges most obviously in his improvisation of a systematic way of recording the paintings that were being produced.

Works of art are initiated into the art market (or the art gallery). To be accepted and acquire value there they need a name (a title or a number), orientation, dimensions; they have to exist in reproduction. The same applies to the artists; they have to be named and possess relevant biographical data. None of these conventions fit the character of artistic production at Papunya. To meet the demands of identification and attribution, Bardon had to be creative. He also had to act fast. In this situation, conceptual, practical, and creative visions were all valuable:

> I was taking annotations, which were necessary for the coherence of the painting images. It was a very demanding process and the diagrams and invoices involved terrific speed and strain. Many paintings had to be photographed by me before they could be placed in the utility vehicle. Upon completion of the annotations I would carry out each painting and place it on the red sand and take two photographs of each piece until I had completed several rolls of film. Without these photographs many hundreds of paintings would never be known. Many paintings show the surrounds of footprints in the sand in colour and there were several sets photographed in black and white. . . . The circumstance of photographing on the sand was in keeping with their origin as sand paintings in traditional practice.[100]

In this context "finish" wasn't simply a matter of aesthetic preference. It was the precondition of migrating from one cultural system of representation to another. One has to assume a dialectical relationship between teacher and painters that was at times subtle. If the narrative clarity was an important criterion in evaluating the painting's formal success and "finish"—and the price it was likely to fetch—a delicate balance between elaboration and simplification had to be achieved. In the heady months between February and June 1972 in the painting room—at the end of the year the painters had transferred to a storage room in the Town Hall—Bardon behaved like a conductor or film director:

> Often I selected a topic and asked a painter if, as a courtesy, he would tell this story for me. I would mime the bigness of the story and its power, or its quietness and special gentleness. . . . I would exhort the painters and pass among

them in the painting room, saying "do this way right", to be "strong, flash, maybe not here", but always no whitefella forms; I would often courteously ask a painter where to stop, but of course also this was not always what occurred and the painters would by themselves, or with me, seemingly do exactly as they wished.[101]

A painting perceived to be carelessly executed or left off too early led to discussion about its meaning. On such occasions, Bardon reports, he "slowed the men down to improve workmanship and take advantage of superior sable brushes, clean water."[102] He "ceremonialised these 'story' occasions and sketched the 'story meaning' for identification by the Stuart Art Centre."[103] Here, it would seem, Bardon's sense of a completed narrative influenced the point at which the painter was encouraged to finish.

An examination of Bardon's "sketches" reveals another value of the archetype. His story diagrams reproduced the main features—the archetypal elements as they were hieroglyphically configured—of the paintings, and annotated these features. The annotations were summary—as Bardon notes, "the implications of plants, geography and tribal importance [were] almost ignored"[104]—and the annotations were often conspicuously incomplete. This wasn't because of carelessness or lack of time but because Bardon felt that the meaning of certain archetypes could be taken "as read." Hence, the field drawing of Ronnie Tjampitjinpa's "Children's Story" annotates tjurungas, waterholes, and clay pan, while ignoring two longitudinal forms at either end of the line of waterholes. In writing up his field annotation, though, Bardon added, "The straight lines are travelling signs."[105]

Besides the limited scope of the annotations, another conundrum of interpretation stemmed from the simple act of trying to write down the "story meaning" in English. Bardon emphasized,

> The Western Desert painters of my experience felt no need to read a painting from right to left or from a standing position as presented upon a wall. A work was read from any direction, as if it were lying upon the earth, and able to be walked about; yet this capacity to read from any direction did not call forth a need to walk to the position from which the reading might take place, for the artists could read their paintings as if the representations were upside down, with ease and naturalness. The provisional visuality of the representation did not, in my experience, mean that there was no imparted visuality, but rather that an idea was drawn or depicted so as to be seen, as a writing felt by hand, and therefore touched as well, as an expression of the object's received idea.[106]

In that case, how could the linearism of English script possibly represent the painting's "story meaning"? In practice (presumably following the painter's cue),

Bardon's write-ups of his annotations tend to begin with a human subject, followed by a radiating set of predicates—these paratactically added aspects of the subject corresponding roughly to the environment within which the story occurs.

The Papunya artists appear not to have had names for their paintings. Asked what they called them, they might reply simply (in English at least) "mine" or "my country."[107] The names under which the paintings circulate in the auction rooms or scholarly publications are Bardon's. They also derive from the information recorded in the field notes. For example, Charlie Tarawa (Tjaruru) Tjungurrayi's "Wintertime Dreaming" derives its title from the following field note: "Two men on cold day are looking at Mountain very closely at Winter time 'Ngingna.' "[108] In titling works Bardon sometimes introduced appreciative epithets such as "special" or "big": "Big Kangaroo Dreaming" refers not to the size or species of kangaroo but to the perceived importance of the painting. Sometimes names were subsequently revised. The generic term "ceremony," for example, was later substituted for "corroboree," a word with paternalist overtones.[109]

Bardon's annotated field sketches defined the white reception of the paintings in another way, by *endowing them with an orientation*. Bardon's field notes are pages from a book. There is a naturally a tendency to read them from top to bottom. On the basis of the field note drawing, Bardon himself paraphrases "Wintertime Dreaming" as follows: "The expressive shape at the top of the design is a ground drawing-mosaic. Beneath it is a dreaming motif of a journey and the linear pattern is string for a ceremonial hat. Two old men shown by the 'U' shapes in the top left of the picture are on a cold winter's day looking at very distant mountains."[110] In this paraphrase the Pintupi word *nginga*, possibly a rendering of *ngurra*, meaning home or camp, has disappeared, perhaps because in a sense home is everywhere and fails to fit into a linear top-down narrative.

This is the context in which Bardon claims that his photographs of the paintings were "in keeping with their origin as sand paintings in traditional practice."[111] In contrast with the top-down, left-right legibility of the field sketch, his photographs preserved a "plan view" of the paintings, and the fringe of footprints visible in the sand round the edge of the painting alluded at least to the original circumstances in which the designs would have been viewed. That said, Bardon's camera does not entirely conceal its point of view. His photographs usually disclose the immediate environment of the painting perspectivally; the painting acquires qualities of near and far or top and bottom, and a correct viewing position is implied. Nor should one overlook a more subtle aesthetic and technological collusion. In a sense the visual aesthetic informing the paintings is photographic. Their rectilinear form and bold primary colors are exactly what color photography excels in reproducing.

The identification of paintings by name not only adapted them to the market-

place conventions of Western art, it supplied a powerful tool for their classification. The legacy of this is Bardon's division of the paintings documented in his photographic archive into ten thematically distinct "dreamings."[112] This is not the place to discuss the applicability of the English term to the stories told of the Tjukurrpa (a Pitjantjatjara language group term itself sometimes translated as Dreamtime)—but any idea of otherworldliness is to be rejected. Tjukurrpa is the time of creation when ancestral beings arose from the featureless earth, creating in their journeys the present aspect of the country, but their presence is all around and their history is the Western Desert peoples' geography. Bob Innes remarks that the songs told about the wanderings of the ancestors were so evocative that "people could find their way across country hundreds of miles away, which they had never seen, but which they knew about because it was linked to their country and depicted in the songs." He adds, "It is these epic journeys, sites, and spiritual symbolism which is encompassed in the magnificent paintings which have emerged from the desert. The art is the very soul of this ancient continent."[113]

Bardon's classifications have limited ethnographic authority. They were another device for making non-Indigenous sense of the artists' work. As he explains, they often arose "in response to some English language statement by a painter as to what his story meant; in the Western Desert culture all these categories or classifications tended to merge [with] and transverse each other, so that it followed that the terms used to differentiate painting subjects ... were only provisional means for my attempts at establishing a coherence of form, at least for myself."[114] Some of the classifications are thematically reliable. This is true of the Water Dreamings. Others are generic—Bush Tucker Dreamings involved "often undifferentiated representations of yam, wild potato, emu, wallaby or kangaroo." As for Traveling Dreamings, *all* the paintings could be said to fit this category. The same is true of Homeland Dreamings. Some paintings have no doubt been assigned to Traveling or Homeland categories because more detailed information is simply lacking. Yet other classifications are deliberately discreet, the grouping Fire, Spirit, Myth, Medicine, for example. Many paintings could easily be reclassified. There are Kangaroo Dreamings that also fit into certain of the Water or Rain dreaming sequences. To add to the confusion, Bardon notes that the stories attached to certain paintings were not themselves necessarily stable. Asked on different occasions about his Goanna Dreaming, Shorty Lungkata provided markedly different accounts.

In other words, the classifications were talking points, another encouragement to illustration, explication, and innovation. Bardon noticed that different "dreamings" emerged at different times, and among different artists. In the published literature, key paintings by key artists tend to be reproduced. Alternatively, monographs are dedicated to individuals. In this context, one value of the

"dreamings" classification is to intimate the interactive, dynamic group character of the painting production *over time*. At Bardon's request, the artists might paint Children's Dreamings—the patronage and support of the Papunya Special School under its headmaster, Fred Friis, was a crucial element in catalyzing a group mentality in the first months. On the other hand, once an artist had revealed a dreaming of which he was custodian, he was inclined to produce a series of paintings on the same topic. No two designs were identical, but they had a cumulative authority that one by itself lacked. Within this complex situation, a further classification problem arose when artists emulated each other, either by painting their own Water or Fire Dreamings or by imitating another's style. Finally, and always, there was a driving genius toward *playfulness*. Exiles always have to master irony. Many of the thousand or so paintings produced at Papunya at that time were masterpieces of ambiguity, equivocation, and disguise.[115]

### Ways of Life

These notes have tried to bring into focus the transactional environment in which the Papunya Tula painting movement was mobilized. It goes without saying that only one side of it is described. The painters' collective and individual understandings of what they were engaged in, what was being communicated, and to what end, were different, perhaps radically so. But the encounter between Geoffrey Bardon and such individuals as Johnny Warrangkula and Tim Leura—men who became his friends—was not another stereotypical instance of white exploitation of the black imaginary. It produced something new out of the misery, life-affirming and life-changing expressions of love. In no small part this was due to the fact that "Mr. Patterns" had a design on the designs; his conceptual energy (reflected in his reinvention of such art educational terms as hapticity, archetype, and hieroglyph) was as important as his boundless physical energy (embodied in his tireless performance and participation in the practices of everyday life) in effecting this transformation. In this regard, even the relatively dry business of documentation was an occasion of creative invention.

I may seem to have said more than enough about the theory of Bardon's practice, but before concluding, let me emphasize that even this account only scratches the surface. I have said nothing here about the impact of the Papunya experience on Bardon's own filmmaking—already in July 1971 he was acting as official photographer at the Western Desert Sports Carnival, the footage of which later became his film *The Richer Hours*. I haven't mentioned the gift that Bardon gave back, in the form of a European-style mural of Haast's Bluff painted on another of the school's walls. Nor have I discussed a myriad of tiny details that, insignificant by themselves, were, cumulatively, critical to the maintenance of the fragile cultural space Bardon created. There is the image of transposed cer-

emonial life disclosed when Bardon recalls "[t]wo old men, Old Bert Tjapangati and Old Tom Onion Tjapangati, not being painters, would crush the ochres to be mixed with polyvinyl acetate glue. They were giving stories to Old Walter and Old Mick."[116] There is the image of a home *for painting* briefly defined and soon wiped out: "The relatively dust free Great Painting Room with its repaired glass louvre windows was closed to the painting men by the end of 1972; the men then had to work outdoors in the weather in their camps."[117]

Shortly after Bardon's time, in an act of political self-determination, Pintupi men, women, and children began to leave Papunya. In June 1973, two hundred Pintupi moved to Yayayi, twenty-six kilometers (sixteen miles) west of Papunya and established a school there the following year. Through this and similar initiatives, the outstation movement was born. By 1976, 40 percent of Papunya's Aboriginal inmates (numbering around twelve hundred in Bardon's time) were living at outstations. Tim Rowse writes, "Pintupi people, who since 1982 have lived on their own country to the west, remember Papunya as a foreign, miserable place of alcoholism, drunken fighting, car accidents and murder."[118] Official reports make appalling reading. One study of health on central Australian settlements and missions between 1965 and 1969 showed that the "settlement Aborigines" infant mortality rate (for children under one year of age) was seven times as bad as the rate for Australians as a whole.[119] Bardon scarcely exaggerates when he describes Papunya as a death camp in all but name.

These facts highlight the bitter serendipity of Bardon's intervention. They explain his claim that in their paintings, remembering the country from which they had been removed, the artists expressed "the enigma of a homeland place."[120] In "the anguish of exile," through their painting, "the artists reclaimed the interior of the Australian continent as Aboriginal land."[121] But they did more than this. They found a visual language that brought over that country into a new place. This, for Bardon, was the significance of the different stages in the production of the Honey Ant Dreaming mural.[122] If the first version (Plate 2) had been too traditional, using secret/sacred motifs the uninitiated shouldn't see, the second version had been too European (Plate 6). In the third, at Bardon's request, Indigenous motifs were reinstated to create a "modified traditional image" in which Bardon discerned not only an aesthetic revolution but a great political statement (Plate 7).

In an image acceptable to all the tribal groups, a network of related journeys stretching ultimately to every part of Australia was envisaged, and, in modifying it for the uninitiated, an image had been devised at once democratic, permanent, and, in the new space of exile, powerful. "This was the beginning of the Western Desert painting movement when, led by Kaapa, the Aboriginal men saw themselves in their own image and before their very own eyes, and upon a European

building. Truly, something strange and marvellous had begun."[123] After the murals' completion "there were enormous roars, and wild acclamation and dancing, and singing, in the great camps at night, and a sense of our best affirmations coming to life."[124]

Frequently in those months, Bardon had the sense of being a somnambulist, of living in a dream. The meaning of the paintings was imponderable, their ambiguity and disguise redoubled in his attempts to understand them. But far more enigmatic was the environment of human transactions: people habitually said one thing, meaning another. Opposites frighteningly merged and fused. Hope and despair circled each other. Freud claimed that "the alternative 'either-or' cannot be expressed in dreams."[125] And indeed, on this and many other accounts, Bardon's "interpretation" of Indigenous dreams suggests an exploration of the unconscious played out in the waking world.

After the success of the Honey Ant mural, Bardon recalls, "The Pintupi men from the park or from the farm would paint and draw on anything at all. Men would bring scrap wood or fibro to my flat to ask for [paint, crayons, or ink]. . . . At this time quite a few homes were having new floors laid, with the old [linoleum floor] tiles dumped on the street."[126] Compare this with the behavior of the hysterical subject, which Freud compared to *Gschnas*, the Viennese pastime of "constructing what appear to be rare and precious objects out of trivial and preferably comic and worthless materials (for instance, in making armour out of saucepans, wisps of straw and dinner rolls)."[127] Of course, the "hysterical subject" is a misogynistic invention of Freud's,[128] but the larger point remains: the emotionally displaced subject exhibits a displaced creativity. And this applies to the interpreter of dreams as well as the dreamer. Psychoanalysis, according to Freud, was "accustomed to divine secret and concealed things from despised or unnoticed features, from the rubbish-heap, as it were, of our observations."[129]

But perhaps the closest analogy is topographical. Gustav Theodor Fechner, one of very few psychological predecessors whom Freud was prepared to acknowledge, had compared the conscious and unconscious states to two different "scenes." These states might be likened respectively to life in the city and the country—"as a man may conduct a quite different life in town than in the country, and when passing from one of his residences to the other he can always come back again to the same coherent way of life; but it would be impossible for him to change his way of life while staying in the same place."[130] Paraphrasing this—"the psychical territory on which the dream process is played out is a different one"—Freud commented, "It has been left to me to draw a crude map of it."[131] Something comparable happened at Papunya, where a ceremonial tradition was carried over to another place and changed.

The object of the ceremonies was to tell again the journeys of spiritual an-

cestors "whose 'creative dramas' established the appearance and patterns of life experienced today."[132] The imagery of linked concentric circles symbolized for the Tingari "the ancestral journeys of men and women whose creative deeds may be known only to a select few."[133] The performers painted their bodies with the same designs. They danced the ground. They sang the stories, minutely coordinating song phrase and dance figure, and adjusting both to the ground design. The designs' "sacred geometry" referred "to ceremonial body paint designs, the cartography of the country and particular narratives of the Tingari ancestors."[134] The iconographic modification and democratic remembering of this four-dimensional knowledge in two-dimensional designs was an extraordinary feat of therapeutic self-consciousness.

And it depended to a degree on Bardon's being aligned to the spirit of this journey. Unlike Freud, he did not attempt to rationalize the "dreamings." He exemplified the position of Jungian psychoanalyst James Hillman that understanding needs to emerge homeopathically or *methektically*: "if the soul wanders from the body in sleep, then our way of letting the soul return to concrete life must follow the same wandering course, an indirect meandering, a reflective puzzling, a method that never translates the madness but speaks with it in its dream language."[135]

Elsewhere I have argued that Freud's "psychical territory" was not metaphorical. The underworld of his dreams bore a surprising resemblance to the upperworld of late nineteenth-century Vienna.[136] So the Freudian analogy here is not meant to divert attention from a geographically located historical event. What it does suggest, though, is that the mobilization of the Papunya Tula painting movement was an occurrence in spatial history. It involved creative agency. It welled up from powers and desires that could not be explained rationally or contained by administrative protocols. It came also from the unconscious. But—and this is spatial history's insight—that unconscious was the spreading environment, all I have called "the lie of the land." It did not lie in the past, elsewhere. Its being was in the act of repeated becoming, a place inseparable from the process of making a pattern.

What would it be like to inhabit an environment composed of movement forms, semantically attuned to the kinetic body, dyadically composed like the left-right of forward walking? Watching how a "painter would invoke images of thought in the patterns and exposures of dance where intensities were enacted as the sand was hit or caressed by the foot, the dance having a systemic quality of life substitutions which is spoken to in the painting," Bardon witnessed answers to this question.[137] It is not likely that the painters at Papunya considered Bardon's shaping presence as integral to their work. For his part, Bardon, unlike the Viennese interpreter of dreams, deliberately avoided pulling aside the veil.

Instead, he contracted himself in a double sense to the purpose of the painters. He participated in a movement of spirit in a way that made it topical in a new place, irrevocably (and ironically) political in a whitefellow space. But Bardon was remarkable for not looking too far ahead; he understood that a condition of trust was the protection of a shared realm of unknowing. He studied to understand the dreams being told in front of him, and in time, by listening, by helping, by improvising the tools of translation, he became part of that dream. Mediating different ways of life, refusing to "wake up" and flee, Bardon helped ensure that the knowledge brought over, of black loss and white forgetfulness, was not a symptom but a diagnosis. Its topography was not metaphorical but a matter of fact, a design on our design.

**Notes**

1. H. Perkins and H. Fink, eds., *Papunya Tula: Genesis and Genius* (Sydney: Art Gallery of New South Wales, 2000). This volume contains a comprehensive listing of earlier exhibitions as well as an extensive bibliography. The inquiries Hetti Perkins and Hannah Fink made in the course of compiling a chronology of the painting movement confirmed in every detail the factual accuracy of Geoffrey Bardon's own account. This was important as previously Bardon had been the sole authority for much of what he said had happened from February 1971 to July 1972.

2. Geoffrey Bardon, *Papunya Tula, Art of the Western Desert* (Melbourne: McPhee Gribble, 1991), 8. Until Geoffrey and James Bardon's 2004 publication of *Papunya: A Place Made After the Story: The Beginnings of the Western Desert Painting Movement* (Carlton, Melbourne: Miegunyah Press, 2004) (hereafter PAPUNYA), the best published source for the origin of the painting movement was Geoffrey Bardon, *Aboriginal Art of the Western Desert* (Adelaide: Rigby, 1979), 13–16. Its later history is told in Christopher Anderson and Francoise Dussart, "Dreamings in Acrylic: Western Desert Art," in *Dreamings: Art from Aboriginal Australia*, ed. P. Sutton, 89–142 (Ringwood, Victoria: Viking, 1988); and, most recently, in Judith Ryan, "Identity in Land: Trajectories of Central Desert Art 1971–2006," in *Landmarks*, 107–111 (Melbourne: National Gallery of Victoria, 2006).

3. Geoffrey Bardon, *A Place Made After the Story* (unpublished manuscript, 1999) (hereafter APMS), 336.

4. Bernard Smith, "Letter of Support for the publication of *Papunya: A Place Made After the Story*." Supplied to the author by Geoffrey Bardon.

5. Geoffrey Bardon, *A Place Made After the Story* (unpublished manuscript, 2000) (hereafter PMS), 89.

6. See Paul Carter, "On Salvaging Words, Carrying Meanings," in Paul Carter and Ruark Lewis, *Depth of Translation: The Book of Raft* (Melbourne: NMR Publications, 1999), 22–109, 77ff.

7. Geoffrey Bardon, "Conclusion" (unpublished manuscript, n.d.) (hereafter CONC), 2.

8. T. G. H. Strehlow, *Songs of Central Australia* (Sydney: Angus & Robertson, 1971), 729.

9. Geoffrey Bardon, Report concerning "circumstances leading to the termination of my work at Papunya Settlement," dated August 1972 (in the author's possession).

10. Bardon, PMS, 39; Geoffrey Bardon, "Give to the Innocent that which is their Due" (unpublished manuscript, n.d.) (hereafter GID).

11. Desiderius Orban, *What Is Art All About?* (Sydney: Hicks, Smith & Sons, 1975), 91.

12. Ibid., 94.

13. Ibid., 30.

14. Herbert Read, *Art and Education* (Melbourne: F. W. Cheshire, 1964), 58.

15. Rhoda Kellogg, *Analyzing Children's Art* (Palo Alto, Calif.: National Press Books, c.1970), 215.

16. Orban, *What Is Art All About?* 50.

17. Yee Chiang, *Chinese Calligraphy: An Introduction to its Aesthetic and Technique* (London: Methuen, 1954).

18. Orban, *What Is Art All About?* 51.

19. Geoffrey Bardon, personal communication.

20. Geoffrey Bardon, "Synopsis for *Meanjin* Essay," 19 January 2002, 1–9, 1–2 (in the author's possession).

21. Geoffrey Bardon, "Children's Art" (unpublished manuscript, n.d.) (hereafter CA), 3.

22. Victor Lowenfeld and W. Lambert Brittain, *Creative and Mental Growth* (New York: Macmillan, 1970), 260–262.

23. Ibid., 261; see also Bardon, PAPUNYA, 42.

24. Bardon, PMS, 91.

25. Bardon, PMS, 39; Bardon, PAPUNYA, 3.

26. Lowenfeld and Lambert Brittain, *Creative and Mental Growth*, 267.

27. Chiang, *Chinese Calligraphy: An Introduction to its Aesthetic and Technique*, 10; and Orban, *What Is Art All About?* 50.

28. Wassily Kandinsky, "On the Problem of Form" (1912), in *Theories of Modern Art: A Source Book by Artists and Critics*, ed. H. B. Chipp, 158 (Berkeley: University of California Press, 1968).

29. Paul Klee, "Creative Credo" (1920), in *Theories of Modern Art: A Source Book by Artists and Critics*, ed. H. B. Chipp, 182 (Berkeley: University of California Press, 1968).

30. Bardon, *Papunya Tula, Art of the Western Desert*, 134.

31. Klee, "Creative Credo" (1920), 183–184.

32. Ibid., 184.
33. Kellogg, *Analyzing Children's Art*, 16.
34. Ibid., 156.
35. Bardon, CA, 6; Bardon, PAPUNYA, 10.
36. Bardon, CA, 4; Bardon, PAPUNYA, 3.
37. Bardon, CA, 11.
38. Bardon, PMS, 39, Bardon, PAPUNYA, 10.
39. Paul Carter, *The Lie of the Land* (London: Faber & Faber, 1996), 347–356.
40. See Bardon, PMS; Bardon, PAPUNYA, 3; and Carter, *The Lie of the Land*, 353, for variants on this sentiment.
41. Bardon, CA, 4; Bardon, PAPUNYA.
42. Orban, *What Is Art All About?* 51.
43. Bardon, CA, 7.
44. Ibid., 4.
45. Ibid.
46. Bardon, PAPUNYA, 3 and 5.
47. Bardon, CA, 2.
48. Bardon, PAPUNYA, 14.
49. Carter, *The Lie of the Land*, 350; also Bardon, PAPUNYA, 12–19; and Bardon, GID.
50. Geoffrey Bardon, "The Lives of the Painters" (unpublished manuscript, c. 2000) (hereafter LOP), 18; Bardon, PAPUNYA, 131.
51. Bardon, GID.
52. Summarizing Bardon, PAPUNYA, 43; Bardon, PMS, 254.
53. Geoffrey Bardon, "Theory and Practice" (unpublished manuscript, n.d.) (hereafter TAP), 275; Bardon, PAPUNYA, 43.
54. Bardon, TAP, 267; Bardon, PAPUNYA, 44.
55. Bardon, PAPUNYA, 20; Bardon, PMS, 105.
56. Bardon, GID.
57. Ibid.
58. Bardon, PAPUNYA, 61.
59. Fred Myers, "Traffic in Culture: 'On knowing Pintupi Painting'," in *Impossible Presence: Surface and Screen in the Photogenic Era*, ed. T. Smith, 237–287, 237 (Chicago: University of Chicago Press, 2001).
60. Bardon, LOP, 33.
61. Ibid., 33–34.
62. Geoffrey Bardon to author, 6 September 2002.
63. Ibid.
64. Chiang, *Chinese Calligraphy: An Introduction to its Aesthetic and Technique*, 166.
65. Geoffrey Bardon to author, 6 September 2002.

66. Bardon, LOP, 57
67. Bardon, PAPUNYA, 70.
68. Bardon, PMS, 105–106; Bardon, PAPUNYA, 32.
69. Geoffrey Bardon, "Key Whites" (unpublished manuscript, n.d.), 4; Bardon, PAPUNYA, 11.
70. Chiang, *Chinese Calligraphy: An Introduction to its Aesthetic and Technique*, 10.
71. Bardon, PMS, 263; Bardon, PAPUNYA, 45
72. Bardon, PMS, 264; Bardon, PAPUNYA, 47.
73. Bardon, PMS, 264; Bardon, PAPUNYA, 45.
74. Bardon, PMS, 264; Bardon, PAPUNYA, 45.
75. Bardon, PMS, 260; Bardon, PAPUNYA, 46.
76. Bardon, PMS, 260.
77. Bardon, PAPUNYA, 47.
78. Bardon, TAP, 255.
79. Bardon, PAPUNYA, 46; Bardon, TAP, 272.
80. Bardon, PMS, 284; and personal communication, 4 May 2000. Hetti Perkins advises that an allusion to the female genitals is unlikely and would be considered offensive. I put this to Geoffrey Bardon but he remained adamant about the possibility of this connotation.
81. Bardon, PAPUNYA, 47.
82. Bardon, TAP, 244.
83. Bardon, TAP, 258; Bardon, PMS, 208.
84. Bardon, PAPUNYA, 43.
85. Bardon, PMS, 271.
86. Ibid., 276.
87. Ibid., 247.
88. Ibid.
89. Bardon, PMS, 248; Bardon, PAPUNYA, 42.
90. Bardon, PMS, 267; Bardon, PAPUNYA, 45.
91. Bardon, PMS, 270.
92. Ibid.
93. Ibid., 247.
94. Bardon, PAPUNYA, 45.
95. Bardon, PMS 270–271; Bardon, LOP, 18; Bardon, PAPUNYA, 42.
96. Geoffrey Bardon, personal communication.
97. Bardon, LOP, 37.
98. Bardon, GID.
99. Bardon, CA, 13.
100. Bardon, LOP, 71–72.
101. Bardon, PMS, 111; Bardon, PAPUNYA, 33.

102. Bardon, PMS, 112.

103. Ibid., 112.

104. Ibid., 113.

105. Bardon, PAPUNYA, 479.

106. Paul Carter, "Introduction: The Interpretation of Dreams," in Bardon, PAPUNYA, xvi; also Bardon, PAPUNYA, 41.

107. Bardon, PMS, 93; Bardon, PAPUNYA, 54.

108. Bardon, PAPUNYA, 408. It is important to stress, though, that Geoffrey Bardon recognized that these titles were provisional and pragmatic. "Wintertime Dreaming," for example, was progressively renamed. In Judith Ryan's *Mythscapes* (1989) it is called "Old Man's Dreaming at Mitukatjirri," and in *Papunya Tula: Genesis and Genius* (2000) it is simply called "Mitukatjirri."

109. Geoffrey Bardon, personal communication in response to my questions on these matters.

110. Typed annotation for stock ledger item 14020; paraphrased in Bardon, PAPUNYA, 408.

111. Bardon, LOP, 72.

112. The reference is to the classification used in Bardon, PAPUNYA, 156–473.

113. Bob Innes, "Western Desert Art," typescript supplied by Geoffrey Bardon, dated February 1997, two pages, 2.

114. Bardon, PAPUNYA, 49–54.

115. Bardon, PMS, 103.

116. Ibid., 101.

117. Ibid, 24.

118. A. Curthoys, A. W. Martin, and T. Rowse, eds., *Australians from 1939* (Sydney: Fairfax, Syme & Weldon, 1987), 156–157.

119. Ibid.

120. Geoffrey Bardon's eloquent expression. See also Bardon, APMS, 1031.

121. Hetti Perkins and Hannah Fink, "Genesis and Genius, The Art of Papunya Tula Artists," in Perkins and Fink, *Papunya Tula, Genesis and Genius*, 172–185, 185.

122. Bardon, PAPUNYA, 12–19.

123. Bardon, PMS, 54.

124. Ibid., 47.

125. Sigmund Freud, *The Interpretation of Dreams*, trans. J. Strachey (New York: Basic Books, 1960), 316.

126. Bardon, GID; see also Bardon, PAPUNYA, 21–22.

127. Freud, The *Interpretation of Dreams*, 217 n. 1.

128. See Hannah S. Decker, *Freud, Dora, and Vienna 1900* (New York: The Free Press, 1991), passim.

129. Sigmund Freud, *The Moses of Michelangelo* (1914), *Standard Edition 13*,

ed. J. Strachey (London: The Hogarth Press and the Institute of Psychoanalysis, 1953–1974), 211–236, 222.

130. See Henri F. Ellenberger, *Beyond the Unconscious: Essays of Henri F. Ellenberger in the History of Psychiatry*, trans. F. Dubor and M. S. Micale (Princeton, N.J.: Princeton University Press, 1993), 98. See also Freud, *The Interpretation of Dreams*, 48, 541.

131. Ellenberger, *Beyond the Unconscious*, 98.

132. For early version, see Bardon, *Papunya Tula, Art of the Western Desert*, 8–9.

133. Perkins and Fink, *Papunya Tula: Genesis and Genius*, 180.

134. Ibid.

135. James Hillman, *The Dream and the Underworld* (New York, Harper and Row, 1979), 109.

136. Paul Carter, *Repressed Spaces: The Poetics of Agoraphobia* (London: Reaktion Books, 2002), 102. See also Freud, *The Interpretation of Dreams*, 612.

137. Bardon, PAPUNYA, 42.

## CHAPTER 5
# Making Tracks: Interpreting a Ground Plan

> *There is a lot of thinking and a lot more in the string than just playing a game.*
> —Lewis O'Brien, Kaurna Elder

### Coincidences

In 1839, surveyor-general William Light laid out the city of Adelaide, capital of South Australia, on either side of the River Torrens. In *The Lie of the Land* I argued that Light's plan departed from the conventional colonial grid. His four incomplete and irregular grids showed an awareness of the lie of the land (Figure 20). They also uncannily recalled the character of archaeological sites he had visited and sketched in Italy.[1] The ground plan of Adelaide was not a "self-evident production" in Husserl's sense—an ideal form created and imposed *ex nihilo*. In its awareness of a heritage of earlier traces informing the design, it involved what Derrida describes as "a transmutation and an intensification in order to re-present the work in a way never before seen, a way that appropriates the work to the present and makes it 'topical.'"[2] Light's design adapted and intensified the generic Hippodamian grid to create a ground plan never seen before, one adapted to the political and economic agenda of the free settlers. As a result, it was topical, a product of and at this place not another.

In 1999 an opportunity arose to participate in the redesign of Adelaide's premier street and townscape, North Terrace. Having put forward a theory about the spatial character and design history of Light's ground plan, it was a chance for me to examine the implications of this in practice. An occasion presented itself to recollect those original intentions and through a concomitant mode of production to represent them in an original "coincidence." The rationale for this

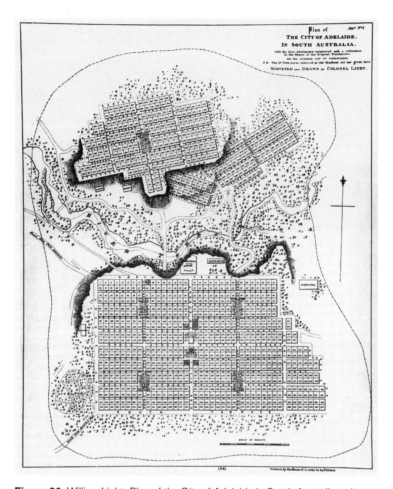

**Figure 20.** William Light, *Plan of the City of Adelaide in South Australia*, published by John Gliddon, South Australian Agent, 3 Austin Friars, 1836. Notice the curious lack of formal (rectilinear) communication between north and south parts of the city. Instead a capillary system of winding tracks is sketched in. In this context the site of the present North Terrace, located inside the coastlike bluff (drawn in dark relief), is a topographic filter, mediating between the "dry" squares of the planned city and the "humid," serpentine zone of the Torrens underneath the Terrace.

approach was that in the century and a half between Light's original plan and our proposal to revisit one of its key components, the townscape's original character had been extensively modified. In a sense this was a sign of the ground plan's success; it created a template of economic and social life so effective that the network of interactions it incubated soon outgrew the original arrangement, here breaking it down, there opening up new lines of communication.

However, as Husserl hypothesized, the ease of transmission of virtual mean-

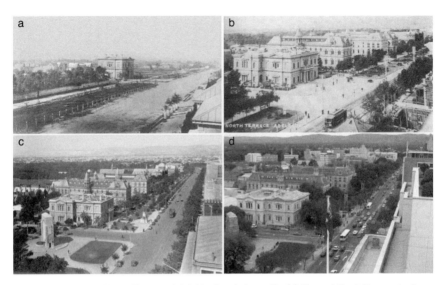

**Figure 21.** Views of North Terrace, Adelaide, South Australia. (a) View of North Terrace looking east, Institute Building in foreground, 1860s (source: *Heritage of the City of Adelaide*, ed. S. Marsden, P. Stark, and P. Sumerling, 1990); (b) View of North Terrace looking east, Institute Building in foreground, c.1915 (Source: *Heritage of the City of Adelaide*, ed. S. Marsden, P. Stark, and P. Sumerling, 1990); (c) View of North Terrace looking east, Institute Building in foreground, 1930s (Source: Mortlock Library Archives); (d) Current view of North Terrace looking east, Institute Building in foreground (source: Taylor, Cullity, Lethlean, 2001).

ings may induce a passivity, a forgetfulness of the original meaning, and hence in the course of time a crisis of understanding.[3] The North Terrace Precinct Redevelopment was living proof of this fact. Over the years, the original intentions of the *terrace* had become obscured. Increasingly, this zone had been linearized —treated as an east-west thoroughfare rather than as a way of stepping northwards out of the grid toward the Torrens valley. Linearization had weakened the relationship between the cultural institutions bordering North Terrace on its north side and the streetscape, and the concentration of motor traffic along the east-west axis had broken down communication between these northern buildings and the edge of the city grid facing them to the south. The forgetfulness of origins had produced a fragmentation, illustrated by the proliferation of different plantings, the miscellaneous distribution of heritage items, and the fierce parochialism of the cultural institutions in defending their own "patch." The result was a crisis of understanding, represented by the "illegibility" of the site and its failure to attract extensive socialization.[4] The initiative of the South Australian state government and the city of Adelaide to commission a master plan for the "North Terrace Redevelopment Precinct" ahead of commissioning a landscape design concept was a response to this perceived loss of meaning (Figure 21).

On the principle that places are made after their stories, and that place names are condensed stories figuratively embodying an encounter in time and space, my contribution to the master plan focused on the interpretation of the word "terrace."[5] Why had Light called the east-west street on the south bank of the Torrens North *Terrace*? The designation had certainly caught on. Light originally applied it to North and South Terrace, but elsewhere where the surveyor-general had written "street," the city fathers later extended the term to create East and West Terrace. Later, Light's nomenclature was adopted outside Adelaide. Remote townships like Marree and Farina—whose ground plan was little more than a generic grid—found their cardinally aligned borders dignified with the description "terrace." This extension of Light's term suggested that it was felt to describe a transition from the exact geometry of the grid to the "anexact" spread of nature. In Adelaide, Light's terraces looked out into land that was intended to become parklands, but in South Australia's far north the desolate terraces of Farina stared out into a desert plain all but indistinguishable from the ground where one stood.

But this review also suggested that from the beginning Light's intention had been flattened out. North Terrace is topographically specific; it creates a rectilinear edge overlooking the gully of the Torrens River (Figure 22). In applying the term elsewhere, where the ground plane of the grid was continuous with the land beyond, later surveyors and naming committees had disregarded the original allusion to a change of level. In a similar way, perhaps, the imposition of the name East Terrace had sidelined Light's odd decision to give the eastern edge of South Adelaide a "stepped" profile. In this case, both in plan and in elevation, the originality of Light's plan in negotiating level changes in the lie of the land had been overlooked. It remained a potentiality of the site plan that the strong ideological attachment to rectilinear rationalization had classified as prerational or protogeometric. In this case, the intriguing possibility arose that Light's plan had never been a "self-evident production" in Husserl's sense. It had never enjoyed "being" in that sense. Although Light's ideal form had been plucked from the flux, it had not necessarily achieved an "objective presence." Instead it might illustrate the argument of Cobb-Stevens, quoted in chapter 3, that "there is no reason to suppose that Husserl tacitly identified being with objective presence, for the self-presence of the living present resists objectification."[6] Light's terrace remained a potentiality of the plan, an intention whose meaning was unfulfilled.

Of course, these reflections were not imposed on my colleagues or on the client, but they provided a theoretical ground for interpreting Light's intentions quite freely. For this was the other corollary of regarding the terrace as a potentiality. In recollecting its meaning through an act of concurrent actual production, the meaning of Husserl's phrase "an original 'coincidence'" was changed. There

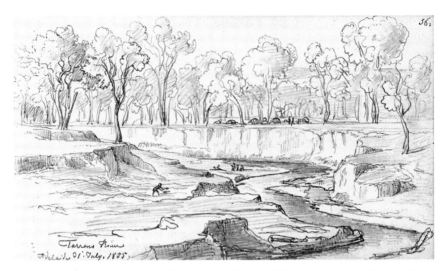

**Figure 22.** Eugene von Guerard, "Torrens River, 31 July 1855," pencil on paper, 8.7 × 15.3cm, Mitchell Library, DGB 16, iii, f.37. Copyright State Library of New South Wales, reproduced by courtesy. In this sketch four or five incipient platforms of terraces have been distinguished. The Aboriginal camp depicted on the far bank has been identified with one near the present Adelaide Botanic Gardens, probably in the angle formed by the junction of First Creek with the River Torrens. The junction is discernible toward the right (east) of Light's plan (Figure 20).

was no longer any question of restoring the site to the designer's original intention. That intention had always been an arrow directed toward the future. It had tracked an elusive quarry. To come into an original coincidence with it would be to align oneself with its line of flight, to retrace the metaphorical path it opened up—that arc between concept and thing in whose interval the history of a place begins to form. Written into the concept of coincidence is not only a notion of self-sameness but an idea of self-departing. Coincidences that do not destroy the free play of creativity are always deferred. They are grasped by Latour's "passengers" on the condition that they do not try to arrest the movement of the line.

One practical outcome of this train of thought was the recovery of the movement form crystalized in the terrace. Extracted from the geometry of the plan and imagined as a design on the lie of the land, Light's terraces could be considered less as the ideal foundations of Adelaide's architectural form and more as invitations to direct and coordinate human communication. Light's four grids stand on either side of a southward bend in the course of the River Torrens. The axes of the three northern grids turn convexly outwards; North Terrace on the south side follows a parallel roughly drawn through the course of the river along its southernmost reach. On the map this arrangement seems pragmatic. However, as an 1853 sketch plan indicates, it was felt on the ground to represent a distinct design on the place (Figure 23). In Barton's drawing, the curvature of the northern grids

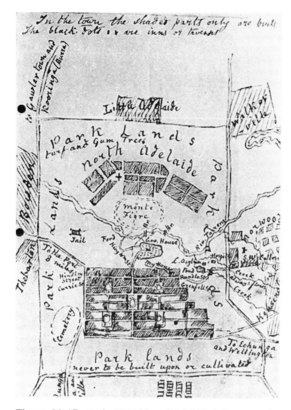

**Figure 23.** "Barton's 1853 Map of Adelaide." Courtesy of the Corporation of the City of Adelaide Archives. Reproduced from A. Grenfell Price, *The Foundation and Settlement of South Australia 1829–1842*. Comparison with Figures 20 and 24 suggests that Barton's map is drawn from memory. From our perspective his reversal of the form of North Adelaide is highly suggestive. Remembering Light's convex outline as concave, Barton captures the psychotopographical effect of Light's plan, its intent to focus civic life and energy on North Terrace. Interestingly, communication between north and south is still informal or speculative.

has been reversed to create a concave theatrical space whose "stage" is the low land around Montefiore and the river flats. Was this sketch done from memory? In any case, it discloses that one Adelaide resident at least felt that Light's North Terrace had the psychological effect of gathering landforms to it. It suggested a movement toward a meeting place in-between the grids of the new city.

The role of North Terrace was to provide the place where this prospect could come into view. In theory, as one walked its length the different axes of the northern grids successively turned toward the walker. The succession of viewpoints

that North Terrace allowed had the effect of "bending" the further bank round, gathering the river flats below into a concentrated site of communication and exchange. This is, of course, highly speculative—and it anticipates the completion of an urban scheme that was, in fact, modified from the start—but it suggests that the terrace was, at least as Light intended it, a *theoretical* place in the etymological sense of that word—a place where visitors might wander about observing the institutions and customs of the people and storing up information about them. It is interesting that over time North Terrace has become the repository of South Australia's collective memory, as its state library, art gallery, and museum stand side by side on its northern edge. But perhaps this association of the terrace with the formalization of a public vision and a sense of gathering significance has obscured the movement that this space also solicited.

It has recently been argued that the raised-up level or platform "prefigures city building or sets the stage for public life."[7] Leatherbarrow bases this suggestion on a passage in the prelude to the *Theogony* where, he says, Hesiod describes the Muses dancing on the terraces of Mount Helicon.[8] But a word equivalent to "terrace" does not appear in the passage in question. In invoking "the Heliconian Muses . . . who hold the great and holy mount of Helicon, and dance on soft feet about the deep-blue spring,"[9] Hesiod's emphasis is less proto-urbanistic and much more choreographic—later, describing the Muses' procession to their "dancing places" (*choroi*) on Olympus, he says, "the dark earth resounded about them as they chanted, and a lovely sound rose up beneath their feet."[10] If terraces *are* evoked in these passages, it is as movement forms rather than landscaped shelves, as the form the lie of the land takes when it is danced. They exhibit the ambiguity of the English word "step," which means both a unit of locomotion and a change of level. In this case, the terrace precedes the road; in the grip of their ecstasy, the maenads are said to have found their way over pathless mountain passes to Delphi.[11] They were not intoxicated but unusually clear-sighted—and sure-footed. They kept their footing, leaping from rock to rock flawlessly, without hesitation. Discovering the flat places across different levels, these Bacchus worshippers measured out the first terraces. The step up or step down from terrace to terrace is the permanent trace of the danced step.

This, then, was the first outcome of reflecting on the meaning of Light's apparently generic place name. It suggested that in order to recollect his original intentions, it was also necessary to understand that these had remained veiled at the time. A concomitant act of production—a new design for the North Terrace Redevelopment Precinct—needed to recognize that from the beginning the "terrace" did not coincide with its original intention. From its inception it was departing from itself. In the same spirit, we should align ourselves with the situation it was designed to bring about. It was not an architectonic master plan but

a score for measuring movement, and the first step in realizing this was to find a way to retrace those mobile patterns of coming and going, communication and exchange.

### Various Directions

Light's North Terrace did not simply differentiate a site where reason ruled from an unruly environment. It distinguished two styles of locomotion. The four different tracks that spread out from North Terrace into the Torrens valley strikingly illustrate this. Light makes no attempt to join North Adelaide and South Adelaide with a straight road. Perhaps influenced by the Baroque cities of Sicily, whose ground plans excel in terraces that offer sublime prospects but minimal communication with the hinterland, Light failed to foresee the rapid evolution of wheeled transport that was shortly to revolutionize the role of streets in urban design.[12] In any case, the serpentine tracks negotiating the terraces of the river are formally and functionally quite different from the rectilinear streets laid out north and south of them. Their twists and turns are the movement forms of people walking and riding or hauling heavy loads with carts. They are the straightest way between two places when the lie of the land is taken into account.

But Light's idea that communication across the river could proceed capillary-like via a multiplication of informal tracks also reflected the fact that his design was not imposed on a trackless surface. G. S. Kingston's map of the distribution of houses in Adelaide, drawn up only three years after the grids had been pegged out, shows how an ideal form was interpreted in reality (Figure 24). Its most telling feature is the host of north-south passages (bolded in black) that have opened up in Light's rectangular city blocks. Of course, as few allotments of land had been enclosed and built on, there was nothing to prevent the proliferation of these informal lanes. But their predominant orientation is significant. It suggests that the main axis of communication was north-south rather than east-west (as Light's plan tended to prescribe). The other striking feature, of course, is the braiding of the various tracks across the Torrens into a single crossing place functionally aligned to Adelaide's King William Street. These developments could easily be interpreted as deformations of the original intention, but in reality they were the trace of an older pattern of tracks that took account of the physical characteristics of the site.

Settlers who found their way to the site of North Terrace did not enter a plain, clear to the horizon. Instead, they stepped into a forest. The so-called "black forest" had its northwest edge along the eastern part of North Terrace. In his recollections of early Adelaide, the pioneer Nathaniel Hailes wrote that Morphett Street in March 1839 "resembled an extensive gypsy encampment. Not the semblance of a street existed on the land, although all the main streets had been

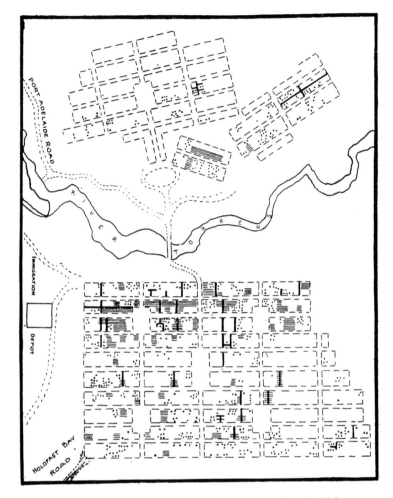

**Figure 24.** G. S. Kingston, "Distribution of Houses in Adelaide, 1842." Courtesy of the Corporation of the City of Adelaide Archives. Reproduced from A. Grenfell Price, *The Foundation and Settlement of South Australia 1829–1842*. Three years after Light's plan, Adelaide has gone backwards, broken lines now replacing continuous ones. Some effort has been made to gather up Light's capillary system of tracks, but the main communication between north and south remains like a dancing ground figure. Most interesting is the breakout within the southern grid of internal fissures and faults, a kind of chemical reaction due to the intense *heat* of settlement around those streets.

duly laid down on the plan. It was, in fact, an extensive woodland with here a solitary tent and there clusters of erratic habitations."[13] And Hailes and others refer to the problems of navigation: "It was easy to lose oneself in the sylvan city even in the daytime, and at night it was scarcely possible to avoid doing so. The Maze-like character of the spot was much enhanced by the multitude of wattles

which occupied the spaces between gum or sheoak trees."[14] Hence: "Often after turning in various directions to avoid the holes of mud and water, the pedestrian, attracted by a light, would find himself about where he had started from."[15]

In other words, North Terrace, the edge that justified Light's irregular plan, was entangled in two other systems of place making and marking. One of these preceded the clearing and laying out of the town blocks and streets. It was an informal network of paths and clearings. The other followed the partial clearing of the site and its division into streets separated from one another by rows of building lots, and it consisted of tracks through these as-yet vacant lots. It can be presumed that the earlier network largely followed in the footsteps of pathways established by the Kaurna people. In this case, the present appearance of North Terrace has its origins in the entanglement of Light's design with at least three other systems of *ground design*. But this expression may be misleading as, unlike the lines of the survey, these systems of marking fused ground and figure. The paths swelled into clearings. The camping sites contracted into snakelike paths that traveled. Traveling and sitting down were two modalities of one existence. To speak graphically, paths were not lines, camping sites were not circles. Both were more or less elongated blots, and, if it could be written down, the pattern they would make collectively would not be a diagram drawn on a white page. It would be something like the chiaroscuro effect achieved in Venetian painting, where the application of the blot technique to a dark ground eventually brings forms to light out of the dark. In these paintings, figure and ground fuse in the passage of the brush, and the work, whatever it represents, is the movement form of all the brushstrokes that have produced it.[16]

Leatherbarrow cites an ancient story according to which the world was formed when Zeus threw a wedding veil over the head of the goddess of the underworld. The veil transformed the earth into a "chart of horizontals," a graph or map formed like textile from a cross-weave of lines. This, he emphasizes, was only "one half of the reality of leveled land." The other half was the vertical differentiation of the dance floor, *choros*, or terrace.[17] This story may explain the derivation of our word map (*mappa*) from a term meaning cloth or nap. The map as utopian ground plan both flattens (lays out) space and constructs it ideally as a kind of platform elevated off the earth and flanked by terraces. But in Light's Adelaide at least the older topography of the "underworld" remained detectable in the new plan. Within its ideal clarities there lurked the maze—which, as the settlers' reports indicate, was in large part a side effect of the attempt to impose rectilinear order on an environment whose organization was distinctly non-linear. It was the conflict between the intuitive logic of the tracks and the counterintuitive (but authoritative) injunctions of the map that caused the newcomers to feel "lost."

An old sense of the verb "to map" apparently means to baffle, maze, or amaze a woman.[18] Perhaps this alludes to the confusion created when the ordinary choreography of everyday life is straitjacketed within the grid. But the gendered nature of this amazement is also intriguing. It corresponds to the ancient personification of the underworld as a goddess. The point perhaps is that the ubiquitous association of women with mapmaking—that is, with weaving the *mappa* or fabric—needs to be tempered with an awareness that this activity has a distinctive environment. The act of weaving is a matter of timing and placing. Just as the map expunges the movement history needed to compile its description of fixed relations, so the cloth woven by the weaver conceals the three- and four-dimensional gymnastic of hand and eye that produced its almost dimensionless, seeming linearity.

Once the master plan had been embraced, the design group responsible for it was invited to develop a design concept that would reflect the site values identified in the master plan.[19] It was agreed that the design should embody our project team's enriched understanding of the connotations of terrace. Our delving into the early movement patterns on either side of the Torrens had been complemented by an analysis of the "desire lines" that currently threaded North Terrace. This had shown that there continued to be a strong argument for facilitating a stronger north-south pedestrian flow across the Terrace. The permeability of the row of institutions along the northern side of the Terrace should be increased to allow an informal "capillary action" connecting the city edge to the banks of the Torrens. The proliferation of north-south passages between North Terrace and Rundle Street Mall showed that a similar capillary movement already stitched the Terrace into the central business district to the south. It made sense to take advantage of this informal capillary system to give the Terrace legibility laterally as well as longitudinally. It was not a question of imposing new crossings but of using materials and plantings to indicate an underlying system of "dogleg" or steplike passages flowing north-south across the site.

This informal pattern could also be discerned at smaller scales. Over time a double pathway had grown up along the northern side of the Terrace, between the buildings and the road. An outer path adjoined the road, while a narrower and more intimate inner path adjoined the public buildings. The outer path took public traffic and accommodated crowds; the inner path was used by those "peeling off" from the mainstream and offered a slower, more contemplative mode of progress. Together, these paths articulated the distinctive character of the Terrace as a place of intensified social and intellectual commerce, but over the years their definition had been weakened and their relationship to each other obscured. Accordingly, the master plan recommended the restoration of the paths. To protect the integrity of this newly intensified rectilinear feature, it was necessary to

design the ways that crossed them differently. Roadways—pedestrian access to the university, museum, library, and art gallery—could be seen as constituting a different system of communication, one whose lines bunched or spread out, communicating not only directly but indirectly. The functional demands for access could be complemented by a system of potential connections. With this aim in mind, an informal dogleg or step pattern was developed between the tram tracks of the inner and outer path, and the north-south pathways indicated in this pattern were selectively allowed to reappear north and south of the tracks.

The template for this pattern was inspired by the "random ashlar" style of wall construction that characterized the early colonial buildings of Adelaide and which remains a typical method of wall construction today. In this way the second scale of the proposed ground pattern was related to a third, yet smaller scale of pattern making. I think that the grouting patterns created by the random ashlar method of building belong to the eidetic unconscious of most Adelaide residents, but there was also a strong historical and topographical argument for taking this intimate feature of the built environment and scaling it up to produce a movement form for negotiating passage across the Terrace.

Unlike Light's reference cities in southern Italy, Adelaide was founded in a place without immediately accessible building stone. As we commented at the time:

> The first building stone in post-white settlement Adelaide was quarried from a soft limestone exposure in the banks of the Torrens on the site of the present Government House garden. A second quarry seems to have been located on the site of the present Festival Centre. The grand ambition of South Australia's promoters—to lay over the land a uniform and universal grid calculated to produce the most rapid and most equitably distributed investment and occupation—was, in a much smaller sphere of influence, shared by Adelaide's first quarrymen and builders, who expected to cut the fortuitously located limestone into regular blocks, in this way maximising the speed with which stone orders could be fulfilled and sturdy buildings erected.
>
> In the event, the local stone proved too crumbly to cut and dress into standard sizes and shapes. Much as Light had to improvise a grid-terrace hybrid that took account of the local topography, so the first builders had to respond flexibly, and creatively, to the geological situation in which they found themselves. As no two blocks were alike, and it was hard, if not impossible, to guarantee sharp-cornered blocks, quarrymen and builders had to work rather in the manner of dry-stone wallers—raising the walls in multiples of courses, aiming over a series of such courses to reconcile *local* irregularities with the *regional* grid or frame presented by the wall's prescribed height and width.

A characteristic effect produced in this way was a proliferation of grouting "terraces" or "steps" dancing diagonally across the walls. The result was a wall whose irregular blocks created along their joins an open, variable grid, a protogeometric, essentially inexact, pattern that, without ever exactly repeating itself, possessed an easily recognisable identity and stability.[20]

When these grouting patterns were scaled up, they produced a surprising effect. The multiplication of corners, T intersections, stepped streets, and "ladders" began to look like a consciously intended maze. If this protogeometrical grid was the map of an imaginary place, it was so in the sense of being the rationalization of a labyrinth, in which an excess of connectivity is cultivated for its own sake, without any ulterior motive (or destination) in mind. The variable grid envisaged here did not so much deform the rectilinear pattern as interfere with it, acting as a shadow or countergrid, alive to different, more fluid, and locally responsive ways of arranging people and things. The social corollary of such a system of communication would be, we thought, an enlarged opportunity for lingering, crisscrossing paths, and meeting. Mediating between contemplative and active east-west tracks, the ground pattern combined movement and reflection. An impression of earlier passages created a sense of belonging, or curious companionship and an intuitive sense of guidance and order. The material treatments, the plantings, and the location of street furniture within this template ceased to be an obstacle to progress and instead mediated the possibility of meetings and the drama of passage associated with this possibility (Figure 25).

### Tracks

As part of the North Terrace Precinct Redevelopment, public artworks were to be commissioned. We expressed the view that these should not be "stand alone" objects but should emerge ideally out of collaborations between the landscape architecture team and the artists (Figure 26). This proposal was initially entertained; later, as a result of the rigidity of the funding structures and internecine rivalry between the cultural institutions represented on the public art selection panel, it collapsed. However, one fruit of the initial willingness to contemplate an artwork integrated into the fabric of the landscape design was the proposal for a public artwork called *Tracks*. Just because a public artwork is integrated into the landscape design does not mean that it becomes physically invisible or materially homogeneous with its surroundings. The four double-faced blades or stelae making up *Tracks* were two-and-a-half-meter-high (eight-foot) structures of perforated steel, standing in-between and at right angles to the east-west flow of the two pathways. Their narrow north and south faces consisted of LED arrays.[21] Physically and materially

**Figure 25.** Paul Carter, Four "Variable Grids." (a) and (b) Concept sketches for *Tracks* (Paul Carter, Notebook A29, 281, 287). (c) and (d) Rationalizations (*Tracks*, LED Component, Power-Point presentation, courtesy of Trampoline graphic design studio, 9 July 2001). Developed from studies of random ashlar walls, the hand sketches locate the logic of the design less in the "random" shape of the building stone and more in the "anastomosing" network of communication ways they generate. This element recedes when the drawings are rectilinearized.

**Figure 26.** Paul Carter, *Tracks*, ground plan, sketch showing "random ashlar" motif at three scales, applied to section of North Terrace landscape, September 2000 (author's collection). The three scales are respectively picked out in black outline, dark gray, and light gray and overlay a planting scheme that initially had three diagonally related rows of spotted gums running east-west along the north side of North Terrace and one row on the south side of the street. Ultimately the client decided it preferred London plane trees; however, the north-south "bars" of garden planting arranged at random intervals did survive to be built. The portico with four pillars indicated at the bottom right of the plan belongs to the Art Gallery of South Australia. They were one point of reference for the four "stelae."

heterogeneous, the only obvious way *Tracks* was integrated into the proposed landscape design was through its location at places indicated by the variable grid we were planning to use as our ground template (Figure 27).

The integration of *Tracks* into the landscape design was not, then, another case of retrofitting a stand-alone work into a largely finished landscape design.

**Figure 27.** Paul Carter, *Tracks*, ground plan, rationalized three-scale random grid, showing location of four stelae ("*Tracks*, early presentation," PowerPoint, courtesy of Buro Plus, February 2001).

Its location, scale, electronic content, and surface treatment were a kind of microcosm of the intentions of the new design as a whole. From the beginning we had approached the redevelopment of North Terrace as an opportunity to inscribe movement into the place. The idea was to materialize passage, to choreograph constantly changing arrangements of people. In a pre-stone-paved or macadamized environment the evidence of movement would, of course, have been visible in a different way: it would have been legible in the tracks left by feet in the soft earth. But in the hard world of contemporary landscape design imposed upon us by public liability regulations, these signatures of things having happened are prevented.

In this context, *Tracks* was conceived as an archaeology of prints, a kind of compendium of natural as well as human inscriptions found in the local environment, which, once upon a time, would—to those who could decipher them—have been eloquent indices of the place's movement history. There was no exact

precedent for the forms I selected or for the ways in which I manipulated them, but the term "iconograph," which the anthropological thinker Roy Wagner uses in discussing Nancy Munn's study of Walbiri iconography, comes some way toward capturing their spirit. These, he writes, are "stylised and abstracted pictures, not of sounds or ideas, but of the impressions that are (or would be) made in the earth by beings that move across it. . . . Many of the most commonly used forms are in fact close imitations of the tracks of human beings or animals."[22]

I interpreted tracks in a rather broader sense. My lexicon of tracks included any kind of inscription found in the environment that was a trace of movement. In the course of collecting materials, I came across a passage written by an English visitor to Adelaide in the 1870s who, walking the beach at Glenelg, was led to reflect:

> As we tread the sand, yet wet with the retiring waters, who can fail remarking, at particular spots, the process by which sandstone is produced? Notice those singular crevices formed by the gentle action of the wind on the waters when the sand is lightly covered; the ripple of the sea is impressed on the sand. When we examine many varieties of sandstone, these curved lines are perfectly distinct, and show that they have been formed by the same process in bygone ages. Were some sudden convulsion to occur which should cover this beach from human observation for ages, and it should again, in course of time, be displayed to view, the discoverer would see on the sandstone the traces which yonder wader is leaving, as she skirts the receding waters in search of her prey; nay, our own footsteps would afford proof that man had been a dweller on the shore of which that stone was once a portion.[23]

The writer was obviously familiar with Hutton's theory of the earth. His confidence that changes in the past can be read in the present appearance of things echoes the skill that Playfair attributed to Hutton, his power of "reading the characters, which tell not only what a fossil is, but what it has been, and [to] declare the series of changes through which it has passed."[24] In any case, it was a fortuitous local authority for an artwork that intended to use "ancient hieroglyphics and cryptic characters" to intimate a history of passage, for, as the Victorian writer appreciated, to track the passage of other people is also to become a tracker who can, in turn, be tracked. It is to pass from being an observer of the human scene to a participant in its production.

We assembled a select visual archive of South Australian "objects" that displayed the series of changes through which they passed. We interpreted this brief quite broadly. Impressions of Lower Cretaceous plants, the tracks of Precambrian worms, and exquisite engravings of Tertiary corals were collected

because they retained a trace of the environmental processes that had shaped, sustained, and ultimately sepulchred them. We selected illustrations of early Cambrian siliceous spicules because their form was, as D'Arcy Wentworth Thompson had shown, the geometrical expression of highly dynamic physical, chemical, and environmental laws.[25] We filed away photographs of animal tracks—the lace hem pattern left by a beetle, the industrial tire track of the green turtle, the sine wave of the saltwater crocodile's belly sliding through the sand. We also assembled illustrated accounts of South Australian Aboriginal rock carvings or petroglyphs, whose execution had the immediacy of graffiti art, and whose subjects (where they could be recognized) were often animal tracks.

These different markings, impressions, and designs had been discovered in the environment; many had been copied there, and others had been collected and deposited in the Museum of South Australia (adjoining the site proposed for *Tracks*). So from the beginning, our inventory of movement forms was not only deciphering overlooked or forgotten marks in the surfaces that composed the material surroundings—it was also a rereading of diagrams, illustrations, and other modes of graphic reproduction through which these forms had been translated into scientific facts. To locate these forms in North Terrace was to track the history of eidetic migration and reinvention through which South Australia's white settler culture had come to make itself feel intellectually at home (Figure 28).

At the same time, that translation of forms that bore witness to "a series of changes" into typical, stable forms—illustrating genres of Aboriginal design, taxonomically distinct kinds of shell, or other scientifically classifiable trace —leached out the movement that had originally informed the traces. It had turned vestiges of flight into images of certainty. In the interests of bringing to light irrefutable evidence of former presences (both human and non-human), it had ignored the significance of the dark writing—the supplement of the pattern that preserved the physical impression of a movement. In this context it did not seem far-fetched to propose that the lexicon of movement forms that had been assembled should be digitized, turned into an alphabet of electronic icons that our LED arrays could display (Plate 8). A continuous flow of icons was imagined. Sometimes the columns of colored light would appear to take the upward paths. At other times they would follow the downward path.

The direction of the flow was to be influenced by the character of the information the screens displayed. The information, presented in an electronic font especially designed for *Tracks*—exhibiting the stepped-structure characteristic of the variable grid and Adelaide's random ashlar grouting patterns—was imagined alternating with the icon stream, creating a further graphic ambiguity in which the pictographic and calligraphic origins of the familiar alphabet

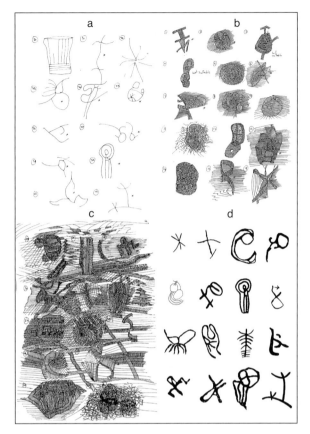

**Figure 28.** Paul Carter, *Tracks*, iconographs, four stages of development. (a) Movement forms copied and edited from illustrations of South Australian Aboriginal rock paintings; (b) Line drawings from Fig 28d redrawn in "hyporelief": (c) Line drawings from Fig 28d redrawn in "hyporelief" and placed in a landscape composed of tracks; (d) Line drawings derived from Figure 28a.

became noticeable. I hoped, too, that these electronic constellations might have a "Cheshire Cat" effect, so that when you shifted your gaze from the screens to the surrounding landscape you would begin to see it differently, discovering faces lurking in the chiaroscuro of the foliage, protoletters or embryonic organic forms in the tiny terraces of puddles, and even puffy footsteps in the clouds. Forms would appear and disappear, and the new landscape would suddenly disclose an underlay of blotches, dapples, flight paths, and constellated sensations that might otherwise have been repressed as so much noise disturbing the direct communication between things.

Although visible by day, the LED arrays would be more alluring by night (Plate

9). Then, their information would reveal its enigmatic base. One kind of reading, in which signs (letters and combinations of letters) stood unproblematically for concepts, would have to yield to another kind of reading—a night reading in which the cryptic forms had to be read in place—as vertical streams of electronic color translating backwards and forwards between sky and earth, to no other end than to assert an endless process of change, transformation, and renewal. By day, the wide, semitransparent perforated steel faces of the stelae would come into their own. The faces had been treated in two ways. Different diameters of perforation had been used to document a variable grid pattern—the same pattern (but at a smaller scale) discernible in the ground around them. Then certain words at the core of the poetic vision for the work were etched into the surfaces in a digital font. The words evoked fundamental themes that would have been developed in the poetic texts composed for the LED arrays located at the north and south ends of the stelae.

The object of using perforated screens, and treating them in this way, was simply to make palpable the perceptual environment of the tracker. It was to counteract any assumption that the new environment of North Terrace was simply a theatrical background, a design where all the choices about passage had already been determined. The world viewed through the screens presented a very different impression—or so we predicted. Their pixelated surfaces would have the effect of digitizing the view behind them. Any movement on the other side of their grid of tiny holes would be subtly broken up into a series of jerky movements. And the same effect would be created by the movement of the observer; anyone on this side of the screens who looked through them as they walked by would have the impression that the landscape behind them was sliding sideways—in this case it would be a static background that seemed to be moving—and again its movement would be made out through the screen of holes, so that it looked like the succession of frames in a silent film.

When these perceptual effects were filtered through the additional pattern of the variable grid and the letters of the digital typography, a complex meditation on the meaning of legibility would be staged. Text would morph into textile, and both, thrown like a veil over the underworld of the background environment, would bring into focus its dark writing of indeterminate shadows, blotches, non-linear patterns, and all the other twinkling incidentals associated with people approaching one another.

### Marrow of Bone

Eventually nothing, or very little, happened. The variable grid ground pattern put forward in the design concept was progressively rectilinearized, simplified, and eliminated. The only sign of its influence on the final design is in the proliferation

of north-south connections between the inner and outer paths on the Terrace's north side, and perhaps subtly in the orchestration of their rhythm.[26] *Tracks*, the public artwork, remained on the public art agenda for a number of years until it eventually faded from memory. It is hard to say why any of this happened or didn't happen. Politicians and their bureaucrats do not in my experience hold conversations; they simply blow hot or cold. Commissions are never exactly rescinded. It is simply that communication ceases. Eventually, the idealism with which the project began, the creative discoveries that caused such excitement, the consolidation of the story lines that so engaged the various heads of our Hydra-headed client—all came to feel like a distant dream. Without the evidence of the sketches, the correspondence, and the photographs, it would be hard to believe that so much hope had been generated, so much opportunity squandered.

However, immersion in the everyday politics of design practice provided an unusual laboratory in which to test the materialization of ideas. Even if, in Paul Klee's terms, we were unable to make our most personal lines "come out"—"the accord between inside and outside was so hard to achieve"—involvement in the redevelopment of North Terrace and in the design conceptualization of *Tracks* was a rare opportunity to investigate what constituted the material expression of a track. For, both practically and theoretically, tracks are, it turned out, not easy to *design*. As the evaporation of the variable grid pattern from the final design suggested, tracks are not easily drawn. They are not roads or paths by another name. They are movement forms whose character cannot perhaps be conveyed using the kind of line drawings usual in architectural and landscape design. According to an early "Vocabulary of the Murray River," collected from people culturally connected to the Kaurna people of the Adelaide plains, there used to exist an Indigenous word *ranko*, with the meaning "path, track, road, marrow of bone."[27] Here, in a sense, our problem was poetically prefigured. If a path or road is to be thought of primarily as a track, then it ceases to have a fixed structure with a definite outline. Instead of resembling a bone—a longitudinal vessel with fixed proportions—it becomes the vital substance inside the form, the fluid sap that animates but which is invisible from the outside.

A similar thought occurs in the philosophy of Maurice Merleau-Ponty, where the method of enquiry is compared to an anatomist's interest in the joints in the body. "The joints of our bodies, as distinguished from the bones, are themselves hollows of a specific kind."[28] That is, they operate in, they articulate, the spaces between substances (bones), and by focusing on these, "philosophy seeks to allow the way the world works to display itself by first subtracting from it the stuff of which it is made."[29] In turn, to go back to Indigenous culture (and to Kaurna culture in particular), Merleau-Ponty's recognition of the importance of human joints as figures of thought is anticipated by the manufacturers of string bags. As

Kaurna elder Lewis O'Brien notes, in the "fibre culture" of his forebears, string and the techniques of stringing together threads to produce baskets, mats, fishing lines, and other objects embodied a sophisticated *topological* understanding of the relationship between things.[30] As a way of thinking, the pattern of a completed string figure is the trace of a complicated path. It materializes holes in the air and captures its invisible dimpling and joins figures of flight into a stable object. Involving a combination of manual dexterity and thorough training, string figures are figural memory aids. They graphically express the history of a journey taken once and retraced many times. They do not exactly represent a movement, but, as the organization of many lines interweaving at that place, they are a collective movement form.

How is the "marrow" of movement to be represented? In conventional maps and ground plans, paths are shown as empty longitudinal spaces defined by bordering lines. They have no existence in their own right. This explains their fragility in the design process and the absence from most designed environments of any awareness of the ordinary qualities of human movement—pace, inclination, approach, entanglement, and passage in general. If lines cannot represent these aspects of the human environment, what can? Well, given that the drawing of lines and the drawing of conclusions are related activities, a different kind of drawing would presumably also entail a different way of thinking. To draw places differently, it is necessary to think about them differently. But this is exactly what *Dark Writing* has been doing. By recognizing that places are made after the story—that they are brought into being discursively—we have been suggesting that places are poetically or metaphorically constructed. They are the expression of a spatial history. It is this poetic origin that embodies the marrow of the place, the sense in which it signifies a space between substances, a gap that the map metaphorically bridges with names and marks. In this case, drawing the line according to inductive reason not only means retracing the generative lines of the *chora*, but following their subsequent history. It is not only the original *ichnoi*, or elemental traces, that determine the nature of the space where things can take place, but all the tracks that follow these original indications, and by a process of concomitant actual production, keep their place-making intention alive.

In a remarkable passage, the English Romantic writer Thomas De Quincey anticipated this argument, capturing its graphic import in a memorable image. All "reasoning . . . carried on discursively," he explained, is "mediate"—"that is, *discurrendo,*—by running about to the right and the left, laying the separate notices together, and thence mediately deriving some third apprehension."[31] The difference of this "apprehension" from an axiom derived by purely logical reasoning is that it retains a trace of the process that brings it into being. It is "reflective" in Ricoeur's sense. To explain this, De Quincey used a striking spatial

figure of speech. The "third apprehension" can be compared to the tracks trading vessels leave in the sea—"so many thousands of captains, commodores, admirals . . . eternally running up and down it, and scoring lines upon its face." If these ephemeral traces could be preserved, the weave of them would yield a pattern, and, De Quincey imagined, "in some of the main 'streets' and 'squares' (as one might call them) their tracks would blend into one undistinguishable blot."[32]

To draw the marrow of the bone, to document the collective movement form that corresponds to the place that makes room for things to happen, might be to put on the plan a "blot." The blot would represent a meeting place composed of all the tracks that made it. While the heritage of trajectories forming it might be "undistinguishable" at a distance, presumably a closer inspection would disclose the archaeology of scored lines that wrote it into being. These would also be the lines that joined one blot or "square" to another. They would be like the woven cords of the string figure. Sallis points out that the *ichnoi* or traces forming the Platonic *chora* did not fly at random; they followed their elemental calling, flying to the places where they belonged.[33] In the same way, the tracks of De Quincey's trading vessels are not scored at random, but follow routes already established. Finally—to go back to De Quincey's notion of discursive reasoning—the position of the "different notices" is not random. Like the participants in the conversational gymnastic of Plato's *Parmenides*, they occupy concrete positions. In other words, a drawing practice that captured the genius of tracks might resemble an interlaced figure, a line or host of lines drawn and redrawn through a series of points, here congregating into a blot, there stretching out to embrace other positions and draw them into the pattern.

There is a strong analogy between this kind of figure and the *figures entrelacées* of the artist Charles Lapicque (Figure 29). Lapicque insisted that these figures arose out of bodies, but it is clear that they are not bodies in Elizabeth Grosz's sense. They do not portray "the very *stuff* of subjectivity"[34] but a personal movement form, a subjective apprehension of being in place. His chiasmatic figures, in which human presences are traced out rather than signified or represented, sprang, Lapicque said, from interior, almost physical rhythms, from random blots or traces (*de taches ou de traits*) that his hand traced aimlessly to begin with. But this was not a preliminary to producing an abstract design. The distinctiveness of Lapicque's random practice lay, he emphasized, in the fact that at a certain moment he perceived in his drawings people (*personnages*), and, in particular, two people entwined.[35] The outwardness of these figures, the sense they give of describing an emotional choreography, the lines of attraction across the gap between people, led the philosopher Emmanuel Levinas to read them as forms of public space design. "Destroying perspective in its function as the order of walking and of approach," he wrote, it "is not space that houses things, but

**Figure 29.** Charles Lapicque, "Figures Entrelacées." (a) "Double tristesse" (1946). (b) "La rencontre" (1946). (c) "Joyeuse rencontre" (1947). (d) "Rencontre" (1947). (e) "La conviction" (1946). (f) "L'accolade" (1947). Pen and ink. (Source: Musée nationale d'Art Moderne, Paris.)

things, by their deletion, that delineate space. The space of each object sheds its volume. From behind the rigid line there emerges the line as ambiguity. Lines rid themselves of their role as skeletons to become the infinity of possible paths of propinquity."[36]

The "iconographs" developed for *Tracks* also shared this property. They were selected because they seemed to preserve a congregation of trajectories. Their eidetic appeal was considerable — and ambiguous. What scale of environmental interaction did they depict? Did they represent ground plans for designed environments? (I experimented with sketching them three-dimensionally, creating in this way micro-environments or playgrounds.) Were they stick figures expressing the essential lines of the human form as it runs, climbs, and leaps? Did they disclose a profound memno-technique for the notation of human movement, a relationship between hand and eye in which the tracks one makes were mysteriously recollected and mapped? One thing is certain: they faithfully posed the problem of designing tracks. Their drawings, suspended between writing and drawing, between images of ideas and traces of movement, slipped through the grid of representation. They belong to the dark writing of a project

that, in the end, had to let the complex ground of its design disappear because it lacked the language that could display it.

## A New Ichnography

A new graphic language was needed. The variable grid could not be drawn in the same way as the regular grid. The generalization that occurs when natural forms are rationalized had to be resisted—as Greg Lynn has observed, "[g]eometric exactitude . . . tends to transform particularities, no matter how precise they may be, into inexactitudes through mathematical reduction. It renders particularities and difference as mere variations beneath which subsists a more fixed and universal language of proportions."[37] In our case, the randomness of our internally coherent but "anexact" pattern could only be preserved by documenting the particular irregularities as carefully as the regularities. The subtly cuneiform character of the grouting zones, the irregularly rounded corners of the blocks, and the occasional bumps protruding into the grouting zones—these need to be rendered in CAD and respected as essential if the interference pattern is to be capable of generating "a multiplicity of unforeseen connections."

But perhaps, in order to garner interest for drawing particularities, it is necessary first of all to have a vocabulary for describing tracks. Despite the attention being paid to paths, lanes, and tracks in the new "terrace," their role continued to be marginalized. Even if they added interest to the place, they were passes in-between more substantial objects. They were "joins" in the fabric, permitting movement but without any critical value of their own. Graphically, for example, they existed as negative spaces, framing positive forms. It was this conceptual vulnerability, as much as the difficulty of representing them, that made their disappearance from the installed landscape predictable. In this context, what was needed, I reflected, was a new science of tracks that would establish the distinctive character of tracks and their significance in making places where things can take place, where passages between objects, rather than the objects, counted. So, to conclude, let me outline a new ichnography.

We have already come across the Greek word *ichnos*. It arose in chapter 3, in John Sallis' discussion of Plato's conception of the *chora* and the way this "region of regions," or place that makes acts of placing possible, comes into being. *Ichnos* means track or trace, footprint or footstep. The word *ichneuein* (which gives the Egyptian carnivore the ichneumon its name) means to hunt for or to track. Traditionally, the term "ichnography" has had two different senses, an architectural one in which the sense of track is used weakly to mean vestige, and a paleontological one in which the strong sense of the term is retained and exploited. Ichnography is the term Marcus Vitruvius Pollio (c.90–20 BCE) used in his *Ten Books on Architecture* to designate a ground plan made by the proper successive use of compasses and rule. He joined it to those other staples of

architectural drawing, *orthographia*, or the drawing of building elevations, and *scaenographia*, or the drawing of buildings in perspective.[38] Vitruvius' use of the term is weak because it grants no heuristic value to the act of making a track; ichnography, he says, is the act of laying out plans "upon sites provided." To mark the outline of a future building means "pacing across the site and placing markers to indicate walls," and this implies that well-proportioned buildings will retain a memory of the mobile body, but no design value attaches to the act of pacing. It is simply the means of defining the length, orientation, and location of the lines defining where the walls will go.[39]

By contrast, the application of ichnography in paleontology is almost too strong. It reveals fossil scientists as deep time detectives with few rivals. It shows that the study of tracks (in principle ichnography encompasses the study of all tracks made by animals) entails a different way of reading (and, by implication, a different way of understanding the act of drawing). The study of tracks is an exercise in recovering the temporal character of events. It is a study that gives back to the phrase "taking place" its double meaning. Except possibly in the theater, events never occur upon sites already provided. They are acts of placing that necessarily circumscribe what is possible there and then. In this sense, the forms of mobility have temporality written into their marrow. In general, the more temporally remote a mark or inscription, the less information it yields. The fossil trace, however, inverts this correlation: the older the mark, the *more* information it is likely to convey, not only because it occupies a horizon generally providing minimal data, but because a future of micro-events may accrue around it. Footprints may act as "traps for bones, teeth and the remains of small organisms."[40] In this way, fossil prints may be the tombs of smaller forms of life. They may also preserve life, creating "microhabitats for communities of invertebrates."[41] In this way fossil tracks serve to arrest temporal processes of erasure and disappearance. As collecting places, they draw together what lies scattered; at the same time their duration in the ground furnishes the material reason, or place, of new communities.

In the study of fossil tracks, attention is paid to the *depth* of the mark. The identity of the track is a product of its outline *and* the impression it makes. In the same way, from a typographical perspective, the writing of the alphabet depends not only on the distinctive outline of each letter but on the depth and strength of the physical impression the letter face or *typon* makes. In ichnography, as in typography, the impression is the product of a relationship. The material in which the type is printed is as important in drawing the track as the stamp, hoof, or foot pressing down. Ichnographers point out that fossilized footprints produce two fossils, the mold or concave *epirelief,* and the cast or convex *hyporelief.* Transmitted prints or ghost prints occur, in which a single foot impact produces an entire stack of footprints, registered increasingly shallowly in descending layers of sediment. This unusual compaction can lead to the topography of the print being reversed,

as the impact of the foot may compress a column of sediment, making it more resistant to forces of erosion. Alternatively, the depression made by the print may be built up, forming a small hill when windblown sand forms dunes in it. In this instance, the ancient track is not simply the container of events—a track that attracts other tracks (windblown sediments, migrant communities)—but an expression in its own right. The track may become the basis of topographical modification, creating *macchie* or blots in the terrain distinguished by their height or depth. A small landscape of fossilized poses may come into being.[42]

These formations not only provide information about the mobile character of the creatures that made them, but they throw light on the *environment* of the track. And here perhaps a blind spot in the science of interpreting fossil tracks surfaces. Fossil footprints are most likely to be preserved in "marginal" environments that have experienced periodic or cyclic accumulations of sediments. They may be useful for "pinpointing and tracing ancient shorelines."[43] Tracks of swimming dinosaurs can indicate the depth of water covering ancient deposits. Tracks, and the creatures that make them, occupy amphibious zones; hence, even these singular traces bear witness to an environment of slowness, of soft ground and unhurried, poised movement.

But this brilliant detective work omits at least two features of the fossil record: first, the possibility that the maker of the tracks was tracked and tracking; and second, that the paleontologists, indeed any interpreters of signs, are themselves trackers—who, following tracks, also leave tracks, and for this reason are susceptible to being tracked. In other words, still missing in this ichnography is the role *reading* plays in writing. Writing that is reduced to the interpretation of signs whose meaning has for the purposes of communication already been fixed (the letters of the alphabet, the "monosemic" conventions of lines on maps[44]) dematerializes the act of reading. It is possible to focus on the signs to the exclusion of their environment. Equally, the environment of the reader can be left out of the communication—questions of orientation, distance, clarity of outline, and surface texture can be ignored.

By contrast, reading writing whose sense has yet to be found means interpreting *all* the evidence, sifting it for the significant patterns that lie buried in it. And, as any Sherlock Holmes coming upon the scene of a crime knows, this means first deciphering the destructive readings of earlier detectives. Hannah Nyala makes both these points eloquently in her book *Point Last Seen*. She explains how

> each track is embedded in a whole web of other spoors: from the insinuated signals of groundwater far below the surface and the composition of its soils, to the constantly eroding rocks and pebbles scattered over or partially buried

in that veneer; from the often conspicuous human footprint or tire track, to the many nearly imperceptible traces left by insects, birds, lizards, or small mammals; from the signs of rainfall, dew, heavy or light winds, to the brands left by an extended drought or flash flood or earthquake.[45]

It is clear from this description that the track is not a line. A reading practice based on repressing the gaps between signs in order to create an orderly linear flow of information will miss the significance of the *rhythm* of the prints as they are placed in relation to one another. It will also overlook the environment of each track, the way it emerges from an "undistinguishable blot" composed of other evidences of passage, change, growth, decay, and the ramifications of these near and far. Further, of course, this attention to the insignificant details afforded by the environment as a whole involves the whole of the reader. Walkers aware of the track they leave behind can discern the path up ahead. Mindful of walking alongside what has already been found, they are writing as they read—engaged in a process of "concurrent actual production." As Nyala says, "the ties between the tracker and the person up ahead constitute the very heart of tracking. Without fail, following someone else's footsteps always forces me to walk alongside them long enough to rethink the most perverse of my origins. As we track, we too are being tracked."[46]

A new ichnography would be a way of writing, drawing, and reading that reconciled the weak and strong meanings of the term—in classical architectural theory and contemporary paleozoology respectively—and applied the result to the theory and practice of design. Ichnography suggests iconography—which in turn recalls Erwin Panofsky's classic *Studies in Iconology*. Perhaps the new ichnography should be defined similarly—as the practice implied by the science of *ichnology*. Though the term appears in his book's title, Panofsky nowhere explains what he means by iconology. As the book is an exploration of different iconographical themes, iconology is, presumably, the generalization of these themes. Thus, practical experience (the prerequisite of "pre-iconographical description"[47]) is possessed by everyone who has ever recognized a footprint as the mark of an earlier presence. Ichnographical analysis "in the narrower sense" of the word[48] is open to anyone with a reasonable knowledge of tracks and their makers, and it allows tracks to be classified according to type and the significance of the types to be interpreted historically. Ernst Bloch demonstrates this skill when he waxes lyrical on the tire patterns the early motorcar left on the as-yet unmetaled roads of Germany—"Ice flowers here, Samarkands there—until both are washed away by the next rain."[49] "A piece of art history," Bloch remarks, "is lying in the highways, mile after mile, imprinted down to the smallest details."[50]

As for the "[s]ynthetic intuition (familiarity with the essential tendencies

of the human mind),"⁵¹ which Panofsky regards as necessary for deeper iconographical analysis, this is exactly what a tracker such as Hannah Nyala possesses in the ichnographic arena. It enables her to become the double of the one she tracks and to bend the life trace into a vortex in which the end is continually renewed or replaced. Aesop's fairy tale character, the deductive fox, knows about this too. When the lion asks why he fails to pay his respects to him, the fox replies, "I have noticed the track of the animals that have already come to you; and while I see many hoof-marks going in, I see none coming out. Till the animals that have entered your cave come out again, I prefer to remain in the open air."⁵² Here ichnography opens out into the larger realm of detection, which, as Dorothy Sayers points out, has one of its origins in the fairy tale.⁵³ Journeys to the other world, descents into the labyrinth, the dark forest, and the maze, in these tales the trail is in the architecture itself. To survive these regions is to learn to read their clues, the irregular geometry of their life design.

Finally, a *logic* of tracks or ichnology would tease out this last strand. It would take it as axiomatic that the track is not a protoline but an incipient plot or spreading field of marks. Like the fairy tale, its interest resides in the suggestion of hidden connections made visible when you only adopt a different point of view. Its appreciation depends on not hurrying on from one point to the next, but in attending to the *drag* of the foot and the mark of it. Our word "drag" belongs to the tract/track constellation of words. The Latin word *tragula* signifies a seine or dragnet or snare; it is a linear figure drawn through the water. The net only functions because of the resistance of the water. The water's current or specific gravity holds the net open, making it billow out; using the water, the net snares what the water holds. *Tragula* also has the sense of javelin. It is speculated that this alludes to the javelin's being "dragged" when fixed in the shield, but it is more likely that the name reflects the fact that the javelin's flight path depends on the air's resistance.⁵⁴ The javelin is like a needle weaving a path through dense air, and the air's drag has to be calculated and utilized if the weapon is to find (and make) its mark.

In these connotations, the track of all tracks is a woven figure or *plot*. The *traho-traxi-tractum* root is associated with English *tram*, a double twisted silk thread or *trama*, the cross-thread of a web, or weft, possibly with the sense of pulled across. This sense of a porous, tense resistance to passage, of a web woven by passing under and over, is also implicit in another meaning of *trama*—"plot." The plot is the cross-weaving of destinies or fateful pathways, but it is also their mutual transformation in the process of tracking through each other. The materiality of a third dimension is essential to this process; otherwise every meeting would cancel out past and future. The rhythm of the fourth dimension is also essential to its design, the wisdom that Lewis O'Brien associates with the

manufacture of the string figure. Only then can a myriad of ephemeral traces track through each other's ways, in the process creating the "undistinguishable blot" of life.

Only then can Vico's triad—recollection, imagination, invention—be an art of becoming at that place, one that treads in the old ways, renewing rather than erasing them. In *The Adventure of Difference* Gianni Vattimo quotes Nietzsche's recommendation: "Turn back and trace the footsteps of mankind as it made its great sorrowful way through the desert of the past: thus you will learn in the surest way whither all later mankind can and may not go again."[55] A new ichnology would show that this thought experiment fails if it does not attend to the character of the footsteps themselves. The "desert" is not a desert but scribbled with dark writing. In reading this, Hannah Nyala's acknowledgment that tracker and track are bound to each other comes into play. It not only defines a practice of writing but the conscience of reading. What can it mean, Vattimo asks, to be freed for the multiplicity of experience "if this liberated man continues to be imagined on the model of the subject who has 'returned to himself' at the end of a wandering itinerary that still covertly follows the dialectical guidebook"?[56] A new ichnology, whose founding axiom is *the tracker is always tracked*, would avoid this solipsism.

## Notes

1. Paul Carter, *The Lie of the Land* (London: Faber and Faber, 1996), 248–250.

2. T. Kisiel, "Repetition in Gadamer's *Hermeneutics*," *Analecta Husserliana*, Vol. II, ed. Anna-Teresa Tymieniecka (Dordrecht, Holland: D. Reidel, 1972), 202.

3. Edmund Husserl, "Appendix VI [The Origin of Geometry]," in *The Crisis of European Sciences and Transcendental Phenomenology*, trans. David Carr (Evanston, Ill.: Northwestern University Press, 1970), 353–378, 361.

4. The comments of an "unidentified politician," which circulated at this time, identified the "problem": "It has become a barrier, rather than a linking and unifying force, a major traffic thoroughfare, noisy, unfriendly and unsafe for pedestrians." Interestingly, the same source attributed this decline to a forgetfulness of what the Terrace had once signified in the collective life of South Australians: "Our lack of appreciation for North Terrace is even more perplexing as North Terrace is not only the most significant public space in the City but also a special place for most South Australians" (unattributed memorandum, author's collection).

5. Taylor & Cullity, Peter Elliott Architects, James Hayter & Associates, and Paul Carter, *North Terrace Precincts Development Framework Plan*, 2000.

6. Richard Cobb-Stevens, "Derrida and Husserl on the Status of Retention," *Analecta Husserliana*, Vol. XIX, 375.

7. David Leatherbarrow, "Leveling the Land," in *Recovering Landscape*, ed. J. Corner, 171–184, 177 (Princeton, N.J.: Princeton University Press, 1999).

8. Ibid.

9. Hesiod, *The Homeric Hymns and Homerica*, trans. H. G. Evelyn-White (London: Heinemann, 1974), 79.

10. Ibid., 83.

11. Carl Kerenyi, *Dionysos*, trans. R. Manheim (Princeton, N.J.: Princeton University Press, 1976), 219.

12. As the distinguished historian A. Grenfell Price pointed out less than a century later. See A. Grenfell Price, *The Foundation and Settlement of South Australia, 1829–1845: A Study of the Colonization Movement, Based on the Records of the South Australian Government and on Other Authoritative Documents* (Adelaide: Libraries Board of South Australia, 1973; orig. pub. 1924), 108.

13. Darrell N. Kraehenbuehl, *Pre-European Vegetation of Adelaide: A Survey from the Gawler River to Hallett Cove, Adelaide* (Adelaide: Nature Conservation Society of South Australia Inc., 1996), 65.

14. Ibid.

15. Rev. E. K. Millar, writing in 1895. Quoted by Kraehenbuehl, *Pre-European Vegetation of Adelaide*, 65.

16. Carter, *The Lie of the Land*, 165–166.

17. Leatherbarrow, "Leveling the Land," 174–176.

18. Ruth Watson, "The Heart of the Map: Material Projections in Art and Cartography" (PhD Thesis, School of Art, Australian National University, Canberra, 2005), 16.

19. Taylor & Cullity, Peter Elliott Architects, James Hayter & Associates, and Paul Carter, *North Terrace Precincts Development Concept Design*, December 2000.

20. Paul Carter, "Adelaide's Mythform: Discovering the Variable Grid (and Applying It)," internal report (November 2000), 1–10, 7. Local stone nomenclature is confusing: "In the early days of the settlement of Adelaide, a fossiliferous calcareous sandstone known as the Adelaide limestone was quarried in the bank of the River Torrens near Government House." *Building Stones of South Australia*, Adelaide, South Australian Department of Mines and Energy (1983), 4.

21. LED signifies light emitting diode. LEDs are a widely utilized mobile electronic text system in commercial and cultural precincts as well as in public spaces generally. In the art world, the best-known exponent of the system is American artist Jenny Holzer.

22. Roy Wagner, *Symbols that Stand for Themselves* (Chicago: University of Chicago Press, 1986), 20.

23. Kraehenbuehl, *Pre-European Vegetation of Adelaide*, 41–42.

24. See chapter 1, note 57.

25. D'Arcy Wentworth Thompson, *On Growth and Form*, 2 vols. (Cambridge: Cambridge University Press, 1942), vol. 2, chapter 11, passim.

26. It is odd now to recall what expectations were held for it. See Stuart Niven, "Surgery and Repair," *Architecture Australia* (May/June, 2001), 72–77, 74.

27. M. Moorhouse, "Vocabulary and Outlines of the Grammatical Structure of the Murray River Languages," in *Reprints and Papers Relating to the Autochthones of Australia,* 2 vols. (Woodville, South Australia, 1923–1930), vol. 2a, 37.

28. Jerry H. Gill, *Merleau-Ponty and Metaphor* (Atlantic Highlands, N.J.: Humanities Press International, 1991), 66.

29. Ibid. Perhaps the identification of joints with hollows still betrays a static, thing-oriented bias. Commenting on the prevalence in Yolngu toponyms and proper names of groups and individuals with "'elbow' and 'knee' names," Tamisari and Wallace comment, "As knees and elbows are the main joints which give movement to a body, so knee and elbow names articulate specific individual and groups' emotional responses with relationships of identification, authority, and ownership of places." Franca Tamisari and James Wallace, "Towards an Experiential Archaeology of Place: From Location to Situation through the Body," in *The Social Archaeology of Australian Indigenous Societies,* ed. B. David, B. Barker and I. J. McNiven (Canberra: Aboriginal Studies Press, 2006), 204–225, 217.

30. Lewis O'Brien, "My Education," *Journal of the Anthropological Society of South Australia* 28: 2 (1990): 105–125, 109–110.

31. Thomas De Quincey, *Select Essays,* ed. A. Masson (Edinburgh: A. and C. Black, 1888), 137.

32. De Quincey, *Select Essays,* 131. Liz Møller notes that De Quincey's style and organization of material both aimed at an effect of simultaneity—much like the spatialization of time envisaged in this passage. (Liz Møller, "Thomas De Quincey's Arabesque Confessions," 1–22 at www.litteraturhistorie.au.dk/forskning/publikationer/arbejdspapir 35, 15) She argues that his essentially digressive sense of form exemplifies Friedrich Schlegel's theory of the arabesque, a graphic improvisation characterized by "its uninterrupted and ever-continuing course and the 'principle of complete coverage'" (9). In this sense De Quincey is as much drawing a picture as narrating an idea; it's just that he uses sentences and concepts rather than curves and motifs.

33. John Sallis, *Chorology: On Beginnings in Plato's Timaeus* (Bloomington: Indiana University Press, 1999), 128 and 128 n. 2.

34. See chapter 3, note 10.

35. Charles Lapicque, *Les Desseins de Lapicque au Musée National d'Art Moderne,* preface by Pierre Georgel (Paris: Centre Georges Pompidou, 1978), 18.

36. Emmanuel Levinas, "The Transcendence of Words: On Michel Leiris's Biffures," in *Outside the Subject,* 146 (London: Routledge, 1990). See also my discussion, *Repressed Spaces: The Poetics of Agoraphobia* (London: Reaktion Books, 2002), 190–192.

37. Greg Lynn, "Multiplicities and Inorganic Bodies," *Assemblage* 19 (December 1992): 36.

38. Vitruvius, *De Architectura,* trans. F. Granger, 2 vols. (London: Heinemann, 1931–1034), 25–27.

39. When Vitruvius' term was revived in the late Renaissance, it was applied to the kind of hybrid town view exemplified by Jacopo de Barbari's great engraving of Venice, in which "the ground plan forms the basic map and the eye, in theory, is overhead but important buildings are shown in elevation." See H. M. Wallis and A. H. Robinson, eds., *Cartographical Innovations: An International Handbook of Mapping Terms to 1900* (Tring, England: Map Collectors Publications Ltd., 1987), 53.

40. Tony Thulborn, *Dinosaur Tracks* (London: Chapman & Hall, 1990), 34.

41. Ibid., 35.

42. This paragraph is developed from Thulborn, *Dinosaur Tracks*.

43. Thulborn, *Dinosaur Tracks*, 14–36.

44. See chapter 1, note 24.

45. Hannah Nyala, *Point Last Seen: A Woman Tracker's Story* (Boston: Beacon Press, c.1997), 150.

46. Ibid., 3.

47. Erwin Panofsky, *Studies in Iconology* (New York: Harper, 1962), 12.

48. Ibid., 16.

49. Ernst Bloch, *Literary Essays*, trans. A. Joron et al. (Stanford, Calif.: Stanford University Press, 1998), 356.

50. Ibid., 356.

51. Panofsky, *Studies in Iconology*, 15.

52. Aesop, *The Complete Fables*, trans. O. Temple and R. Temple (London: Penguin, 1998), 145. Quoting this fable, Sayers commented, "Sherlock Holmes could not have reasoned more lucidly from these premises." Dorothy L. Sayers, "Introduction," in *Great Short Stories of Detection, Mystery and Horror*, ed. D. L. Sayers (London: Gollancz, 1929).

53. See Barbara Reynolds, *Dorothy L. Sayers: Her Life and Soul* (London: Hodder & Stoughton, 1993), 193–194.

54. For semantic associations here and following, see the OED, Walter W. Skeat, *An Etymological Dictionary of the English Language* (Oxford: Clarendon Press, 1910), and A. Ernout and A. Meillet, *Dictionnaire Etymologique de la Langue Latine* (Paris: Librairie C. Klinksieck, 1951).

55. Gianni Vattimo, *The Adventure of Difference: Philosophy after Nietzsche and Heidegger*, trans. C. Blamires (Cambridge: Polity Press, 1993), 84.

56. Ibid.

## CHAPTER 6
## Solutions: Storyboarding a Humid Zone

> *There's no such thing as unskilled labour.*
> —JOHN MORRISON

### Reaches

Shortly after working on *Tracks*, the opportunity arose to advise on the design of a new public space at Victoria Harbour in Melbourne's Docklands. The emergence of the Docklands precinct had been a side effect of the advent of containerization in the 1980s. The Port of Melbourne Authority had made the decision to develop other docks to accommodate the new scale of cargo vessel, and the fate of Victoria Dock as a major commercial wharf was sealed when, as part of the City Link Project, the Bolte Bridge was built just downstream at the junction of the Yarra and Maribyrnong rivers. "The bridge cut off entry from most of the Victoria Dock for all big ships. By 1990, a Docklands Task Force had been established to look at possible new uses of the area."[1] The outcome of this was a Docklands Authority appointed by the Victorian government to manage a private/public partnership to redevelop the Docklands precinct. Among the private developers drawn to the project was the property developer Lend Lease. Taking up an option on the central zone of the precinct—referred to now as Victoria Harbour—they observed the pedestal-style high-rise residential and commercial mix favored by their rival developers to the immediate north and south and decided to convene a charrette where designers, planners, economists, sociologists, and others could contribute to an alternative vision for their site. One outcome of this process was "*Solution*: A public space strategy" prepared for Lend Lease in mid-2002.[2]

This opportunity was of interest to me because it transposed the methodological challenge that coastal cartographers faced into the realm of design. Coast-

lines, as we saw in chapter 2, were graphic projections of the colonizing mind. In creating territories with hard-and-fast edges where water and land decisively met—and were no less decisively differentiated—they left out of representation the character of most coastal zones. The omission of swamps, marshes, and morasses—and the pejorative associations of these terms illustrates the cultural bias against them—was not simply due to a graphic shortcoming. They were left out because the developers of empire did not want them there. The conceptual engineers of the chart were followed by the practical engineers of capitalism, draining unproductive areas, straightening out and regularizing water systems, strengthening and defending embankments. These eliminations favored an economy where wealth depended on the volume and speed of communication and where poverty of mind and body was identified with "waters naturally stagnant" and "stationary whirlpools."

The history of Victoria Harbour illustrated the supremacy of this kind of dry thinking. It is built on the site formerly occupied by the West Melbourne Swamp (Plate 10). The historian John Lack writes of the Woiwurrung people who inhabited this area: "Theirs was the marsh country, down by the salt water."[3] If his speculation that the swamp was "perhaps an area for bartering" is correct,[4] then trade was not a colonial innovation here but belonged to the precolonial uses of the place. Certainly, the borders of Moonee Ponds Creek (which fed into the swamp) were a rich source of food—the yam daisy, or murrnong, was gathered there, and an abundance of wild fowl made for good hunting. With white occupation, though, the swamp acquired new and different connotations. At the back door, so to speak, of Melbourne's rational grid, it became a repository for the city's refuse. Sewage, industrial effluent, and general neglect turned it into a foul-smelling, noisome, and potentially infectious blight on the landscape of civil and economic progress.[5] When the English engineer Sir John Coode, engaged to make the Yarra more navigable and to plan a new harbor, suggested draining the swamp to create a new dock and building a new canal that bypassed the swamp, there was little objection.[6]

There is another reason for discussing *Solution*. Swamps and terraqueous zones generally may be difficult to represent graphically, but they are also difficult to talk about. It is easy to narrate the life of a river. Flowing rivers share the desire of storytellers to get somewhere. But swamps flow nowhere. Nor, on the other hand, do they provide a solid foundation, a theatrical setting for decisive events. Not exhibiting direction, they resist linear logic. Offering no firm footing, they undermine reason. Kierkegaard compared the empty chatter of the modern crowd to a swamp, arguing that, like the "receding ground" of the swamp, the so-called public of public opinion had no clear image of itself. It was neither grounded nor radically ungrounded. It simply washed everything away, mak-

ing "character" as "something engraved," impossible to sustain: "The swamp is just as little fertile as it is infertile, just as little finite as it is undefined."[7] It corresponds to a "talkativeness . . . without expression" that ultimately prevents genuine communication.[8] From Kierkegaard's point of view, perhaps the greatest sin of the swamp—or of the sluggish, self-absorbed discourse it represents—is that its softness "denies anything like a revolutionary moment, a leap into another age."[9]

Evidently, Kierkegaard was seriously misinformed about swamps; any wetlands expert could have put him right. But the landscapes we inhabit are metaphorical as well as physical. And metaphorically, humid zones continue to be associated with qualities of inchoateness, primitiveness, inarticulateness, inutility, sloth, and ease. It is interesting that, despite what Kierkegaard suggests, muddy environments are precisely those that take an impression. They are where tracks can be left. The "character" that a printing press impresses on a page is only a relatively dry version of this older, natural phenomenon—ichnography yields to typography. However, Kierkegaard's bias against the humid is at least consistent, for just as he associates the mindless chatter of the crowd with the swamp, so he compares a writer's bad style to spilling ink: "Indecipherable ink stains and insignificant 'chatter' substitute for each other."[10] In the previous chapter a case was made for seeing blots positively, as hieroglyphs of movement forms, but this doesn't solve the problem of talking about them. The question of how to characterize such environments in language remains. Doesn't discourse itself demand a flat place, something like a playground? How can there be exchange, a running hither and thither, when the ground underfoot offers no support?

Transposed to the discussion about the future development of Victoria Harbour, these reflections presented themselves as a challenge to characterize the site as a *humid zone*, an environment whose best representation was not a plan showing circumscribed geometrical figures (Figure 30), but something that, historically, culturally, and physically, more resembled a blot. It was a challenge to redefine the amphibious as open rather than closed, as mediating exchange rather than clogging it up. In cultural terms, it meant bringing into focus a history that the various material heritage surveys had entirely overlooked: the mental geography of the sailors and the homology of this harbor's design with those around the world between which its vessels traded. The extensive studies of the site's industrial heritage, and even the oral histories that had been compiled, presented an entirely localist, landbound perspective. Sailors, like their vessels, live between places. If they are at home anywhere it is at sea. But the preservation of these non-material realities hardly figured at all in the heritage surveys. There, the sea was treated coastally, as it were, as lying on the side of a line that effectively predefined the harbor as a dry place, ready for reoccupation and rein-

**Figure 30.** Paul Carter, *Solution*, site location (Paul Carter, "*Solution*: A public spaces strategy, Victoria Harbo*r, July 2002," figure 5). Reproduced by courtesy of Lend Lease.

scription.[11] Drained physically in the 1880s, the environment of the Docklands was now, in the first decade of the new millennium, in danger of being drained of its historical character.

In this respect, the name change—from "dock" to "harbor"—was significant. The primary allusion of dock is to a reach, or creek, a body of water between wharves. The verbal form refers to a movement toward, and to the successful meeting or joining of two bodies moving relative to each other. The connotations of harbor are very different. They locate the land as a place of shelter from the sea and as the destination and goal of the voyage. If the arms of the harbor wall reach out at all, it is to draw ships in and absorb them to its bosom. They place the lore of the sea, the rhythmic geography of the sailors' life, out of reach. Two forms of reaching are implied. One values the extension and spread of the environment in which terraqueous exchanges occur. The other foregrounds the supremacy of reason—the reach of the intellect—to enclose, to keep dry, and to exclude. What kind of description could bring the first kind of reach in reach of the other, allowing the humid to percolate through the design?

## Neglected Dimensions

My response to this question was to begin with the site's muddy situation. I took my lead from a Mr. Edmund Gill, who, writing in 1949 about dredging operations in the Yarra estuary, complained that "our so-called history consists of written records which are but interpretations of selected events," and who proposed to tell the "unmistakable story of days that are past" in a rather different way: "the sand and silt and clay from our harbour floor are unadorned facts ... these sediments are a river's trawlings of travel. They tell where the river has been and what were the conditions of travel."[12] Gill's conception of the riverbed as a palimpsest of movement forms can be extended to the composition of the bed itself. Sand suspended in water, oozing mud, or malleable clay possess peculiar physical characteristics of their own; they move in a mysterious way. As Everett remarks, "[p]erhaps the oldest record of a colloidal phenomenon is that of the deposition of silt at river mouths mentioned in the Babylonian Creation myth," and he speculates that "early Man [sic] must also have been familiar with many other colloidal phenomena, such as the effect of walking on wet sand and the treachery of quicksands."[13]

Despite the ubiquity of colloidal systems in nature—clouds, rainfall, smoke, mist, blood, and milk are all colloids—colloid science is a relatively recent development. Perhaps this reflects modern science's bias toward dryness. Just as the Enlightenment geographer made a hard-and-fast distinction between land and sea, so the physicist sharply differentiated between solid and liquid states. In consequence, "an intermediate class of materials lying between bulk and molecularly dispersed systems" was overlooked.[14] The Russian-German chemist Wilhelm Ostwald described colloids as "lying in the World of Neglected Dimensions."[15] This is suggestive in the context of thinking about the graphic representation of movement forms. Colloidal movement forms, it suggests, cannot be rendered using the two-dimensional grid of the plan or the three-dimensional box of the perspective drawing. "They consist of a dispersed phase (or discontinuous phase) distributed uniformly in a finely divided state in a dispersion medium (or continuous phase)."[16] Clay, slurry, and muds, for example, are solids in a dispersed phase distributed through a liquid dispersion medium. To illustrate them, a geometry of neglected dimensions is presumably needed, and a graphic language that can represent it.

It is impossible to give even a summary account of the different kinds of colloidal systems that exist or of their different properties.[17] In terms of *Solution*, I was interested in the way their "World of Neglected Dimensions" was narrated and represented. What figures of speech were used to evoke their characteristics? These would inevitably disclose an anthropomorphic bias. From a scientific point of view this mythological or poetic substrate might represent a lack of objectivity. From my point of view, it showed a play of imagination that might suggest analo-

gies useful in narrating the character of Victoria Harbour. Similarly, the extraordinary calligraphy developed by scientific illustrators of colloidal systems was at best a subjective impression, a kind of graphic snapshot, of an incredibly complex process of continuous transformation. From my perspective they were suggestive for this very reason. Contrasting representations of the spermlike pathways taken by linear macromolecules in "good solvents" or the knotted, barbed-wire clusters formed by the same molecules in "poor solvents" suggested the doodling recommended by art educator Desiderius Orban.[18] Orban, as we noted in chapter 4, thought that creative painting could emerge out of doodling; perhaps designs could emerge in the same way.

The behavior of colloid systems is determined at a molecular level. But its characteristics can be applied at least by analogy at a macro level.[19] Typical features of colloids include their tendency to form tracks and junctions; to exhibit beautifully and irregularly stepped structures; to proliferate surfaces that are rough and irregular; to generate ooze forms, or process forms—serpentine or meander forms are process forms, straight lines reflected in undulating water also exhibit this property; to produce stable suspensions, exhibiting an association of parts based on the principle of "like to like"—without this principle, there would be no films, fibers, glasses, resins, or plastics, no opalescence, "none of the beautiful and varied architecture that utilises as building stones the colloidal particles, which are themselves products of association"[20]; and to develop an enormous area of surface relative to the amount of matter present—the properties of colloidal particles are "largely those of their surface,"[21] the network produced by a body of bubbles being a case in point.

The "architecture" of such systems is one of patterns formed on a principle of self-sameness across different scales. The geometry is fractal, not Euclidean. It is the irregularity of the colloidal surface that precipitates characteristic colloidal phenomena—Millikan's exploding milk drop,[22] the dendritic pattern of the snowflake. Colloids are sticky. They tend to glue together. Adsorption occurs primarily at corners, angles, and steps. This is true negatively as well; a surface of aluminum etched with acid shows "very beautiful steps."[23] Scaled up, these colloidal phenomena conjure up architectural attempts to negotiate swampy environments. Molecular networks can look like the latticework underpinning pile villages. Their interwoven strands resemble the fisherman's net. Their nodal points are like the pilings driven into the silt that distribute the weight of the wharf. Common to all these structures is the dispersal of weight, the continuous communication of it throughout the system.

The figurative power of colloid systems and their representations is not confined to architectural forms. It extends to the modeling of human movement. In his book *On Growth and Form*, a study of the characteristic forms of colloidal

systems, D'Arcy Wentworth Thompson recognized this possibility. When writing about the erratic, apparently unrelated "Brownian movement" of unicellular creatures in a medium, he commented, "One might see the same thing in a crowded market-place, always provided that the bustling crowd has no *business* whatsoever."[24] On this definition, meeting places are not containers set aside for the purpose of bringing people together. Nor are they simply flows of people already aligned in the direction they take. They are the enigmatic combination of these, whose graphic expression is De Quincey's undistinguishable blot produced by the "apparently stepwise or zigzag movement" of people interacting, constantly modifying their direction in response to, or in anticipation of, the movement of others. Those negotiating such zones, alive to the host of potential interactions in which their own movement implicates them, are "here and there" simultaneously. Likewise, their sense of time is not linear but rhythmic, a matter of timing that exists in what Rodolphe Gasché calls the chiasmatic or crossing-over realm of the *"always already* and *always not yet."*[25]

Gasché notes that "the chiasm is one of the earliest forms of thought: it allows the drawing apart and bringing together of opposite functions or terms and entwines them within an identity of movements."[26] But somehow this way of thinking, one in which ground and figure, the One and the Many, stasis and movement, have yet to be defined in opposition to each other, has been lost. It exhibits the multivalency or ambiguity that Enlightenment science and the language of reason sought to expunge. How many artificial obscurities have arisen from this desire for clarity! Ambiguity does not imply conceptual indistinctness. It is simply the property of phenomena when they are viewed as a whole from every point of view. It is the attribute of a world composed of many things in which the observer is immersed. This is not to say that it cannot be represented, but the representation will not be linear. It will be in the round and its apprehension will be mobile.[27]

The sculptor Alberto Giacometti clearly grasped this when, in reference to his groups of figures (many of them simply called "Public Square"), he wrote, "Every moment of the day people come together and drift apart, and approach each other again to try to make contact anew. They unceasingly form and reform living compositions of incredible complexity. What I want to express in everything I do, is *the totality of this life."*[28] Some have interpreted Giacometti's figures not simply as separated but as absolutely separate, immobile, frozen in an irremediable aloneness. I think this interpretation is contradicted by the animation of the statues. They are mid-stride, solicit one another's attention or, if alone, engage the distance. Playwright and essayist Jean Genet thought the beauty of Giacometti's statues stemmed "from the incessant, uninterrupted to-and-fro movement from the most extreme distance to the closest familiarity:

this to-and-fro movement doesn't end, and that's how you can tell they are in movement."[29] I agree and, if designers of public space want to develop a method of notating public space, they can do no better than to begin with Giacometti.

The graphic expressions of colloidal systems have their counterpart in the stories appropriate to these realms. Mr. Gill thought the bed of the Yarra represented a different kind of history because it yielded "unadorned facts," but, taking Gasché's hint, the rhetorical analogue of a "dispersed phase (or discontinuous phase) distributed uniformly in a finely divided state in a dispersion medium (or continuous phase)" is a history that is polytopic. In relation to the global maritime economy that brought Victoria Dock into being, it is a history that perceives ships and sailors as belonging simultaneously in many places and which plots their lives as a pattern of trajectories being constantly scored and rescored in the surface of the sea. This does not mean committing ourselves to writing a universal history of the sea. The sea in this parable is the "dispersion medium." The ships that navigate it—the totality of all their voyages—is the movement form proper to the dispersed medium. As De Quincey's picture of discursive reasoning explains, the lines composing it would not compose a uniform warp and weft, a fine-grained material version of the cartographer's latitude and longitude lines; it would fall into "streets" and "squares" corresponding to the economic desire lines of the system and the nodal points, or ports, composing the stable positions in their capitalist choreography.

Even though documents like the Melbourne Docklands Heritage Review can consider their task accomplished when they confine their inventory to historic buildings, sites of aesthetic or historic interest, and sites of potential archaeological significance, a polytopic history is by no means an arcane conception. In the decade when Victoria Dock opened for business, the English writer Richard Jefferies described an Australian clipper moored in the London Docks. The bulk of the vessel amazes him, its bowsprit alone as large as a mature English oak. It inspires in him a desire to clamber over it and its rigging: "Only . . . by the height of a trapeze, by the climbing of a ladder, can I convey to my mind an estimate of this gigantic bowsprit."[30] Jefferies wishes that a new race of Venetian painters would arise to depict this new romance of world trade. He also recognizes the *colloidal* character of its construction—the way its form is designed to spread the load of wind and water and to preserve a stable equilibrium in the midst of rolling surfaces: "This red bowsprit at its roots is high enough to suspend a trapeze; at its head a ladder would be required to mount it from the quay."[31] And his imagination makes a further leap: "it is not the volume, not the bulk only; cannot you see the white sails swelling, and the proud vessel rising to the Pacific billows, the north star sinking, and the advent of the Southern Cross; the thousand miles of ocean without land around, the voyage through space made visible as sea, the far, far south, the transit around a world."[32]

Jefferies intuits the movement form of the clipper. This emerges exactly in the conjunction of the ship with the dock. Towering there, it creates in Jefferies the fantasy of stepping offshore, of climbing into a realm where locomotion is conducted differently. His imaginary trapeze and ladder were the stevedores' equipment. The "bottom enders" who stowed the cargo and the "top enders" who unloaded it had to be masters of timing and balance.[33] They had to catch rapidly rising and descending baskets. They had to ensure the stowage was correct so that nothing shifted during the voyage.[34] They had to work together, as finely attuned to each other as highwire trapeze artists; the hatchman signals to the holders (the men below) and to the winch drivers, then, as writer John Morrison lyrically recalls, when the derrick is rigged over the hold, "[i]t's fixed, the plumb is there, they don't move the derrick during operations. The yard-arm derrick is over the wharf. They're discharging cargo." There is—there has to be—a "perfect understanding."[35]

All of this Jefferies intuits. But he also senses that the clipper's design represents an orientation toward other places; he sees it plowing the waves, not so much navigating by the stars but drawn along in their net—after all, it's in the nature of ships to sail, they are not lost at sea but at home. But the threads of the voyage are sewn together with ports. It is the commodities exchanged at these places that lend the vessels their sobering ballast, assisting them in steering a course across the face of the winds and the currents. The ports in this narrative are always part places. The fingers of the wharves are like the fingers of one hand. The other hand with its wharves may be half a world away. If the ship makes a return voyage, then its path is truly chiasmatic in the rhetorical sense, for we can say: "The *Argo* sails to Australia, from Australia the *Argo* returns." Ships, in fact, are mobile geographies. For just as English and Scottish and Irish names migrated from their homelands to the British colonies around the world, so with ships, whose names may be read one day in Canton, another in the Malacca Straits, and another beside Canary Wharf. So firmly painted underneath the figurehead, these names are as paradoxical as those the navigators applied to the Australian coast; for if we ask where they belong, we must say nowhere and wherever they happen to appear.

Finally, as Jefferies again recognizes, sailors sailed by the dark as well as the day. Stars were not only pathways but companions. They had names that showed this. This world's *Argo* had its heavenly double in Argo Navis. The zoologist François Péron, who accompanied Baudin on his voyage of scientific discovery, was enchanted by the phosphorescent organisms fished up from the nighttime sea: "The prodigious number of these animals, their symmetrical and exotic shapes, their beautiful colours and the suppleness and swiftness of their movements, were a spectacle which excited pleasure in the extreme."[36] Transposed to the watches of the night, these were the sensations of Palinurus so long as he remained alert

to steering a course. Unlike the coastlines established by geography, the stars traveled with the traveler. Their risings and settings showed there was a limit to this sympathetic identification, and it was a way of telling where on the globe the voyagers were. But it is not hard to imagine that the dark writing of constellations was more congenial to these people than the solar reason of daylight. Stars seemed to move in a medium like theirs, and their galaxies could readily be imagined as undistinguishable blots, crowded marketplaces where the bustling crowd has no *business* whatsoever.

### Storyboarding

Colloidal systems have their own graphics and their distinctive narratives. This poetic discovery laid the groundwork for *Solution*, the public spaces strategy I prepared for Lend Lease in 2002. *Solution* was not a landscape design. It did not assume a piece of ground already available for development. Nor did it seek to mark a site positively with the usual lexicon of gardens, street furniture, and paths. Its aim instead was to give graphic expression to public space as such. Its aim was to write—or draw—a place into being. I felt that the occasion for doing this was propitious because, as the meditation on colloidal systems had suggested, there was a natural connection between the physical character of the harbor's swampy foundations and the Brownian motion ideally found in public spaces.

Of course this was idealistic. Writing of the new global cities where no one "lives," Jean-François Lyotard notes that the megalopolis "does not permit writing, inscribing."[37] "It follows that public space, *Öffentlichkeit*, in these conditions, stops being the space for experiencing, testing and affirming the state of a mind open to the event, and in which the mind seeks to elaborate an idea of that state itself, especially under the sign of the 'new.' Public space today is transformed into a market of cultural commodities, in which 'the new' has become an additional source of surplus-value."[38] The client had given me no reason to suppose that they disagreed with this analysis. On the other hand, they had expressed a desire to differentiate their response to the character of the place from those of their developer rivals.

To describe the method I used to produce a public space design, I borrowed a term from film production. The technique of storyboarding appealed because it involves the simultaneous use of words and drawings. Words are used to indicate actions; drawings—diagrams, cartoons, indications of movements—are used to outline the growth of the plot, the "through line" as Eisenstein called it. There is a productive hybridization of text and image in the formation of an in-between language that materializes the physical relation between speech and movement, intention and realization. Of course, conventional landscape design is cinematic. Landscape architects envisage their invented places theatrically—and draw walk-

ers, groups of people, shoppers, and lovers to show how the everyday drama of the place will unfold. They also represent their vision over time as a succession of "stills," a technique that is essential if they are to sell their long-term revegetation or tree-planting schemes.

But these appropriations of film studio method are weak and superficial. No integration of word and image is attempted. In this context I intended something stronger. Following what has been argued in earlier chapters, I envisaged a place made after the story. The story was not simply a rhetorically comforting frame placed round the image. It possessed a spatial character whose traces could be mapped. Words were to be interpreted as place-making instructions. They were enigmatic diagrams for meeting places. They were topics that possessed *topoi*, or their proper places. In these circumstances it is not the uniqueness of a word or poetic concept that is fetishized; one looks instead for the repetition in different guises of the same essential thought form. The assumption is that this will manifest itself not only in the historical testimony but in the lineage of drawings made of the place.

The way the essential thought form emerges is through the gathering together of words, ideas, concepts, and images that appear to have been scattered. When these are brought together a common form condenses from them. Perhaps it was there from the beginning but had been obscured, or else it was always a potentiality of the site, an unrealized intention that the new design unveiled. Perhaps, and most likely of all, it belonged equally to past and future, as the creative principle of place making itself, corresponding to Rosalind Deutsche's conception of public space as the locus of free speech which has to be non-existent, at least in any stable form, because the essence of democracy is that it is an open, not closed, form of society, "where meaning continuously appears and continuously fades."[39]

Among the scattered terms whose repetition I noticed as I assembled my archive of histories, stories, plans, and charts was, in fact, *Argo*. In Western myth, the *Argo* is the archetypal ship. In Euripides' *Medea,* the nurse attributes the birth of imperialism to its voyage; had Jason and the Argonauts not sailed to Colchis to retrieve the Golden Fleece, the entire bitter chain of revenge and counterrevenge that has overwhelmed her and her country might never have happened. Perhaps because of this archetypal identification, every ship that sets out on a voyage of colonization is an *Argo* whatever the name it carries on its side. Consequently it is not surprising that there are many local *Argo*s associated with Melbourne's foundation and, later, with its Docklands. Besides the *Argo* in which Charles Joseph La Trobe sailed to England at the termination of his Victorian governorship,[40] there is the same vessel in the lives, letters, and diaries of hundreds of other colonial fortune seekers, administrators, and families. This *Argo* was not simply a

means of physical transportation. In more than one case it inspired poetic flights of fancy, as travelers took advantage of the name to allegorize the significance of their own voyage. One passenger wrote a long poem called "The Voyage of the Argo."[41] If you were to put together these scattered notices of journeying, you would recover the neglected dimensions of Australia's white settlement, the sense in which it came into being as a gathering place of all these experiences scored into the water of the globe.

From a nautical point of view, the constellation Argo Navis had another significance. Apart from the general allusion to sailing, it had a special meaning for transequatorial travelers because it was the one major constellation known in the northern hemisphere which could only be *fully* seen in the southern hemisphere. Because of this, it seems to narrate a process of unveiling. It plots progress toward an ideal goal. But it also locates arrival within a network of memories and associations. If it indicates crossing over to the other side, it also supplies the thread back out of the labyrinth. For the mythologically minded, the constellation is also a site of intercultural translation. Canopus, the second brightest star after Sirius and the most prominent member of the Argo constellation, is associated with water—in Hindu myth it is identified with the helmsman of Varuna, goddess of the waters,[42] while in the Indigenous belief systems of the Melbourne area, it is associated with Pallian, "supreme over rivers, creeks, and lagoons; and the sea obeys him likewise."[43] These humid associations are either serendipitous or generated from traditions of stargazing whose motivation is to discover analogies between great and small movements, between the cycles of the stars and the cycles of life on earth. But in any case they insist that local movements are interlocked with regional and global ones, small cogs within the movement of a cosmic clock.

As a mythologically resonant name, Argo was an instruction for place making. It drew attention to the harbor's place within a network of traces left behind by a history of commerce with other places. It also suggested a way in which the redevelopment of the site might proceed. For the Structuralist critic and writer Roland Barthes, the story of the *Argo* contained an argument about the nature of creativity or innovation. As Rosalyn Krauss explained,

> The Argonauts were ordered by the Gods to complete their long journey in one and the same ship—the *Argo*—against the certainty of the boat's gradual deterioration. Over the course of the voyage the Argonauts slowly replaced each piece of the ship, "so that they ended with an entirely new ship, without having to alter either its name or its form. This ship *Argo* is highly useful," Barthes continues. "It affords the allegory of an eminently structural object, created not by genius, inspiration, determination, evolution, but by two modest actions (which cannot be caught up in any mystique of creation): substitution (one part

replaces another, as in a paradigm) and nomination (the name is in no way linked to the stability of the parts): by dint of combinations made within one and the same name, nothing is left of the origin: *Argo* is an object with no other cause than its name, with no other identity than its form."[44]

This Structuralist myth of creativity intersects with two others that have been invoked in *Dark Writing*: Giambattista Vico's *verum ipsum factum* principle and Husserl's notion of "an activity of concurrent actual production." Although they approach the problem from different points of view, all respond to the enigma of origins and originals. The one thing of which we can have certain knowledge, Vico proposed, is that which we ourselves have made. The first science to be learned is mythology, "or the interpretation of fables," because it is these poetic inventions that define us as human. The new science he proposes does not therefore scrutinize origins. It focuses on processes of transformation; creativity is defined as a three-faceted capacity of recollection, imagination, and invention. Husserl, who *was* committed to defending concepts of unmediated authenticity and originality, seems to have overcome the logical conundrums of his own position by locating creativity within intentionality itself. His argument that perception was always perception *of something* made consciousness constitutionally a shaping faculty, a power to extract forms from the living flux. In this sense, the origin of consciousness was reinhabited whenever anyone actively participated in the bringing into being of an idea or form.

Barthes' *Argo* tale, and Krauss' interpretation of it, need to be taken with a pinch of salt. Applied too literally, their reductionism becomes patent. As Donald Kusbit observes, "[i]t is as though the voyage is not part of a larger history—a relatively isolated moment in a complicated, all too human development. Barthes strips the story of its emotional momentum and, more broadly, of its subjective import. He also ignores the heroic invention of the *Argo* itself, which was technically advanced for its day. Krauss, following Barthes, has 'decontextualised' the *Argo*."[45] But surely the point of their fable is not to give a historically plausible account of a mythological event—an exercise of dubious value—but to provide a parable about the production of art and the myth of originality. Despite what Kusbit says, there is no intrinsic reason why the principle of substitution should prohibit transformation. Evolutionary embryology furnishes endless examples of homologous structures that have developed diversely in different creatures according to different criteria of selection.

Similarly, the fact that the name can migrate and enjoys no naïve connection to the materiality of what it names—the *Argo* can change every plank and still remain the *Argo*—does not make the idea of creativity an irrelevant hypothesis. The *Argo* was named after its creator, but it is interesting that Argus the builder sailed with the Argonauts.[46] He did not stand outside his creation but was caught

up in its transport, participating in a long and arduous voyage, in the course of which his One and ideal vessel was completely dismembered and remembered through a myriad of operations, its history becoming the trace of the Many that had kept it intact. *Argo*, the name, expresses the poetic identity of the ship. The logical conundrums Barthes exploits only arise when it is assumed that names must enjoy an unequivocal, one-to-one relation with objects or concepts. But *Argo*, the name, refers to creativity itself, to the myriad of transformations that lend the process of invention its identity. It describes the principle of change at that place and time—where these are *also* understood mobilely as acts of timing and spacing. If the ship is the obvious incarnation of this process, then the port is the equally obvious matrix out of which it emerges—for even an entirely decontextualized account of the *Argo* cannot dispense with a network of dry docks where the progressive replacement of the ship's timbers is carried out.

These niceties of creative theory did not make their way into *Solution*. However, the recommendation that the new public spaces strategy should embody what I called the "Argo principle" preserved the main point:

> Historically, the Harbour has been a site of exchange. Exchange occurs wherever a place of meeting produces change. As the focus of trade, the Harbour married movement and change. To pass through the harbour meant a change of value and state. It meant entering a zone of flux and transformation. Over time every element in the Harbour was replaced, repriced, relocated, reinvented. This Principle doesn't mean ignoring what is reported in recent Melbourne Docklands Heritage Studies. It simply means looking at that information differently—as a legacy of appearances and disappearances, in short, as a history of change. In this way attention shifts from static objects to mobile processes. It becomes possible to see the space as a dynamic, self-reinventing network of tracks, outlines, shadows, edges, sightlines and wakes—to see it as if it were reflected in the ever-changing face of the water.[47]

In storyboarding Victoria Harbour, another poetic word or concept was also used. The Argo principle tried to evoke an environment of potential meeting. It differentiated public space from both architecture and landscape architecture. Public space, it suggested, was the "undistinguishable blot" of all the comings and goings that constituted it as a meeting place. The function of a public spaces strategy should be to reinforce this motion, whether it was "Brownian" or dictated by ulterior commercial motives. Where it did not exist or had grown stagnant, the strategy should recollect and graphically embed the physical and cultural heritage of journeys and exchanges, the trawlings of travel, that in my view constituted the generative history of the site. But this method of place making differed from that

adopted by architects and landscape designers in another way. Not only did it attempt to materialize motion, to create a physical template likely to foster sociability, it proposed that this could best be achieved *negatively*. Instead of magically reinventing the presently abandoned site in the form of a swarm of positivities—brightly preordained paths, garden beds, water-edge boardwalks, and lighting in the form of imitation rigging—it needed to indicate the heritage of traces that could not be represented, objectified, and otherwise presented as past.

To capture this argument, *Solution* therefore proposed what it called the "Asterisk principle." Analogies between the character of the place and the cultural meanings of the sky were proving to be an important way of understanding the place-making process at Victoria Harbour. I had also been struck by the physical appearance of the yam daisy, or murrnong, once common around the West Melbourne Swamp. Its star-shaped white flower had inspired botanical taxonomists to classify it in the family Asteraceae. One could imagine a time when fields of these daisies must have formed a Milky Way of blooms along the muddy edges of the swamp.[48] In this context I came across a passage in Isidore of Seville's *Etymologiae* that seemed to capture exactly the negative quality of the design approach I was advocating. Defining the figure used in writing known as the asterisk, he wrote, "The Asterisk is placed against [verses] which have been omitted in order that what seems to be omitted may shine forth. For in the Greek language a star is called aster."[49]

The Asterisk principle, then, described a kind of design that paid attention to the character of what had been omitted. It recognized the existence of, and drew inspiration from, the non-material heritage of traces. It was axiomatic that this inheritance of relative placings and timings was not represented positively. The design object should not be to make up for, or (once again) to cover over, the omission by representing it theatrically through the usual cultural tourism mix of symbolic artwork, heritage walks, and suddenly pious signage. Instead, the aim should be to mark these omissions in such a way that the omission themselves *shone forth more clearly*, an aim which I interpret as being consistent with Husserl's notion of an "active recollection" in which an intention (a might be or might have been) is conjured up to produce an original coincidence.

### Starboard

The application of these principles to the history of Victoria Harbour brought into focus a place that was not represented on maps. As the meeting place of global, regional, and local trajectories, its proper character was better represented by an undistinguishable blot. As a site characterized by a history of physical traces, it was not the vestigial presences that defined it—remnant capstans or derricks, rotting sheds, and occasional plaques—but the non-material network

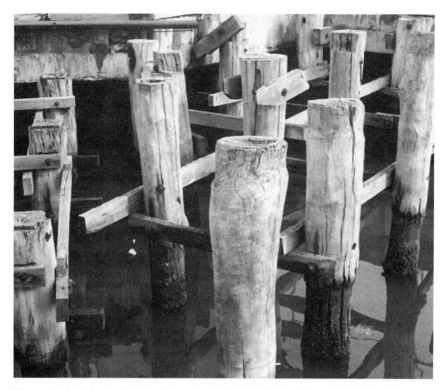

**Figure 31.** Paul Carter, *Solution*, "Forest in the Harbo*r, Timber Pilings, North Wharf" (Paul Carter, "*Solution*: A public spaces strategy, Victoria Harbo*r, July 2002," figure 24).

of story lines, the heritage of intentions focused on it that expressed its unique place in Victoria's culture. Of course, the influence of this colloidal or humid constitution on its formation wasn't simply poetic. It found material expression in the emergence of the harbor's physical appearance. For example, Coode Island silt, the natural basis of the Melbourne Docklands site, is colloidal in its behavior, a fact that proved decisive in an early dispute between Sir John Coode and engineer Joseph Brady. Coode had proposed using concrete blocks for the foundation of the south side of the dock. Brady, however, pointed out that the researches of "local professional men in the blue argillaceous silt and underlying wet sandy deposit in the deep cavity [now occupied by] the present swamp" showed that Coode's proposal wouldn't work.[50] Brady successfully recommended timber pilings. The legacy of Brady's recommendation is what J. B. O. Hosking calls "a forest in a port," referring to the city of pilings underpinning the wharves[51] (Figure 31). And just as living trees individually bend and sway in a gale, and yet as a group remain stable, so with the harbor's wooden foundation; provided loads are distributed equably across them, the timbers' minute rise, fall, and lean preserves an overall high load-bearing capacity.

But the main object of *Solution* was to show that a natural coincidence existed between the character of the site and the character of public space. To engender a revivified place of meeting, Lend Lease did not need to invent *ex nihilo* a new theater geared to stimulating and satisfying consumers' needs. It had only to excavate and regroove the buried traces of meeting, exchange, and accruing interest that already lay latent in this terraqueous zone. Following the indications of the Argo and Asterisk principles, *Solution* sought to materialize the traces of passage in a ground pattern. The ground pattern was the graphic development of two major investigations of the cartographic archive, one relating to the history of maps associated with the site, the other derived from charts of the heavens and, in particular, drawings of the annual rotation of the constellation Argo Navis. The poetic coherence of these investigations arose from the fact that a study of the myriad of planning schemes that had been proposed for West Melbourne Swamp and its adjoining suburbs over the 150 years of white occupation revealed a persistent star device. Constrained to relate the natural form of the swamp and the winding Moonee Ponds to the rigid grid of the Melbourne central business district, planners and engineers had repeatedly negotiated the transition from one geometry to another by drawing radiating streets joined by concentric crescents. Stellate forms had also been repeatedly proposed in various speculative schemes for the extension of the docks. In other words, the physical geography of the site had generated a field of asterisks—star-shaped configurations signifying forms of meeting that had never been realized (Figure 32).

A palimpsest of these stellate forms produced a constellation of possible places, a ground figure signifying a heritage of missed opportunities. These unrealized schemes formed the shadow history of the site as the positive structures—the adopted shapes of the different docks, the orientation, location, and scale of the wharves—were located dialectically, in relation (and in opposition to) these alternative schemes. As the adopted schemes were invariably less complex and less responsive to the lie of the land, the constellation of unrealized intentions largely unmarked in the present built environment not only recalled us to the politics of place making and to the supplement of visions that always crowd in upon even the blandest of designs, they also preserved the trace of an alternative way of imagining the place, one not predicated on the imposition of hard-and-fast lines, but alive, often ironically so, to the ideological basis of designs that passed themselves off as the most efficient answer to an environmental challenge. The scheme that proposed locating an island in the shape of Great Britain within a crescent-shaped lake at the meeting place of a quiver of roads illustrated this well.[52] The insertion of a cartographic gestalt within the proposed new suburb was analogous to those naming practices that borrowed English place names to denominate new places in Australia. It illustrated a habit of thinking analogically, in terms of macro-micro comparisons. It stemmed from the fact that Melbourne's

**Figure 32.** Paul Carter, *Solution,* "Utopian Projections, Victoria Harbo*r" (Paul Carter, "*Solution:* A public spaces strategy, Victoria Harbo*r, July 2002," (figure 15). A selection of site representations illustrating (left to right, top to bottom): presettlement hydrology overlaid onto Lend Lease street layout proposal; topographical plan identifying low-lying sites prone to tidal inundation (courtesy Lend Lease); Coode's 1879 "Herringbone" proposal for wharf location; composite of different stellar counterpatterns embedded in road and wharf schemes proposed between 1860 and 1930; Harbour Trust modernization proposal, c.1910; double harbor scheme dating from c.1875; Victoria Harbour site c.1990 (courtesy Lend Lease); Harbour Trust scheme c.1915.

Docklands always existed in the collective imagination doubly, as a physical place and as a microcosm in which the macrocosm of an imperial history was enigmatically contracted.

A ground pattern derived from the graphic archaeology of unrealized schemes formed one component of a pattern that, *Solution* recommended, should provide the template of the proposed redevelopment. Perhaps its most distinctive feature was the reiteration of wedge forms or pre-exact triangular shapes. These were the shapes that emerged when the encounter between the ideal grid and real winding slopes of the swamp was represented lineally. The "herringbone" that emerged did not reproduce any positive (albeit unimplemented) scheme, or even an overlay of these. It preserved a supplement of part-shapes, geometrical debris if you like, produced by the clash of designs on the land. When assembled together, these supplementary traces gave an impression of forms migrating historically across the site. Their multiplication of lines suggested a kind of movement form, the symbolic writing of change. Giambattista Vico wrote that the *cuneus* or wedge was the cosmic form of creativity.[53] Perhaps these acute angles manifesting themselves in the surface of Victoria Harbour had a similar significance.

The second pattern used in the ground template was derived from a study of the constellation Argo Navis as it rotates annually through the southern sky. The *Solution* document asserted,

> What mattered to seamen in reading the skies was not only the star patterns themselves, but their changing place in the sky throughout the year. The apparent journeying of the stars revealed the revolution of the earth. Tracing the successive positions of these constellations across the year, *Solution* expresses a collective experience of movement and repeated return. Navigators and astronomers divide the Argo constellation into three smaller constellations, Carina (the Keel), Puppis (the Stern) and Vela (the Sail). It is the annual rotations of these three smaller constellations that are mapped onto the Victoria Harbour site.[54]

The point was not to suggest that generations of seamen carried a planetarium in their heads.[55] It was not even to suggest a collective unconscious where the night sky cinematically played during sleeping hours. Like the cuneiform ground pattern, the rotational marks derived from the sky pattern were indications for the design of a public space. They were intended to provide an intuitively engaging choreography, a notation of potential passages and possible meeting places. They did not prescribe positive structures, but instead gave negative spaces a place in the design (Plate 11).

These negative places articulate the properties of a place when it is conceived as a meeting place, a collective movement form. These properties are invisible, and indeed imperceptible, when the imagined viewpoint is that of the solitary observer. They are sensations that originate in a relation with others; they include experiences of approach, concentration, distance, and dispersal. The lines that narrate these sensations are like Plato's *ichnoi*, or elemental traces, always fleeing to their proper places. They do not map a theater of prescribed actions and fixed positions. They evoke a terrain of rhythmically shifting, intersubjective transactions.[56] They are the dark writing of a place where things are felt to have happened already and—at the same time and because of this—to be about to happen, a chiasmatic realm where, as noted, Rosalind Deutsche says "meaning continuously appears and continuously fades."[57]

The novelty of *Solution* was, among other things, to dissolve the conventional distinctions between master planning and urban design, and between architecture and landscape architecture. To master plan a public space, it suggested, was not simply to prescribe economically, socially, and morphologically desirable outcomes. To design it was not merely to translate these desiderata into the provision of better lines of communication, safe gathering places, appropriate seating, and leisure facilities. A coalition of architects and landscape architects can materialize the urban design according to their own interests, but they cannot generate environments without edges, where public and private spaces have yet to be delineated and separated, and where walls, paths, doors, and all the other paraphernalia used to digitize our spatial explorations have yet to be thought of, let alone drawn (Figure 33).

From a functionalist perspective, *Solution*'s proposal to create passages is obviously impractical. It factors timing and spacing into the design of public space. In particular, it makes room for waiting. Waiting is a phenomenon particularly associated with international gateways. It is a by-product of the attempt to legislate movement across edges; the customs house and the lazaretto are among its institutional expressions. And of course its theaters of immigration produce a strange negative community, the "shadow world" of refugees, mercenaries, and guest workers that novelist Bjarati Mukherjee evokes: "landing at the end of tarmacs, ferried in old army trucks . . . we are roughly handled and taken to roped-off corners of waiting rooms"; whose fate is expressed in their makeshift furniture: "sleeping in airport lounges . . . unwrapping the last of [our] native foods, unrolling our prayer rugs."[58]

But waiting is also the experience that might bind the slaves of empire to empire's beneficiaries—once the latter accept that their fortress nation-states are no longer tenable. The imagined community of Victoria Harbour, or of any in-between place of this kind, *could* be imagined in terms of what the French

**Figure 33.** Paul Carter, *Solution*, "Humid Edge Forms, concept sketches for edge structures and treatments" (Paul Carter, "*Solution*: A public spaces strategy, Victoria Harbo\*r, July 2002," figure 30). "Generally, 'dry' sharp lines should be avoided. Instead, stepped structures, including platforms, terraces, floating walkways and other edge forms should be encouraged. . . . The bunching and spreading out of linear forms reflected in water illustrates the principle" (Paul Carter, "*Solution*: A public spaces strategy, Victoria Harbo\*r, July 2002," figure 30 caption).

philosopher Jean-Luc Nancy defines in the abstract as a community "lying in wait." Such a community "is not simply an empirical reality or presence, but rather an advent or a calling or something lying in wait."[59] This "lying in wait" characterizes a social experience primarily rooted in a sense of relative placing and relative timing. Nancy speaks of a community of "singular beings" whose finitude emerges relationally "in a shared space or world." "What is involved in this originary sociality is not fusion or exclusion but a kind of 'communication' that is vastly different from a mere exchange of information or messages."[60] In this, space and time are materialized and community is "located in the interstices of mutual exposure, in the in-between space of co-appearance."[61] Doubled or produced through an exchange with the other, the identity incubated here is erotic: "marked by a basic lack or absence, [it] lacks a substance or stable identity that could be fixated once and for all."[62]

Evidently this way of conceiving—and designing—public space is antithetical to the interests of private investors. D'Arcy Wentworth Thompson stipulates that the "public" enjoys a distinctively public space when it assembles there "with no *business* whatsoever." A bustling crowd of this kind is not necessarily anticapitalistic in character, but it is *solvent,* in a position, that is, to dissolve or pay its bills. Its freedom to move amounts to this. But without a willingness to go into debt, what profit is to be made? To levy a toll on this movement, it is necessary to encourage a retreat from the shared space or world. Participants in the production of shared space have to be encouraged to retreat into the relative solipsism of consumption. Such a retreat is the public space equivalent of what political scientist David Marquand refers to as the "exit," or substitution of market relationships for political ones, which, he says, characterized the neoliberal ascendancy in the 1980s. It is "almost by definition, expressive, free and spontaneous. It is individualistic and, in a profound sense, private."[63] The convenient corollary of this narcissism is that its identification of the world's value with an individual's self-interest keys in directly to global capitalism's agenda. "Emotionally, perhaps even intellectually, those values [of authenticity, of direct experience, of all that was implied in the fashionable solipsism 'doing your own thing'] are first cousins to the values of market liberalism."[64]

Transposed to the physical domain, the meeting place that is the same as the marketplace encourages a swift, purposeful traverse toward a destination beyond it. It encourages silent consumption rather than noisy protest. Above all, it creates an impatience with waiting, for waiting implies a primary vulnerability, a dependence on what lies outside, and, among equals, an opening toward the other.

## In Other Words

Throughout *Dark Writing* the point has been made that speaking and drawing are two forms of discourse. The existence of a common language—writing—proves this. If this is true, what kind of discourse does *Solution*'s ground pattern represent? In contrast with Descartes' "architectonic line," these "lines" are intended to represent vectors, lines of attraction, or clines, gradients of difference. They are ambiguous in representing both bodies and channels. It is true that these interpretations cannot be drawn from the plan *as drawn*—although they can be deduced when the pattern is read in context—but the complexity of the pattern, its excess of linearity, is suggestive. In contrast with the "one dimensional line" that, as Brodsky Lacour puts it, translates thought onto an empty surface, my pattern purports to report what has already been thought at that place. If, as Verene says, the critical philosophy Descartes inaugurated eliminated memory, then the object of *Solution* is clear: to engage drawing in an act of remembering. But this is precisely what modern drawing disallows. Descartes' "well-ordered [modern] towns and public squares that an engineer traces on a vacant plan according to his free imaginings [or, fancy]" not only depended upon erasing the traces of earlier, "poorly proportioned" cities,[65] they depended upon drawing as such. In this sense, the *Solution* ground pattern is not a "drawing" in a conventional "architectonic" sense. Although linear in appearance, it is in spirit much closer to the visual writing discussed in chapter 4, resembling a story told as a result of a movement made between places or story situations.

The discourse that corresponds to this kind of drawing is allegory. If, to pick up Jean-François Lyotard's point, the market-economy-driven megalopolis "does not permit writing, inscribing," then the place of renewed democratic community is by definition the place that writes itself. It is the gathering whose *discourse* (etymologically, a running hither and thither) is allegorical or other-speaking. And just as the meaning of *agora* is ambiguous—the crowd defining the place of gathering, and the place giving form to the people gathered there—so with allegory; it is not only a way of speaking, but a way of *drawing* people together.[66] Poetic language is a way of bringing places into being. The mythosymbolic language of Enlightenment geography conjures up places of encounter with the other. In this case allegory, the discourse that speaks in other words, is an advance on mythosymbolic discourse. Acknowledging the otherness in language, it makes room for a distance between self and other, word and concept, line and thing. In an influential re-evaluation of the term, Paul de Man argues that allegorical writing embodies a suspicion of symbols precisely because their magical presencing disguises the reality of temporal and spatial disjunction. "Whereas the symbol postulates the possibility of an identity or identification," allegory, viewed positively, "designates primarily a distance in relation to its own

origin, and, renouncing the nostalgia and the desire to coincide, it establishes its language in the void of this temporal difference."[67]

Differentiated from metaphor, symbol, and conventional prosopopoeia, allegory here recovers its privileged role as the discourse of the other place, that other place being understood now as "other" to the "market of cultural commodities." If public space is understood as creating the distance that allows an approach to the other that does *not* lead to enslavement, the collapse of solvency, allegory's recognition of the limits of what can be represented and communicated becomes its greatest political and poetic virtue.[68] Suspending identification, allegorical discourse is the speech "in other words" that characterizes public speech when the ideology of the free market has privatized the traditional domain of public speech. Far from depending upon a shared horizon of belief, it appeals to what cannot be known, the ever-present and unsettling horizon that is the background wherever things *take place*. The revivified allegory evoked here recapitulates the origins of civil society, in which communication is necessarily open, incomplete, and renewed. We experience this individually whenever we open ourselves to whomever is clearly not self-same (but "other" by definition).

Maurice Merleau-Ponty argues that the first "other" is "a primordial relation between me and my speech. . . . Through this relation, the other myself can become other. . . . The common language which we speak is something like the anonymous corporeality which we share with other organisms."[69] It is "common" by virtue of a certain figurative, gestural invitation: "in speech we realise the impossible agreement between two totalities not because speech forces us back upon ourselves to discover some unique spirit in which we participate but because speech concerns us, catches us indirectly, seduces us, trails us along, transforms us into the other and him into us, abolishes the limit between mine and not-mine."[70] In a related spirit, Emmanuel Levinas also revives the allegorical mode. In place of the worn-out figure of personification or prosopopoeia, which all too easily renders the strange familiar, he defines the face as that which cannot be alienated, referring to "the 'beyond' from which the face comes."[71] In place of the horizon conceived as the vanishing point and limit of representation, he conceives of the other approaching us from beyond the horizon.[72] In this reformulation, allegory preserves, rather than tames, the finitude of all communication. Its double register reflects the inevitable difference written into all relations between things.

Ironically, the recommendation of *Solution*—that it should be understood as a generative platform, as a critical framework for ensuring the heterogeneity of Lend Lease's physical, social, and environmental design on Victoria Harbour—was not taken up. Despite the willingness of the commissioning architects and project manager to wrestle with its implications, and despite initial meetings with commissioned architects and landscape architects—who correctly interpreted

the public spaces strategy as a catalyst of better invention—our conversation was overtaken by market forces. A dip in the value of the parent company on the global stock market produced a corporate shudder whose reverberations eventually filtered down to our exercise in long-term planning. It was deemed too speculative, too unlikely to produce the short-term return that shareholders were allegedly demanding. As a result, an unusual dialogue, a rare instance of two kinds of speculation finding common ground, was quietly dissolved.

I said I wouldn't mention it again, but the quiet dissolution of *Solution*, no less than the idea it promoted of a colloidally constructed environment, reminds me of Boucher's painting, discussed in the introduction. Why in his personifications of the arts and sciences did he pair Architecture with Chemistry? It doesn't seem to make any sense. But perhaps in the wake of *Solution* it does. Boucher not only paired like with like. He also paired the challengingly unalike, and perhaps this was the point. Boucher was a colorist as well as a draftsman; any professional painter of his day mixed his own colors. The mortar and pestle depicted at the foot of the child chemist belong as much in the artist's studio as the alchemist's laboratory. The secret link between Architecture and Chemistry is the artist himself, whose practice incorporates the skills of both arts. But there may be something more, a discernment that architecture and chemistry represent opposed modes of modeling the world—different ways of designing it.

Architecture is obsessed with foundations. Piling stone on stone, it seeks to amass, fix, and consolidate. It is Platonic in the sense that it seeks to fill in a pre-existing outline. Contemporary architectural practice may try to escape this heritage, but its drawing practices continue to invoke stable forms. Chemistry, by contrast, is transformative. Separation and combination, represented respectively by the alembic and the pestle and mortar, were the two means that, together with heating by fire, chemists (and before them alchemists) used to explore the nature and property of matter. In a chemical reaction, according to the most important chemical theorist in the period prior to Boucher's painting, Robert Boyle, nothing "is separable from a body by fire that was not materially pre-existent in it, for it far exceeds the power of natural agents, and consequently of the fire, to produce anew so much as one atom of matter, they can but modify and alter, not create."[73] But this does not preclude the appearance of things that have not been predicted. Boyle revived the Greek term *chrysopoeia* to describe his lifelong study of elemental transmutation. His pioneering attempts to define chemical elements and understand materially how they were modified did not prevent him from looking for the philosopher's stone, whose possession, he believed, would attract angels.

*Solution* was a form of transformation. The lines of development it recommended were to be read *chemically* rather than architecturally. They were to be treated in the way that Protogenes and Apelles treated each other's lines: Apelles

painted a line, Protogenes painted a *differently colored* line inside it, and so on. Each new line seemed to emerge inside the old one, altering it rather than beginning anew. The transformation, not the deletion, of the old line was what amazed. The process in which the new line modified what was materially pre-existent rather than either eliminating or copying it resembled a chemical reaction. So with the creative template *Solution* proposed. It was not a blueprint but an invitation to engage in a concomitant act of production. But the way our culture imagines, plans, and implements the construction of infrastructure prevented this from happening.

**Notes**

1. Judith Raphael Buckrich, *The Long and Perilous Journey: A History of the Port of Melbourne* (Melbourne, Melbourne Books, 2002), 199.

2. Paul Carter, "*Solution*: A public spaces strategy, Victoria Harbo*r, July 2002," is a twenty-eight-page A3 landscape report with forty-two figures. The body of the report is a "site myth analysis" divided into three sections—micro-macro cosmic analogies, colloidal forms, and humid edges. The document also contains a number of worked examples, showing different design applications of the mythform and a public art strategy. (The document is obtainable from the author.)

3. John Lack, *A History of Footscray* (North Melbourne: Hargreen Publishing, 1991), 20.

4. Ibid.

5. Buckrich, *The Long and Perilous Journey*, 74.

6. Olaf Ruhen, *Port of Melbourne, 1835–1976* (Stanmore, N.S.W.: Cassell Australia, 1976), 136ff.

7. Peter Fenves, *"Chatter": Language and History in Kierkegaard* (Stanford, Calif.: Stanford University Press, 1993), 219.

8. Ibid.

9. Ibid., 223.

10. Ibid., 48.

11. See, for example, Andrew Ward & Associates, *Melbourne Docklands Heritage Study* (June 1991) and *Melbourne Docklands Heritage Review* (June 1997).

12. Edmund G. Gill, "History from our Harbor Floor," *Port of Melbourne Quarterly* (January–March 1949): 30–33, 31.

13. D. H. Everett, *Basic Principles of Colloid Science* (Letchworth: Royal Society of Chemistry, 1987), 11.

14. Ibid.

15. Ibid.

16. Ibid.

17. References to the sources I consulted are in these notes.

18. See chapter 4, note 11.

19. Thompson frequently used macro-analogies to express the poetry of forms

produced through the action of osmosis and surface tension. In the context of the discussion of methexis in chapter 3, Wentworth's comment on the colloidal principles informing radiolarian skeletons is suggestive: "These owe their multitudinous variety to symmetrical repetitions of one simple crystalline form—a beautiful illustration of *Plato's One among the Many*." [Italics in original.] As he explains, "the radiolarian skeleton rings its endless changes on combinations of certain facets, corners and edges within a filmy and bubbly mass." D'Arcy Wentworth Thompson, *On Growth and Form*, vol. 1 (Cambridge: Cambridge University Press, 1917, 1942), 695.

20. Everett, *Basic Principles of Colloid Science*, 6–7.

21. Ibid., 7.

22. Referring to the famous photograph.

23. B. Jirgensons and M. E. Straumanis, *A Short Textbook of Colloid Chemistry* (London: Pergamon Press, 1954), 70. These authors illustrate the most common shapes of colloidal particles; see illustrations on pages 70, 159, 197, 199, 214, 351 of that text. James W. McBain, *Colloid Science* (Boston: D. C. Heath and Company, 1950), also has some suggestive electron microscope photographs (especially pages 21 and 410). There is a definite period style about the illustrations used—the stylistically similar illustrations in H. R. Kruyt, ed., *Colloid Science*, vol. 2, "Reversible Systems" (New York: Elsevier Publishing, 1949), are remarkable acts of visualization (see especially pages 489, 495, 496, 497, 508, 715).

24. Wentworth Thompson, *On Growth and Form*, vol. 1, 76.

25. Rodolphe Gasché, *Of Minimal Things: Studies in the Notion of Relation* (Stanford, Calif., Stanford University Press, 1999), 267.

26. Ibid., 273.

27. See Donald N. Levine, *The Flight from Ambiguity* (Chicago: University of Chicago Press, 1985), 8.

28. R. Hohl, *Alberto Giacometti: Sculpture, Painting, Drawing* (London: Thames and Hudson, 1972), 31.

29. Jean Genet, "The Studio of Alberto Giacometti," in *Fragments of the Artwork*, trans. Charlotte Mandell (Stanford, Calif.: Stanford University Press, 2003), 51.

30. Richard Jefferies, "Venice in the East End," in *The Life of the Fields* (Oxford: Oxford University Press, 1983), 210–214, 211.

31. Ibid., 214.

32. Ibid.

33. Wendy Lowenstein and Tom Hills, *Under the Hook: Melbourne Waterside Workers Remember, 1900–1998* (Melbourne: Port Melbourne Historical and Preservation Society, 1998), 40.

34. Ibid., 51, 53.

35. Ibid., 147.

36. Susan Hunt and Paul Carter, *Terre Napoleon: Australia through French Eyes, 1800–1804* (Sydney: Historic Houses Trust of New South Wales, 1999), 90.

37. Jean-Francois Lyotard, "Domus and the Megalopolis," in *The Inhuman: Reflections on Time*, trans. G. Bennington and R. Bowlby, 191–204, 202 (Stanford, Calif.: Stanford University Press, 1991).

38. Jean-Francois Lyotard, "Time Today," in *The Inhuman: Reflections on Time*, trans. G. Bennington and R. Bowlby, 58–77, 76 (Stanford, Calif.: Stanford University Press, 1991).

39. Rosalind Deutsche, "Agoraphobia," in *Evictions: Art and Spatial Politics* (Cambridge, Mass.: MIT Press, 1996), 269–327, 324.

40. Mentioned in T. F. Bride, ed., *Letters from Victorian Pioneers* (South Yarra, Melbourne: Lloyd O'Neil, 1983; orig. pub. 1898), 443.

41. Samuel Pratt Winter, "The Voyage of the Argo," in *The Winter Cooke Papers*, Melbourne, La Trobe Library: WCP, 5, 2.4. Ms Collection 86647007.

42. James Nangle, *Stars of the Southern Heavens* (Sydney: Angus & Robertson, 1958), 76–77.

43. Pallian, like War in Djadjala, the language of the Boorong people (formerly of the country south of Swan Hill in Victoria), is of the Crow moiety. War I associated with Canopus. See R. Brough Smyth, *The Aborigines of Victoria and Other Parts of Australia and Tasmania*, 2 vols. (Melbourne: John Curry O'Neil, 1972; orig. pub. Melbourne: Government Printer, 1876). vol. 1, 422; and John Morieson, "The Night Sky of the Boorong: Partial Reconstruction of a Disappeared Culture in North-West Victoria" (MA thesis, University of Melbourne, 1996), 154.

44. Quoted by Donald Kuspit, "The Semiotic Anti-Object," at www.artnet.com/Magazine/features/kuspit/kuspit4-20-01.asp, 10.

45. Ibid., 11.

46. Apollonius of Rhodes, *Argonautica*, Book 1 (London: Heinemann, 1912), l.322.

47. Carter, "*Solution*: A public spaces strategy, Victoria Harbo*r, July 2002," 7.

48. See Gary Presland, *The Land of the Kulin* (Melbourne: Penguin, 1985), 42–43.

49. M. B. Parkes, *Pause and Effect*: *An Introduction to Punctuation in the West* (Berkeley, Los Angeles: University of California Press, 1993), 173.

50. Ruhen, *Port of Melbourne*, 149.

51. J. B. O. Hosking, "A Forest in a Port," *Port of Melbourne Quarterly* (July–September 1948): 16–18, 38, 49.

52. Maps used included (Note: * signifies their use in overlay studies; AL signifies supplied by Allom Lovell & Associates.) * 1835, John Batman's Map of Part of New Holland (in Miles Lewis, *Melbourne: The City's History and Development* (Melbourne: City of Melbourne, 1994); 1837, Robert Russell, Map Showing the Site of Melbourne (in Lewis); c.1839–1842; Robert Hoddle, Town of Melbourne—Plan of the Settlement of Port Phillip (in Lewis); December 1850, "Proposed Canals to

Sandridge: David Lennox's Scheme," *Illustrated Australian Magazine* (in Lewis); 1851, Proposed Canals to Sandridge: Henry Ginn and James Blackburn's schemes & C. Pasley's "practicable cut" at Humbug Reach (in Lewis)*; 1855, Colonial Engineers Report: map (C. Pasley), 1855, SLV 821.09 A 1855. AL; 1855, Plan of Melbourne and its Suburbs (in Metropolitan Town Planning Commission Report, 1925); 1860, John Millar, Design for Ship Canal or 'tidal harbor' and Docks for the Port of Melbourne (in Lewis). It is this proposal that has a landscape designed in the form of Great Britain cradled inside "Britannia Crescent"; 1863, Stephens Map of Melbourne and Suburbs; 1873, Sands & McDougall Map of Melbourne and suburbs (in Metropolitan Town Planning Commission Report); 1875, Proposed Ship Canal and Dock, Port of Melbourne (N. Munro), SLV 821.03 GMFS 1875,* AL; 1879, Detail Plan Shewing Proposed Floating Dock and Improvements in the River Yarra . . . Drawings numbers 3 & 4, (Sir John Coode), SLV 821.03 GMFS 1879,* AL; 1879, Coode Report, Drawing 1; 1910, Melbourne 1910, Surveyor General, SLV 821.09 GMBH 1910-*; 1915, MHT – Proposed Harbour Improvements 1915, SLV 821.03, GMPS 1915. AL; 1925, Metropolitan Town Planning Commission, Map F, opposite 26. JB/AL; 1925, Melbourne & Suburbs, Area A (in Metropolitan Town Planning Commission Report); 1925, Local Topography, Metropolitan Town Planning Commission Report; 1929, MHT Map, River Yarra and Docks, SLV 821.03 EMFS, AL.

    53. Mario Papini, *Arbor Humanae Linguae* (Bologna: Capelli Editore, 1984), 123ff.

    54. Carter, "*Solution*: A public spaces strategy, Victoria Harbo*r, July 2002," 22.

    55. B. Krasavtsev and B. Khlyusten, *Nautical Astronomy*, trans. G. Yankovsky (Moscow: MIR Publishers, 1970), 136–137, make the poetic but practical point that the mariner proceeds "hand over hand" from constellation to constellation.

    56. "A successful grouping is chiasmatic, like the agora. It is poised between growing more dense or diffusing. In this moment of accidentally achieved balance, a maximum ambiguity obtains. The space between figures is flirtatiously charged. A surplus of possible paths of propinquity opens up." Paul Carter, *Repressed Spaces: The Poetics of Agoraphobia* (London: Reaktion Books, 2002), 199.

    57. See note 39 above.

    58. Bharati Mukherjee, *Jasmine* (Melbourne: McPhee Gribble, 1992), 101.

    59. Fred Dallmayr, "An 'Inoperative' Global Community? Reflections on Nancy," in *On Jean-Luc Nancy: The Sense of Philosophy*, ed. D. Sheppard, S. Sparks, and C. Thomas, 174–196, 179 (London: Routledge, 1997).

    60. Ibid., 181.

    61. Ibid., 182.

    62. Ibid., 182.

    63. David Marquand, *Decline of the Public* (London: Polity Press, 2004), 92–93.

    64. Ibid.

    65. Claudia Brodsky Lacour, *Lines of Thought: Discourse, Architectonics, and the Origin of Modern Philosophy* (Durham, N.C.: Duke University Press, 1996), 33.

66. See Paul Carter, "Other Speak: The Poetics of Cultural Difference," in *Empires, Ruins + Networks: The Transcultural Agenda in Art*, ed. S. McGuire and N. Papastergiadis. 240–265, 260 (Carlton, Melbourne: Melbourne University Publishing, 2005).

67. Discussed in Murray Krieger, "'A Waking Dream': The Symbolic Alternative to Allegory," in *Allegory, Myth, and Symbol*, ed. M. W. Bloomfield, 14–15 (Cambridge Mass.: Harvard University Press, 1981).

68. In *The Visible and the Invisible*, Merleau-Ponty describes the distance between the seer and the thing thus: "it is not an obstacle between them, it is their means of communication." Maurice Merleau-Ponty, *The Visible and the Invisible*, ed. C. Lefort, trans. A. Lingis (Evanston, Ill.: Northwestern University Press, 1968), 135.

69. Maurice Merleau-Ponty, *The Prose of the World*, trans. John O'Neill (Evanston, Ill.: Northwestern University Press, 1973), 140.

70. Ibid., 145.

71. Emmanuel Levinas, *Basic Philosophical Writings*, ed. R. Bernasconi, S. Critchley, and A. Peperzak (Bloomington: Indiana University Press, 1996), 59.

72. Thus, "I set the signifying of the face in opposition to understanding and meaning grasped on the basis of the horizon." Emmanuel Levinas, *On Thinking of the Other: Entre-Nous*, trans. M. B. Smith and B. Harshav (London: Athlone Press, 1998), 10.

73. Robert Boyle, *Sceptical Chymist* (1661), 104. http://oldisdte.library.upenn.edu/etext/collections/science/boyle/chymist/104.html.

## CHAPTER 7
## Trace: A Running Commentary on *Relay*

*A line of games which begins somewhere in the Stone Age.*
—Argus

### Starting Block

Both *Tracks* and *Solution* tried to reintegrate the two elements of *place making*. Instead of separating the design of public space from the activities of the public, they identified public space design with the choreography of everyday life. Place making, they argued, was an art of placing and timing. Coherence and stability arise in this situation because public spaces are constitutionally discursive, sites incubating a primary sociality characterized by a desire to meet. The relationship of the movement form (De Quincey's "undistinguishable blot") to design is the same one occupied by rhythmic geography in the field of cartography. Notating what goes missing when the made world is reduced to a diagram of dimensionless lines, the restitution of omitted connections counterpoints the light writing of disembodied reason with the dark writing of embodied memory. Then there emerges a language of traces; movement is not represented but instead the places that movements make—broken lines of footsteps, the curvatures of flight paths—together with the indices of movement's materiality—density, gradient, orientation, acceleration, and pause.

In theory, the places brought into being this way are inseparable from the movement of the public. The corollary is that the greatest obstacle to successful place making is the theatrical mindset that wants to prescribe in advance what is called (symptomatically) an event space. But events only matter to those to whom nothing has ever happened. For something to happen, passages must be opened up, but in ways that preserve their sense of hazard. Movement is everywhere

implied, but it is not laid down in advance. Its fleetingness—the fact that its history occupies the instant between two strides—must be understood as the one permanent and inalienable feature of democratically aspirational places, where meanings, like meetings, continuously appear and fade.

*Tracks* and *Solution* imagined bringing places of movement into being. But what happens when an impression of movement is requested after the new place has been constructed? This is the question I want to explore in this third case study. In 1998 the Olympic Coordination Authority commissioned me to design a public artwork for a site adjacent to the main stadium at Homebush Bay, Sydney. I invited artist Ruark Lewis to collaborate on this project, and together we created *Relay*. When we began, Fig Grove, the site where our work was to fit, existed only on paper. But this hardly mattered because Hargreaves and Associates had designed a landscape that was rigorously linear; when it was built its sharp edges and uniform surfaces were simply scaled-up and materialized versions of the technical specifications (Figure 34). There were no surprises springing from an exact geometry. Nothing had been left to chance.

The public art brief invited artists to propose a text-based artwork on the theme of "the meaning of the Olympics to Australians." And it seemed to me obvious from the beginning that any history of the Olympics that captured the genius of exceptional athletic achievement needed to be a history of instants. It had in some way to be a history of those moments in which the steady tread of historical time is suspended. As a work celebrating *kairos*, time as timing, time as opportunity, against *chronos*, time as regularly calibrated line, *Relay* had to *participate* in the experience it evoked.[1] *Relay* had to be written, and the writing designed and arranged, in a way that induced in the readers a sense that they were athletes, participating in the recollection of exceptional moments when history was, as Kafka described it, present in the instant between two strides. The challenge of the design was, through a mode of concurrent or concomitant actual production, to renew a heritage of originally self-evident events.

But how was this possible when the location of the work had already been supplied? Dark writing dissolves the distinction between tenor and vehicle, between message and medium. The meaning emerges from a pattern that can only be created where the material—the page—is soft enough to take an impression. And that pattern of traces constitutes a spatial lexicon, a repertoire of iconographs that can only be read by the reader who is prepared to be a tracker—one already immersed in a community of traces. Built of Riverina granite, the smooth bleachers of Fig Grove, by contrast, resembled the hard pages of a book. They were ready to take a light writing that communicated movement conceptually, but nothing in their design suggested that any form of movement had influenced their austere geometry. One might write *on* them but hardly *with* them.

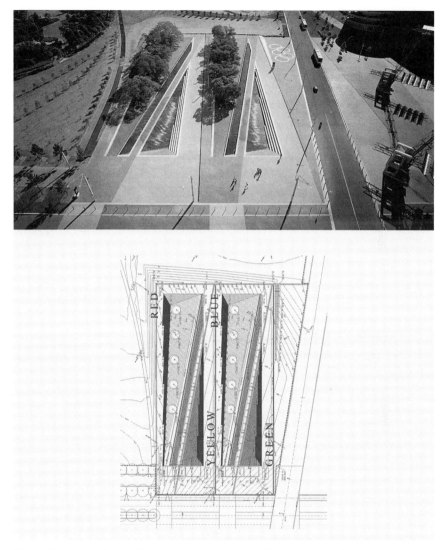

**Figure 34.** Paul Carter and Ruark Lewis, *Relay*, site location. (top) Aerial view of Fig Grove, west-northwest from Novotel, 1999 (Copyright Sydney Olympic Park Authority, reproduced by courtesy); (bottom) Fig Grove & Central Water Feature Grading Plan, May 1998 (Copyright Hargreaves and Associates, reproduced by courtesy). The plan is oriented to the direction from which the aerial photograph is taken and the location of the four tiers indicated.

Could Fig Grove be *retrofitted* with a system of markings, with typographies of various kinds, and arrangements of iconographs, in order to make legible a movement form? There might be a formal resemblance between the terraces of Fig Grove and the dancing terraces of Greek myth. But there was nothing in the scale, the materials, or the environment of Fig Grove to suggest that the design-

ers were interested in creating a playground for the people, a place likely to induce sociability. The very name "grove" invited repose rather than reaction.

My first response to these questions was to consider the character of the letters. Figurative language, and metaphor in particular, engages the imagination to make a leap from one idea to another. Bringing two formerly unrelated things together, it provokes a movement of the mind that produces a new concept. Could a similar effect be created perceptually, by the way the writing was *designed*? This was the line of thought reflected in the first name given to the proposed artwork: "Starting Block." The name referred to the wooden wedges sprinters use to brace their feet at the beginning of the race. But it also suggested the printer's block, the piece of wood or metal engraved for printing. An analogy was implied between the foot that treads and the type that prints. As athletes burst from the starting blocks, so readers find in the character of the letters an impression of movement.

In ancient Greece, the discus thrower, or discobolus, performed on a raised thrower's stand—a stone slab marked with incised lines that gave him a firm footing.[2] To be effective the pattern incised into the stone needed to answer to every successive momentary pose the athlete adopted as he whirled round to release the discus. The engraved design notated his movement; it was the permanent trace of his athletic achievement. With a little ingenuity the successive poses the athlete adopted in performing his throw could be reconstructed, simply by retracing the pattern in the stone. Could this principle work the other way? Could letters be designed that, while they recognizably belonged to the alphabet, were incised in such a way that suggested athletic poses?

The obvious objection to this line of thought is that when every letter is a starting block, the usual practice of reading from left to right is inhibited rather than encouraged. To create a movement both conceptual and perceptual, semantically clear as well as calligraphically indicated, it is the arrangement of the letters rather than their individual design that matters. The reading eye *already* moves unconsciously along the lines of letters; the challenge is to make readers physically conscious of this. This reflection led to the second iteration of the project. The instant between two strides is not an empty interval but a constantly appearing and disappearing arc of space caught in the passage of one limb across another. It is the footstep considered bipedally as a pace. Structurally, it is a movement form whose defining characteristics are the stride in which left and right foot are at their maximum distance from each other and the syzygy of the same limbs as one instantaneously crosses the other midstride. The character of this movement form is that it is rhythmic. It is, as Lacoue-Labarthe puts it, "the form at the moment it is taken by what is in movement, mobile, fluid, the form that has no organic consistency."[3]

Formally, I had been interested from the start in documenting the poetic inscriptions in *scriptio continua*. Continuous writing, where one word follows another without a space between them, is the manner of most classical inscriptions. It was appropriate in the context of celebrating an institution whose origins go back to ancient Greece. But it was also the perfect vehicle for drawing attention to the act of reading. Greek and Roman monumental epigraphy lacks punctuation. The visual cues that enable us to scan a line of writing quickly—capital letters, periods, commas, as well as spaces between words—are missing. This means that readers are placed in the position of children learning to read: they have to spell out the word experimentally, testing the emerging pattern of syllables against their auditory associations. On the way to discovering the word intended by the writer, they have to consider and progressively reject any number of other possible words. This also involves their going back to the beginning of the word, to check that it *is* the beginning.[4]

As they stumble toward the intended sense, such readers are acutely aware of themselves as trackers of the sense, deciphering one path of meaning amongst many. And even when they have the sense they remain conscious of other unintended meanings secreted in the text. While punctuated writing linearizes writing and reading, serving the cause of a reasoning that is linear—univocal, unambiguous—continuous writing gives graphic form to the etymological sense of discourse as a running hither and thither; the reader's eye darts back and forth, picking its way through a forest of symbols, conscious all the while that the act of interpretation is creative. The reader is not subjugated to the imperious will of the writer but becomes another writer, creatively restoring the meaning of the text. Bringing ambiguities to the surface, seeing in the conjunction of letters and syllables unintended connotations, the reader may even surpass the writer, discovering a meaning not there before. In any case, by inviting the reader to participate in the production of meaning, continuous writing physicalizes a movement of the mind. The reader follows in the writer's footsteps and occasionally overtakes her, as in a race.

*Scriptio continua* offered a simple way of involving readers in a concomitant act of production. Used to engrave the poetic inscriptions into the risers of the terraces at Fig Grove, it turned readers into treaders. For some of these lines extended as far as they could see, and to read them the *reader* had no choice but to become a *treader*, an athlete of meaning, walking back and forth as the sense progressively came into view.[5] To formalize this gymnastic of eye and foot, to intensify the game of winning through to the sense—which is, after all, a race that never ends—I decided to introduce into the composition of the inscriptions one intentional ambiguity of my own. As far as possible, the words composed for Fig Grove would share their first and last letters. This would create a momentary syzygy between words,

suggesting that they belonged to a single larger rhythm of constantly stretching and contracting meanings. Handed over to the next word, the last letter of the previous word could be compared to a baton handed over in a relay. The letters as a whole were a multitude of runners. This was how *Relay* acquired its name.

### Something Greek

In presenting our intention to engrave twenty lines of poetic text into the risers of Hargreaves' design—producing in the process well over a kilometer of typography—to the Olympic Coordination Authority's public art committee, I had pointed out that the association of poetry with sport was an ancient one (Plate 12). The great fifth-century BC Greek poet Pindar had written odes for various games including those of Olympia. But this information failed to reassure the committee, one of whose members rounded off his skepticism about the practicability of *Relay* by saying, "And another thing, we don't want anything Greek: These are the Australian Olympics." This was a pity because the most direct literary influence on the composition of *Relay* was Pindar's First Olympian Ode.

But it was also unfortunate in another way. Besides the lines of text printed along the risers of the Fig Grove terraces (Plate 13), we wanted to engrave thirty "graffiti clusters" into the horizontal surfaces of the site. These calligraphic markings would be located in a way that suggested an enigmatic connection with the vertically positioned texts in their neighborhood. We meant to suggest a translation between writing and drawing and through this to suggest a rhythmic logic —an informal choreography running throughout the site. The rationale for this idea was derived from our understanding that Pindar's odes had been written for performance. His words were well-placed in a double sense. The texts that have come down to us were originally cogs in a choreographic machine, whose other cogs included music, the dance, and the terrain where they were performed.

Poets like Bacchylides and Pindar attended the public games and wrote choral odes commemorating the victors. The athlete's performance could be compared to a poetic composition because both recognized that transcendent excellence depended on a perfect command of *measure*. The conquering athlete enjoyed *charis*, a word used to designate his victory and the joy that attends upon it, but also to evoke the favor of the god that blazes into appearance for the hero, sometimes a gift given in return for his deserts and sometimes an inexplicable grace that descends upon him.[6] The poet may recommend that the athlete "consolidate his ability to hold to the *charis* of the moment of victory over against the many dark moments that cannot help but succeed it in his mortal span."[7] Above all, though, he advises him *not to overstep the mark*. The athlete's mobile figure, his marriage of space and time, depends, like the poet's line, on achieving an exact balance between Dionysian desire and Apollonian decorum.

The measure common to athletic and poetic excellence was not regarded simply as a poetic figure of speech; it also determined the way the odes were composed. Their structure was dance-like. As performers might form a line, a circle, a chain winding back on itself, or an arc swinging out across the floor, so the poet presented his argument non-lineally, from many angles and under different figures of speech. The importance of *charis*, for example, is not indicated by announcing it at the beginning or by leading up to it at the end (as a rhetorically constructed literary narrative might proceed), but by having it emerge in the middle, where it stands out: "Pindar almost always proceeds by first rearranging the chronological sequence into some kind of ring-composition and then selecting those moments in the ring on which he wishes to focus."[8]

The danced ode, for example, consisted of three figures, "the strophe, danced by the chorus moving in a circle in one direction, the antistrophe, danced in the reverse direction, and the epode, sung standing in one place."[9] The epode would have stood out in dramatic contrast to what came before and after it, "for as the eye ceased to be engaged with the circling of the dancers, the ear would be engaged all the more deeply with the sound and meaning of the song."[10] Hence the epode, which supplied the "climactic moment at which it [*charis*] is made to stand forth in radiance," was determined jointly by the evolution of the matter of the poem and the evolution of the dance, for it was understood that "the words and the figures of the dance flow from the same rhythm," even though this need not mean anything so literal as "one motion of the foot for every syllable of the language."[11]

The climactic moment at which the gift of *charis* is announced and stands forth not only celebrated a transcendent moment internal to the form of the ode. In the context of the meaning of the words, it invited the participants in the dance to reground themselves historically and geographically. As Pindar always places the athlete's victory inside a heroic genealogy, the danced measure expresses a view of historical time: the strophe suggests a return toward increasingly distant matter; the epode marks the prudent terminus of that enquiry in "the analogical moment of grace";[12] and the antistrophe symbolizes the return from that distant place and time to the present—"as one hears the words move back in time one also somehow sees the dancers turn their steps back toward the heroic ages, and as one then hears the words return to the present one also sees the dancers return."[13]

The same was true spatially; the danced ode embodied a poetic geography, enacting how the known world came into being through the journeys and deeds of the ancestral heroes and gods. In the epode, where the athlete is warned not to go further, "[o]ften the great image summoned up is that of the pillars or stelae that Herakles set up at the straits of Gibraltar." In one of the odes Pindar com-

posed for the Isthmian Games, the members of the athlete's clan (who are said to have reached the pillars of Herakles) are told to seek no further at the very moment (at the beginning of the epode) where the dancers stop moving: "To the very limits of manliness / They have reached out and touched the pillars of Herakles. / Further excellence is not to be sought!"[14]

Pindar's technique of composing words according to a "topographic plan," to borrow Paul Klee's phrase, recalls the "hieroglyphs" of the Papunya Tula painters, figures simultaneously drawn, indited, and, in ceremonial contexts, also danced. Four-dimensional writing systems of this kind are able to communicate the movement form in a way that two-dimensional writing and design clearly cannot. They are able to express the continuous transformations of meaning that occur when the points of view are multiple, timed, and spaced in relation to one another and when the meaning is nothing less than the successful performance of the gymnastic as whole. When we learn that in Pitjantjatjara culture to the southwest of Papunya, whose integrated song, body, and earth marking and dance ceremonies resemble those further north, "[a]t any given point . . . the painted design on the body of a dancer may have one specific meaning (for example, 'home') and the song text with its associated rhythmic pattern may have another (for example, a description of a journey),"[15] it is clear that the rationalized systems of notation used in Western culture are extraordinarily attenuated and rigid.

The calligraphic flourishes that characterized the thirty "graffiti clusters" distributed irregularly across the site were derived from monograms, signatures, and other types of picture writing collected from former and present-day Australian Olympic athletes.[16] A relationship to the *Relay* text was indicated by inlaying the designs with phrases drawn from the adjacent risers. Reproduced in an informal lowercase font and arranged in the manner of a concrete poem, these phrases staged a passage from writing to drawing. The intimate scale of the letters and their greater spacing (although still in the *scriptio continua* style) suggested dotted lines. Their arrangement in coils or crosses or grids created pictographs, letter patterns that resembled images of the concepts or objects to which the letters referred.

The athletes' signatures and monograms were interesting because they seemed to revive a hybrid form of writing able to represent the movement form peculiar to the different sports. In the absence of a shared graphic lexicon, they improvised a rhythmic style that seemed to notate the race. They could be read as graphic mnemonics of the poses that form the unit of running, swimming, or throwing. This was equally true where, as in the case of Dawn Fraser and Shane Gould, whose fish monograms obviously referred to their own pre-eminence as swimmers, the designs had a symbolic significance. Similarly, cartoons representing a bicycle or a high jump or even a yacht were notable for the sureness of the

**Figure 35.** Paul Carter and Ruark Lewis, *Relay*, monograms. Miscellany of sources and first manipulations. (top left) Dawn Fraser. (top right) Ruark Lewis, Graffiti Cluster Design using Dawn Fraser's monogram. (bottom left) Ruark Lewis, Graffiti Cluster Design using Betty Cuthbert's signature. (bottom right) Ruark Lewis, Graffiti Cluster Sketch using Shane Gould's monogram. 300 × 420mm, watercolor ink on paper (Original monograms courtesy of Harry Gordon, *Australia and the Olympics*, dedicatory copy).

graphic flourish traveling through them, a line of power that subtly revealed the movement principle these static forms served, and the arrow of the athletes' passage drawing them into the line of their own rhythmic excellence (Figure 35).

The graphological discovery that the athletes' handwriting possessed a distinctive kinesthetic charge influenced both the selection of material and the way it was edited, enlarged, and arranged. In this way a lexicon of essential poses and trajectories was deciphered, and from the seemingly casual marks a history of the instant between two strides collected. In doing this there was a sense of recapitulating the history of symbolic representation alluded to in the discussion of the children's art at Papunya. Meanders and doodles signifying nothing but their own manual history began, when enlarged, to suggest primary imagery, of birds, dancers, athletes, and above all various fish and dolphin forms. It was striking that the athletes seemed to draw designs appropriate to the element in which they operated. The swimmers produced amphibious imagery, while the jumpers and sailors favored cloud patterns. The runners, pre-eminently Betty Cuthbert, scored the earth with visionary lines in which time first stretched out, then coiled up under the resistless pace of nearing feet. These were genuine monograms; inside their tiny marks flowered the entire essential history of an athletic achievement. In the image of movement was notated the figure, the complex of poses, that brought supreme achievement, momentarily conquering space and time.

In this context the fugitive phrases detached from the endings of the hori-

zontal lines assumed a new role, as running commentaries on the graffiti designs. Graffiti Cluster 1 (green tier), for example, is composed from three elements, a dedicatory inscription, "For all those 'Times,'" a graffito of a running figure, which is also the signature of "Peter" [Montgomery], and a poetic fragment derived from red tier 4, "ordinary wonder sport is art of life" (Plate 14). The graffiti cluster that results articulates in a new way the paradox already alluded to—What are the "times" of sport? How is the history of a sport related? Ordinary history consists of events that leave a legacy—but the sports event leaves nothing behind. Sports are composed of a history of instants, of events no sooner witnessed than melting away into nothing. How, then, does sport leave its mark on our lives? In the wake of the running figure, exactly copying the angular lines of his energetic forward thrust, springs up the answer: the fly-away Peter leaves in his wake his double, the words "wonder" and "ordinary" and "sport is art [of life]."

The "times" of sport are not only measured in sharp lines, calibrated tracks, and stopwatches. The "art" of sport is not in the record achieved but in the effortless flow of limbs, in the "ordinary wonder" of the human body transformed into a figure of motion. So, to complete the legacy that the athlete's flight leaves behind, it is necessary that the spectator enter empathetically into the runner's movement; hence, the completion of the message springing up in the runner's wake, the phrase "of life" is drawn as if by some magnetic principle of sympathy into the curvilinear flourish representing the runner's trailing leg. This is sport's lesson: there is no spectator, no athlete; in life the two merge. This is the "art" of life sport teaches. The runner is composed of both linear, angular elements and flowing arabesques. It is this combination that uniquely produces those "times" that history cannot annotate. The leftover text predominantly imitates the linear element. The remainder of the graffito, composed of long, looping calligraphic flourishes, remotely mirrors the curvilinear forms—those analogues of instants whose endless moment of self-production finite lines cannot express.

By such improvised means *Relay* attempted to restore the kind of environment from which Pindar's odes sprang. Their combinations of words and cartoons could not be read in the way the odes or the Pintupi hieroglyphs can be read—as choreographic notations. In the absence of a four-dimensional writing tradition, we had to go by the energy of the symbolic flourishes, interpreting these as a kind of manual index of what fleet bodies had once known, an art of timing and spacing exactly adjusted to an environment experienced as a manifold of passages (Plate 15).

### Marking Passing

There was, though, a far more explicit way in which "something Greek" was smuggled in. The risers of three of the four tiers at Fig Grove bear poetic in-

scriptions whose ultimate inspiration is the *priamel* (or opening) of Pindar's First Olympian Ode.

Fig Grove is a fine example of linearist design used creatively. It consists of two rectangular landscape modules placed side by side on a rectangular ground. By inserting a lengthwise diagonal cut into the module, and by alternately creating an upper terrace along one long side and a lower terrace (below the ground plane) inside the line of the other flank, the designers created a surprising drama. In addition, the module was gently tilted lengthwise with the result that the lower terraces disappeared at one end into the ground. When repeated, this two-part module gave us four terraces or tiers, each consisting of five giant steps or bleachers. The vertical faces or risers of these tiered structures provided twenty pages on which we were invited to write a history of the meaning of the Olympics to Australians.

They were not ordinary pages, of course. They were designed to accommodate the kind of fantasy Stéphane Mallarmé indulged when he wrote his last poem, *Un coup de dès*, as a single, continuous line. Each of the twenty poetic texts for *Relay* was also composed as a poem in a single line. Most poems are not written like this. They have a rhythmic structure discreetly adjusted to the bookish convention of writing poems in lines. The line ending arrests the movement of the line and initiates a new beginning that is rhythmically related to what has gone before. But a line without ending—or at least a very long line—cannot use this kind of scaffolding to moderate its movement. Line endings usually correspond to breath patterns, making it possible to read the lines aloud. But what happens where no in-breath is indicated, no pause before beginning again? Then the reader is in the same position as the runner or swimmer whose race is without repose. Athletes obviously take many breaths in the circuit of the race, but in another way they hold their breath throughout the race, and the entire account of their experience occurs in the swelling instant between two breaths.

The twenty lines of *Relay* were composed in the form of races. They put together idiomatic expressions culled from the autobiographies of Olympian athletes, fragments of children's rhymes, and phrases referring to the history of the Games that were rendered enigmatic when torn from their context. A deliberately ungrammatical style known as *anacoluthon* was cultivated to suggest a crowd of voices in which meanings continually appeared only to fade again—much as, in a race, one leader may be repeatedly replaced by another. And, to give a mythological coherence to this stadium of syllables, the opening lines of Pindar's First Olympian Ode were invoked. In these the poet praises Olympia. As a place for a festival, he says, it surpasses all others. And he uses three poetic comparisons to justify his claim. First, Olympia is pre-eminent as water is; second, it is comparable with gold, which, like fire blazing at night, gleams more brightly than any

other form of wealth; and third, it outshines all other places as the sun outshines all other stars.[17]

To meet the requirement that *Relay* should interpret the meaning of the Olympics to Australians, I focused on three historical moments (influenced by Pindar's imagery) and one moment in the future. The historical moments were the birth of the modern Olympic movement and the first modern Games held in Athens in 1896; the 1956 Games, which took place in Melbourne, Australia; and the (at that time) imminent 2000 Sydney Olympics. The moment I imagined in the future was one in which the neo-imperialism that seemed to have subverted the Olympic spirit was reversed, and a green, socially democratic, and environmentally sustainable Olympic Games was put in place. This would not be entirely an innovation. It would recollect and reinvent the principles that informed the 1896 Olympics. As we had four tiers or terraces at our disposal, we were able to dedicate each tier to a different historical moment.

Further, we were able to differentiate the four tiers *chromatically*: besides using a basic palette of black and white, Lewis and I had decided that the letters of *Relay* should be picked out in four colors: red, blue, yellow, and green. Lewis both designed the typography and blended the colors. We used these colors to create respectively a "red" tier (1896 Games), a "yellow" tier (1956 Olympics), a "blue" tier (2000 Olympics) and a "green" tier (a future Olympic festival). The quotation marks indicate that the tiers were by no means entirely composed of one color. Each of the four tiers used all the colors, as well as black and white; it was the relative predominance of one color over another that changed from tier to tier. In the same way, we allowed ourselves some license in interpreting the symbolic significance of the different colors. There is, for example, an obvious correlation between Pindar's second simile, comparing Olympia to gold, and the association of the Melbourne Olympics with the color yellow. And, in fact, the sense that the 1956 Olympics provided a kind of golden summer in the relatively bleak midwinter of cold war politics is one of the themes developed in that tier. In other tiers, though, the correlations are less exclusive.

The Roman poet Horace wrote that Pindar's figures of speech, one tumbling out after another, recalled "a river rushing down from the mountains and overflowing its banks."[18] Of course, *Relay* did not claim Pindar's metrical mastery, but its lines certainly conveyed a sense of tumultuous movement. Take the second line of the red tier where the courageous women themselves are addressed (Plate 16):

SEMIMONSTERSOSWIFTANDBLITHESOMEWATERBORNEADROITAS
DIVERSHEAROHERAOURBLOODISRACINGWELESSTHANZEROTAKE
OURCHANCESANDWITHOUTWINGSWOOINGENIUSPIRALUPWARD

AIRSBATONBREATHINTIMEOUTLAPPEDFORSISTERSWHOHAVE
PASSEDAWAYEVERUNNINGEVERAPT

Here the formal devices mentioned before are illustrated: the printing of the text in *scriptio continua*, the frequent overlap of first and last letters, the ungrammatical, *anacoluthon* style of writing. The frequent changes of voice are also evident. In the first phrase, it is the voice of the public that addresses female athletes as "semi monsters"; a little later, it is the athletes themselves who address their patron, Hera; further on, the prayer of the sisters is itself dotted with quotations that reflect the historical struggle of women to gain acceptance and recognition in the arena of competitive sport.

Late Victorian men used all manner of pseudo-scientific arguments to justify their prejudice against women's competing in sport. In a pastiche of Darwin, they claimed, for instance, that women were less well-formed, and therefore insufficiently developed, to exhibit the skills required to excel in life's supreme race. Women were still immersed in their primeval animal natures; creatures of ocean, their sinuous, curviform bodies indicated their watery origins. Added to this was their biological function; the fertile womb and its entrance were likened to underwater passages and caves, or to bivalves and other muscular mollusks. In this context, the second line of the red tier suggests that in order to gain recognition women had, both metaphorically and mythologically, to emerge from the sea onto dry land. If they remained fluid, they could leave no trace behind, make no mark in history. Male pundits greeted the successes of pioneering women athletes with derision—a woman who offended against her supposed true nature, as the pioneer cyclist Frances Willard was supposed to have done, was a "semi-monster."[19] Even in praising the female athletes' performance—as "adroit as divers"—patronizing marine imagery was never far from the surface. When today's women celebrate victory, they also commemorate those whom prejudice once prevented from competing. Adapting a remark of Debbie Flintoff-King, they run "for sisters who have passed away." "Eve running," it is asserted, is "Eve rapt." But the fusion of words creates an ambiguity that allows us to read, against the male bigots, the feminist argument that Eve was "ever apt."[20]

Similar historical information is secreted in the other lines of *Relay*, and it is a pity that the Olympic Coordination Authority failed to honor its commitment to print a guide to the work. *Relay* was not intended as a history lesson, but, as we pointed out in presenting the concept, it had obvious and exceptional educational potential—how could it be otherwise when the brief called for a work that would represent to Australians the meaning of the Games? It also, we thought, articulated key themes of the Sydney Olympics—a prophecy remarkably fulfilled in the Games' opening ceremony. Instead, the rhetorical appropriation of the

work before the Olympics—I believe it was the first of the commissions to be installed—was as remarkable as its neglect after the Olympics. History is permissible in political culture on the condition that it makes no difference. Public servants willingly endorse events provided that nothing whatsoever happens.

One of the leading and recurrent themes of the inscriptions was, in fact, a history in which things happen or take place. While many nuggets of quoted testimony were caught up in the tumbling rhythms, the movement of the lines themselves was intended to articulate a history in which time was replaced by timing. In this even what is permanent or enduring only becomes real when it is actualized. Pindar's poetic athlete experiences *charis* between two strides of the dance, or in the instant, which is always both timeless and fleeting. A line in the yellow tier, which adapts a recollection of the great runner Betty Cuthbert, illustrates this (Plate 17):

MOUTHOPENWIDETOWARDSENDHURTINGCANTSTOPTOSHUT
ITNOWGOINGTODOITWINITDONEITIMETHEREVERSAMEAGAIN
SIDEMERIDERLESSBEATHISHOOVES

In the wake of winning the race, the blood beats in her ears as loudly as horses' hooves. It is as if the rhythm of her running has been extended beyond the end of the race into the life that follows. Through the body's memory, it becomes the measure against which other events are calibrated. *Kairos*, the time of opportunity—represented here by Cuthbert's genius in threading the eye of time—is not wholly swallowed up in the moment, but leaves a lingering trace, like footsteps impressed in the pavement of *chronos*.[21]

Sport is in a sense a history of ecstasis, of moments in which exceptional athletes stood outside themselves, and this history also presumably has its history. One of its origins, as a passage developed from a remark of Olympian athlete Glynis Nunn suggests, is childhood daydreams. Children are nurslings of immortality in a double sense when they lie in the grass, watching the clouds float by overhead; then they remember where they came from, and imagine where they can go:

DIDYOUSETOLIELONGRASTORYSHAPEINCLOUDSOWHATOBETHEN
PASSNOTREPOSERECALLDESIREACHILDLISTENTOTHEWINDBLOW

A history of instants, like a rhythmic geography, is composed of a dyadic relation. As the stride always means a minimum of two footsteps, so the movement of a history imagined as Kafka imagines it, is always suspended between

stillness and the leap. The environment of the supreme pose in which the athlete is completely one with her motion is one of repose. It is the intuition of an utter stillness that distinguishes the greatest athlete; but for this their achievement could not stand out. It would merge with the general cinematic blur of things passing by. It could not be marked in passing.

The same logic applies to the eyewitnesses of this history. The spectators who appreciate what is happening in front of them are not the same people who idly take account of the confusion of trajectories that impinge on them in the high street as they weave a pedestrian path or dodge the traffic. They are rapt, caught up in a sympathetic movement experienced kinesthetically as well as visually. And this movement is moral; if it were not, to speak of *bad* spectator behavior would be meaningless. A proper appreciation of sport is one that admires the manifestation of measure or *charis*. The crowning achievement of *charis* is to harmonize ambition, to turn the arrow of limitless ambition into an arc that shows us the way back to ourselves and to a richer inhabitation of the ordinary ground. This memory of extraordinary grace is the lesson a history of instants teaches. As the fourth line of the red tier says:

COURAGENDURESLOVESHALLOFAMEANDORDINARYWONDER
SPORTISARTOFLIFEATHISFARGOANDNOMORE

"Art of life" in this formulation is the art of meeting. It is the cultivation of that kind of "communication," imagined by Jean-Luc Nancy, that produces neither fusion (unanimity) nor self-interested exchange, but embodies a primary sociality "located in the interstices of mutual exposure, in the in-between space of co-appearance."[22]

Athletes, *Relay* suggests, also make history in a double sense. They not only perform feats that are exceptional and memorable, they are the writers of their own deeds. This is poetically justified by the close resemblance between the words "sprint" and "print"; when written in *scriptio continua*, it is not easy to decide which word is intended. St. Paul used the simile of printing to explain the process of conversion to Christianity; one was imprinted with the character of Christ.[23] This thought came back to me when I read a comment by that most intriguing of Australian Olympians, Shane Gould. Alluding to her victories, she quoted from St. Paul's second letter to the Corinthians—"We are not competent to claim anything for ourselves but our competency comes from God."[24] Part of this line occurs in blue tier 1. In the same letter Paul explains that God has made the followers of the New Testament ministers "not of the letter, but of the spirit."[25] In this regard a new kind of "glory" is theirs—for, like athletes, these

slaves of the lord have opened up new paths of hope. In a way, they have put to death Death. In embracing the promise of immortality, they have outsprinted the grave.

MASTERSOFMETRESHEARERSECONDSTRETCHOUTHEREAFTER
MINEWHATHANDSANDFEETDOBRINGSRENOWNDEATHSPRINTERS

Elsewhere, this race of puns continues: for even their flight from the grave is engraved—in the marks their renown has left—in the tablet of the memory.

The green tier suggests that what is true individually might, in principle, come to pass collectively.[26] But the realization of a green Olympics—in many senses—would require a capacity to think figuratively, to embrace the spirit of the Games rather than seeing it as a competition whose only object is to glorify the host nation. An Olympics of the spirit would be one in which the architecture of the event would merge with all that happens. The ground plan would be written through the trajectories of the athletes themselves. As those paths follow traditional routes—athletes are the most pious of people because they tread religiously in the footsteps of those who have gone before—the patterns made would be a concomitant mode of production through which an originally self-evident creation was regained. But this achievement demands a different view of history, one where we participate in the production and renewal of the past. It demands the mediation of the artist; isn't it through the painted ground of their designs that the Western Desert painters induced renewal? (Plate 18)

ACITYBUILTOFEETISAWLETTERSPRINTINGKNEESHARDASQUARTZ
GREATSIRESOFTHISPAINTEDGROUNDINCREASEITSYIELDFLOWER
INWORDSTRUEANDFAITHFULDEARPEOPLELOOKNOTBEYONDER
AIRGRAINSOFSENSECRETEDHEREADVANCEAUSTRALIAFAIR

The new Australia will not be "pure gold, like unto clear glass."[27] Its re-foundation depends on attending to the humble ground, to the dwelling place it affords us, to the sustainable society it invites if we learn to read what is written there, playfully following the paths it opens. For this re-foundation to happen, these graven letters would have to rediscover their physical origins in the dance work of human limbs. It would be necessary to understand sport, like society, as the performative renewal of place, as an act of collective self-becoming there. Reading the "grains of sense secreted here," *Relay* suggests, visitors not only repeat the words of their national anthem but repeat them differently.[28]

But, again, where does this future vision come from if not the observation of children playing? So green tier, line 3 runs:

OGREENGRAVELETTERSTOMYLOVEILOSTHEREMAYICROSSYOUR
GOLDENRIVEREADYESTOMORROWAITODAYOUNGANDSTEADYET
READAPATHANDSDANCINGAMEASUREPLAYSMAGICOMINGAFTER
WINSTHETAGOLD

Imagining the future of the Olympic Games as green in many senses, I borrowed here from a children's game known as "Green Gravel."[29] The line is a compacted anthology of *going* rhymes of the "how many miles to Babylon" variety. It suggests that mastery of the stadium, no less than of life, consists, in the first instance, of playing among these granite tiers. There is no hurry. Besides, if you care to decipher the intellectual hopscotch secreted inside the line, not least in the terms "engrave" and "grave," you will see all the future captured in an instant. But the instant, and the desire to grasp it, constitute a history in themselves, one only those prepared to hazard everything can enter, a point green tier, line 4 makes as it evokes again the temporal enigma of athletic excellence, on this occasion through the experience of the semimythical Dawn Fraser:

ATIMESHOULDEREACHANCELAPSEIZEROUTHROWHAZARDICEAS
AHEADAWINICKAIROSWIMMEROBYAFINGERTIPANEWORLDEFINE

Before Mallarmé promoted it as a tool of poetic composition, hazard was a dice game "in which the chances are complicated by arbitrary rules."[30] Here the complicated rules of *Relay* allowed me to seize the opportunity of secreting the Greek word *kairos* inside the English line. It signifies the reader's chance to read against the grain, to see physically as well as conceptually that instant between two strides in which a way opens up and the great design momentarily emerges. Then, as the fifth line ambiguously suggests, momentarily severed from the nightmare of things going on as before, one is, through the artwork written in stone and played upon by fountains, joined to a history of instants endlessly renewed.

STONELIPFLOWMAKEINSTANTSEVERLASTOSHINE

### Secreted Sense

The texts of *Relay* tried to meet an educational brief. In addition, they take the paradoxical invitation to write a history of instants as an occasion to explore the way writing and drawing are designs on the world. In this sense, an attempt *was* made to retrofit the Hargreaves design with a movement form that would equip it for future performances of sociality. But this was only part of our design. The addition of four colors to our black and white palette meant that we could

exploit the ambiguities deliberately written into the inscriptions. Some of these were lateral, depending on where the reader chose to make a break between words, but others were deep, relating to words secreted inside words or phrases. Easily passed over or even consciously repressed as semantic noise, these other words constituted the dark writing of *Relay*. By using a different color to highlight them, we could display a different, sometimes subversive countermeaning in the text. Inside the tumbling, breathless progress of thoughts, there was something that might cause readers to stumble, to catch their breath.

Welling up from within the materiality of the lettering were patterns of meaning that arose unbidden, as if English orthography had the power not only to spell out the words we wanted but to bring along with them a shadow company of other, related words whose function was to bring us back to the occasion of reading, the place where we stood. We used this facility to let the omitted history of the Fig Grove site shine through. But we also used it to reflect on the category of public writing itself, for traditionally monumental lettering in public places has been used to commemorate the dead. What could the genre of epitaphs have to do with an artwork that intended to celebrate an art of life in which Death was, however briefly, outwitted? And underlying both these questions was the interrelated one of Indigenous presence and absence, both from public memory and from the history of the Games.

We knew two great facts about the Fig Grove site. First, that from an Indigenous perspective, it is "not a place that can be easily defined as being either coastal or inland." In conflicts between Garug and Eora/Dharawal people, it served as a zone where the usual rules of survival could be suspended and where, transcending tribal restrictions, the people coming there recognized Homebush Bay as "a meeting place shared between inland and coastal groups."[31] If this is true, our modern monument to the athlete was to be built on a site once dedicated to acts of ephemeral amity, a place where playfulness was politically, as well as poetically, prized. Second, we knew that, in more recent times—when Indigenous people had been violently driven away from the place—the site of our work had been a public slaughterhouse. The Moreton Bay Figs that would shade visitors to the Games had formerly given cattle respite from the sun as they waited their turn to be slaughtered. The slaughterhouse had not been forgotten; its physical footprint had been preserved in the paving pattern Hargreaves had designed for the new site. But this elegant assimilation of a lost heritage to a new amenity hardly, of course, preserved the groans and cries.

Because of the ancient Greek inflection of *Relay*—how could a history of the Games not recollect and seek to renew its beginnings? These associations of the site with death and forgetting made me think about the meaning of *writing here* in classical terms. In the Western tradition, most public writing, as I said,

takes the form of an apostrophe to the living to remember the departed; dedications, epitaphs, and other memorials may address us in the here and now, but only to recall us to the hereafter. Classical poets told the story of the Arcadian shepherds who came upon a tomb on which were inscribed the words *Et in Arcadia ego*—words that, as the art historian Erwin Panofsky argued, are not those of the deceased but mark the pervasive presence (and chisel) of Death.[32] In this sense, locating writing in the arcadia of Fig Grove is to be the amanuensis of mortality. It is to accept an unresolvable dilemma: that, while the stone lettering lasts, the events it commemorates fade away. The liveliness of the lines, their very lack of irony, becomes profoundly ironic. And their colored dance becomes a veil disguising the actual rottenness that lies on the other flank of beauty.

The Greeks got round this in a way by arguing that something in a life was immortal. As an athlete could enjoy *charis*, so men (*sic*) in general could possess *arête*; while acknowledging that the gods were literally everlasting, they thought that a mortal being could by virtue of a great deed pass outside time into a timeless condition "in which his *arête* is fixed and permanent."[33] It is this intuition, according to Sir Maurice Bowra, that "lies behind their statues, their epitaphs, their funeral *lekythoi*, their gravestones, above all their songs which recall a man as he was at his triumphant best and enshrine him in the memory of later generations against the enmity of time."[34] In this sense "visible memorials" attested to an invisible virtue. To see, and to read, were, even in ancient times, not innocent acts. Acknowledging an absence, they were by their very nature commemorative or elegiac. In this case, *whatever they said*, the letters of *Relay* signified the presence of Death. The mistake would be to presume they merely addressed readers in the here and now and referred only to the affairs of the upper world, when in reality they addressed an unspeakable absence.

But in this case the challenge was not to allow the inscriptions to bury what had happened again. Suppose that *Relay* had piously aimed to resurrect the missing Eora legacy, or suppose it had insisted on reminding sports goers that this had once been a place of sacrifice—in both cases, this risked making these facts part of the upper world's great historical pageant. Instead of marking an absence, it would have created a presence that, while calculated to satisfy a queasy conscience, avoided any uneasy encounter with the nature of what had happened. After all, no one *wanted* to remember what had happened. They wanted to bury it in the past. A commemorative text that truly remembered would remember this desire to forget. But is this possible? Could a dark writing be imagined that communicated what distinguished Aboriginal performer and actor Ernie Dingo refers to when he says that in white Australia Aboriginal culture is like the dark side of the moon?[35] Such a dark writing would have to conceal its meaning from eyes all too ready to scan it quickly for its immortal meaning? Only then, in the

senses secreted between the words, could a writing be imagined that survived the tomb of reading and enlisted a style of interpretation in which the traces of the forgotten shone forth more brightly.

On this basis the *Relay* inscriptions were richly loaded with puns, with isolated proper names and quotations that, like Edgar Allan Poe's purloined letter, lay in full view but on that very account remained disguised. In red tier 2, 3, and 4, Ate, daughter of Strife, appears, she who leads men and women into rash and intemperate actions, who sabotages *arête*; also Dis, the god of death and the hollow underworld; and finally, mysteriously, *Argo*, the name of the ship that delivered Jason to the labyrinth and whose voyage (according to Seneca) inaugurated imperialism. In these cryptic words within words—whose letters were always documented in a single color so that they should stand forth even if they seemed to make no sense in the context of the text as a whole—the authority of the stone writing was simultaneously preserved and eroded. If, as Panofsky speculated, the author of this kind of writing was none other than Death, then, in the surfacing of these unintended expressions, Death began to spell out its own name.

From an Indigenous perspective these inarticulate portents hidden in the matrix of eloquence recall another death—that of the Sydney Language. At least the learned can recognize words culled from ancient Greek, but who can speak the oldest languages of the place? To address this, the first line of the blue tier 1 asks what the "golden age" of the Melbourne Olympics means nearly fifty years on when Australia's federal government still blocks all attempts at both symbolic and practical reconciliation. It does it punningly and secretively: Embedded in the phrase "now the ore era comes round" is the word "Eoreera," meaning in the tongue of the Eora people *to throw*[36] (Plate 19). The phrase not only means "now the golden age [the era of *ore*] comes to an end"—with all the Western mythological associations of successive ages, declining one from another—but has embedded in it another idea, of *whirling*—a bullroarer image of the sacred, where whirling both flings away and brings back.

A more viscerally ambiguous use of an Eora word occurs in blue tier 3 where, immediately after the prayer "reconcile us to our history" is written "turn war away your past relay u [or yu] win." The final phrase, which looks like text message talk for "you win" (i.e., by facing up to your history, you all—the entire nation—win), is glossed in an early *Vocabulary of the Sydney Language* dating from 1790 as an affirmative interjection meaning "Indeed! Or it is true."[37] But the key ambiguity occurs earlier where "turn war away" has embedded in it the word "wara," widely attested in First Fleet sources as meaning "stop" or "go away."[38] To have grounds for reversing this injunction is the aim of reconciliation—and to achieve it is, in any language, to turn war away.

But what of the site's recent industrial history? Animals could hardly speak

of their suffering. Besides, any allusion to the site's function as a slaughterhouse needed to be in keeping with *Relay*'s thematic and mythological repertoire. From the time I first saw them, Hargreaves' drawings had struck me as intensely theatrical. When I tried to visualize their "grove" with its approach of giant steps, I was reminded of the stage directions for Sophocles' *Oedipus at Colonus*. Set apart from the citadel of the main Olympic Stadium but adjacent to it, wasn't Fig Grove's situation rather like that of "the native seat of rock" within a grove that Antigone directs her blind father to as they come within view of Athens?[39] And the similarity was not only physical; enquiring the name of the place, the Thebans find that they have trespassed where the Furies, "Dread brood of Earth and Darkness," preside.[40] At length the Chorus, representing native worshippers, lead father and daughter away: "Move sideways towards the ledge / And sit crouching on the scarped edge."[41] In any case Oedipus has clearly stumbled into a realm where, despite its appearance of arcadian welcome, chthonic powers rule, turbulent forces continually threatening to spring back from the underworld.

When, a year after *Relay* had been completed, an adjustment to the landscape design created an opportunity to supplement our work, I remembered the Oedipus connection—and the unfinished business at the site. I also recalled that at the end of the play, as Oedipus prepares to sacrifice himself for the general good, he is attended by the king of Athens, Theseus, the same hero who made a career of slaughtering animals. First there was the Marathonian bull, then, with Ariadne's help, he penetrated the Cretan labyrinth and slew the Minotaur—to whom each second year Athens had been obliged to sacrifice seven maidens and seven youths. (An important link in this associative chain, it occurred to me, was the word "Crete" already secreted in the first line of the green tier when *Relay* was originally composed but whose significance had hitherto remained obscure.) Clearly, the semimythical bull slaughterer enjoyed a particular wisdom and familiarity with the kingdom of Death. This is not surprising in view of his exploits in the labyrinth, but in fact he owed his knowledge of the underworld to another exploit.

In his own day the lyric poet Bacchylides was as famous as Pindar, but as mere fragments of his work survived from antiquity, little was known about him. Then, in the year the first modern Olympic Games were held in Athens, a papyrus preserving some of his odes was discovered. Among them was an elaborate poem describing how, even before reaching Crete, the great legendary hero of Attica had successfully challenged and outwitted the tyrant of Minos. Hearing of his reputation, Minos had taunted him, saying that if Theseus were indeed the son of Poseidon, god of the sea, let him dive to the bottom of the sea and recover a ring of his that had been lost there. This was an invitation to drown himself. Yet Theseus accepted it and dived overboard. Escorted by dolphins to a marine

underworld and presided over by his mother Amphitrite, Theseus returned to the surface, not with the ring of Minos but with a wreath, symbol of the knowledge with which his dive had crowned him. This wreath was the original of those later bestowed upon Olympian athletes and other victors in life's race.[42]

So, in memory of those gone down to the underworld, a diver was placed in our design (Plate 20). Derived from the famous tomb painting of a diver found inside a fifth-century BC tomb in Paestum, southwest Italy—the fresco is roughly contemporary with Pindar's First Olympian Ode—his figure commemorated the slaughter upon which our shining monument of praise had been erected. He was the one whose absence had been felt. A true athlete of the spirit, he had understood the sacrifice demanded when the Chorus approached Dis with the urgent prayer "Speed this stranger to the gloom."[43] But it was not all darkness. When the fountains came on, and when the children ran squealing under their arcs of water, their limbs criss-crossing the background of letters, moving forms began to plunge, and the stones wetting their lips seemed to make the "buried sounds to sing."

## Notes

1. See Paul Carter, *The Lie of the Land* (London: Faber and Faber, 1996), 78, 318–320.

2. Philostratus, *Imagines*, trans. A. Fairbanks (London: W. Heinemann, 1931), 94 n. 2.

3. Philippe Lacoue-Labarthe, *Typography: Mimesis, Philosophy, Politics* (Cambridge, Mass.: Harvard University Press, 1989), 201.

4. See Paul Saenger, "Physiologie de la Lecture et Separation des Mots," *Annales ESC* 4 (Juillet–Aout 1989): 939–952, 943. *Scriptio continua* presumed that the reader was to some extent already familiar with the text and could therefore read it rhythmically, bunching its elements into meaningful phrases. Punctuation and spacing became important when familiarity with the texts diminished (or, which is the same thing, the audience for them expanded). Punctuation was a visual scaffolding erected to disguise the breakdown of shared pathways of memory. M. B. Parkes, *Pause and Effect: An Introduction to Punctuation in the West* (Berkeley, Los Angeles: University of California Press, 1993), 23.

5. This notion is a variation on Husserl's idea that the intention of the original is recaptured through a "concomitant mode of production." The Russian writers Velimir Khlebnikov and A. Kruchonykh expressed an analogous thought in their manifesto "The Letter as Such": "When a piece is copied over, by someone else or even by the author himself, that person must re-experience himself during the act of recopying; otherwise the piece loses all the rightful magic that was conferred upon it

by handwriting at the moment of its creation, in the 'wild storm of inspiration.'" *Collected Works of Velimir Khlebnikov, Vol. 1: Letters and Theoretical Writings*, trans. P. Schmidt (Cambridge, Mass.: Harvard University Press, 1987), 258.

6. W. Mullen, *Choreia: Pindar and Dance* (Princeton, N.J.: Princeton University Press, 1982), 100.

7. Ibid., 118.

8. Ibid., 101.

9. Ibid.

10. Ibid., 92.

11. Ibid., 90.

12. Ibid.; also see Pindar, "Peer no Further into the Beyond," in *The Odes of Pindar*, trans. Sir J. Sandys (London: Heinemann, 1919), 15.

13. Mullen, *Choreia: Pindar and Dance*, 116.

14. Ibid., 130.

15. In a similar spirit Walter Benjamin speculated, "'To read what was never written'. Such reading is the most ancient: reading before all languages, from the entrails, the stars, or dances. Later the mediating link of a new kind of reading, of runes and hieroglyphs, came into use. It seems fair to suppose that these were the stages by which the mimetic gift, which was once the foundation of occult practices, gained admittance to writing and language." Walter Benjamin, "On the Mimetic Faculty," in *Reflections* (New York: Schocken Books, 1986), 160–163, 162–163.

16. The great majority had been inscribed in a dedicatory copy of Harry Gordon's *Australia and the Olympic Games* (St. Lucia: University of Queensland Press, 1994), and we remain grateful to Harry Gordon for making his copy available to us (and of course to the athletes).

17. Pindar, *The Odes of Pindar*, 5.

18. Ibid., xvii.

19. Frances E. Willard, "How I Learned to Ride the Bicycle," in *Out of the Bleachers: Writings on Women and Sport*, ed. Stephanie L. Twin, 105 (New York: The Feminist Press, c.1979). The editors of *Readings in the Aesthetics of Sports* put it more positively. Recalling Sir Thomas Browne's description of man as "the Great Amphibian," born of the waters of the womb into the free air, they see immersion in sport as a return to that experience of psychophysical integration. H. T. A. Whiting and D. W. Masterson, eds., *Readings in the Aesthetics of Sports* (London: Lepus Books, 1974), 13.

20. A useful source of information for this tier was Dennis H. Phillips, *Australian Women at the Olympic Games, 1912–1992* (Kenthurst, N.S.W.: Kangaroo Press, 1996).

21. An important source of words was Betty Cuthbert, quoted in Marion K. Stell, *Half the Race: A History of Australian Women in Sport* (North Ryde, N.S.W.: Collins/Angus & Robertson, 1991), especially 119ff.

22. See chapter 6, note 61.

23. See Paul Carter and Ruark Lewis, *Depth of Translation: The Book of Raft* (Melbourne: NMA Publications, 1999), 77.

24. 2 Corinthians 3:5.

25. 2 Corinthians 3:6.

26. Without wanting to inflate the importance of *Relay*, its style is "pre-dictive" in Julia Kristeva's sense because it defines the future as a historical epoch whose completion can already be imagined now. Her point is that certain kinds of poetic language possess this power, as they respond to a present crisis (political, social, or cultural) "with a future then impossible, but which takes the appearance of an anteriority." The "elitism" of the Futurists' style is defended on these grounds. One reason why poetic language can work in this way is because it is rhythmic—"risky" because it allows "the speaking animal to sense the rhythm of the body as well as the upheavals of history." See Thomas Foster, "'Prediction and Perspective': Textuality and Counterhegemonic Culture in Antonio Gramsci and Julia Kristeva," in *Maps and Mirrors: Topologies of Art and Politics*, ed. S. Martinot, 222–246, 227–228 (Evanston, Ill.: Northwestern University Press, 2001).

27. Revelations 21:18.

28. On the need to reorient the Olympic movement generally, see John A. Lucas, *Future of the Olympic Games* (Champaign, Ill.: Human Kinetics Books, 1992), especially 210–214.

29. Found in Alice B. Gomme, *The Traditional Games of England, Scotland and Ireland*, 2 vols. (New York: Dover Publications, 1964), vol. 1, 170.

30. *Shorter Oxford English Dictionary* (Oxford: Clarendon Press, 1968), 874.

31. Emma Lee and Darwala-Lia, *Aboriginal History of Homebush Bay Olympic Site* (Sydney: Metropolitan Local Aboriginal Land Council, 1999), 20.

32. Erwin Panofsky, *Meaning in the Visual Arts* (London: Peregrine, 1970), 340ff.

33. Maurice Bowra, *The Greek Experience* (New York: New American Library, 1957), 213. The connection between *arête* and athletics is the subject of Stephen G. Miller's *Arete: Greek Sports from Ancient Sources* (Berkeley: University of California Press, 1991).

34. Bowra, *The Greek Experience*, 213.

35. Quoted by Colin Tatz, *Obstacle Race: Aborigines in Sport* (Kensington: University of New South Wales Press, 1995), ii.

36. Jakelin Troy, *The Sydney Language* (Canberra, Panther Publishing, 1993), 70. The word is found in William Dawes language notebooks. Troy reads "eereera"; I thought the second letter was an "o."

37. Troy, *The Sydney Language*, 80.

38. Ibid., 79.

39. *Sophocles*, trans. F. Storr, 2 vols. (London: Heinemann, 1946), vol. 1, 147.

40. Ibid., 151.
41. Ibid., 165.
42. Anne P. Burnett, *The Art of Bacchylides* (Cambridge, Mass.: for Oberlin College by Harvard University Press), 29–37.
43. *Sophocles*, 287.

CHAPTER 8
# Dark Writing:
# The Body's Inscription in History's Light

> *A knowledge of photography is just as important as that of the alphabet.*
> —László Moholy-Nagy

## Underwriting

What is "dark writing"? In the first three chapters it referred to the trace of movement that is arrested in spatial representations. A history of journeys, encounters, inclinations, and leaps of faith can be shown to survive in maps and plans once their symbolic character is recognized, and it is these supplementary inscriptions that constitute dark writing. Dark writing alludes to the bodies that go missing in the action of representation. But it does not seek to replace them—to represent them. Aligned to their passage, it registers their passage graphically, as a pattern of traces. In the last three chapters, three projects were narrated in which this theory of the movement trace was put into practice. These showed among other things that dark writing is not simply a figure of speech for what is left out of Enlightenment-inspired descriptions of space. It is a method, a poetic praxis that works outwards from a perceived anomaly, absence, or oversight toward its marking. Instead of seeking to manage a swarm of positivities, a design language that emerges in this way makes room for the swerve, the passage, the fold in space-time that materializes movement. It puts the body back into space, not in the form of an obstacle to movement but as a figure glimpsed midstride.

This approach to thinking, writing, and drawing is vulnerable. Its commitment to invention, to a process of coming across things, is easily overtaken by theories of place making that pre-empt the role that the lie of the land may have

in their formation. In these, the ideal grid of the map is thrown over the earth with such authority that the particularities that grow up in its midst—the rationally organized cities and the checkerboard of countryside squared off for farming—are homologous with it; whatever may be the case in rural France, there is in the "China" of colonial agriculture no room left for margins or movement of any kind. In an illuminating discussion of the ontology of mathematics in the work of Alain Badiou and Gilles Deleuze, Daniel Smith explains how Greek geometry distinguished between theorems and problems. Theorems "concerned the demonstration, from axioms or postulates, of the inherent properties belonging to a figure, whereas problems concerned the construction of figures using a straightedge and compass."[1] Because of this, "in theorematics, a deduction moves from axioms to the theorems that are derived from it, whereas in problematics a deduction moves from the problem to the ideal accidents and *events* that condition the problem the cases that resolve it."[2] As a design practice easily overridden by the *force majeure* of axiom-based linearism, dark writing is problematic in both senses.

As a philosopher committed to demonstrating the ontological status of problematics, Deleuze is clearly on the side of inventors. But he is also conscious that the weakness of problem-based science (by definition it is vulnerable to the external accidents that condition it) also prevents it from being autonomous. It stands in a hierarchical relationship with axiomatics; the "translation" between the "'ambulatory' sciences" and the Royal science of disciplines that are axiomatically grounded is unavoidable. For this reason it is where an engaged philosophy (and geography) has to focus.[3] The challenge is always to prevent an act of intellectual homogenization designed to restore the authority of axiomatics. It is this reduction that is played out in the domain of Enlightenment cartography, where the problematic status of geographical knowledge (based in events) is repeatedly disguised so that (for example) the movement forms of the navigator's chart reappear in the published work as stable outlines reinscribing the geographical status quo, the sharp distinction between land and sea. The relative triumph of the theorematic over the problematic in Greek geometry, Smith explains, presented itself "as a necessary 'rectification' of thought—a 'rectification' that must be understood, in a literal sense, as a triumph of the rectilinear over the curvilinear."[4] By contrast, a problem-based science, inclined to follow the course of events, would not conceive the line as an essence. It would regard it as a verb rather than a noun, defining drawing the line as "a continuous process of 'alignment.'"[5]

Ambulatory science does not have to submit to Royal science—even if it did in the case of *Tracks* and *Solution*. By chance, while writing this book, I had the chance to study the elaborate dock system in Liverpool. I wanted to know how it was done, what theory of construction, in particular, did Jesse Hartley, the mid-

nineteenth-century chief engineer responsible for much of it, deploy? How could he confidently raise five-story warehouses close to the edges of masonry walls sunk directly into the alluvial silt of the Mersey (or fragilely resting on scanty submarine rafts of wood)? But the answers to these questions proved remarkably hard to find. Smith and Weir (respectively experts in the history of design and in engineering conservation), in an article raising just these questions, confess themselves baffled. They conclude that Hartley was not a civil or structural engineer, proceeding on the basis of mathematical calculation and physical theory, but a craftsman, whose practices were guided by successful precedent, by a feel for his materials, and by the practical exigencies of the situation. Hartley had "to exude confidence that he already knew," and the authors compare him to Isaac Newton, who "seems to have known, in some mysterious intuitive way, far more than he was ever willing or able to justify."[6]

Hartley's achievement was, it seems, a perfect example of Deleuze's "ambulatory" science at work. These sciences—they include metallurgy, surveying, stonecutting, and perspective—"subordinate all their operations to the sensible conditions of intuition and construction—following the flow of matter, drawing and linking smooth space."[7] And this sensitivity to fluctuations "coextensive with reality itself," Deleuze argues, means that they can never be "autonomous"—a vulnerability of which axiomatically based science takes full advantage, at the same time making the work of the craftsman "difficult to classify, [its] history ... even difficult to follow."[8] The point then is that, on this account, Hartley's demiurge-like ability to improvise and innovate depended on the impression he communicated that he was *not* inventing anything new. Smith and Weir's puzzlement simply illustrates the hierarchical relationship between axiomatically grounded theory (in this case in the form of the arithmetically formalized principles taught to engineers) and problem-based and problem-generated practice. Making can be theorized, but that doesn't produce a theory of making.

The genius of Hartley points to an important feature of dark writing. As an approach to design, its aim is not to increase the legibility of the environment. The object is not to make the environment more significant—to replenish its scrubbed-clean board with signs of life and indications of action. To do this is the scriptural equivalent of the modern world's attempt to plan the future without any memory of the past—it can only, as Verene says, produce an intensification of the present. When Abraham Moles announces the graphic designer's project as "to increase the legibility of [the] environment," he conceives it in terms of "an action landscape—a limitless text we must decipher through an effort, of which the 'printing types' are the elements of the structure and the recognizable 'signs', of which the 'phrases' are the successive decors of our wandering, and of which the unfolding constitutes the very context of each person's life, something

like a reading of the world."⁹ The difficulty of this approach is that it reduces the world to a text and the "wanderer" to an interpreter. The graphic designer—but it might be the author of any design that reduces the "limitless" to order—risks the imminent exhaustion of qualities of variety, difference, heterogeneity, and transformation that constitute the interest of the world.

To conceive of the environment as a page onto which are printed milieux of action is to perpetuate the myth of drawing itself, that the ground qua environment is the passive receptacle of actions (represented in the drawer's practice by figures). Moles' scheme offers a simulacrum of intercourse with the world but does not produce any mutual change. He sees his action landscape through the window of a speeding train. The act of decipherment is really an index of the varying speeds of the train rather than an insight into the appearance of the world. To gain that, it would be necessary to reflect on the tools of representation— on the fact that the "text" of the world is "written" in ways that cannot be translated using the designer's working principles of abstraction, simplification, and signification. The dark writing of the world cannot be read as if it were a particularly cryptic form of light writing. The materiality of its symbolic forms demands a different reading technique.

Materiality is the key here. Ernst Bloch reflected that the Enlightenment sought "to dispel imagined fear as a veil of fog." In the Nazi period this lust for legibility left people nowhere to hide. The lesson now is that "we must look beyond a partial, superficial form of enlightenment, sweeping away not only the fog but everything else that is not crystal clear, according to some narrow understanding whose field of vision is so constrained that less accessible material is completely excluded from it." This lesson has been widely taken to heart. Anthony Vidler's *The Architectural Uncanny* draws attention to a countertradition in modern design, originating in the architectural concepts of Boullée and Ledoux. "Transparency, it was thought, would eradicate the domain of myth, suspicion, tyranny, and, above all, the irrational." Against the Enlightenment's optimism that transparency could eradicate the irrational, Boullée's designs exhibit a "relentless desire to mimic the 'engulfing' of the subject into the void of death, a desire itself mimicked by Ledoux when he speaks of composing 'an image of nothingness' in his Cemetery project of 1785."¹⁰ Gilles Deleuze makes the connection between architectural projections and writing more explicit when, in *The Fold*, he describes the baroque crypt as the site of a special type of reading (and by implication, writing). In this connection, Gregg Lambert quotes Michel Serres: "it is probable that true knowledge of the things of this world lies in the solid's essential shadow, in its opaque and black density, locked behind the multiple doors of its edges, besieged only by practice and theory."¹¹

But when the writing in question is neither the darkness as such (Serres'

shadow world) nor the writing of the dark (in Vidler's example), but simply that dimension of inscription that exceeds the concepts communicated, then it is neither prerational nor postrational. It does not represent a collective inheritance of superstition, hearsay, and untested belief that inductive reasoning must painfully sift, reducing the "facts" to order. Nor does it signify a class of discursively destructive logical artifacts—shallow paradoxes, classificatory contradictions, binary oppositions, and other unintended consequences—that open up in the pavement of reason when its arguments go beyond the grounds supporting them. The dark is instead the interest of the phenomenal environment, its tendency to fall into movement forms, but for which stable ideas could not take shape. Consider the medium of printing as an illustration of this. If modernity is characterized by a flight from darkness, it is odd that print technology still utilizes *black* letters. No doubt there are technical, as well as traditional, reasons for this, but the inscription of knowledge in a sign system visualized, in dreams and in figures of speech as well as in printing practice, as spindly shadows, graphic brands, or other maskings of the light, white page—this may also indicate a cultural pattern. For one thing, the design of the printed page shows that the negative and positive aspects of light are related; black letters are the phenomenal appearances that allow the light of reason to be materialized. The enigma of their materiality —the sense in which the arbitrary glyphs of the alphabet resist the logical endgame of reason—is essential to their legibility and to our understanding of what they mean.

Dark writing is not opposed to the interests of light, it *underwrites* them. And it is tempting to try to retrace the pathways by which the term, and its Latinate double *subscribe*, received their present meanings. The legal authority of an underwritten agreement arises from the fact that the guarantor signs his or her name. It is the recognizably individual signature that shows they subscribe to the intention of the agreement. A legitimacy that goes beyond the letters of the law depends upon a return of the graphic repressed. It is the underwriter's handwriting that insures the legal document's power to bind. Whether the agreement secured in this way is inked, typed, or printed, it is the underwriting that *embodies* the intention of the document. The body in writing is, on this definition, its style, the calligraphic trace of the writer's presence. Insofar as typography carries conviction, it is because its design, the kerning of individual letters, the use or otherwise of serifs, the handling of the relationship between upper- and lowercase letters, imitates the movement forms of handwriting, imparting to the printed lines a *rhuthmos* visible to the eye ahead of any auditory impression that lines may make. It is the design of writing and typography that enigmatically bodies forth thought in a form that makes it persuasive. The clarity of an argument is inseparable from the orchestration of the signs that communicate it.

These, if they are to body forth ideas, must employ a visual rhetoric, appearing to retrace the becoming of an idea into being, so that in tracking the arrangements of letters on the page, the reader is retracing graphically the movement of the writer's mind.

Dark writing, as this book understands it, is the trace of the body. It is the registration of a double movement, intellectual and physical. It is what becomes discernible when we are angled toward our surroundings, proprioceptively navigating them. And it is the objective equivalent of this subjective impression of dappled order, the actual character of the environment, mottled, streaked, rough, modeling a history of passage. But the body that starts to form when dark writing is read is not an image. It is an alignment with an indication, a sensation the reader has of being induced to inhabit the gesture of another, and through that a personal history as it has been played out in the surroundings of a life. To illustrate this, let me offer three examples, one drawn from literature, another from the early history of photography, and the third from the realm of funerary art. This last manifestation of dark writing—painting explicitly designed for interment along with the dead—brings us back, incidentally, to the figure with which the last chapter closed: the painting of the Diver from Paestum.

### Julie's Hand

The peculiarly Germanic "sciences" of graphology and characterology (no less) might seem to be of purely historical interest. Still, it's worth dwelling on them for a moment if only because they provide an important intellectual context for modern ideas about the line and its moral and metaphysical significance. For instance, without the graphological idea that the lineaments of the soul are somehow inscribed in a person's handwriting or facial expression, the figures of speech Danish philosopher Søren Kierkegaard employed to describe various forms of social decadence are inconceivable. Kierkegaard identified true communication with the drawing of strong clear lines, pointing out that "unruly ink blots are hardly able to keep things clear and distinct."[12] The same train of thought leads him to identify the chatter of experience untransfigured by any coherent "life-view" with the hieroglyph. Both claim a spurious authority. By contrast, the individual who possesses character displays distinctive traits.[13] But for this assumption, the challenge that Kierkegaard's fictional ego, Johannes Climacus, sets for himself—"I can put my own life on the line"[14]—would make no sense.

As we saw, Kierkegaard readily extended this moralizing to the landscape.[15] A morally productive landscape is one lifted out of the swamp of muddled motives and dissipated intentions. One recalls in this context Thomas Mann's evaluation of Sigmund Freud: that he drained the swamp of the instincts.[16] It possesses a

topography that lets you know where you are. It can be marked, engraved with the signs of human progress, but it is sufficiently hard to resist being washed away. It is historical, bearing the traces of passage, but it also transcends the meaningless to and fro of everyday events. This characterological evaluation of the landscape not only ascribes moral qualities to it, recalling Playfair's claim that the geologist Hutton had a special gift for "perceiving the characters of natural objects," it is evident that a landscape in which the pencil of nature has visibly been at work has a metaphysical importance. Hutton's effort was directed at interpreting the "signification" of "the ancient hieroglyphics"—a task that would be futile if the characters did not truthfully communicate the nature of their origins. The same logic applies to Kierkegaard's swamp; expressionless, unable to retain impressions, and therefore offering no solid ground for the "leap" into the "avenue of the idea," it "confounds spirit and spiritlessness."[17] Its abyss is metaphysical as well as moral, not least because it is no abyss at all but an endless level.

In the context of our earlier account of the construction of the coastline in Enlightenment geographical discourse, the belief that moral and spiritual attributes could be derived from physical appearance—most influentially propounded in the phrenology of Francis Joseph Gall—also had an important colonial inflection. It is rarely pointed out that the colonial subject that forms such an intense focus of postcolonial discussion was not only human but topographical. The trope of ascribing a "face" to the landscape, and writing of places that looked ripe for settlement in anthropomorphic terms, presupposed a direct analogy between physical appearance and a potential for development. "Promising" or "smiling" prospects were those whose character suggested a readiness to be cultivated and civilized.[18] It's often said that the rise of dynamic psychology in the nineteenth century, dedicated to exploring facts of consciousness, displaced the older characterological tradition. But, in the work of Hermann Rorschach at least, a hybrid psychology emerged; his notion that a study of reactions to blots could provide an insight into unconscious motivation allied him with the school most famously represented by Sigmund Freud, but his faith in blots as hieroglyphs that signified clearly reflected a debt to the older tradition.[19]

Interestingly, in more recent attempts to ground dynamic psychology theoretically, the language of graphology has made a reappearance. Examining the figures of speech Freud used to describe the mechanisms of the unconscious, Jacques Derrida, for instance, has argued that "Repression 'contains an interior representation,'" for what is repressed is neither forgotten nor remembered. It exists in and as *writing*, the writing of the machine of consciousness that at once retraces. Repressed memories are remembered, but, he contends,

> one must emphasise the "re," both to account for the "original" and always unavailable writing (which is also and always its simultaneous effacement) and

for the return to consciousness of the repressed. For consciousness remembers by a further act of reinscription. It does not unearth the repressed. It rewrites it. "Press" in repression is etymologically one with "press" in impression—or in the printing press; repression, even as a word, implicates the scene of writing, and the holding back of the "re" is, at the same time, the duplication of what is inscribed along the facilitating and blocked paths of memory.[20]

In these accounts, writing gives access to inward, psychic states.[21] My interest here, though, lies in the possibility of a writing style that draws us *outwards*, extending a line from the depths of the psyche to the dappled environment of the everyday. Writing of this kind would be a contribution to the genre of self-writing referred to in chapter 1, which, instead of representing a personal psychological history, is a trace of the *periautographical*, or objective, conditions of a life. The line of such writing might be the graphic trace of *ingegno*, as Vico defines it, drawing *i contorni*, the "surroundings" or "environment" of a life. As has been pointed out already, though, the meaning of writing is tied to the way it is read. To discern the environmental trace embedded in writing would, of course, mean reading its signs differently, assigning value to stylistic qualities that in other psychological readings go unmarked. It would in all likelihood also mean reading environmentally—attending to the peripheral influences on the writings, its materials, its location, its occasion.

Here's an example. Anyone who has read Charles Morgan's *The Fountain*, curious perhaps about the interwar reputation of this now largely neglected novelist, will see that he is no female psychologist. His insight into women's lives is limited in the extreme—a special case, some would say, of his alienation from ordinary, everyday life in general. His psychological inexperience has, though, this advantage: it causes him to fall back on a kind of reverie about his emotional environment, and—in the character of Lewis Alison, musing on a letter he has received from his former pupil, Julie—this precipitates a curious process of deduction. Many years, it seems, have passed. Julie has married, but Lewis and she find themselves exiled in Holland. Some ancient undercurrent of attachment flows between them, but there has been no communication. Hence Julie's letter comes only vaguely attached to an image, and Alison, in responding to it, finds himself diffident in interpreting its meaning. It seems that Julie shares this uncertainty, as she follows up her first formal letter with a second, informal note.

From the beginning, though, Alison's interest in the letter is less focused on its possible purport than on its physical character. He is not interested in reading between the lines. It is "the material substance, the paper, the envelope, the handwriting" that fascinates him.[22] For, as he qua Morgan solemnly reflects, "[i]n the first letter that a man receives from a girl unknown to him but of whom an image, undefined but beautiful, has already formed itself among

the half-shadows of consciousness, there is an exquisite prompting or summons that is independent of the words' message."[23] That prompting is not a motive to penetrate the other's reserve by another means, to speculate about unconscious impulses:

> The summons is not that of curiosity only, and certainly not of analytical curiosity. Lewis did not examine the handwriting as a graphologist would have examined it, seeking indications of character in the upstrokes or the down, the fine, soaring t's, the g's that tucked their tails away under their bodies like little fat dogs seated on a hearthrug, the light, airy swirl of a capital S, the mingling of childish compactness and flowing impulse that was Julia's hand.[24]

Instead, Lewis discerns in the character of the handwriting and the letter as a whole something else: "not the particular indications that it gave but the feminine presence that it evoked."[25]

This impersonal discernment depends upon not having an image of her in mind. To have a representation of her before him would limit his imagining. It would enslave Julia to his idea of her:

> [H]er very self was communicated in the letter that had lain beneath her hand, and the communication seemed to be the more complete because it represented no particular aspect of a known human being. If he had known what her fingers were like, his imagination of the contact of a hand with this sheet of paper would have been restricted by his knowledge. If he had ever seen her at any writing-table, twisting her foot, perhaps, round the leg of her chair or dipping her pen in some especial manner, his imagination would have been pegged by fact: he would not have been aware, as he now was, of a thousand opposed but, in his own mind, harmonious possibilities.[26]

What are these possibilities? Well, to risk a little solemnity of our own, they flow from regarding Julia not as a static figure (in the manner of a novelist painting a scene) but in movement, under the aegis of *rhuthmos*, as an ideal figure captured in the shapeliness of its movement.

Regarding her as a representation, Alison "could not have perceived the light, hard pressure of a table's edge beneath her breasts, the indentation made by her leanings, the coolness of polished wood beneath her wrist, and, at the same time, have watched the writing of this letter on a stool beside a fire."[27] Freed from the novelistic obligation to unveil her personality, Morgan's alter ego

> seemed to hold in his hand not a letter, a thing completed and therefore sparkless, dead, but the animation, the moving essence, from which it had sprung,

and the name Julie seemed to him a kind of wordless confession; for, he thought, her signature, when her eye falls upon it, does not appear to her as a label which, like a number, is useful to distinguish her from others, but as an expression of herself of which the ever-changing secret eludes her. While she was writing, the word Julie was for her a coded summary of her mysteries. Between the J and the e she was lying, her inmost self as much expressed and as much concealed as when, in that other visible but clouded formula—her body, she lay extended long ago on sunlit grass, or stood looking up at him, being then a child.[28]

A postfeminist sensibility isn't needed to find this vapid, even distasteful. Morgan's brand of Christian mysticism, his determination to decipher inklings of other worlds in the ordinary facts of this one, also seems dated. Still, it is in Morgan's taste for the veiled that a sympathetic interpretation of this passage would have to begin. The author wants to deepen the mystery of the other. He grasps, in a pre-Derridean way, the fact that the act of remembering does not *unearth* what is hidden; if psychic impressions are forms of writing, then retracing (remembering) them deepens them—at the moment that the original impression is retraced and brought to light, it is also grooved deeper and irrevocably changed. Then, if reading/remembering always fatally alters what is written (impressed and traced), the challenge is to find a way of deciphering the writing without touching and corrupting it. Alison's response to all this is, in effect, to draw a veil over any obvious constructions that might be placed on the letter he holds in his hand. Instead of approaching it more closely, he tries to put a distance between himself and Julie's hand. In this way, the logic seems to be, he can possess her non-possessively—or, as Ludwig Klages, author of *The Principles of Characterology* (1910), puts it, "whoever seeks to negate distance is characterised by a possessiveness that is fatal to Eros, to the glowing nimbus of the world, and, ultimately, to actuality itself."[29]

Writing grows dark when distance is read into it. Usually, distance is regarded as a kind of obstacle to progress. In the erotic sphere, the aim is always to close the distance between lover and beloved. One is captured in the sharp focus of the other's desire. A similar principle of clarification, in which the blurriness of distance is swept away, informs the use of centralized linear perspective constructions in Florentine Renaissance painting, where the distance is contracted to a vanishing point. Distance disappears, and, in its place, the images represented in the picture plane no longer seem to emerge from the dark, but give the wonderful illusion of being wholly present, epiphanic, and timeless. No doubt the restitution of becoming in Venetian painting through the mechanism of chiaroscuro is partly a reaction to this bleaching of shadows.[30] More to our purpose, distance is conspicuously absent from the ichnographic practices of

the architect, designer, and cartographer. Substituted for distance in their plans and maps is an angelic detachment. This detachment is the mirror image of the vanishing point in perspective constructions, and both, it should be recognized, represent a negation of distance quite as powerful as that associated with erotic intimacy.

As Klages intimates, the writing of distance takes the paradoxical form of a cloud, a veil that enlightens. In contrast with its surroundings, it glows. But, in contrast with the unblemished light of positivist reason, it is dark, like the shadow bulk of cumulus clouds assembling ahead of a storm, or like any species of lightness that wears the trace of the dark whence it is born. Morgan intimates this when he discerns in Julie's hand "that other visible but clouded formula—her body"; Klages speaks of "the glowing nimbus of the world." In both cases, the world of the other is not written in lines but in the form of a light-dark blot, a patch of grayness that shines, a track of silvery light. Conceived like this, distance is not associated with isolation. On the contrary, in a world of linearities, whose spaces induce a kind of agoraphobia, it provides consolation, a form of shelter. And gray—the hue of the unfocused that our culture so disparages—is its sign. In this case, Morgan's vagueness joins up, rather surprisingly, with the preoccupations of artists as diverse as Alberto Giacometti and Daniel Libeskind, who in their different ways champion gray as the signature of a humanizing distance whose absence from modern life is a symptom of tyrannies at once spiritual, spatial, and brutally political.

Gray, the color of disappearance, is, as I noted in *Repressed Spaces*,

> The colour of appearance. It is the colour of the "appearance of the whole", when far-off faces are set into the black above and the buildings either side, like stars. It is the silver-grey of Libeskind's zinc-clad void, but it is also the hue of Freud's nightmare: glaucoma, the illness of seeing the world through a steely grey-blue veil, as if the environment were permanently smoke-bound, and the dawn (unless it is dusk) a long time coming. Its hollow green pallor draws attention to the absence of what Ernst Bloch calls "the old, familiar this-worldliness of human nature and its encompassing arc of reason."[31]

### Shadow Writing

The earliest photographs of Henry Fox Talbot also seem to have been taken through smoke. A constitutional mistiness invests his earliest photograms—the negative images produced by pressing insect wings, ferns, or convolvulus flat on photosensitive paper are accurate in outline, but their lacework abstraction is ghostly. Reversal of the negative—treating it as an object to be laid over another

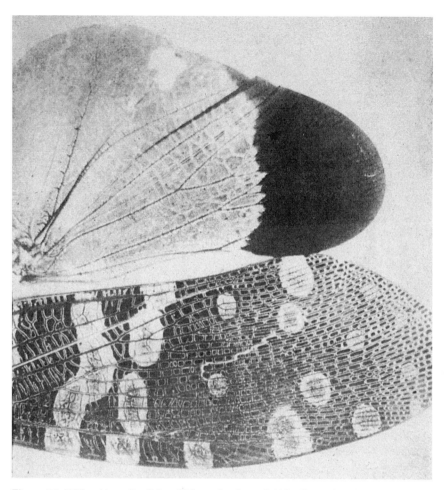

**Figure 36.** William Henry Fox Talbot, "Wings of an Insect," 1839. Reproduced by courtesy of the Science & Society Picture Library, London. Photogenically mediated, Nature's pencil, in contrast with the human one, draws "lines" as anastomosing channels and finds a pattern in random blots. Modeled is a system of bifurcations and multiplying crossing or meeting places.

photosensitive surface to produce a positive image—does not disperse the early-morning fog that seems to hang over the classical busts, Gothic architectural details, or stableyard scenes that form Talbot's characteristic subjects (Figure 36). It simply makes the glaucoma optic more plausible—only the fact that the same dreamy aura surrounds a harp inside the library and an elm outside in the park discloses the artefactual nature of the blotchy smoke that everywhere floats like the aura of a departed body, softening the focus and laying the screen of distance over reality. From the words he invented to describe his new process, I take it that Talbot recognized and valued these effects. First, he called his new art "sciag-

**Figure 37.** William Henry Fox Talbot, "Spade and Broom," c.1840. Reproduced by courtesy of the Science & Society Picture Library, London. Unlike the better-known calotypes of scenes around Fox Talbot's home at Lacock Abbey, which strongly differentiate figure and ground, this slightly earlier photogenic drawing preserves an equality of parts that is both less mysterious and more enigmatic. Less mysterious because the scene is not steeped in shadow, more enigmatic for the same reason—it is impossible to say where the drama lies. In this scene hands and eyes are everywhere, and the levitation of the spade and broom might be due to an unseen sorcerer.

raphy," the depiction of objects through their shadows.[32] Then, or alternatively, he referred to it as "photogenic," or born of light.[33]

Given photography's subsequent cultural and technical development—almost exclusively toward recording the sharply focused and instantaneously captured—it is surprising to find one of its inventors evaluating its potential in terms of writing the dark. The new art will record the shadow born of light; light may be the writing machine, but what it prints—making it visible in unprecedented detail—are the tonalities of darkness, from the lightest gray of suntinseled foliage to the deepest blue-black of the doorway's hollow (Figure 37). When the elements of Talbot's neologisms were recombined, they produced our familiar term, photography. At the same time, two other terms—*scia* and *geny*—were consigned to the conceptual rubbish heap of history. Photography arose out of their shadow, but their presence at the birth of photography was soon forgot-

ten. These terms attached the new writing method to an image of the world "undefined but beautiful," as Charles Morgan might have said, formed "among the half-shadows of consciousness." Light writing (photography) was born of shadow (sciagenic), but this genealogy, this shadow lineage, was not acknowledged. As a result, the spiritual enlargement the new technology promised was sacrificed to take advantage of the obvious visual mastery it brought within grasp.

The spiritual enlargement obscured here at the beginning of photography had nothing mystical about it. The "fair luminous cloud / Enveloping the Earth," as Coleridge might have said, which photography brought into view, was not otherworldly but a new vision of "Nature."[34] The art of documenting the life of shadows recovered the body that had gone missing in geometrical reasoning. Photography could hold the "fair luminous mist" of the dappled environment that slipped through the reticule of Enlightenment reason. In allowing the appearance of the whole, Charles Morgan's withdrawal conjured up not simply Julie's hand but "that other visible but clouded formula—her body." By different technical means, Talbot's earliest experiments with light writing produced the same results, capturing the body of "Nature." Doubt has been cast on Talbot's famous account of the origins of his invention. In *The Pencil of Nature*, he attributes it to his deficiencies in drawing, citing landscapes sketched while staying on Lake Como in 1833 as evidence of this. Aside from the fact that these camera-obscura-assisted line drawings are anything but incompetent, it is hard to see what role Talbot's later photogenic process could have had in improving them.[35] The critical point—clear from Talbot's earliest choice of subject matter, intricately fronded ferns, minutely cellular fields of lace—is that the "pencil of nature" did not draw in the same way as the human hand. The liberating novelty of nature's writing resided in the fact that it did not draw with lines. Nature's pencil copied what an artist using a camera obscura could never represent; the infinitely complex, dappled body of "Nature," its blotted rocks, its tirelessly detailed foliage, its fussy but exquisite filigree, its casual, overlooked but vivifying coincidences, "Life's effluence, cloud at once and shower."[36]

It has been suggested that Talbot felt in his photographic experiments "some echoes of the saturnine melancholia of the alchemical adepts" and that he succeeded where others had failed "because of his preparedness to contemplate the dark side of things."[37] If so, in his writings at least, Talbot reined in his gothic tastes, giving them a technical inflection. It was, for example, in reference to the difference between the image furnished by the camera lucida and his attempts to copy it that Talbot wrote, "I found that the pencil had only left traces on the page melancholy to behold."[38] The choice of adjective here *is* significant, but also precise. Melancholy is associated with the weak, inexact, and incomplete, with what is left in the dark. To overcome it, to bring what lies hidden to light, is the

genius of photography, but it does not imply the banishment of shadow, only its illumination. Given that Talbot's experiments took place not under flawless Italian skies but in the generally murky interiors of his mock-Gothic country seat, Lacock Abbey in Wiltshire, I am inclined to think that the Italian origins of his invention are a red herring. Even now, to visit Lacock (one of the best-preserved villages in England) is to be struck by the *technical* resemblance between Talbot's earliest outdoors photographs and the ordinary appearance of the place, blotchy, foliage-crazy, cloud-changeable, stonewall intricate, mazy with straw details. In this environment photography would not originate in a desire to imitate the clarity of sunlit forms. No one would try to paint *these details* with the aid of a camera lucida.

These ingredients of lowland English countryside fall below the focal point of those generations of aristocratic sketchers in northern Italy. There is lacking in this bothersome close-up detail the clear enclosures and divisions that allow the eye-hand its vicarious ownership of the scene. Forms break up, colors, if there were any, are composites of rusty tones and breed lichens of gray. In the dim morning the buildings absorb shadow into their stained Cotswold walls. The uncurbed florescence of nettle-embattled borders, branch-clinging brambles, and elders are a fabric of dark patches. Under the chestnut the layers of green lucent palmate fronds reproduce and multiply stories of shadow to the production of a dark green hall. The resemblance of these colorless scenes to the first photographs is uncanny. Their sepias, marble pallors, and pebbled gray textures are not chemical effects but the ordinary appearance of things at the corners of the day. It's hard not to think that Talbot's invention made sense because of this visual coincidence. The form of Lake Como, and the reason of the viewpoints, are grasped at a glance. The appearance of Lacock lies latent in its shadows.

Lacock Abbey, Talbot's home, breaks out, its picturesque park beginning the classification of masses (clouds, reed patches in the water meadows, puffs of foliage). But inside the village shadows invest their originals so pervasively that they prevent the classification of blots. Wondering where barn and wall meet, where water's edge and bridge merge, you enter shadowland whose writing is different. The grass verges hooped with dew, the roof tiles pincushioned with moss, the ladders of chestnut leaves, stamping shadow with shadow to create the dapple, the puddle of sky—a black mirror in the cup of the road—are the blurry hieroglyphs of a topographical body whose alphabet has to be made out gradually, indirectly. Understanding the buried life of the place would be greatly aided if these degrees of indistinctness could be accurately captured, transcribed, and translated at leisure. Why not suppose *this* was Talbot's purpose, or part of it at least—not to reproduce southern outlines, whose clarity makes reproduction a kind of tautology, but to retrace with the pencil of nature the shadow of light, the *informe* of the northern overlooked?

**Figure 38.** William Henry Fox Talbot, "Entrance, University College, Oxford," 1843. Reproduced by courtesy of the Science & Society Picture Library, London. Another effect of the calotypic process is to emphasize the latent design of architecture; the dark volume of shadow between the two courtyards might have been cut out of black paper. Chiaroscuro is here reinvented as collage; from this translation of topography into dark or light geometric shapes, it is only a short step to the invention of letter forms.

Talbot found a method of inscribing the body of things, the shadow supplement of appearances that defined the linear representations produced by the human pencil. I acknowledge that the next remarks are speculative, but it is interesting to ask whether that body had a distinctive nature or form. Two apparently unrelated photographic interests of Talbot's may be of interest here—his long-term fascination with, and photographic documentation of, ancient scripts and non-Roman typographies, and his architectural studies, particularly of Oxford colleges (Figure 38). Isn't there an odd generative homology between these subjects and the negative-positive method that underwrote Talbot's breakthrough? In the context of the previous discussion about a writing convention that prints or inscribes letters in black on a white surface, Talbot's photographs

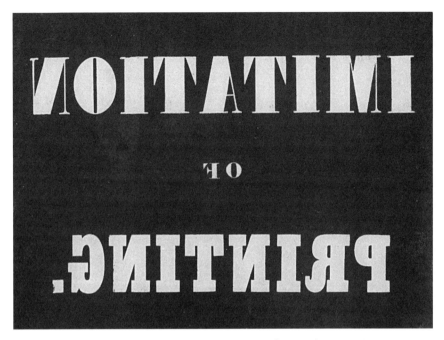

**Figure 39.** William Henry Fox Talbot, "Imitation of Printing" (reversed), c.1844. Reproduced by courtesy of the Science & Society Picture Library, London. The enigma of this study lies, as the title suggests, in one writing form (photography) imitating another (typography). Through this emerges the mystery of print and what it conveys. It is sensed as a process of exposure analogous to what happens when the latent image becomes visible. Writing about the Filipino patriot José Rizal, Vicente Rafael sees this as a postcolonial strategy, arguing that this process of "exposure" is analogous to the "proofs" furnished by photographs that "reveal and reproduce faithfully what is otherwise inaccessible to our eyes." Both print and photography permit "the mechanical reproduction of the appearance of what was once hidden, mak[ing] visible to the mind's eye what had remained obscured or dimly perceived. . . . Both suggest surfaces infiltrated by hidden depths, presences haunted by secret histories, and visible forms sustained by invisible forces" (Vicente L. Rafael, *The Promise of the Foreign* [Manila: Anvil Publishing, 2006], 70–71). And this fact could, in the hands of a nationalist committed to liberating his country from imperial rule, be a powerful force.

of writing were technical puns on that process (Figure 39). His negatives turned pages black and made letters light. They created look-alike engravings but with this important difference—that the production of a second negative (the positive, or photograph) did not involve *reversing* the image but a second exposure to light. The metaphor of truth finding in engraving is the mirror. In the negative-positive method of photography it is the doorway, where, simply by deepening the impression, its meaning emerges. In the photographic method, light and dark do not cancel each other out but are the twinned modalities of space that secure its depth and volume.

Talbot's photography similarly punned on architectural space. As Russell

Roberts notes, "Many of his photographs from Oxford demonstrate an interest in the networks of quadrangles, arches and facades. Doorways open onto other doorways, framing courtyards, cloisters and windows, suggesting a pattern of recursion or nesting."[39] The idea informing Talbot's choice of subject matter, and the way he frames it, is that there are patterns in things that emerge simply through reproduction. When, in a gothic doorway, the fragment of a gothic façade is glimpsed, one architectural element does not reproduce the other, or simply repeat it. The translation between the two elements is felt to disclose an architectural logic (or pattern) that goes beyond what can be seen.

Translation is an apt figure of speech, for, in deciphering the scripts of ancient languages, Talbot worked in the same way, using informed guesswork to reproduce the sounds of individual letters, until, by repeatedly substituting one for another, revising and refining these reframings in the light of clarifications made in other parts of the text, the pattern of the whole emerged.[40] Deciphering Nature, Talbot's photography worked metonymically and materially, by a reproduction of parts bringing into view the order of the whole. The second step in Talbot's method—the production of a positive image from the negative—did not reverse what had been done. It was not a mirror held up to the dark. It reproduced the first step, advancing deeper into the dark, until there was light at the end of the tunnel, as one finds on emerging from the medieval gloom of the cloister into a quadrangle's rational glare.

The form of Nature's body that Talbot elicited through photographs is not found in a class of previously neglected phenomena—shadows, or the miscellany of blots, bruises, speckles, and other manifestations of the luminous overlooked. It is captured in the doorway between the two moments of his photographic technique, in the discovery, to put it another way, that the processes of enclosure and disclosure—in Kierkegaard's language ("enclosure or disclosure, unfreedom or freedom, silence or speech") mutually exclusive[41]—can instead be related. How could this be? At first, exposure times were inconveniently long. To reduce them became a major ambition of all later developments in photography. As a result, photography became associated with the immobilization of movement, the elimination of change from its subject matter. And it was forgotten that in the earliest experiments the enclosure of the object and its disclosure in a photographic image were locked in a temporally binding relationship. This was patently true when Talbot discovered the phenomenon of latency, but it also applied to the earliest experiments—*exposure* referred to a time of passage from one state to another, to a *period* of transformation. In short, the act of enclosing the other in a process of reproduction *could* initiate a dynamic process of self-disclosure or self-becoming at that place.

In other words the body that photography elicited was not the statuesque

figure familiar from Victorian studio portraits, but a movement form, a mental figure akin to the one Lewis Alison ascribes to Julie. There is plenty of *negative* evidence for this earlier, mobile body. It comes in the form of the statuesque portrait characteristic of Victorian photography. According to his grandson, Jean-Paul Sartre, Charles Schweitzer was "victim of two recently discovered techniques: the art of photography and 'the art of being a grandfather.'"[42] But were not these really one and the same? To attain the statuesque inertia proper to grandfatherhood, what better training could have been contrived than the *photo de pose*? What could better distinguish a grandfather of the old empire than an ability to become one's own statue?[43] It would be interesting to know whether our patriarchal image of Victorian society is not so much recorded by the camera as produced by it. Photography reinforces a penchant for the melodramatic. It also proposes an identity. Enduring that age of exposure, the sitter feels a temptation not to be who he is; the politician betrays a tremor of doubt, the syphilitic poet smiles inadvertently. Old men develop into grandfathers. Sitters become what they were not: themselves — someone whom, in real life, they would never have recognized. As Walter Benjamin, writing later of Kafka, noted, "[e]xperiments have proven that a man does not recognise his own gait on the screen or his own voice on the phonograph."[44]

This artificial self, this *face*, which was developed in response to photography's demand that the sitter hold a pose, became the subject matter of a new, distinctively modern genre of writing, autobiography (Figure 40). But the self thus produced for reproduction shouldn't be mistaken for what J. S. Mill calls "the inward domain of consciousness,"[45] or what we might call the movement form of a life, which registers so long as one lives "a thousand opposed but harmonious possibilities," entwined chiasmatically "in that other visible but clouded formula," the body.[46] It is a lesson that biographer Richard Holmes has to learn when, seduced by Felix Nadar's photographic "portraits" of famous Parisian artists: "It struck me that from 1850 onwards a wholly new kind of biography might be possible — because of photography."[47] The people enclosed in these photographs, he thought, would never be lost in "history" and "The very process of aging itself — which is the existential equivalent of the biographer's chronological narrative," could now become biographical material.[48]

But Holmes finds he is mistaken. What proof has he that the expression Baudelaire puts on for the camera signifies "he is proud of what he is" or "inner struggle"?[49] Who in real life identifies himself with his own decay? In effect, this is Holmes' discovery when, inspired by a photograph of Gérard de Nerval, he decides to write the poet's "life." In the end, no clear picture emerges. The life behind the mask remains enigmatic. Holmes is forced to entertain another, non-photographic kind of biography: "the past is not simply 'out there', an objective

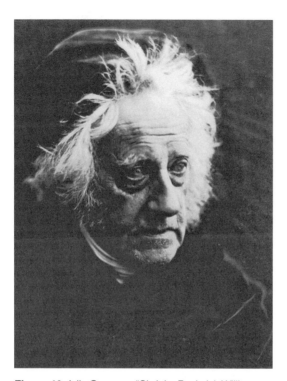

**Figure 40.** Julia Cameron, "Sir John Frederick William Herschel," April 1869. Reproduced from *Victorian Photographs of Famous Men and Fair Women by Julia Margaret Cameron*, 38; by courtesy of the Hogarth Press. Part of the sitter's charisma derives from the fact that he seems not to have sat perfectly still. The wet collodion process Cameron used demanded a lengthy exposure, which meant that the sitter was likely to move. As a result, Roger Fry thought, "[b]oth expression and form were slightly generalized," and photographs made like this "had not that too acute, too positive quality from which modern photography generally suffers" (Roger Fry, "Mrs. Cameron's Photographs," *Victorian Photographs of Famous Men and Fair Women by Julia Margaret Cameron*, 23–28, 26). Proposing the simultaneity of a multitude of moments, this photograph is truly a drawing in John Berger's sense (see the conclusion to this volume).

history to be researched or forgotten, at will . . . it lives most vividly in all of us, deep inside, and needs constantly to be given expression and interpretation."[50]

Rediscovered here is periautography, that older conception of a life as a narrative of "the reality of the knower," as James Hutton put it, for our perceptions are as much realities to us "as if they were the exact copies of things really existing."[51] In this older theory of subjectivity, the history of a life was not to be found

"deep inside." The correspondences that existed between "our perceptions" and "things really existing" were secured by a characterological theory of selfhood; an individual's personality could be deciphered in the same way as the "ancient hieroglyphics" of nature. If this is true, then the invention of photography did not automatically sound the death knell of this older form of dark writing. On the contrary, as an art of shadow writing, it brought the study of the correspondences between our perceptions and things really existing to a new level of refinement.

Its images, or at least the earliest images that Talbot created, were not exposures in which a living world was immobilized. Instead, they made available to discourse what our perceptions had always known, that the world was composed of changing bodies of living shadows. Even when the mastery of light had begun to tame this first wild intuition, relics of it remained. In "The Ladder" and "The Open Door," calotypes dating from 1845 and printed in *The Pencil of Nature*, the new history told is not of a broom, a ladder, a hanging lantern, or a group of figures still as mourners. It is the correspondence of light and dark that discloses something new—the alignment of the leaning broom to the doorway's slanting shadow, tracing the harmony among a thousand possibilities, the shadow ladder leaning back, the natural wit of its acute angle dark writing the architecture "deep inside" the appearance of things (Figure 41).

### Hand-held

A third kind of dark writing seems to have no truck with light at all. If the spirit is associated with vision, then the reader of this writing is eyeless, like Oedipus. The address of this writing is the body, but ironically, the place of this writing is where the body is not, the tomb. Tomb writing, though, has its degrees. There is, for example, a genealogy of hands that links the underworld to the upper world. Decorating the approaches to Hades, the realm of what hasn't been seen, as Pythagoras thought,[52] are for example Talbot's study of a hand (1841), whose "cryptic message" has intrigued historians (Figure 42); the old custom, "when some favourite was going to a foreign clime, to chalk the inside of his hand, and stamp the impression on the wall";[53] and those paradoxes of self-writing, the hosts of Palaeolithic hands stenciled onto the roofs and walls of Australian caves. Entering the tunnels that lead down, you find graffiti, not just the classical obscenities of the cryptoporticus[54] but the contemporary discourse of drains. Eventually, though, a seal is placed on these transactions between light and dark, and a class of inscriptions exclusively designed for the dead is built into the place of interment in such a way that no one again will ever see their pictures or read their writing, in this way securing what must have faded in the sun—the vitality of their execution.

The tomb paintings of ancient Etruria have furnished me with the best examples of this third kind of dark writing. The ancient Greek word *graphein* could

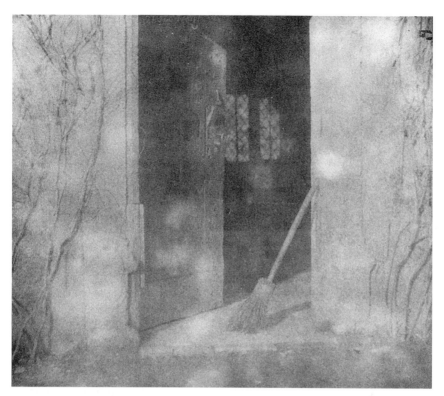

**Figure 41.** William Henry Fox Talbot, "Soliloquy of the Broom," 21 January 1841. Reproduced by courtesy of the Science & Society Picture Library, London. It is hard not to see the broom in this calotype as a metonymic representation of Nature's pencil. The alignment of its shadow to that cast by the door ajar suggests an ordering principle resident in the broom itself. It mediates between dark and light. It has the power of an angelic calling card; something humbly human has just fled the scene leaving behind a strangely numinous relic of labor. Again, the image seems steeped in a multiple temporality, at once human, technological, and cosmic.

mean drawing (and painting) as well as writing.[55] In this sense, the decorated interior walls of Etruscan tombs are among the most iconographically elaborated programs of dark writing in existence, even though inscriptions form a small part of them. They are also amongst the most this-worldly in terms of style and theme (Plate 21). There is no mystical moonshine about them. They depict the death of the deceased, the *prothesis* or laying out, and those come to mourn him. Scenes from life also decorate the walls, but, as they mainly show charioteers or armed warriors in combat, their significance may be symbolic rather than biographical. Gift giving is shown, and attention is paid to the interior decoration of the represented rooms; pomegranates hang like Christmas balloons, and there are wreaths and garlands. All in all, the tomb is like a camera in whose photosensitive darkroom a montage of images has been captured.

To furnish rooms for the dead so liberally suggests an optimistic view of

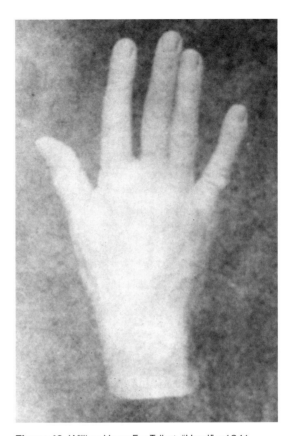

**Figure 42.** William Henry Fox Talbot, "Hand," c.1841. Reproduced by courtesy of the Science & Society Picture Library, London. Russell Roberts speculates about the "cryptic message embodied in this gesture" (Russell Roberts, "Traces of Light: The Art and experiments of William Henry Fox Talbot," in *Huellas de Luz, El Arte y los experimentos de William Henry Fox Talbo*t [Madrid: Museo Nacional Centro de Arte Reina Sofia, 2001], 361–377, 366). But surely the obvious explanation of its enigma resides in the fact that it *writes the hand that writes*, wittily drawing writing back into the physical laws of its own production. Its disembodiment is only cryptic because what it displays is the bodily medium through which disembodied messages are made manifest (as writing).

soul migration; the tomb is a doorway to another world, which, to judge from the painted architecture and objects found there, is not unlike ours. Nested underground, it is also a world that, like Talbot's gothic cloisters framed in gothic doorways, is nested inside our own. It is this atmosphere that makes a Pythagorean explanation of Greco-Etruscan tomb art counterintuitive. In the *Gorgias*, Plato speculates that the word for body (*soma*) is derived from the word for tomb (*sema*),

on the Pythagorean argument that "our present life is a death, our body (*soma*) a tomb (*sema*)."[56] In this case, the tomb is a genuine sign (*sema*) of the body and the natural site of the body's signature, of those marks it makes when writing or drawing. But the exuberance of the scenes painted for the adornment of the dead seems to contradict this otherworldly asceticism. It suggests, in fact, a lively attention to the travails of passage the departed is likely to undergo in making the leap from this world to the next. The festal interiors are inductive in the sense that they seek to encourage movement. And, as the departed is to be imagined as still clinging to vestiges of corporeality, suspended between the memory of the body and the hope of the soul, the induced movement has to be depicted in a way that copies the fashions of this world while symbolizing the practices of the next.

Retrospective rationalization aside, how were these funerary designs intended to be read? Commissioning them would have been expensive. They may have enhanced their patron's reputation, albeit posthumously. But even this must have been a side effect; one intent on securing his after-fame in this world would have ordered something lastingly visible. In contrast, these paintings were intended to be forgotten. Whatever solace they might bring the eyes of the dead, they were designed to be invisible. They mocked light, in the end escaping its voracious desire to suck out the marrow of their meaning. The Etruscans probably didn't imagine these graves surviving intact for two and a half thousand years, but even in the lifetime of their culture the ineluctably growing presence in their country of a shadow community of Hadean images must have had its effect.

Perhaps it was therapeutic. As these eidetic treasuries could not be brought back to light and consumed by the eye, they belonged outside history—for, as Giorgio Agamben has noted, "[l]ike the word indicating the act of knowledge [*eidenai*], so too the word *historia* derives from the root *id-*, which means to see. *Histor* is in origin the eyewitness, the one who has seen."[57] Because they could only be remembered, they assisted the process of mourning and forgetting. They were, in this case, pure gifts in Derrida's sense, subverting an economy of social relationships where no freedom (no gift) is possible because the circle of giving and receiving is complete and closed. To break this chain it is not enough to remove the gift from circulation. The act of giving must coincide with an act of radical forgetting: "we are speaking here of an absolute forgetting—a forgetting that also absolves, that unbinds absolutely and infinitely more"[58]—an idea Derrida links to funerary practices, writing that "this radical forgetting . . . should accord with a certain experience of the *trace* as *cinder* or *ashes*."[59]

These absolute forms of dark writing were gifts in this special sense. This is one explanation, anthropological in a way. But, bearing in mind the distinction just made between a photographically pursued biographical enclosure and an older form of life-world disclosure, perhaps their understanding lies elsewhere. In an anthropological interpretation of the funerary art of Etruscan Italy, no

thought is given to the role the archaeologist plays in their recovery. We moderns are like Richard Holmes studying the face of the poet in a photograph, imagining a different narrative of the past, one that will change "history." But, as Holmes found out, detached scrutiny of the graphic trace did not enable him to decipher the truth about another's life. That could only emerge when he took into account his own experience as a biographer, allowing the *encounter* with his subject and his or her life-world to become part of his story. The same may be true of the study of funerary art. To understand its significance, it may be necessary to reflect on our encounter with it, on the ethical and metaphysical issues posed by seeing it at all.

To illustrate this, let me take the case of the so-called Tomb of the Diver, found near the ancient Greek colony of Paestum (Poseidonia) in southern Italy in 1968—and whose image was, as described in the last chapter, adapted to become part of *Relay* (Plate 22). Instead of simply trying to interpret the meaning of the imagery found inside the tomb, let us reflect on the discovery itself, on a moment in late July when a workman raised his pickaxe and brought it down with a crushing blow on what proved to be the lid of the tomb. What happened then when light flooded into the darkened chamber as if a photograph were being taken?

In a way, the pickaxe that cracked its limestone lid in two, letting the light into the tomb's two-and-a-half-millennia-old darkness, proved Derrida's point. No sooner was fresh air ushered into the grave than the burnt bones of the defunct turned to dust: ashes to ashes. The violence that split the subsequently famous ceiling fresco of a diver in two, and the final transubstantiation of body into air, were foremost in a cascade of transformations played on the baroque theme that life's a dream, death an awakening. The melody used in these variations was light, the death-dealing blow that illumination inflicts when it seeks, Orpheus-like, to penetrate the dark and to bring back from it and preserve semblances of beauty. What the axe blow initiated, the curators continued; to dismantle the painted walls and lid of the tomb, to open them out like the pages of a book and to display them butterfly-wise on the wall of a museum, was profoundly to contradict the spirit in which they were made and decorated.[60]

In this metaphysically dubious environment, practical challenges inevitably involved ethical and aesthetic questions. To determine the light levels in the room where the Diver and its four related frescoes were displayed was not only to resolve a technical issue. Nor was it just a matter of how best to prevent the painted surfaces from fading. The question was more profound: What theory of visualization could inform the setting of light levels when the whole purpose of these works was, presumably, to thwart the *photologos* of history?[61] What kind of sightedness should be encouraged? Inevitably, to look at the insides of the tomb from the outside was to deploy a kind of X-ray vision, but nothing in the exhibition design

suggested that degrees of darkness were being factored into the intellectual illumination on offer.

These familiar conundrums of the museum industry arose from an ideology of display from which the body must, as far as possible, be absent. The disturbance of the dark that occurred when the workman's axe broke through was the first in a cascade of *historical* strokes designed to banish the body of light from consideration. Henceforth, in the interests of their immortality, the wall works must be preserved against every encounter with the dark. The same principle is applied to us. The air we museum visitors exhale as we shuffle past must be dried out. It seems that exudations from our mouths and skins are causing salt secreted in the limestone to rise to the surface. The flawless skin of the diver, the erotic flesh of the lovers, is beginning to blemish and grow old. We, the supposedly living, draw near, and these figures from whom the trace of time was withdrawn, recede into the past. With or without the assisted passage of our stolen flashlit photography, they gradually grow diseased and vanish in front of our eyes.

And this, I am saying—the paradoxically death-dealing encounter with a secreted life—is *also* part of dark writing's experience. After all, the word *experience* is derived from the Latin *experiri*, meaning "to undergo." The radical is *periri*, which we find again in *periculum*, peril, danger.[62] Dark writing recalls us to the body and its fate. This is why it places us metaphysically in danger. It draws us time and again to attend to the passage between one state and another, to the moving shadow that life casts as it plunges into the deep (Plate 23).

## The Night Preserved

The history of writing shows a persistent tendency to dematerialize the writing process. A reading practice that minimizes the physical experience of the text is a corollary. The effect of this general abstraction of the act of interpretation from an encounter located in a particular time and place is to produce the environment of mechanically and electronically mediated script communication that we now take for granted, in which the conceptual freight of what is written is skimmed off and processed without any regard for the *design* of the script or the page where it appears. Here, the field of dark strokes and dots evaporates into the light of reason. The body of writing is lost in the glare of spiritual understanding. Then, the purport of this chapter is plain. The reason for studying dark writing is that in contrast with light writing, it seeks to inscribe the body into our graphic representations of the world. The body—whether it resembles Julie's "visible but clouded formula," Fox Talbot's patterns of recursion, or the "leap" of the Poseidonian diver—is not statuesque. It is a movement form composed of the relation between subject and object, between writer and reader.

In its earliest days, as I said, photography possessed an intuition of this. But when it succumbed to *photologos*, the materials its shadow writing furnished to read the world were ignored. Instead of the maculated and shadowy movement form, an increasingly crisp precinematographic "still" was substituted. The Pegasus leap of movement came to be represented as a stuttering and stumbling sequence rather than as the trace of a process whose temporality was contained in the character of the forming pattern. "I look only at the movements," Kierkegaard wrote, explaining that the only true leap is the absolute leap of faith, the transcendent renunciation of all measurement.[63] Glossing this, Gilles Deleuze and Félix Guattari write, "Perception will no longer reside in the relation between a subject and an object, but rather in the movement serving as the limit of that relation, in the period associated with the subject and object."[64] It is this period of movement—Kafka referred to it as "the instant between two strides taken by a traveller"—that dark writing notices and notates.

Dark writing recovers a body that has been lost. But it is reasonable to ask *from where* has it been lost? The movement form that constitutes the subject of dark writing goes missing in Enlightenment geography (chapter 1). The graphic orthodoxies of cartography and architectural drawing also eliminate it (chapter 2). To judge from chapter 3, theoretical models of cultural production likewise ignore it. These discoveries raise further questions: Why has our post-Enlightenment culture refused to accord ontological value to the subject-object relation and, in particular, to the period of their encounter and the responsibilities that might entail? One answer is suggested in chapter 4; disparaging the lie of the land, the "anexact" environment of cross-cultural encounter, is an important intellectual, as well as administrative, strategy of imperialism. Some design responses to this exclusion of the movement form are described in the three case studies that follow, but the vicissitudes suffered in the attempt to realize those designs illustrate the recalcitrant power of linearist thinking. The body that disappears in design is also the body that is lost in history. The erasure occurs in both cases for the same reason—because the kind of vision invoked in both cases is blind to the environment of seeing. Taking its cue from Bishop Berkeley, it anticipates the technology of the camera, regarding the eye like the camera lens as "blind." When the eye can only see what the mind directs it to see, seeing becomes a vast tautology—the same sees everywhere the same.[65]

This reflection recalls Walter Benjamin's meditations on the *photologos* of history, which Eduardo Cadava has skillfully elucidated. Benjamin, as Cadava explains, understood the illuminations (and deadly eliminations) of history photographically. Keeping close to photography's origins as an art of ghost worship, as a new chapter in the West's death wish, he meditates on that paradoxical moment of illumination, the flash of light exploding inside the dark, in which the subject

is blinded in order that his image can be taken, and he can see (in reproduction) what was formerly invisible. And Benjamin opposes history's photographic recall via images to an experience of lived time that cannot be mechanically reproduced — "The true picture of the past flits by. The past can be seized only as an image which flashes up at the instant when it can be recognised and is never seen again."[66]

In other words, in the instantaneous recall of the photograph, there lurks a forgetfulness—in the heart of its lightning flash a blind spot: "Lightning signals the force and experience of an interruption that enables a sudden moment of clarification or illumination. What is illumined or lighted by the punctual intensity of this or that strike of lightning, however—the emergence of an image, for example—can at the same time be burned, incinerated, consumed in flames."[67] And, one might add here, this association of photography with burning is implicit in photography's origins; photography is light *writing* because it tames light, its effect being "controlled by the lens in much the same way that a pen controls the flow of ink to a manuscript."[68]

The first use to which children put the lens is not to tame the light but to release its savage power. Focusing sunlight on a sheet of paper until it begins to smolder, they discover a dark writing, a mark that consumes itself in the lived moment, never to be seen again. As Cadava observes, "[n]ot only is the writing-that-lightning-is immolated at the very moment of its emergence, but the illumined objects of its reflections go up in flames in order to make reflection itself possible."[69] Is it fortuitous that this analysis foreshadows what happened one afternoon near Paestum in the summer of 1968, when a pickaxe unexpectedly bit into an ancient tomb lid, producing a fissure in it like a jagged bolt of lightning, in which the illumined objects went "up in flames"? The true history of that moment has nothing to do with the history uncovered. It begins with a recognition of the catastrophe that has occurred and leads to an awakening from the myth of waking from history's dream. It is found in the illumination that illumination (history's goal) is an eternal repetition, like copies of a photograph or the repeated cliché of the camera's shutter, a repetition of the same that gets us nowhere. A true historical awakening incorporates "[what] Bloch understands as the darkness of the lived moment" into an understanding that "[t]here is a not-yet-conscious knowledge of the past, whose furthering has the structure of awakening."[70]

Armed with this insight it might be possible to look at the Diver. Is it a historical accident that the fresco was painted roughly twenty-five kilometers (sixteen miles) away from the Phoeacian colony of Elea, and, to judge from the style of pottery found in the tomb, that it dates from a period overlapping the life of Parmenides, the great philosopher of Being discussed earlier? Is it an accident that the crack in the tomb that resembled a lightning bolt split the composition

of the Diver in two, introducing an abyss into the gap where the diver plunged harmoniously toward the sea? Inside the brackets of history construed in terms of Being, bracketed off from their destructive visions, a supreme image of Becoming was secured. His posed instant between two strides discloses what cannot be seen, what goes missing in the light of history, the catastrophe of extinction.

Referring to certain half-formed ideas, Benjamin once wrote to Florens Christian Rang, "These ideas are the stars, in contrast to the sun of revelation. They do not shine their light into the day of history, but only work within it invisibly. They shine their light only into the night of nature. Works of art are thus defined as models of a nature that does not await the day. . . . The night preserved."[71] The Diver conforms to this logic. The Diver is not a movement figure paradoxically stilled, *photographically* represented as a thing of joy forever, because no one can bear witness to him. He does not await the resurrection of day. However, like a luminous shadow, like dispersed starlight, he works invisibly inside it. This was why he was prepared for what happened, in the lightning flash of excavation already steering a course into the night.

### Notes

1. Daniel W. Smith, "Badiou and Deleuze on the Ontology of Mathematics," in *Think Again: Alain Badiou and the Future of Philosophy*, ed. P. Hallward, 77–93, 79 (London: Continuum, 2004).

2. Ibid., 79–80.

3. Ibid., 83.

4. Ibid., 80.

5. Ibid.

6. Kenneth Smith and Ian Weir, "The Engineering of Liverpool's Old Masonry Dock Walls," in *Albert Dock: Trade and Technology*, ed. A. Jarvis and K. Smith, 43–52, 45 (Liverpool: National Museums and Galleries on Merseyside, 1999).

7. Smith, "Badiou and Deleuze on the Ontology of Mathematics," 84.

8. Ibid.

9. Abraham A. Moles, "The Legibility of the World: A Project of Graphic Design," in *Design Discourse: History, Theory, Criticism*, ed. V. Margolin, 111–129, 126 (Chicago: University of Chicago Press, 1989).

10. Vidler links the "spatial ambiguity" cultivated here with the "dark space" that Roger Caillois discusses in his classic essay "Mimicry and Legendary Psychasthenia," characterized by a darkness that is "filled"—"it touches the individual directly, envelops him, permeates him, and even passes through him." Anthony Vidler, *The Architectural Uncanny: Essays in the Modern Unhomely* (Cambridge, Mass.: The MIT Press, 1992), 173.

11. Gregg Lambert, *The Non-Philosophy of Gilles Deleuze* (New York: Continuum, 2002), 46.

12. Peter Fenves, *"Chatter": Language and History in Kierkegaard* (Stanford, Calif.: Stanford University Press, 1993), 49.

13. See chapter 5; trait is connected to the *traho-traxi-tractum* cluster. In the context of our discussion of the role of induction in creating geographical knowledge, it is interesting that someone who displays distinct traits is by definition tractable, ductile, easily, or at least disposed to be, led. Gasché discusses the meaning of the term in Heidegger's thought, concluding that "trait is presencing as relation *and* difference and is therefore the relation as such." Rodolphe Gasché, *Of Minimal Things: Studies in the Notion of Relation* (Stanford, Calif.: Stanford University Press, 1999), 218.

14. Fenves, *"Chatter": Language and History in Kierkegaard*, 113.

15. See chapter 6, note 9.

16. In the same architectural spirit, Mann observed that "no less firmly do I hold that we shall one day recognize in Freud's life-work the cornerstone for the building of a new anthropology and therewith of a new structure, to which many stones are being brought up today, which shall be the future dwelling of a wiser and freer humanity." Thomas Mann, "Freud and the Future," in *Essays of Three Decades*, trans. H. T. Lowe-Porter (New York: Alfred A. Knopf, 1976), 411–428, 427.

17. Fenves, *"Chatter": Language and History in Kierkegaard*, 219.

18. Paul Carter, "Second Sight: Looking Back as Colonial Vision," *Australian Journal of Art* XIII (1996): 9–36, 9–16; and Paul Carter, *Material Thinking* (Carlton, Melbourne: Melbourne University Publishing, 2004), 36–38.

19. Henri F. Ellenberger, "The Life and Work of Hermann Rorschach," in *Beyond the Unconscious: Essays of Henri F. Ellenberger in the History of Psychiatry*, trans. F. Dubor and M. S. Micale (Princeton, N.J.: Princeton University Press, 1993); see also Carter, *Material Thinking*, 36–38.

20. Jonathan Goldberg, "On the Other Hand . . . ," in J. Bender and D. Wellbery, *The Ends of Rhetoric: History, Theory, Practice*, 77–99, 92 (Stanford, Calif.: Stanford University Press, 1990).

21. A straightforward account of the implications of Derrida's ideas for design is contained in Ellen Lupton and J. Abbott Miller, "Deconstruction and Graphic Design: History Meets Theory," at www.designwritingresearch.org/essays/deconstruction.html.

22. Charles Morgan, *The Fountain* (London: The Reprint Society, 1941), 61.

23. Ibid., 61–62.

24. Ibid., 62.

25. Ibid.

26. Ibid.

27. Ibid.

28. Ibid., 63.

29. Ludwig Klages, "Cosmogonic Reflections," No. 292, at www.revilo-oliver.com/Writers/Klages/300.html, translated from *Sämtliche Werke*, vol. 3 (Bonn: 1965–1992), 482.

30. Paul Carter, *The Lie of the Land* (London: Faber & Faber, 1996), part 2, passim.

31. Paul Carter, *Repressed Spaces: The Poetics of Agoraphobia* (London: Reaktion Books, 2002), 208.

32. Mike Ware, "Invention in Camera: The Technical Achievements of WHF Talbot," in *Huellas de Luz: El Arte y los Experimentos de William Henry Fox Talbot* (Madrid: Museo Nacional Centro de Arte Reina Sofia, 2001), 343–346, 343.

33. Ibid.

34. Samuel Taylor Coleridge, "Dejection: An Ode," (1802), ll.55–56, 48.

35. See Michael Gray's skeptical account of Talbot's Lake Como anecdote in Michael Gray, "Towards Photography," in *Huellas de Luz: El Arte y los Experimentos de William Henry Fox Talbot*, 347–354, 347–348 (Madrid: Museo Nacional Centro de Arte Reina Sofia, 2001).

36. Samuel Taylor Coleridge, "Dejection: An Ode," l.66 (1802).

37. Ware, "Invention in Camera: The Technical Achievements of WHF Talbot," 343.

38. Gray, "Towards Photography," 347.

39. Russell Roberts, "Traces of Light: The Art and Experiments of William Henry Fox Talbot," in *Huellas de Luz, El Arte y los Experimentos de William Henry Fox Talbot* (Madrid: Museo Nacional Centro de Arte Reina Sofia, 2001), 361–378, 373.

40. Roberts discusses a heavily chloride-fixed print of a study of a hieroglyphic tablet which, in his view, does not so much reproduce the hieroglyphs as bring them into a more distinct relief. By copying them with interest, the technical process contributes to their elucidation in some way. Roberts, "Traces of Light: The Art and Experiments of William Henry Fox Talbot," 370.

41. Fenves, *"Chatter": Language and History in Kierkegaard*, 107.

42. Jean-Paul Sartre, *Words [Les Mots]*, trans. I. Clephane (Harmondsworth: Penguin, 1967), 19.

43. Ibid.

44. See Eduardo Cadava, *Words of Light* (Princeton, N.J.: Princeton University Press, 1997), 151 n. 91.

45. John Stuart Mill, "On Liberty" (1860) (Harvard Classics, vol. 25, P. F. Collier & Son, 1909), 1860.

46. Ibid.

47. Richard Holmes, *Footsteps: Adventures of a Romantic Biographer* (London: Hodder and Stoughton, 1985), 204.

48. Ibid., 204–205.
49. Ibid., 205–206.
50. Ibid., 208.
51. Chapter 1, note 55.
52. An etymological explanation often associated with Pythagoras, because he was supposed to have visited Hades himself.
53. A seemingly traditional practice, but I have not been able to locate a clear documentary source.
54. Claude Calamé, *The Poetics of Eros in Ancient Greece*, trans. J. Lloyd (Princeton, N.J.: Princeton University Press, 1999), 106.
55. See James A. Francis, "Living Icons: Tracing a Motif in Verbal and Visual Representation from the Second to the Fourth Centuries C.E.," *American Journal of Philology* 124 (2003): 575–600, 581 n. 16.
56. Plato, *Gorgias*, trans. W. Hamilton (Harmondsworth: Penguin, 1960), 493, 92.
57. Cadava, *Words of Light*, 145 n. 63.
58. Jacques Derrida, *Given Time, I: Counterfeit Money,* trans. P. Kamuf (Chicago: University of Chicago Press, 1992), 16–17.
59. Ibid.
60. Mario Napoli, one of the tomb's discoverers, gives an account of the event in Mario Napoli, *La Tomba del Tuffatore: La scoperta della grande pittura greca* (Bari: De Donato, 1970).
61. The neologism is Derrida's (Cadava, *Words of Light*, 136 n. 7).
62. Cadava, *Words of Light*, 147 n. 77.
63. Søren Kierkegaard, *Fear and Trembling*, trans. W. Lowrie (Princeton, N.J.: Princeton University Press, 1954), 104.
64. Gilles Deleuze and Félix Guattari, *A Thousand Plateaus: Capitalism and Schizophrenia*, trans. B. Massumi (Minneapolis, University of Minnesota Press, 1987), 282.
65. David Appelbaum, *The Stop* (Albany: State University of New York Press, 1995), 25.
66. See Cadava, *Words of Light*, 3.
67. See Ibid., 22.
68. Carl Miller, *Principles of Photographic Reproduction* (New York: Macmillan, 1942), 5.
69. Cadava, *Words of Light*, 22.
70. See Ibid., 71.
71. See Ibid., 30.

CONCLUSION
# Linings

> *Say beauty lies but in the meet of lines,*
> *In careful-spaced sequences of sound.*
> —GERARD MANLEY HOPKINS

### In-lines

In his *Archeticture*, David Krell argues that the paradoxes of Husserl's account of the origins of geometry are tied up with an architectonic conception of geometry. It is the identification of geometry with foundations that produces what Krell calls Husserl's "impossible passion for the chain"[1]—that notion of tradition as an endless repetition of the ideal, discussed in chapter 3. To escape this "dictatorship of fundaments, foundations, technologies of measurement, universalities, and idealities,"[2] Krell proposes that architecture needs to revisit Husserl's genealogy of geometry, resuscitating his notions of the pregeometric and protogeometric: "It must learn, for example, to dally with rough surfaces, unclean edges, muted corners, hazy lines—and all of it with no *point* at all."[3]

A practical instance of Krell's recommendation occurs at Federation Square in Melbourne, where Peter Davidson and Donald Bates of Lab architecture studio applied what they called a "postlinear" approach to architectural design, characterized by the multiplication of lines and the dissolution of hard-and-fast distinctions. Drawings produced in this way are not the representation of a place but an analogue of the process of place making (and changing). And, as I noted, at Federation Square there was a felicitous coincidence between design and storyboard: Lab architecture studio's predilection for "textures and fields of lines produced out of redundancy, superfluity, and excess" and their advocacy of "architectural lines . . . increasingly multitudinous and excessive"[4] were a physical analogue of

260

the "redundancies, overlap, disproportions, inconsistent distribution of powers" that distinguish federal systems.[5]

The problem is that these conceptual breakthroughs do not translate into studio practice. In the end, however much fuzziness there may be in the sketches, the culture of contemporary construction demands hard-and-fast lines. This predilection is reinforced when digital drawing programs are used to generate the drawings, as these, while they can fabricate aesthetically pleasing images of the redundant, the superfluous, and the excessive, remain linear in their constitution, and therefore inferior as tools to represent the spread of the environment or the passage of bodies. Because of this, protogeometric designs do not emerge as an analogue of a process; they remain an aesthetic preference that has to be violently imposed on a recalcitrant drawing program. The superfluity, instead of being aligned with the actual behavior of collectivities of bodies in motion, or the movement form of a place, is perceived negatively, as a self-indulgent addition of complexity. This perception does not negate the architects' intent, but it underlines the difficulty of overthrowing the linear—both as a drawing practice and as an irrefutable logic, or economy, of doing things.

Brodsky Lacour traces the descent of the modern architectonic line—both a line of drawing and a line of thinking—back to Descartes. In Descartes' thinking line—"thinking and being are never conflated by Descartes into a single moment or (as Jaspers has suggested) a single point. In the *Discours* and the *Géométrie*, thinking thinks into being what is not itself—a thing, or a line."[6] Isn't this oddly close to Krell's call for a drawing practice "with no point at all"? Of course, Descartes' line is firmly founded, but, drawn out of itself like a spider's thread, it carries its foundations forward, as it were, in this way constantly living through its original, foundational experience. But this Cartesian provenance is, as it were, overdrawn. As I have suggested, the modern line of design has a double ancestry. Besides the deductive ideality of Descartes' pure line of thought, there is a messier, even hazy origin in the rise of the inductive sciences. An interesting line in the history of thought could be drawn from William Hogarth's serpentine "line of beauty" (1753) to John Ruskin's abstract lines that characterize the most frequent contours of natural objects celebrated in *The Stones of Venice*. Along its axis would be found William Playfair's innovative use of line graphs to represent economic data (1786), Ernst Chladni's visualization of sound as vibration patterns (1787), Erasmus Darwin's derivation of the "Aesthetic sense" from the infant who "[p]rints with adoring kiss the Paphian shrine, / And learns erelong, the perfect form confess'd, / Ideal Beauty from its mother's breast" (1803),[7] and William Whewell's own Inductive Charts.

These intellectual events had in common a reconceptualization of the line as an empirical generalization. Inductively founded empiricism had, as Darwin's

origin of "Ideal Beauty" makes clear, replaced Cartesian deductionism; general truths were now to be built up inductively from particular instances. Empirical truths were speculative abstractions, but they had a probability of being true. If the Cartesian line drawn out of the self is "freely drawn," the inductive line is constrained by an external destination. If one tends to the formalism of a geometrical figure, the other is a "gradual and continual discovery of a beauty in natural forms,"[8] as Ruskin puts it, which leads to a formal pattern.[9] Put like this, the modern line of architectural drawing, and design generally, is not a graphic fossil left over from the seventeenth century; it has an ambiguous heritage. Inside the freely drawn dimensionless line, there open up other lines tangentially connected to the world at large.

It is these hidden force lines that modernists wanted to recover, expose, and harness. The line was no longer to be an abstraction, a coating of inert forms, because forms themselves were no longer to be treated as statuesque. The forms taken were the forms of their energy and contained their own reason; lines were emanations of that reason and radiated its energy rather than compressing and containing it. If the line was abstracted from its traditional role of providing objects with a surface, a definite edge and end, it was because those objects, as forms of energy, had become spiritualized, instances of mobilized energy, crystalizations of cosmic forces. Thus, before the First World War Umberto Boccioni had proclaimed "the absolute and complete abolition of the finite line and self-contained statues. Let us tear open the figure and incorporate the environment inside it."[10] Lyonel Feininger wanted to do something similar to buildings. Extending their vanishing lines, he sought to attain their "emanation" into the environment and to equalize the picture plane so that searchlight lines of flight enjoyed equal reality with the missile forms of skyscrapers.[11]

In their *Realistic Manifesto* (1920) Naum Gabo and Antoine Pevsner succinctly glossed this double reinvestment of the line with physical and spiritual meaning: "We renounce the line, its descriptive value; in real life there are no descriptive lines, description is the accidental trace of a man in things, it is not bound up with the essential life and constant structure of the body. Descriptiveness is an element of graphic illustration and decoration. We affirm the line only as a direction of the static forces and their rhythm in objects."[12] The Futurist line may not have delivered what was hoped, but this did not mean that the line was to be renounced. Instead, it must be further spiritualized. This had implications for the artist: If the line was to become one "with the essential life and constant structure of the body," the artist had to acquire something of the line's precision, its *tonos* or harmonic potential. Gabo and Pevsner: "The plumb-line in our hand, our eyes as precise as a ruler, in a spirit as taut as a compass . . . we construct our work as the universe constructs its own, as the engineer constructs his bridges, as the mathematician his formula of the orbits."[13]

But these attempts to move beyond outlines—or, more correctly, to get inside lines and materialize their spiritual energy—remained tied to the euphoric rhetoric of progress. Even if they were postlinear in one sense, in another they remained tied to the idea of advance, of movement with a definite purpose toward a definite, if spiritual, destination.[14] This is reflected in their attitude toward so-called primitive art and to the artistic culture of Central Australia in particular, made known in Europe through the research of Spencer and Gillen. Bardon found certain ideas of creativity derived from Modernist pedagogy useful in glossing the practice of the Papunya artists because, in part, these ideas were derived from Central Australian culture. There, Modernist artists and educators thought they could see the childhood of creativity, a living culture that still reproduced "the *feeling* of being in the world."[15] These European practitioners and theorists were engaged, like Husserl, in a search for origins. Seeing the psychology of child development as the recapitulation of the intellectual evolution of modern man (*sic*), they were carried back, when they read accounts of Arrernte ceremonies, to the point from which the entire evolution of creativity as such could be reconstructed. Inscribing Aboriginal design within their own "impossible passion for the chain," they aligned it with their own interests rather than questioning the line as such.

Take Eisenstein's interpretation of Arrernte art (which he learned about from Emile Durkheim, who in turn derived his material from Spencer and Gillen). Eisenstein shared with many scholars of his generation the idea that "language derived from some primeval action that was imitative in character."[16] Influenced by Durkheim's analysis of abstract geometric depiction among the Australian Aborigines—who do not seek "a portrait that constantly renews the sensation [of the totem]" but aim instead "to *represent the idea*" through "a material sign"[17]—Eisenstein developed a concept of "primitive mimesis," a "primeval generalisation (*obobschenie*) or 'principle'"—which he identified with the line: "[I]t is quite natural to 'think' in a de-intellectualised way: running your eye over the contours of objects is an early form of rock drawing and is closely linked . . . to the cave paintings which are linear."[18]

This thinking through lines could be applied to all kinds of art. Yampolsky writes, "Line was revealed in music as melody, in theatre staging (*mise-en-scène*) as the movement of the actors, in literary subject-matter as plot, in rhythm as invariant schema."[19] Grasping the "inner grapheme" or linear nature of different objects, it was possible to exploit the psychology of synesthesia and create in the film medium an abstract geometric mimesis of reality; this was the function and rationale of montage. Eisenstein asks,

> What is *mise-en-scène*? *Mise-en-scène* (in all stages of its development: gesture, mimicry, intonation) is the graphic projection of the character of an event. In

its parts, as much as in their combination, it is a graphic flourish in space. It is like handwriting on paper, or the impression made by feet on a sandy path. It is so in all its plenitude and incompleteness. . . . Character appears through actions. . . . Specific appearance of action is movement (here we include in "action" words, voice etc). The path of movement is *mise-en-scène*.[20]

The trouble with Eisenstein's "inner grapheme" or "path of movement" is the primitivism of their inspiration. The Aboriginal designs he drew on were someone's story. They were maps of the journeys the totemic ancestors had made in the course of creating the country in its present form. Ownership of a story was proof of a right to live among the places named in the story. It located the storyteller socially, in relation to others, and historically, in kinship relations that stretched out before and behind in time. In Eisenstein's through line, the dark writing of these designs has been forgotten. In ignorance of this lost terrain or linen of cross-hatched connections, a new motivation for their drawing has to be found. Eisenstein accordingly attributes a Dionysiac energy to the process of graphic representation. A dot-and-circle painting shows, as it were, not only all the footsteps but the little intervals of rational intuition between them.

In Eisenstein's montage, these untrodden paths of possibility, corresponding to the endless, everyday performances of mutual timing and spacing, are repressed. One cut is violently soldered onto the next to create an illusion of ineluctable inner energy that cannot be resisted. Ordinary acts of walking, approaching from different directions, of erring, pausing, deviating, and passing are turned into a procession, a mass of feet all stumbling, jog-trotting, and finally running in the same direction. Etkind believes that in Eisenstein's work "the 'Age of the Mob' discovered its most exceptional artist," and "totalitarianism found its aesthetic."[21] This is so because his filmic manipulation of time and space mimicked the fascist fantasy of total control, over society and all the territory of its comings and goings.

### Stitching

In this sense, the lines that "postlinear" architects draw are different because their political visions are different. Contending that with the dissolution of Eastern Europe (a federation of sorts), the future of architecture as geometry has been fused with the "affirmation of democracy as a transcendent (or at least satisfied) political order," Lab architects Donald Bates and Peter Davidson themselves recognize that to build "after geometry" is no less than to imagine our situation "after democracy."[22] It is to reinvigorate a tradition in danger of losing its historical awareness, its sense of contingency. This is not to pose a crisis, but it is to foresee the need for more complex organizational structures. Unlike the

mere pluralism that passes for contemporary democracy, federalism, returning to its ancient etymological roots in the concept of *covenant*, "implies a commitment to a contractual arrangement between political units that decide to create a new political space."[23] In formal and spatial terms, and in their commitment to making manifest the materiality (and irreversibility) of temporal process across the Federation Square site, Lab clearly imagines an analogue of that "mode of political activity that requires the extension of certain kinds of cooperative relationships throughout any political system it animates."[24]

But the question of how this is translated into practice remains. Perhaps the postlinear is not to be imagined as an excess of lines outside the line. Instead it should be imagined inside the line. Picking up the lesson of Pliny's anecdote about Protogenes and Apelles, the darkness of lines emerges not when they are drawn over, redrawn roughly until they form a sheaf of approximate trajectories. It is found when the line is recognized as a field underwritten by lines. Lines, we can say, have a lining. The external garment of the map has a linen underlay figuratively as well as literally. The map is not merely printed on linen; its linear overlay presupposes a protolinear underlay. In existential terms the maze of scorings and cross-hatchings into which the line of progress is inscribed is the heritage of tracks out of which the path emerges. Further, the path never entirely replaces the wake of trails it braids into an authoritative route. The grid through which cartography sees the world remains crazed because even when a persuasive linearization of the environment is managed at one scale or in one region, its maze of speculation is cast over phenomena that are anticipated but as yet unknown.

In a fascinating discussion of the seventeenth-century Miller Atlas, Christian Jacob points out how cartographers trying to reconcile the flatness of maps with the curvature of the globe used conjectural lines, whether "[s]traight, curved, or serpentine" to save appearances.[25] The function of these lines, representing as yet unknown coasts, rivers, and islands, is to hold open the possibility that geographical figures will join up. They represent graphically the conceptual space between the theoretical openness of the map and the experiential closure of the globe. The conjectural outline, "drawn without any indication of its abstract nature . . . only to produce a realistic effect,"[26] illustrates the composite origin of the modern line. It is freely drawn, a pure extension of the Cartesian thinking subject. At the same time, it anticipates obstacles. It imagines an irregular, undulating, jagged topography. These arabesques are drawn inside the ideal grid of the map; they represent a stylistic *geo-graphisme* that warps them toward certain forms, and adventitious drawing styles, rather than others. Something similar happens when maps are scaled up. The Mandelbrot paradox, that differently scaled maps display more or less the same degree of irregularity, is an illustration

of the fractal character of environments, but it also demonstrates the repressed materiality of cartographic practice. Inside the line other self-same lines breed, reproducing the same conjectural complexity at different scales. In other words, in this graphic arena, a principle of incremental growth exists inside the abstract line. The very notion of reproducing it *at a different scale* proves this.

Lines have linings. This is their dark writing. But what is the relationship between the garment and the lining, between the outline and the in line? How, to invert Klee's problem, does the outside line acquire an inside, a lining that adheres to it and underwrites it? Bruno Latour identifies "three principal strategies" philosophers have used to save what he calls "the modern Constitution." "The first consists in establishing a great gap between objects and subjects and continually increasing the distance between them; the second, known as the 'semiotic turn', focuses on the middle and abandons the extremes; the third isolates the idea of Being, thus rejecting the whole divide between objects, discourses and subjects."[27] All these positions make a fragmentary appearance in *Dark Writing*. James Hutton's fear that there is "no resemblance between the world without us, and the notions we form of it" exemplifies the first position, in which an abyss separates the human subject from the world of mute Nature. The second position, which Latour identifies with Hegelian dialectics—"Dialectics speaks of nothing but mediations"[28]—is exemplified in the reception of Aboriginal art in Europe; it is treated as a system of representation ready for mediation, as a stage in the progress of art toward true representation. The third position is represented by phenomenology's attempt to spread itself over the middle, but, as Latour puts it, "[t]he 'consciousness of something' becomes nothing more than a slender footbridge spanning a gradually widening abyss."[29]

It is high time, Latour thinks, that we negotiated the relationship between Nature and society differently. He proposes that "we reverse the direction of the modernising transcendences."[30] When we do this a new (or perhaps very old) idea of transcendence emerges, one he defines as "the maintenance in presence by the mediation of the pass."[31] Or, as he explains, "[w]hen we abandon the modern world, we do not fall upon someone or something, we do not land on an essence, but on a process, on a movement, a passage—literally a pass, in the sense of this term as used in ball games. We start from a continuous and hazardous existence—continuous because it is hazardous—and not from an essence; we start from a presenting, and not from permanence."[32] A feature of this reversed transcendence is that it brings the body back into play. Thus, in a similar vein, David Krell characterizes Merleau-Ponty, Bataille, and Irigaray as "thinkers of body spaces for unhomelike bodies," explaining: "For them, the body is not so much *in* passage as it is *passage itself*. Passage itself is not embarkation for a world beyond this one and only world. Passage is not transcendence. Passage is 'at the

same time' seepage, *within* the one and the two, *within* the great chaos of the world of space and time and the microchaos of human bodies."[33]

For Nigel Thrift, I suspect, these ontological agonies appear rather old-fashioned. In his view, the cumulative effect of the quantification of the world (in which the standardization of space and time in the eighteenth and nineteenth centuries played an important part) has produced a situation in which "numerical flux becomes central to activities, rather than incidental, giving rise to more and more 'flow architectures.'"[34] He quotes Knorr Cetina: "In a timeworld or flow-world...the content is processual—a 'melt' of material that is continually in flux, and that exists only as it is being projected forward and calls forth participants' reactions to the flux."[35] Thrift comments: "In a world in which numerical calculations are being done and redone continuously, so that static representation becomes subordinated to flow (not least because 'the image, in a traditional sense, no longer exists'), the nomadologic of movement becomes the natural order of thought."[36] Thrift thinks these developments "are producing a new sense of space as folded and animate."[37] Evidence of this may be the emergence of new forms of anxiety and phobia, one that assumes a moving point of view—and he finds that my discussion of agoraphobia, although "frustratingly oblique," contributes to the elucidation of the new "movement space."[38]

In any case, Thrift is optimistic that "in a qualculated world"—in which new configurations of space-time as fluid are "generating new cultural conventions, techniques, forms, genres, concepts, even...senses"[39]—some of the conceptual challenges to representing movement described in *Dark Writing* will melt away. He thinks that "a sense of direction will become a given...wayfinding will become a much easier matter...[and] space will increasingly be perceived as relative."[40] And he speculates "that egocentric co-ordinate systems will be strengthened, precisely because that movement is able to be more fully registered."[41] Some of these features of Thrift's new movement literacy are also old ones. The topological geometry of the child's first experiential space exhibits, according to Piaget, a similarly fluid perception of spatial relations. In a way Thrift, like Latour, recommends a kind of reverse transcendence in which we abandon the static forms of Euclidean geometry (whose representations, after all, we never inhabited) and return to a topologically constituted movement space. Only this return will be new because it is not dialectically defined in relation to the static but is underwritten by the triumph of calculation. In future, Heraclitus rules, the flow will be all.

So foundations give way to passage, and both are subsumed in a larger movement space. But the question remains: How is this new environment envisaged? How is it figured and drawn? When all is in flux, where do Cetina's participants stand? They must be differentiated from the flow, otherwise they could not perceive it, let alone react to it. But we are to suppose that they, too, are only

passages. To answer this question—and to try to be less oblique—it is necessary to recognize that the new flow is not seamless. Just as the lining is stitched into the garment of linear representation, so with the flow—it continually generates "movement forms." It is these constitutionally localized and choreographed forms that compose the "undistinguishable blot" of the meeting place. In the same way, the geography of process—the discourse that lets back in all the passages out of which the static diagrams of the map crystalized—is a *rhythmic* geography. Without this sense of contraction—of space-time continually opening and closing—the flux would be indiscernible and immeasurable. Without this bipedal consciousness wayfinding might be easier, but traveling—the effort of placing one foot in front of the other—would remain inscrutable. Because, for all the attention to energy transfer, bodies also sleep; without their occasional lapse into unconsciousness, the conscious leaps of the imagination would go nowhere. There would be direction but, competing with it, a colossal inertia, a sense that where everything moves there is no longer any need to move.

To pose the question differently: What is the *content* of the new movement space? To escape the dead weight of statics and of static representations is no doubt to sever constraining ties. But what is it designed to preserve? What, to repeat Vattimo's question, can it mean to be freed for the multiplicity of experience— Thrift refers to the discovery of "multiplicity" as a thinkable entity—"if this liberated man [sic] continues to be imagined on the model of the subject who has 'returned to himself' at the end of a wandering itinerary"?[42] My suggestion is that this solipsism is avoided when what I shall call an *eido-kinetic intuition* is recognized.[43] This neologism refers to the inherent sense mobile subjects have of their relationship with their surroundings. It is highly developed in ballplayers who are able simultaneously to see all the passages forming and closing about them. It is the capacity to intuit directly the nearness of things and to have the measure of them. It seems to stem from our capacity to see the components of our world under the aegis of movement. Perhaps this is the condition natural to hunters. In this a wall, a tree, a gap, another person carries with its appearance the memory of all the approaches that constitute its movement history—a history spelled out in the running, leaping, and walking that has mediated its place in our lives. Such objects are eido-kinetic because the recollected mental image associated with them is kinetic.

We know the intimate spaces of our lives first, I suggest, not through phenomenological reflection but through projective fantasies in which we fly, leap, somersault, and glide about the surfaces of our rooms, gardens, and streets. It is this angelic topology that supplies the first Ariadne's thread into the labyrinth of the world. With the whole body we effortlessly belay spires and treetops and swing between them. Birdlike, we clip cloud edges or swoop under bridges. This is in keeping with the observable fact that the infant's first gesture is not

to stretch out graspingly but to seek to sheathe hand and fingers in the glove of space. It is the passage that is inhabited first; objects and the separation of fixed positions come later. From this first navigation of the environment, one in which the ballast of the body secures ascension and leverage on the air, our later taste for architecture derives. Buildings we intuitively read as a forest of poses. Their appeal is to suggest landing places, diving boards, rebounding surfaces, angles of incidence. We are the movements that articulate these relationships, inhabiting the world as potential geometrical figures discovering the secret logic that holds these surfaces and shapes together, inscribing them with our mobile biographies.

Perhaps these fantasies sound cinematic, conjuring up images of Spiderman. Then we should talk about a kinematics rather than mere kinesics, a generalized movement logic where bodies are merely agents of endless flow, their powers adjusted to the medium, leached of that intentionality without which architectural form is impossible. Russian filmmaker Dziga Vertov successfully captured this kinematic thesis; revealing men and women as "catalysts, converters, transformers, which received and re-emitted movements, whose speed, direction, order, they changed," he made the body into architecture, providing the scenography of revolutionary change.[44] Even so, as machines interacting to effect "the (communist) transition from an order which is being undone to an order which is being constructed,"[45] an interval of movement had to be observed. Vertov identified this with perception, the glance of the eye, or rather the eye of the camera, the eye in matter. Isn't "the eye in matter" not only a technological fact but the sensation of the ballplayer, who has eyes only for the flight of the ball, who is wholly enveloped in the time-space envelope of play? But the difference is that ballplayers retain an awareness of the background of all moving objects, and it is the capacity to keep in play a multiplicity of possible passages that defines their art.

The eido-kinetic intuition resists this kind of technological disembodiment and semiotic reduction. Watch the child go out walking; look how her hand passes like a conductor's baton or a water diviner's rod along low walls at the edge of the pavement, making loops over dustbins or delicate undulations along sharp-tipped palisades. The movement outlined here is passage apprehended as a localized rhythm. Later still, these vernacular orchestrations of the mobile body will produce a darker, more complex cross-rhythm of passes. There is the child again, leaping from rock to rock next to the resounding sea: "Although off the ground, he is of the place. He does not aim at flight, escape from the body; quite the opposite, he makes his centre of gravity a finely balanced bow vibrating across a highly strung surface. And the harmony between the physical gesture and physical place is both open-ended and unrepeatable. Nothing can be taken away and yet he has been transported."[46]

Later still, this figure morphs into the diver who knows, like Arakawa/

Madeline Gins, that "[e]verywhere is cleaving: massenergy cleaves itself, cleaves to and from itself. In this way, it makes from and of itself dimensions and turns itself gradually into various tissues of density."[47] Out of this tendency the same artists propose the emergence of a condition antithetical to that of the tabula rasa, yet closely mimicking it. Omnipresent cleaving creates at first "that set of conditions which make it most likely for there to be some events which will repeat."[48] "Different textures of density, configurations of massenergy, are coordinated through and by these cleaving agents,"[49] and there develops "an indeterminate forming state or blank"[50] and out of this "a sense (or fiction) of place."[51] The diver is not pure passage; his consciousness is colloidal, being formed at the place where surfaces meet. In that cleaving, in the friction generated by passage, he knows himself. Such self-knowledge is not a return to self. It is contingent on trusting to the eido-kinetic intuition as a result of which throwing oneself into the abyss turns out to be threading the gap.

The eido-kinetic intuition is our body's design on our world. It is the world shaped according to the "thrownness" of the body, that primary need to measure out our surroundings through a continuous process of imagined "being there," hence our instant capacity to measure intervals, to judge proximities, to assess the scale of things. But an eido-kinetic consciousness is also a dialogical awareness, beginning in the sense of the mutual placedness of things, as potential relations rather than separate objects. We can suppose that a designed environment that satisfactorily engages this extensive, giant body of ourselves, and so gives us a sense of being at home in the world, will engage the eido-kinetic faculty, stimulating those primary fantasies of being there and their concomitant activities of flight, leaping, diving, and walking. The features of this interactional space include a sense of measure or interval, of "pacing"—not at all to be identified with a regular, march-like progression of forms alternating with empty spaces—and, perhaps centrally, a recurrent feeling of cleavage in the double sense of the term.

The rhythmic expectation that enables us to know instantly that a crack in the pavement up ahead will, or will not, fall in the instant between two strides is also the criterion we use for place making. The materiality of surfaces is discerned as offering our passage a coefficient of friction that is pleasing. This is why smooth surfaces produce vertigo. Walking I am suddenly elated to find myself on paving flags. At slightly different levels, sunken here or rising there to create a mild buckling of planes, they seem to bear the imprint of different weights distributed as time and chance have dictated across their faces.[52] Like exfoliated ledges of horizontal limestone near the sea, subject to daily immersion and evaporation, to the erosion of minute particles of sand driven across their flaking edges, these flags mind pockets of water, whose miniature shorelines

form depressions somewhat like footprints. After the sensory deprivation of asphalt and tarmac, to feel these elastic flags underfoot is to be made aware of the stride and the footfall, to recover again that pride of ambulatory locomotion largely lost when we design for pneumatic tires rather than human feet.

An eidetic person may recall a particular object after its disappearance, even years later "seeing" it in exact detail; an eido-kinetic sensation would be presumably the same experience transferred to the realm of movement. Hence, alighting on the limestone flags I can conjure up in the exactest detail the leaps—the intervals, flight paths, the planes, angles, and momentary poses—associated with those places. It's not a place that is recalled but a dynamic field characterized by many gaps to be negotiated. The memory of those places must be like the player's memory of the game—which, identified with the ceaseless bound and rebound of the ball, with the ebb and flow of opportunities opening in the elastic space, resembles a time that repeatedly crystalizes into an ephemeral architectural form where all the elements are momentarily equipoised . . .

This describes the eido-kinetic intuition—and to return to Thrift, this or something like it provides the content of the movement space. Otherwise the infinite possibilities it opens up would induce agoraphobia. Robert Musil's character Ulrich can hardly put one foot in front of another, but he recognizes that the fault is not entirely his own, reflecting that it is "an extremely artificial state of mind that enables man to walk upright between the circling constellations and permits him, in the midst of the almost infinite terra incognita of the world around him, to place his hand with dignity between the second and third buttons of his coat."[53] Quite so; when the possible passages are limitless, any route taken is a tightrope suspended over an abyss. But people more in touch with their environmental unconscious might feel their trajectory like the arc of a needle stitching the hems of surfaces together. They would sense inside and outside in step. And instead of trying to construct the world by copying it step by step, they would yield to the terra incognita of their surroundings as if it possessed a rhythmic geography, a manifold of passes joining all the possible poses, confident that it would both cleave *to* them and *for* them.

### Unpicking

The line of dark writing is rhythmic. It periodically intersects with the linear expressions of light writing in exactly the same way that the needle that stitches the lining repeatedly pushes through the fabric of the outer garment. But however fine the stitch, the lining and the cloth are not completely joined. The hem where they meet is in profile puckered, a contraction that, when it is unpicked, expands again. The relationship between the notation of the movement form and the language of quantification—whether this is static or fluid—is an inter-

mittent one. And it is this double relation in which coincidence alternates with separation—the cleaving in both senses characteristic of walking—that defines the difference of design from the world it designs—and its occasion. If rhythm is everything, as the German poet Hölderlin asserted, it is because rhythm "reveals a more original dimension of time and at the same time conceals it in a one dimensional flight of instants."[54] Rhythm is the "dark" dimension of time. It is also the more original dimension the traveler gives to time (and its flight of instants) because she is walking, proceeding bipedally, or rhythmically. It is the rhythm of the work of art that, as Agamben says, "situates it in a dimension in which the very structure of man's being-in-the-world and his relationship with truth and history are at stake."[55] Kafka wasn't exaggerating when he considered that the history of mankind could be contained in the instant between two strides.

Rhythm is the formalization of the eido-kinetic intuition, organizing the chance marks we make on the world into a memorable pattern. But for this no imprint of passage could occur. In making an impression, the traveler is a kind of *typographer*. In *Typography*, Lacoue-Labarthe shows that the relationship between foot and footprint, or stamp and impression, isn't simply a physical one. It implies a stance or attitude. The relationship is ethical. This association is present in the word "character," which denominates both the form of a letter and a human disposition. In the same way, the *type* is not simply the seal or letter object; it is a moral classification. In short, as we write, so we are written. But this only emerges in the movement of the writing. A letter resembles a *skhema*—"a fixed, realised form posited as an object."[56] It begins to speak when it is laid next to another. And what these impressions first communicate is not a legible message but the *character of movement*—rhythm as such. If *skhema* designates "a stable form, therefore a figure or Gestalt," *rhuthmos,* Lacoue-Labarthe writes, is "the form at the moment it is taken by what is in movement, mobile, fluid, the form that has no organic consistency."[57] The script of the new geography proposed here is not, then, footsteps as such (or any other kind of ground impression), but the rhythm of them. We could say that it is marking of any kind considered as a track. Lacoue-Labarthe implies as much when he suggests that rhythm is "something between beat and figure"—something, he adds, "that never fails to designate mysteriously the 'ethical.'"[58]

In this case the dark of dark writing is its rhythm. Drawing draws apart from writing where this becomes apparent. Writing draws close to drawing when it is poetry. But this chiasmatic relationship has been lost. In the rush to escape from the realm of static representation, drawing has been merged with the ideal forms of geometry. But perhaps it was never representational, and always a way of notating time, lending movement form. In his essay "Drawn to That Moment," John Berger insists on the distinctive temporal vision of drawing: "In the nineteenth

century when social time became unilinear, vectorial and regularly exchangeable, the instant became the maximum which could be grasped or preserved. The plate camera and the pocket watch, the reflex camera and the wrist-watch, are twin inventions. A drawing or painting presupposes another view of time."[59] If, he argues, these innovations were seen as improving on "static images," it was because the meaning of the static image had been lost. The static did not mean stillness, deadness, eternal repose (he writes this in the context of drawing his dead father). The static image stages an act of recognition: "Recognition depends upon the phenomenon of reappearance sometimes occurring in the ceaseless flux of disappearance."[60]

In this regard, in staging re/disappearance, Berger finds drawing privileged over painting: "Drawings reveal the process of their own making, their own looking, more clearly."[61] For this reason they lapse less easily into representation; they preserve better the trace of their motivation, their reason for coming into being. "Drawing refuses the process of disappearances and proposes the simultaneity of a multitude of moments."[62] This act of recollection makes the drawing work "because from being a site of departure, it has become a site of arrival."[63]

A different engagement with time as well as space is implied in which the archaeologist's preoccupation with the weave of time, with a texture that is the palimpsest of eons of crisscrossing, is replaced by the athlete's measuring of the ground, in which, through an activity of concurrent actual production, the pressure applied at that spot releases a figure of thought, in whose gymnastic, materialized in the environs, the once self-evident idea reappears in original "coincidence." Paul Virilio has described the weaver's shuttle, "contrary to the proverbial stream that never flows back, [as] a figure of the speed of passing time," calling it "the perfect illustration of the constant feedback of our now globalised Time."[64] He has contrasted shuttle time with the way of thinking and being in time represented by the pulley, which lifts up *what weighs down*, it is like the concept that allows *what thinks and is thought* to be released and take off.
. . . [T]he pivot of the pulley would then represent the axis of a Time belonging to a reason that tries to disclose the hidden meaning of the Event."[65] The eido-kinetic intuition, developing out of a primordial experience of the body as the vehicle of ascension, exists in pulley time.

Likewise dark writing. Its hidden design on public space, the event it wants to trace out—anticipated in De Quincey's metaphor of the undistinguishable blot—is not the cumulative trace of a multiplicity of shuttles but a movement form that continuously crosses itself out. The meeting place—both temporal and spatial—is the pivot where the hidden meaning of history—the instant between two strides—declares itself. This is why it cannot be filled in or projected toward

the future; it is a hinge space, it runs on the spot, drawing out and gathering in simultaneously. Likewise the passengers of these places; they are not passages but pivots on which passages turn. It is their continuous improvisation of poses in relation to one another and to the non-human milieu at large that secures a public space where meanings are constantly appearing and fading away, where room is constantly created in which things can take place.

The choreographer Steve Paxton has developed a system of movements called "contact improvisation."[66] The key to this technique is the use of the performer's own weight "as the pivot for movement which closely involves another." The Scottish Arts Council website explains:

> Contact improvisation is a way of dancing playfully with a partner, grounded in physical sensation, which investigates how to play through sharing touch with the earth, with gravity and momentum, and with others or simply the awareness of space. There are no "moves" to learn, it's more like a moving puzzle. Contact dances can range from the quietly meditative to the exuberantly acrobatic, from using little or light touch to sending weight through a partner's body to fly.

And the same source stresses that while improvisation is very adaptable, it is no longer contact improvisation "once the moves become set for a performance." So with the character of meeting places, which are both the puzzle and its solution, both the place of assembly and the act of assembling. The script of these zones, the dark writing of their rhythmic design, would be composed of pivotal figures which together notate the localization of a movement form.

In practical terms, these reflections imply an unpicking of the present contract between architect and builder, and between both and the users of the spaces they design and build. Nelson Goodman anticipates this position when he argues that architectural plans are not representations, but scores.[67] On the face of it, this judgment contradicts common sense and professional custom. Builders are expected to follow the architect's drawings slavishly, and even if the built outcome is a designed space that is empty, ready for action, the process of delivering it has left nothing to chance. Goodman's claim can be rehabilitated, though, if *score* is understood less as a set of instructions and more as an invitation to improvise. This would involve understanding things arranged spatially as possessing a rhythm, as spatio-temporal relations. To draw out that rhythmic relation would be to inscribe the eido-kinetic intuition into the constitution of the place, in this way giving room to bodies. To give room to bodies is not to provide vast expanses of level territory, it is to license the sensation of touching the ground, to extend trust to sensations of gravity and momentum. An open score of this kind "provides a space in which to dwell."[68]

Bruce Ellis Benson makes this claim in relation to music, but there is no reason why his argument should not extend to place making. Benson suggests that in the realm of musical composition, dwelling occurs when a musical work "provides a world in which music making can take place. Performers, listeners, and even composers in effect dwell within the world it creates. Their way of dwelling is best characterised as 'improvisation.'"[69] The application of this argument to place making seems obvious. Improvisation in place making is the invitation that an enlarged graphic practice allows to dwell. Improvisation is derived from the Latin *improvisus*, a term meaning unforeseen, and only tangentially related to the French *emprouer*, yet the meanings converge. To improve is "to make profitable use of, to take advantage of, to inclose [sic] and cultivate [wasteland]; hence to make land more valuable or better by such means." Dwelling, then, is not simply "taking up space." It transforms the space in which one dwells. In dwelling, one must "fabricate out of what is conveniently to hand." Both improvisation and improvement work with the given to "create" something new.[70] The critical point is that improvisation prevents improvement from being an act of pre-emptive enclosure. It defines a "dwelling *at the limits* of the space and transgressing those limits."[71] The created space is context, room for performances that are always altering, transgressing, "improving."

Transposed to the field of design, what is conveniently at hand is the drawing, the set of instructions for making dwelling places. But written into these instructions is the unforeseen, the usually neglected dimensions of approach, reciprocity, transgression—whose trace is dark writing's graffiti. This gives a new and amplified meaning to contraction. Maps and architectural plans contract the immense complexity of the earth's spread. Traditionally, this characteristic has been used strategically, to facilitate territorialization ahead of the land's subdivision into quantifiable units. But the abbreviation of charts and the schematic reductions of plans could be interpreted differently, as a representational contraction offering a new contract with the reader/dweller. In this the builder is offered a ground and an invitation to improvise variations on it. Builders, in turn, would have to draw together their ideas in communication with those destined to dwell in the places thus constructed. You could imagine the design as a palimpsest of sketches, whose compilation of lines, blots, hieroglyphs, and scribbles resembled an undistinguishable blot of passages.

Such a plan would track the approaches taken rather than pre-empting the place of arrival. What is the "place" that emerges when such acts of triangulation are multiplied to produce a rhythmic geography? Fluid, constantly changing, and interacting but stable, it might resemble the open, cellular system envisaged by the Austrian American architect Frederick Kiesler, which "puts forth myriad threads of its own in order to entangle itself still further in life. It cannot live

without others. Its life is community. Its reality is a co-reality ... of co-ordinated forces which condition, limit, push, pull, support one another"—a performance "like acrobats in the circus, who transform themselves from one unit of two or more bodies into another unit, without losing their balance."[72] It would write remembering into the future. "Truth itself is a mass of stops and gaps," the poet Francis Webb reflected, and, following this, it would reflect the incompleteness of the historical record and the necessity in any case to invent—"I follow charts of guesswork, shape a cloud / Formless, unplotted, rotten with endless change."[73]

\* \* \*

Who will inhabit these new places? Who will be the new explorers, the ones prepared to inhabit a fluid geography? The Austrian writer Ingeborg Bachmann gives us answers. The title of her short story *The Thirtieth Year* suggests a time that both precedes and contains a date, which has both already happened and is yet to happen, and in which (consequently) history as a sequence of milestone events yields to repeated experiences of happening. As her male narrator reflects: "No, the day will not come—it was already there, contained in all the days of this year which he has survived with an effort and at a pinch."[74] In this experience of place and time the meaning of hope is reconfigured. It no longer describes a feeling about a possible future state. Change exists as a condition of living in the here and now. It refers to the constitutionally incomplete state of being, being as a manifold of possible relations, none of which can be fully decided. To live "in hope" is to experience being as a state in which necessity and possibility are both transcended; what has happened has also yet to happen because of the constitutionally incomplete nature of being *with*. As Bachmann says in "Letter in Two Versions," "I am amongst it all—what do you expect"[75]; and again in "The Game Is Over": "your age and my age and the age of the world / cannot be measured in years."[76]

To live in this state is to live in the instant between two strides, and it is to live veiled. Happiness in such a state is a matter of timing. In *The Thirtieth Year* the narrator returns to Vienna. "He bought a guide to the city in a bookshop, a guide to the city where every smell he knew and about which he knew nothing worth knowing."[77] The results are disorienting. "He put his hand over his eyes and thought: All that is impossible! It is impossible that I have known this city. Not like this."[78] That is, the narrator has made the mistake of thinking he could return. Instead of living in flight, constitutionally in the in-between, he has succumbed to a Romantic nostalgia for the fixed, immobile ground. When he makes this mistake, he learns that being, exposure at that place, produced a knowledge that cannot be represented. The guide maps a city under the aegis

of territory and event, as if it were already complete, the logical outcome of its historical and geographical necessity. But to live there had been to be in flight from certitude, to live in a state of undecidabilty. It is this the narrator discovers when he attempts to return. His project—"My plan: to arrive"[79]—proves to be an oxymoron. First, to plan in this way is already to arrive somewhere in one's life—it is to embrace the condition of being in flight. Second, to arrive, by apparently exhausting the possibility of future flight, renders the project of hoping (planning) null and void. Evidently the only success in this situation can come from his hope's disappointment. As Jean-Luc Nancy suggests, in the *chora* communication must disappoint.[80] The "inoperative" community withdraws from closure; its exposures constantly defer the prospect of unification.[81]

The design of dark writing—a writing that cannot be finished, but simply stops where a gap opens up—is the emergence of a truly public space, global, mortal, careful of its ground. In contrast with the light writing of empire, whose messages (at least as the TV and its faithful mimic Hollywood report them) seem increasingly spelled out in flares, incendiaries, and figures fleeing in flames, dark writing takes Bachmann's motto as its own: "Hope: I hope that nothing happens as I hope it will."[82] The promise of dark writing, if its character can be grasped, is that it brings these never realized democratic vistas within the realm of design. Then the mystery of design is not a euphemism for the epistemological limitations of graphicality, but identifies the existence within drawing of a fertile enigma, one that is bound to provoke invention. Dark writing is only dark because it illuminates more than light writing. By making the stops and gaps part of what is communicated, it defines the limits of design not as an edge beyond which we cannot go, but as a breaking up of the line as such. When this happens, the result is not disorientation but a new attention to the lie of the land, to the tracery of actions that holds together the spread of things: "We say that there are no human tracks in the sand if we cannot find any impressions shaped like a human foot, though perhaps there may be many unevennesses made by human feet, which can therefore in another sense be called human tracks."[83]

It is good to conclude with words translated from the author of the *Discourse on Method*. In the genealogy of intellectual infidels to which many writers subscribe these days—to the point where his name is regularly confused with *cartography!*—Descartes stands at the head. But this lineage, too, needs to be exposed as an oversimplification. René Descartes called his epoch-making work of logic a *discourse*, a running hither and thither, because he wanted to make the point that the right way only emerges after being "led down 'unknown paths', wandering 'through the streets', blundering along 'so fortunately', and walking 'in the dark.' "[84] Even the most influential philosopher of linear thinking was first of all a cryptographer of the dark and the crooked. Even if his algebraic reasoning

flattened out the terrain of reason, it did not map the entirety of his thought. It was Descartes who entertained the possibility that the topology of consciousness was creased, describing memories as "traces in the brain," and speculating that remembering something was "rather as the folds in a piece of paper or cloth make it easier to fold in that way than if it had never been so folded before."[85] This explains the historical approach taken in *Dark Writing*. I wanted to locate the discussion inside the folds of the Enlightenment's and post-Enlightenment's collective memory. When this is done, the dark writing referred to is found to reside not simply in a different graphic practice, but in a different way of reading our intellectual lineage. Inside the received lines of wisdom—nowadays so often seen one-sidedly as reductive—there are other lines. Without their dark writing ours would be all but illegible.

### Notes

1. David Farrell Krell, *Archeticture: Ecstasies of Space, Time and the Human Body* (Albany: State University of New York Press, 1997), 185.

2. Ibid., 187.

3. Ibid.

4. Donald Bates and Peter Davidson, "Textural Order: Two Recent Projects by Lab," *Assemblage* 29 (1996): 103–114, 103.

5. M. Frenkel, *Federal Theory* (Canberra: Australian National University, 1986), 141.

6. Claudia Brodsky Lacour, *Lines of Thought: Discourse, Architectonics, and the Origin of Modern Philosophy* (Durham, N.C.: Duke University Press, 1996), 149.

7. Erasmus Darwin, *The Temple of Nature* (1803), Canto Three, II, 174–176.

8. John Ruskin, *The Stones of Venice*, 3 vols. (London: Dent, 1907), vol. 1, 197.

9. Ibid., 184.

10. Umberto Boccioni, "Technical Manifesto of Futurist Sculpture," in *Theories of Modern Art: A Source Book by Artists and Critics*, ed. H. B. Chipp, 303 (Berkeley: University of California Press, 1968).

11. "Emanation" was a favored term of Der Blaue Reiter group, with which Feininger was identified.

12. Naum Gabo, "'The Realistic Manifesto', Moscow, 5 August 1920," in *Theories of Modern Art: A Source Book by Artists and Critics*, ed. H. B. Chipp, 329 (Berkeley: University of California Press, 1968).

13. Ibid., 328.

14. Thus Boccioni was of the view "[t]hat the straight line is the only means that can lead to the primitive virginity of a new architectural construction of sculptural masses or zones." Boccioni, "Technical Manifesto of Futurist Sculpture," 303. Similarly, Le Corbusier reveled in the fact that "[a] Modern city lives by the straight line,

inevitably." Le Corbusier, *The City of Tomorrow and its Planning*, trans. F. Etchells (Cambridge Mass.: Harvard University Press, 1971), 97.

15. See chapter 4, note 16.

16. M. Yampolsky, "The Essential Bone Structure: Mimesis in Eisenstein," in *Eisenstein Rediscovered*, ed, I. Christie and R. Taylor (London: Routledge, 1993).

17. Quoted in Yampolsky, "The Essential Bone Structure: Mimesis in Eisenstein," 178.

18. Ibid.

19. Ibid., 179.

20. Quoted by A. Khopkar, "Aspects of the Art of *Mise-en-scène*," in *Eisenstein Rediscovered*, ed. I. Christie and R. Taylor, 152 (London: Routledge, 1993).

21. Alexander Etkind, *Eros of the Impossible: The History of Psychoanalysis in Russia*, trans. N. and M. Rubins (Boulder, Colo.: Westview Press, 1997), 319.

22. D. Bates and P. Davidson, "Editorial," *Architectural Design Profile* 127 (1997): 7–11.

23. Alain-G. Gagnon, in *Comparative Federalism and Federation: Competing Traditions and Future Directions*, ed. M. Burgess and A-G. Gagnon, 17 (New York: Harvester Wheatsheaf, 1993). For an extended discussion see also T. Daffern, "The Etymology of Federalism and the Dissemination of Federal Ideas in Europe," in *The Federal Idea*, ed. A. Bosco, vol. 1, 66–67 (London: Lothian Foundation Press, 1991).

24. Ibid., 17.

25. Christian Jacob, *The Sovereign Map: Theoretical Approaches in Cartography throughout History*, trans. T. Conley (Chicago: University of Chicago Press, 2006), 147.

26. Ibid., 146. But see the whole of this fascinating discussion.

27. Bruno Latour, *We Have Never Been Modern*, trans. C. Porter (Cambridge, Mass: Harvard University Press, 1993), 55–56.

28. Ibid., 57.

29. Ibid., 58.

30. Ibid., 128.

31. Ibid.

32. Ibid., 129.

33. Krell, *Archeticture: Ecstasies of Space, Time and the Human Body*, 174.

34. Nigel Thrift, "Movement-space: The Changing Domain of Thinking Resulting from the Development of New Kinds of Spatial Awareness," *Economy and Society* 33: 4 (November 2004): 582–604, 590.

35. Ibid.

36. Ibid.

37. Ibid., 592.

38. Ibid., 596.

39. Ibid., 583.
40. Ibid., 600.
41. Ibid.
42. Gianni Vattimo, *The Adventure of Difference: Philosophy after Nietzsche and Heidegger*, trans. C. Blamires (Cambridge: Polity Press, 1993), 3–4.
43. See Paul Carter, "Arcadian Writing: Two Text into Landscape Proposals," *Studies in the History of Gardens and Designed Landscapes* 21: 2 (2001): 137–147, 137.
44. Gilles Deleuze, *Cinema I: The Movement Image*, trans. H. Tomlinson and B. Habberjam (London: Athlone Press, 1992), 39.
45. Ibid., 40.
46. Paul Carter, *The Sound In-Between: Voice, Space, Performance* (Sydney: New Endeavour/University of New South Wales Press, 1992), 136.
47. Arakawa Shusaku and Madeline Gins, *Pour Ne Pas Mourir* [*To Not To Die*] (Paris: Editions de la Différence, 1987), 48.
48. Ibid., 50.
49. Ibid., 52.
50. Ibid., 58.
51. Ibid., 60.
52. Or as the poet Hopkins said more lyrically, "All the world is full of inscape and chance left free to act falls into an order as well as purpose." Gerard Manley Hopkins, *The Note Books and Papers*, ed. H. House (Oxford: Oxford University Press, 1937), 173.
53. Robert Musil, *The Man Without Qualities*, 3 vols., trans. E. Wilkins and E. Kaiser (London: Secker & Warburg, 1979–), vol. 2, 276.
54. Giorgio Agamben, "The Original Structure of the Work of Art," in *The Man Without Content*, 100 (Stanford, Calif.: Stanford University Press, 1999).
55. Ibid., 101.
56. Philippe Lacoue-Labarthe, *Typography: Mimesis, Philosophy, Politics* (Cambridge, Mass.: Harvard University Press, 1989), 200–201.
57. Ibid., 201.
58. Ibid., 202.
59. John Berger, "Drawn to That Moment," in *Selected Essays*, ed. G. Dyer, 421 (London: Bloomsbury, 2001).
60. Ibid.
61. Ibid., 421–422.
62. Ibid., 421.
63. Ibid., 423.
64. Paul Virilio, "Foreword," in John Rajchman, *Constructions*, vi–vii, vii (Cambridge, Mass.: The MIT Press, 1999).
65. Ibid., vi.

66. All quotations in this paragraph are from Steve Paxton, Anne Kilcoyne, and Kate Mount, "On the Braille in the Body: An Account of the Touchdown Dance Integrated Workshops with the Visually Impaired and the Sighted," *Dance Research: The Journal of the Society for Dance Research* 11: 1 (Spring 1993): 3–51.

67. Nelson Goodman, *Languages of Art: An Approach to the Theory of Symbols* (Indianapolis, Ind.: Hackett, 1976).

68. Bruce Ellis Benson, *The Improvisation of Musical Dialogue: A Phenomenology of Music* (Cambridge: Cambridge University Press, 2003), 31. The original reference is to Martin Heidegger, "The Origin of the Work of Art," in *Poetry, Language, Thought*, trans. A. Hofstadter (New York: Harper & Row, 1971).

69. Benson, *The Improvisation of Musical Dialogue*, 32.

70. Ibid.

71. Ibid., 150.

72. Frederick Kiesler, "Pseudo-Functionalism in Modern Architecture" (1949), in *Frederick Kiesler, 1890–1965*, ed. Y. Safran, 56 (London: Architectural Association, 1989).

73. Francis Webb, "A Drum for Ben Boyd," in *Cap and Bells: The Poetry of Francis Webb*, 43 (Sydney: Angus & Robertson, 1991).

74. Ingeborg Bachmann, *The Thirtieth Year*, trans. M. Bullock (New York: Holmes & Meier, 1987), 55.

75. Ingeborg Bachmann, *Songs in Flight: The Collected Poems*, trans. P. Filkins (New York: Marsilio Publishers, 1994), 201.

76. Ibid., 111.

77. Bachmann, *The Thirtieth Year*, 38.

78. Ibid.

79. Ibid., 48.

80. Jean-Luc Nancy, *The Birth to Presence*, trans. B. Holmes et al. (Stanford, Calif.: Stanford University Press, 1993), 314.

81. See Georges Van Den Abbeele, "Lost Horizons and Uncommon Grounds: For a Poetics of Finitude in the Work of Jean-Luc Nancy," in *On Jean-Luc Nancy: The Sense of Philosophy*, ed. D. Sheppard, S. Sparks, and C. Thomas, 12–18, 17 (London: Routledge, 1997).

82. Bachmann, *The Thirtieth Year*, 25.

83. René Descartes, *Philosophical Letters*, trans. and ed. A. Kenny (Oxford: Clarendon Press, 1970), 234.

84. John R. Cole, *The Olympian Dreams and Youthful Rebellion of René Descartes* (Urbana: University of Illinois Press, 1992), 134–135.

85. Ibid., 148–149.

## BIBLIOGRAPHY

Aesop. *The Complete Fables.* Translated by O. Temple and R. Temple. London: Penguin, 1998.

Agamben, Giorgio. "The Original Structure of the Work of Art." In *The Man Without Content.* Stanford, Calif.: Stanford University Press, 1999.

Alberti, Leon Battista. *On Painting.* Translated by J. R. Spencer. New Haven, Conn.: Yale University Press, 1977.

Anderson, Christopher, and Francoise Dussart. "Dreamings in Acrylic: Western Desert Art." In *Dreamings: Art from Aboriginal Australia,* edited by P. Sutton. Ringwood, Victoria: Viking, 1988.

Apollonius of Rhodes. *Argonautica,* Book 1. London: Heinemann, 1912.

Appelbaum, David. *The Stop.* Albany: State University of New York Press, 1995.

Arakawa Shusaku and Madeline Gins, *Pour Ne Pas Mourir [To Not To Die].* Paris: Editions de la Différence, 1987.

Ash, Thomas. "Is it Rational to Believe in Induction?" At <www.bigissueground.com/philosophy/ash-induction.shtml>.

Atherton, Margaret. *Berkeley's Revolution in Vision.* Ithaca, N.Y.: Cornell University Press, 1990.

Bachmann, Ingeborg. *Songs in Flight: The Collected Poems.* Translated by P. Filkins. New York: Marsilio Publishers, 1994.

———. *The Thirtieth Year.* Translated by M. Bullock. New York: Holmes & Meier, 1987.

Balint, Michael. "Friendly Expanses—Horrid Empty Spaces," *The International Journal of Psycho-Analysis* 26 (1955): 4–5.

Ballard, J. *Mercator's Projection and Marine Cartography in H.M.S. Endeavour.* Duntroon, N.S.W.: Royal Military College, Faculty of Geography, occasional paper No. 34, 1983.

Bardon, Geoffrey. *Aboriginal Art of the Western Desert.* Adelaide: Rigby, 1979.

———. "Children's Art." Unpublished manuscript. N.d., 1–13.
———. "Conclusion." Unpublished manuscript. N.d.
———. "Give to the Innocent that which is their Due." Unpublished manuscript. N.d., unnumbered.
———. "Key Whites." Unpublished manuscript. N.d., 1–4.
———. Letter to author, 6 September 2002.
———. *The Lives of the Painters.* Unpublished manuscript. c.2000, 1–131.
———. *Papunya Tula, Art of the Western Desert.* Melbourne: McPhee Gribble, 1991.
———. *A Place Made After the Story.* Unpublished manuscript. 1999, 1–1093.
———. *A Place Made After the Story.* Unpublished manuscript. 2000, 1–342.
———. Report concerning "circumstances leading to the termination of my work at Papunya Settlement." August 1972. Author's possession.
———. "Synopsis for *Meanjin* Essay." 19 January 2002. Author's possession.
———. "Theory and Practice." Unpublished manuscript. N.d.
Bardon, Geoffrey, and James Bardon. *Papunya, a Place Made After the Story: The Beginnings of the Western Desert Painting Movement.* Carlton: Miegunyah Press/Melbourne University Press, 2004.
Bastin, John. "Introduction." In Alfred Russel Wallace, *The Malay Archipelago.* Kuala Lumpur: Oxford University Press, 1986.
Bates, Don, and Peter Davidson. "Editorial." *Architectural Design Profile* 127 (1997).
———. "Textural Order: Two Recent Projects by Lab." *Assemblage* 29 (1996).
Berger, John. "Drawn to That Moment." In *Selected Essays,* edited by G. Dyer. London: Bloomsbury, 2001.
Benjamin, Walter. "On the Mimetic Faculty." In *Reflections.* New York: Schocken Books, 1986.
Benson, Bruce Ellis. *The Improvisation of Musical Dialogue: A Phenomenology of Music.* Cambridge: Cambridge University Press, 2003.
Bertin, Jacques. *Semiology of Graphics.* Madison: University of Wisconsin Press, 1983.
Bloch, Ernst. *Literary Essays.* Translated by A. Joron et al. Stanford, Calif.: Stanford University Press, 1998.
Boccioni, Umberto. "Technical Manifesto of Futurist Sculpture." In *Theories of Modern Art: A Source Book by Artists and Critics,* edited by H. B. Chipp. Berkeley: University of California Press, 1968.
Bowra, Maurice. *The Greek Experience.* New York: New American Library, 1957.
Boyle, Robert. *Sceptical Chymist.* 1661. <http://oldisdte.library.upenn.edu/etext/collections/science/boyle/chymist/104.html>.
Bride, T. F., ed. *Letters from Victorian Pioneers.* South Yarra, Melbourne: Lloyd O'Neil, 1983. Originally published 1898.
Brodsky Lacour, Claudia. *Lines of Thought: Discourse, Architectonics and the Origin of Modern Philosophy.* Durham, N.C.: Duke University Press, 1996.

Brough Smyth, R. *The Aborigines of Victoria and Other Parts of Australia and Tasmania*. Melbourne: John Curry O'Neil, 1972. Originally published, Melbourne: Government Printers, 1876.

Buckrich, Judith Raphael. *The Long and Perilous Journey: A History of the Port of Melbourne*. Melbourne: Melbourne Books, 2002.

*Building Stones of South Australia*. Adelaide: South Australian Department of Mines and Energy. 1983.

Burnett, Anne P. *The Art of Bacchylides*. Cambridge, Mass.: For Oberlin College by Harvard University Press, 1985.

Cadava, Eduardo. *Words of Light*. Princeton, N.J.: Princeton University Press, 1997.

Calamé, Claude. *The Poetics of Eros in Ancient Greece*. Translated by J. Lloyd. Princeton, N.J.: Princeton University Press, 1999.

Carr, David. *Interpreting Husserl*. Dordrecht, Holland: Martinus Nijhoff, 1987.

Carter, Paul. "Adelaide's Mythform: Discovering the Variable Grid and Applying It." Internal report, November 2000.

———. "Arcadian Writing: Two Text into Landscape Proposals." *Studies in the History of Gardens and Designed Landscapes* 21:2 (2001).

———. "Ground Designs and the New Ichnology." In *Disputed Territories: Land Culture and Identity in Settler Societies*, edited by D. Trigger and G. Griffiths. Aberdeen, Hong Kong: Hong Kong University Press, 2003.

———. "Interest: The Ethics of Invention." At <www.speculation2005.qut.edu.au/papers/Carter_keynote.pdf>.

———. "Introduction: The Interpretation of Dreams." In Geoffrey Bardon and James Bardon. *Papunya: A Place Made After the Story: The Beginnings of the Western Desert Painting Movement*. Carlton, Melbourne: Miegunyah Press, 2004.

———. "Invisible Journeys: Exploration and Photography in Australia, 1839–1889." In *Island in the Stream*, edited by Paul Foss. Sydney: Pluto Press, 1988.

———. *The Lie of the Land*. London: Faber & Faber, 1996.

———. *Living in a New Country*. London: Faber & Faber, 1992.

———. *Material Thinking*. Carlton, Melbourne: Melbourne University Publishing, 2004.

———. "On Salvaging Words, Carrying Meanings." In Paul Carter and Ruark Lewis, *Depth of Translation: The Book of Raft*. Melbourne: NMR Publications, 1999.

———. "Other Speak: The Poetics of Cultural Difference." In *Empires, Ruins + Networks: The Transcultural Agenda in Art*, edited by S. McGuire and N. Papastergiadis. Carlton, Melbourne: Melbourne University Publishing, 2005.

———. *Repressed Spaces: The Poetics of Agoraphobia*. London: Reaktion Books, 2002.

———. *The Road to Botany Bay*. London: Faber & Faber, 1987.

———. "Second Sight: Looking Back as Colonial Vision." *Australian Journal of Art* XIII (1996).

———. "*Solution*: A public spaces strategy, Victoria Harbo*r," July 2002. Unpublished.
———. *The Sound In-Between: Voice, Space, Performance*. Sydney: New Endeavour/University of New South Wales Press, 1992.
Catana, Leo. "Meanings of 'Contraction' in Giordano Bruno's *Sigillus Sigillorum*." In *Giordano Bruno: Philosopher of the Renaissance*, edited by H. Gatti. Aldershot, Hants: Ashgate Publishing, 2002.
Chiang, Yee. *Chinese Calligraphy: An Introduction to its Aesthetic and Technique*. London: Methuen, 1954.
Clark, Justine. "Smudges, Smears and Adventitious Marks." *Interstices* 4, at <www.architecture.auckland.ac.nz/common/library/1995/11/i4/THEHTML/papers/clark/front.htm>.
Cobb-Stevens, Richard. "Derrida and Husserl on the Status of Retention." *Analecta Husserliana*, vol. XVII, 1985.
Cole, John R. *The Olympian Dreams and Youthful Rebellion of René Descartes*. Urbana: University of Illinois Press, 1992.
Coleridge, Samuel Taylor. "Dejection: An Ode." 1802.
Colley, Ann C. *The Search for Synthesis in Literature and Art*. Athens: The University of Georgia Press, 1990.
Coltman, Rod. *The Language of Hermeneutics, Gadamer and Heidegger in Dialogue*. Albany: State University of New York Press, 1998.
Corbin, Alain. *The Lure of the Sea: The Discovery of the Seaside in the Western World, 1750–1840*. Translated by Jocelyn Phelps. Cambridge: Polity Press, 1994.
Cottom, Daniel. *Abyss of Reason: Cultural Movements, Revelations, and Betrayals*. Oxford: Oxford University Press, 1991.
Curthoys, A., A. W. Martin, and T. Rowse, eds. *Australians from 1939*. Sydney: Fairfax, Syme & Weldon, 1987.
Daffern, T. "The Etymology of Federalism and the Dissemination of Federal Ideas in Europe." In *The Federal Idea*, vol. 1, edited by A. Bosco. London: Lothian Foundation Press, 1991.
Dallmayr, Fred. "An 'Inoperative' Global Community? Reflections on Nancy." In *On Jean-Luc Nancy: The Sense of Philosophy*, edited by D. Sheppard, S. Sparks, and C. Thomas. London: Routledge, 1997.
Dalyell, John Graham. *Shipwrecks and Disasters at Sea*. Manchester: S. Johnson, 1837.
Darwin, Charles. *The Origin of Species*. London: John Murray, 1859.
Darwin, Erasmus. *The Temple of Nature: or, The Origin of Society: A Poem*. London: Printed for S. Johnson, 1803.
Davies, Alun C. "Testing a New Technology: Captain George Vancouver's Survey and Navigation in Alaskan Waters, 1794." In *Enlightenment and Exploration*, edited by Stephen W. Haycox, James K. Barnett, and Caedmon A. Liburd. Seattle, Wash.: Cook Inlet Historical Society, 1997.

Decker, Hannah S. *Freud, Dora, and Vienna 1900*. New York: The Free Press, 1991.
Deleuze, Gilles. *Cinema I: The Movement Image*. Translated by H. Tomlinson and B. Habberjam. London: Athlone Press, 1992.
Deleuze, Gilles, and Felix Guattari. *A Thousand Plateaus: Capitalism and Schizophrenia*. Translated by B. Massumi. Minneapolis, University of Minnesota Press, 1987.
De Quincey, Thomas. *Select Essays*. Edited by A. Masson. Edinburgh: A. and C. Black, 1888.
Derrida, Jacques. *Given Time, I: Counterfeit Money*. Translated by P. Kamuf. Chicago: University of Chicago Press, 1992.
Descartes, René. *Philosophical Letters*. Translated by and edited by A. Kenny. Oxford: Clarendon Press, 1970.
Deutsche, Rosalind. "Agoraphobia." In *Evictions: Art and Spatial Politics*. Cambridge, Mass.: MIT Press, 1996.
Edney, Matthew H. *Mapping an Empire: The Geographical Construction of British India, 1765–1843*. Chicago: University of Chicago Press, 1997.
Ellenberger, Henri F. *Beyond the Unconscious: Essays of Henri F. Ellenberger in the History of Psychiatry*. Translated by F. Dubor and M. S. Micale. Princeton, N.J.: Princeton University Press, 1993.
———. "The Life and Work of Hermann Rorschach." In *Beyond the Unconscious: Essays of Henri F. Ellenberger in the History of Psychiatry*, translated by F. Dubor and M. S. Micale. Princeton, N.J.: Princeton University Press, 1993.
Ernout, A., and A. Meillet. *Dictionnaire Etymologique de la Langue Latine*. Paris: Librairie C. Klinksieck, 1951.
Etkind, Alexander. *Eros of the Impossible: The History of Psychoanalysis in Russia*. Translated by N. and M. Rubins. Boulder, Colo.: Westview Press, 1997.
Everett, D. H. *Basic Principles of Colloid Science*. Letchworth: Royal Society of Chemistry, 1987.
Eyre, Edward J. *Journals of Expeditions of Discovery into Central Australia (1845)*. 2 vols. Adelaide: Libraries Board of South Australia, 1964. Originally published, London: T. and W. Boone, 1845.
Fenves, Peter. *"Chatter": Language and History in Kierkegaard*. Stanford, Calif.: Stanford University Press, 1993.
Feyerabend, Paul. *Realism, Rationalism & Scientific Method: Philosophical Papers*, vol. 1. Cambridge: Cambridge University Press, 1985.
Fisher, Robin. "George Vancouver and the Native Peoples of the Northwest Coast." In *Enlightenment and Exploration*, edited by Stephen W. Haycox, James K. Barnett, and Caedmon A. Liburd. Seattle: Cook Inlet Historical Society, 1997.
Flinders, Matthew. *Private Journal*, 14 September 1811.
———. *A Voyage to Terra Australis*. 2 vols. Adelaide: Australian Facsimile Edition, Libraries Board of South Australia, 1974. Originally published 1814.

Forster, Georg. *A Voyage Round the World in His Britannic Majesty's Sloop Resolution, Commanded by Capt. James Cook, During the Years 1772, 3, 4 and 5*. Edited by Johann Reinhold Forster. London: Printed for B. White, J. Robson, P. Elmsby, and G. Robinson, 1777.

Foster, Thomas. "'Prediction and Perspective': Textuality and Counterhegemonic Culture in Antonio Gramsci and Julia Kristeva." In *Maps and Mirrors: Topologies of Art and Politics,* edited by S. Martinot. Evanston, Ill.: Northwestern University Press, 2001.

Francis, James A. "Living Icons: Tracing a Motif in Verbal and Visual Representation from the Second to the Fourth Centuries C.E." *American Journal of Philology* 124 (2003).

Frenkel, M. *Federal Theory*. Canberra: Australian National University, 1986.

Freud, Sigmund. *The Interpretation of Dreams*. Translated by J. Strachey. New York: Basic Books, 1960.

———. "The Moses of Michelangelo" (1914), *Standard Edition 13*. Edited by J. Strachey. London: The Hogarth Press and the Institute of Psychoanalysis, 1953.

Frome, E. C. *Outline of the Method of Conducting a Trigonometrical Survey for the Formation of Topographical Plans*. London: J. Weale: Architectural Library, 1840.

Fry, Roger. "Mrs. Cameron's Photographs." In *Victorian Photographs of Famous Men and Fair Women, by Julia Margaret Cameron*. Boston: David Godine, 1973.

Gabo, Naum. "'The Realistic Manifesto', Moscow, 5 August 1920." In *Theories of Modern Art: A Source Book by Artists and Critics,* edited by H. B. Chipp. Berkeley: University of California Press, 1968.

Gadamer, Hans-Georg. "Discussion." *Analecta Husserliana,* vol. II. Edited by Anna-Teresa Tymieniecka. Dordrecht, Holland: D. Reidel, 1972.

———. *Philosophical Hermeneutics*. Translated by D. E. Linge. Berkeley, University of California Press, 1976.

———. Gagnon, Alain-G, and M. Burgess, eds. *Comparative Federalism and Federation: Competing Traditions and Future Directions*. New York: Harvester Wheatsheaf, 1993.

Ganascia, Jean-Gabriel. "Logic and Induction: An Old Debate," at <www-poleia.lip6.fr/~ganascia/Archives_postcript/logique_induction.ps>.

Gasché, Rodolphe. *Of Minimal Things: Studies in the Notion of Relation*. Stanford, Calif.: Stanford University Press, 1999.

Genet, Jean. "The Studio of Alberto Giacometti." In *Fragments of the Artwork,* translated by Charlotte Mandell. Stanford, Calif.: Stanford University Press, 2003.

Gibson, J. J. *The Ecological Approach to Visual Perception*. Boston: Houghton Mifflin, 1979.

Gill, Edmund G. "History from our Harbor Floor." *Port of Melbourne Quarterly,* January–March 1949.

Gill, Jerry H. *Merleau-Ponty and Metaphor*. Atlantic Highlands, N.J.: Humanities Press International, 1991.

Goetsch, James Robert. *Vico's Axioms: The Geometry of the Human World*. New Haven, Conn.: Yale University Press, 1995.

Goldberg, Jonathan. "On the Other Hand . . ." In J. Bender and D. Wellbery, *The Ends of Rhetoric: History, Theory, Practice*. Stanford, Calif.: Stanford University Press, 1990.

Gomme, Alice B. *The Traditional Games of England, Scotland and Ireland*. 2 vols. New York: Dover Publications, 1964.

Goodman, Nelson. *Languages of Art: An Approach to the Theory of Symbols*. Indianapolis, Ind.: Hackett, 1976.

Goodman, Paul. *Kafka's Prayer*. New York: Vanguard, 1947.

Gordon, Harry. *Australia and the Olympic Games*. St. Lucia: University of Queensland Press, 1994.

Gosse, Edmund. *Father and Son*. Harmondsworth: Penguin, 1982.

Gray, Michael. "Towards Photography." In *Huellas de Luz: El Arte y los Experimentos de William Henry Fox Talbot*. Madrid: Museo Nacional Centro de Arte Reina Sofia, 2001.

Harley, J. B. "Deconstructing the Map." In *The New Nature of Maps: Essays in the History of Cartography*, edited by Paul Laxton. Baltimore: The Johns Hopkins Press, 2001.

Harpur, Charles. *Charles Harpur: Selected Poetry and Prose*. Edited by M. Ackland. Melbourne: Penguin, 1986.

Heidegger, Martin. "The Origin of the Work of Art." In *Poetry, Language, Thought*, translated by A. Hofstadter. New York: Harper & Row, 1971.

Hesiod. *The Homeric Hymns and Homerica*. Translated by H. G. Evelyn-White. London: Heinemann, 1974.

Hillman, James. *The Dream and the Underworld*. New York: Harper and Row, 1979.

*Historical Records of New South Wales: Hunter and King, 1800–1802*, vol. 4, facsimile reprint. Mona Vale, N.S.W.: Landsdown Slattery & Company, 1976.

Hoare, M. E., ed. *The Resolution Journal of Johann Reinhold Forster, 1772–1775*. 4 vols. Cambridge: Cambridge University Press, 1982.

Hogarth, William. *The Analysis of Beauty*. London, 1753. Printed by J. Reeves for the author.

Hohl, R. *Alberto Giacometti: Sculpture, Painting, Drawing*. London: Thames and Hudson, 1972.

Holmes, Richard. *Footsteps: Adventures of a Romantic Biographer*. London: Hodder and Stoughton, 1985.

Hopkins, Gerard Manley. *The Note Books and Papers*. Edited by H. House. Oxford: Oxford University Press, 1937.

———. *The Poems of Gerard Manley Hopkins*. Edited by W. H. Gardner. Oxford: Oxford University Press, 1970.
Hosking, J. B. O. "A Forest in a Port." *Port of Melbourne Quarterly* (July–September 1948).
Hunt, Susan, and Paul Carter. *Terre Napoleon: Australia through French Eyes, 1800–1804*. Sydney: Historic Houses Trust of New South Wales, 1999.
Husserl, Edmund. "[Appendix VI] The Origin of Geometry." In *The Crisis of European Sciences and Transcendental Phenomenology*. Translated by David Carr. Evanston, Ill.: Northwestern University Press, 1970.
———. *The Crisis of European Sciences and Transcendental Phenomenology*. Translated by David Carr. Evanston, Ill.: Northwestern University Press, 1970.
Hutton, James. *An Investigation of the Principles of Knowledge and of the Progress of Reason*. 3 vols. Edinburgh: Strahan and Cadell, 1794.
Ingleton, Geoffrey C. *Matthew Flinders, Navigator and Chartmaker*. Surrey: Guildford, 1986.
Ingraham, Catherine. *Architecture and the Burdens of Linearity*. New Haven, Conn.: Yale University Press, 1998.
———. "Initial Properties: Architecture and the Space of the Line." In *Sexuality and Space*, edited by Beatriz Colomina. New York: Princeton Architectural Press, 1992.
Innes, Bob. "Western Desert Art." Typescript supplied by Geoffrey Bardon, dated February 1997.
Jacob, Christian. *The Sovereign Map: Theoretical Approaches in Cartography throughout History*. Translated by T. Conley. Chicago: University of Chicago Press, 2006.
Jefferies, Richard. "Venice in the East End." In *The Life of the Fields*. Oxford: Oxford University Press, 1983.
Jirgensons, B., and M. E. Straumanis. *A Short Textbook of Colloid Chemistry*. London: Pergamon Press, 1954.
Jones, Frederic J. *Giuseppe Ungaretti, Poet and Critic*. Edinburgh: Edinburgh University Press, 1977.
Kafka, Franz. "Third Octavo Notebook." In *Wedding Preparations in the Country and Other Posthumous Writings*, translated by E. Kaiser and E. Wilkins. London: Secker & Warburg, 1954.
Kandinsky, Wassily. "On the Problem of Form" (1912). In *Theories of Modern Art: A Source Book by Artists and Critics*, edited by H. B. Chipp. Berkeley: University of California Press, 1968.
Kant, Immanuel. *Anthropology from a Pragmatic Point of View*. Translated by M. J. Gregor. The Hague: Martinus Nijhoff, 1974.
Kearney, Amanda, and John J. Bradley. "Landscapes with Shadows of Once-living People: The *Kundawira* Challenge." In *The Social Archaeology of Australian

*Indigenous Societies*, edited by B. David, B. Barker, and I. J. McNiven. Canberra: Aboriginal Studies Press, 2006.

Kellogg, Rhoda. *Analyzing Children's Art*. Palo Alto, Calif: National Press Books, c.1970.

Kerenyi, Carl. *Dionysos*. Translated by R. Manheim. Princeton, N.J.: Princeton University Press, 1976.

Khlebnikov, Velimir. *Collected Works of Velimir Khlebnikov, Vol. 1: Letters and Theoretical Writings*. Translated by P. Schmidt. Cambridge Mass.: Harvard University Press, 1987.

Khopkar, A. "Aspects of the Art of *Mise-en-scène*." In *Eisenstein Rediscovered*, edited by I. Christie and R. Taylor. London: Routledge, 1993.

Kierkegaard, Søren. *Fear and Trembling*. Translated by W. Lowrie. Princeton, N.J.: Princeton University Press, 1954.

Kiesler, Frederick. "Pseudo-Functionalism in Modern Architecture" (1949). In *Frederick Kiesler, 1890–1965*, edited by Y. Safran. London: Architectural Association, 1989.

King, Phillip P. *Narrative of a Survey of the Intertropical and Western Coasts of Australia*. 2 vols. Adelaide: Libraries Board of South Australia, 1969. Originally published, London: John Murray, 1827.

Kisiel. T. "Repetition in Gadamer's Hermeneutics." *Analecta Husserliana*, Vol. II. Edited by Anna-Teresa Tymieniecka. Dordrecht, Holland: D. Reidel, 1972.

Klages, Ludwig. "Cosmogonic Reflections." No. 292, at <www.revilo-oliver.com/Writers/Klages/300.html>. Translated from *Sämtliche Werke*, vol. 3. Bonn: 1965–1992.

Klee, Felix, ed. *The Diaries of Paul Klee, 1891–1918*. Berkeley: University of California Press, 1964.

Klee, Paul. "Creative Credo" (1920). In *Theories of Modern Art: A Source Book by Artists and Critics*, edited by H. B. Chipp. Berkeley: University of California Press, 1968.

———. *Pedagogical Notebook*. Translated by S. Moholy-Nagy. London: Faber & Faber, 1968.

Kraehenbuehl, Darrell N. *Pre-European Vegetation of Adelaide: A Survey from the Gawler River to Hallett Cove, Adelaide*. Adelaide: Nature Conservation Society of South Australia Inc., 1996.

Krasavtsev, B., and B. Khlyusten. *Nautical Astronomy*. Translated by G. Yankovsky. Moscow: MIR Publishers, 1970.

Krell, David Farrell. *Archeticture, Ecstasies of Space, Time and the Human Body*. Albany: State University of New York Press, 1997.

Krieger, Murray. "'A Waking Dream': The Symbolic Alternative to Allegory." In *Allegory, Myth, and Symbol*, edited by M. W. Bloomfield. Cambridge, Mass.: Harvard University Press, 1981.

Kruyt, H. R., ed. *Colloid Science*. 2 vols. New York: Elsevier Publishing, 1949.
Kuspit, Donald. "The Semiotic Anti-Object." At <www.artnet.com/Magazine/features/kuspit/kuspit4-20-01.asp>.
Lack, John. *A History of Footscray*. North Melbourne: Hargreen Publishing, 1991.
Lacoue-Labarthe, Philippe. *Typography: Mimesis, Philosophy, Politics*. Cambridge, Mass.: Harvard University Press, 1989.
Lambert, Gregg. *The Non-Philosophy of Gilles Deleuze*. New York: Continuum, 2002.
Lapicque, Charles. *Les Desseins de Lapicque au Musée National d'Art Moderne*. Preface by Pierre Georgel. Paris: Centre Georges Pompidou, 1978.
Latour, Bruno. *We Have Never Been Modern*. Translated by C. Porter. Cambridge, Mass.: Harvard University Press, 1993.
Leatherbarrow, David. "Leveling the Land." In *Recovering Landscape*, edited by J. Corner. Princeton. N.J.: Princeton University Press, 1999.
Le Corbusier, *The City of Tomorrow and its Planning*. Translated by F. Etchells. Cambridge Mass.: Harvard University Press, 1971.
Le Doeuff, Michèle. *The Philosophical Imaginary*. Translated by C. Gordon. London: Continuum, 2002.
Lee, Emma, and Darwala-Lia. *Aboriginal History of Homebush Bay Olympic Site*. Metropolitan Local Aboriginal Land Council, 1999.
Leibniz, G. W. *Philosophical Writings*. Translated by M. Morris. London: J. M. Dent, 1961.
Levinas, Emmanuel. *Basic Philosophical Writings*. Edited by R. Bernasconi, S. Critchley, and A. Peperzak. Bloomington: Indiana University Press, 1996.
———. *On Thinking of the Other: Entre-Nous*. Translated by M. B. Smith and B. Harshav. London: Athlone Press, 1998.
———. "The Transcendence of Words: On Michel Leiris's Biffures." In *Outside the Subject*. London: Routledge, 1990.
Levine, Donald N. *The Flight from Ambiguity*. Chicago: University of Chicago Press, 1985.
Lewis, Miles. *Melbourne: The City's History and Development*. Melbourne: City of Melbourne, 1994.
Lingis, Alphonso. "Hyletic Data," *Analecta Husserliana*, vol II. Edited by Anna-Teresa Tymieniecka. Dordrecht, Holland: D. Reidel, 1972.
Loraux, Nicole. *Mothers in Mourning, with the Essay "Of Amnesty and Its Opposite."* Translated by Corinne Pache. Ithaca, N.Y.: Cornell University Press, 1998.
Lowenfeld, Victor, and W. Lambert Brittain. *Creative and Mental Growth*. New York: Macmillan, 1970.
Lowenstein, Wendy, and Tom Hills. *Under the Hook: Melbourne Waterside Workers Remember, 1900–1998*. Melbourne: Port Melbourne Historical and Preservation Society, 1998.

Lucas, John A. *Future of the Olympic Games.* Champaign, Ill.: Human Kinetics Books, 1992.
Lupton, Ellen, and J. Abbott Miller. "Deconstruction and Graphic Design: History Meets Theory." At <www.designwritingresearch.org/essays/deconstruction.html>.
Lynn, Greg. *Folds, Bodies and Blobs: Collected Essays.* Brussels: La lettre volée, 1998.
———. "Multiplicities and Inorganic Bodies." *Assemblage* 19 (December 1992).
Lyons, Joan. *Artists' Books: A Critical Anthology and Sourcebook.* New York: Visual Studies Workshop Press, 1985.
Lyotard, Jean-François. "Domus and the Megalopolis." In *The Inhuman: Reflections on Time,* translated by G. Bennington and R. Bowlby. Stanford, Calif.: Stanford University Press, 1991.
———. "Time Today." In *The Inhuman: Reflections on Time,* translated by G. Bennington and R. Bowlby. Stanford, Calif.: Stanford University Press, 1991.
Mack, Mary. *Jeremy Bentham: An Odyssey of Ideas, 1748–1792.* London: Heinemann, 1962.
Mali, Joseph. *The Rehabilitation of Myth: Vico's New Science.* Cambridge: Cambridge University Press, 1992.
Mann, Thomas. "Freud and the Future." In *Essays of Three Decades,* translated by H. T. Lowe-Porter. New York: Alfred A. Knopf, 1976.
Marion, Jean-Luc. *Being Given: Toward a Phenomenology of Givenness.* Translated by J. L. Kosky. Stanford, Calif.: Stanford University Press, 2002.
Marquand, David. *Decline of the Public.* London: Polity Press, 2004.
Marvin, F. S. in *Geography* 17 (1932). In *Historical Geography: A Methodological Portrayal,* edited by D. Brooks Green. Savage, Md.: Rowman & Littlefield, 1991.
McBain, James W. *Colloid Science.* Boston: D. C. Heath and Company, 1950.
McIntyre, Donald B., and Alan McKirdy. *James Hutton: The Father of Modern Geology.* Edinburgh: The Stationery Office, 1997.
Merleau-Ponty, Maurice. *The Prose of the World.* Translated by John O'Neill. Evanston, Ill.: Northwestern University Press, 1973.
———. *Signs.* Translated by Richard C. McLeary. Evanston, Ill.: Northwestern University Press, 1964.
———. *The Visible and the Invisible.* Edited by C. Lefort. Translated by A. Lingis. Evanston, Ill.: Northwestern University Press, 1968.
Michl, Jan. "Form Follows What? The Modernist Notion of Function as a Carte Blanche." At <www.geocities.com/Athens/2360/jm-eng.fff-hai.html>.
Mill, John Stuart. *On Liberty* (1860), vol. 25, Harvard Classics. New York: P. F. Collier & Son, 1909.
Miller, Carl. *Principles of Photographic Reproduction.* New York: Macmillan, 1942.
Miller, Mitchell H. *Plato's* Parmenides. Princeton, N.J.: Princeton University Press, 1986.

Miller, Stephen G. *Arete: Greek Sports from Ancient Sources.* Berkeley: University of California Press.

Mitchell, W. J. T. *Picture Theory: Essays on Verbal and Visual Representation.* Chicago: University of Chicago Press, 1994.

Moles, Abraham A. "The Legibility of the World: A Project of Graphic Design." In *Design Discourse: History, Theory, Criticism,* edited by V. Margolin. Chicago: University of Chicago Press, 1989.

Møller, Liz. "Thomas De Quincey's Arabesque Confessions." At <www.litteraturhistorie.au.dk/forskning/publikationer/arbejdspapir>.

Montgomery, Keith. "Siccar Point and the Teaching of Geology." *Journal of Geoscience Education* 51: 5 (November 2003).

Moorhouse, M. "Vocabulary and Outlines of the Grammatical Structure of the Murray River Languages." In *Reprints and Papers Relating to the Autochthones of Australia.* 2 vols. Woodville, South Australia, 1923–1930, vol. 2a.

Morgan, Charles. *The Fountain.* London: The Reprint Society, 1941.

Morieson, John. "The Night Sky of the Boorong: Partial Reconstruction of a Disappeared Culture in North-West Victoria." MA Thesis, University of Melbourne, 1996.

Mukherjee, Bharati. *Jasmine.* Melbourne: McPhee Gribble, 1992.

Mullen, W. *Choreia: Pindar and Dance.* Princeton, N.J.: Princeton University Press, 1982.

Musil, Robert. *The Man Without Qualities,* 3 vols. Translated by E. Wilkins and E. Kaiser. London: Secker & Warburg, 1979–.

Myers, Fred. "Traffic in Culture: 'On knowing Pintupi Painting'." In *Impossible Presence: Surface and Screen in the Photogenic Era,* edited by T. Smith. Chicago: University of Chicago Press, 2001.

Nancy, Jean-Luc. *The Birth to Presence.* Translated by B. Holmes et al. Stanford, Calif.: Stanford University Press, 1993.

Nangle, James. *Stars of the Southern Heavens.* Sydney: Angus & Robertson, 1958.

Napoli, Mario. *La Tomba del Tuffatore: La scoperta della grande pittura greca.* Bari: De Donato, 1970.

Niven, Stuart. "Surgery and Repair." *Architecture Australia,* May/June 2001.

Nyala, Hannah. *Point Last Seen: A Woman Tracker's Story.* Boston: Beacon Press, c.1997.

O'Brien, Lewis. "My Education." *Journal of the Anthropological Society of South Australia* 28: 2 (1990): 106–126.

Orban, Desiderius. *What Is Art All About?* Sydney: Hicks, Smith & Sons, 1975.

Panofsky, Erwin. *Meaning in the Visual Arts.* London: Peregrine, 1970.

———. *Studies in Iconology.* New York: Harper, 1962.

Panzac, Daniel. *Quarantaines et Lazarets: l'Europe et la peste d'Orient, XVIIe–XXe siecles.* Aix-en-Provence: Edisud, 1986.

Parkes, M. B. *Pause and Effect: An Introduction to Punctuation in the West*. Berkeley, Los Angeles: University of California Press, 1993.
Parkinson, Sydney. *A Journal of a Voyage to the South Seas*. London: Stanford Parkinson, 1773.
Papini, Mario. *Arbor Humanae Linguae*. Bologna: Capelli Editore, 1984.
Paton, John G. *Missionary to the New Hebrides*. London: Hodder & Stoughton, 1919.
Paxton, Steve, Anne Kilcoyne, and Kate Mount. "On the Braille in the Body: An Account of the Touchdown Dance Integrated Workshops with the Visually Impaired and the Sighted." *Dance Research: The Journal of the Society for Dance Research* 11: 1 (Spring 1993).
Perkins, Hetti, and Hannah Fink. "Genesis and Genius, The Art of Papunya Tula Artists." In *Papunya Tula, Genesis and Genius*, edited by H. Perkins and H. Fink. Sydney: Art Gallery of New South Wales, 2000.
Perkins, H., and H. Fink, eds. *Papunya Tula: Genesis and Genius*. Sydney: Art Gallery of New South Wales, 2000.
Phillips, Dennis H. *Australian Women at the Olympic Games, 1912–1992*. Kenthurst, N.S.W.: Kangaroo Press, 1996.
Philostratus. *Imagines*. Translated by A. Fairbanks. London: W. Heinemann, 1931.
Pindar. *The Odes of Pindar*, translated by Sir J. Sandys. London: Heinemann, 1919.
Playfair, John. "Life of Dr Hutton." In James Hutton, *Contributions to the History of Geology: Volume 5*, edited by G. W. White. New York: Hafner Press, 1973.
Plato. *Gorgias*. Translated by W. Hamilton. Harmondsworth: Penguin, 1960.
Pliny the Elder. *The Natural History,* book XXXVI. Cambridge, Mass: Harvard University Press, 1984.
Presland, Gary. *The Land of the Kulin*. Melbourne: Penguin, 1985.
Price, A. Grenfell. *The Foundation and Settlement of South Australia, 1829–1845: A Study of the Colonization Movement, Based on the Records of the South Australian Government and on Other Authoritative Documents*. Adelaide: Libraries Board of South Australia, 1973. Originally published 1924.
Rafael, Vicente L. *The Promise of the Foreign: Nationalism and the Technics of Translation in the Spanish Philippines*. Manila: Anvil Publishing, 2006.
Rasmussen, David M. *Mythic-Symbolic Language and Philosophical Anthropology: A Constructive Interpretation of the Thought of Paul Ricoeur*. The Hague: Martinus Nijhoff, 1971.
Read, Herbert. *Art and Education*. Melbourne: F. W. Cheshire, 1964.
Reynolds, Barbara. *Dorothy L. Sayers: Her Life and Soul*. London: Hodder & Stoughton, 1993.
Roberts, Russell. "Traces of Light: The Art and Experiments of William Henry Fox Talbot." In *Huellas de Luz, El Arte y los Experimentos de William Henry Fox Talbot*. Madrid: Museo Nacional Centro de Arte Reina Sofia, 2001.

Robinson, A. H. *Elements of Cartography*. New York: John Wiley and Sons, 1960.
Rousseau, Jean-Jacques. *The Confessions*. Translated by W. Conyngham Mallory. New York: Tudor, 1935.
Rowland, Ingrid D. "Giordano Bruno and Neapolitan Neoplatonism." In *Giordano Bruno, Philosopher of the Renaissance*, edited by H. Gatti. Aldershot, Hants: Ashgate Publishing, 2002.
Ruhen, Olaf. *Port of Melbourne, 1835–1976*. Stanmore, N.S.W.: Cassell Australia, 1976.
Ruskin, John. *The Stones of Venice*, 3 vols. London: Dent, 1907.
———. "Traffic." In *The Crown of Wild Olive*. London: George G. Harrap, n.d.
Ryan, Judith. "Identity in Land: Trajectories of Central Desert Art 1971–2006." In *Landmarks*. Melbourne: National Gallery of Victoria, 2006.
———. *Mythscapes: Aboriginal Art of the Desert*. Melbourne: National Gallery of Victoria, 1989.
———. *Spirit in Land: Bark Paintings from Arnhem Land*. Melbourne: National Gallery of Victoria, 1990.
Saenger, Paul. "Physiologie de la Lecture et Separation des Mots." *Annales ESC* 4 (Juillet–Aout 1989).
Sallis, John. *Chorology: On Beginnings in Plato's Timaeus*. Bloomington: Indiana University Press, 1999.
Sartre, Jean-Paul. *Words [Les Mots]*. Translated by I. Clephane. Harmondsworth: Penguin, 1967.
Sayers, Dorothy L. "Introduction." In *Great Short Stories of Detection, Mystery and Horror*, edited by D. L. Sayers. London: Gollancz, 1929.
Semple, Ellen. *Influences of Geographic Environment*. New York: Henry Holt & Co., 1911.
Serres, Michel. "China Loam." In *Detachment*, translated by G. James and R. Federman. Athens: Ohio University Press, 1989.
———. *The Troubadour of Knowledge*. Translated by S. F. Glaser and W. Pauldon. Ann Arbor: University of Michigan Press, 1997.
Shapiro, Gary. *Alcyone: Nietzsche on Gifts, Noise, and Women*. Albany: State University of New York Press, 1991.
Sheets-Johnstone, Maxine. "On the Significance of Animate Form." *Analecta Husserliana*, Vol. LV. Dordrecht: Kluwer Academic Publishers 1998.
Shields, Rob. *Lefebvre, Love and Struggle*. London: Routledge, 1999.
*Shorter Oxford English Dictionary*. Oxford: Clarendon Press, 1968.
Skeat, Walter W. *An Etymological Dictionary of the English Language*. Oxford: Clarendon Press, 1910.
Smith, Bernard. "Letter of Support for the publication of *Papunya: A Place Made After the Story*." Supplied to the author by Geoffrey Bardon.
Smith, Daniel W. "Badiou and Deleuze on the Ontology of Mathematics." In *Think*

*Again: Alain Badiou and the Future of Philosophy*, edited by P. Hallward. London: Continuum, 2004.

Smith, Kenneth, and Ian Weir. "The Engineering of Liverpool's Old Masonry Dock Walls." In *Albert Dock: Trade and Technology*, edited by A. Jarvis and K. Smith. Liverpool: National Museums and Galleries on Merseyside, 1999.

*Sophocles*. Translated by F. Storr. 2 vols. London: Heinemann, 1946.

Stell, Marion K. *Half the Race: A History of Australian Women in Sport*. North Ryde, N.S.W.: Collins/Angus & Robertson, 1991.

Stokes, John Lort. *Discoveries in Australia, with an Account of the Coasts and Rivers Explored and Surveyed etc.* 2 vols. Adelaide: Australian Facsimile Editions, Libraries Board of South Australia, No. 33, 1969. Originally published 1846.

Strehlow, T. G. H. *Songs of Central Australia*. Sydney: Angus & Robertson, 1971.

Tamisari, Franca, and James Wallace. "Towards an Experiential Archaeology of Place: From Location to Situation through the Body." In *The Social Archaeology of Australian Indigenous Societies*, edited by B. David, B. Barker, and I. J. McNiven. Canberra: Aboriginal Studies Press, 2006.

Tatz, Colin. *Obstacle Race: Aborigines in Sport*. Kensington: University of New South Wales Press, 1995.

Taylor & Cullity, Peter Elliott Architects, James Hayter & Associates, and Paul Carter. *North Terrace Precincts Development Framework Plan*, 2000.

———. *North Terrace Precincts Development Concept Design*, December 2000.

Tench, Watkin. *Sydney's First Four Years: Being a Reprint of a Narrative of the Expedition to Botany Bay*. Introduction and annotations by L. F. Fitzhardinge. Sydney: Library of Australian History/Royal Australian Historical Society, 1979. Originally published 1798.

Thompson, D'Arcy Wentworth. *On Growth and Form*. 2 vols. Cambridge: Cambridge University Press, 1942.

Thrift, Nigel. "Movement-space: the Changing Domain of Thinking Resulting from the Development of New Kinds of Spatial Awareness." *Economy and Society* 33: 4 (November 2004).

Thucydides. *History of the Peloponnesian War*. Translated by R. Crawley. London: Dent, 1910.

Thulborn, Tony. *Dinosaur Tracks*. London: Chapman & Hall, 1990.

Troy, Jakelin. *The Sydney Language*. Canberra: Panther Publishing, 1993.

Turnbull, Robert G. *The* Parmenides *and Plato's Late Philosophy: Translation of and Commentary on the* Parmenides *with Interpretive Chapters on the Timaeus, the Theaetetus, the Sophist, and the Philebus*. Toronto: University of Toronto Press, 1998.

Tymieniecka, Anna-Teresa. "Logos and Life: Creative Experience and the Critique of Reason." *Analecta Husserliana*, Vol. XXIV. Dordrecht: Kluwer Academic Publishers, c.1986.

Vasari, Giorgio. *Lives of the Artists*. Translated by G. Bull. Harmondsworth: Penguin, 1965.
Van Den Abbeele, Georges. "Lost Horizons and Uncommon Grounds: For a Poetics of Finitude in the Work of Jean-Luc Nancy." In *On Jean-Luc Nancy: The Sense of Philosophy*, edited by D. Sheppard, S. Sparks, and C. Thomas. London: Routledge, 1997.
Vattimo, Gianni. *The Adventure of Difference: Philosophy after Nietzsche and Heidegger*. Translated by C. Blamires. Cambridge: Polity Press, 1993.
Verene, Donald. *Philosophy and the Return to Self-Knowledge*. New Haven, Conn.: Yale University Press, 1991.
Vico, Giambattista. *The New Science of Giambattista Vico*. Translated by M. H. Wallace and T. G. Bergin. Ithaca, N.Y.: Cornell University Press, 1984.
———. *On the Most Ancient Wisdom of the Italians*. Translated by L. M. Palmer. Ithaca, N.Y.: Cornell University Press, 1988.
———. *On the Study Methods of Our Time*. Translated by Elio Gianturco. Ithaca, N.Y.: Cornell University Press, 1990.
Vidler, Anthony. *The Architectural Uncanny: Essays in the Modern Unhomely*. Cambridge, Mass.: The MIT Press, 1992.
Virilio, Paul. "Foreword." In John Rajchman, *Constructions*. Cambridge, Mass.: The MIT Press, 1999.
Vitruvius. *De Architectura*. Translated by F. Granger. 2 vols. London: Heinemann, 1931.
Von Hartmann, Eduard. *Philosophy of the Unconscious*. Translated by W. C. Coupland. 3 vols. London: Trubner & Co., 1884.
Wagner, Roy. *Symbols that Stand for Themselves*. Chicago: University of Chicago Press, 1986.
Wallace, Alfred Russel. *The Malay Archipelago*. Introduction by John Bastin. Kuala Lumpur: Oxford University Press, 1986. Originally published 1896.
Wallis, H. M., and A. H. Robinson, eds. *Cartographical Innovations: An International Handbook of Mapping Terms to 1900*. Tring, England: Map Collectors Publications Ltd., 1987.
Ward, Andrew, & Associates. *Melbourne Docklands Heritage Review* (June 1997).
———. *Melbourne Docklands Heritage Study* (June 1991).
Ware, Mike. "Invention in Camera: The Technical Achievements of WHF Talbot." In *Huellas de Luz: El Arte y los Experimentos de William Henry Fox Talbot* Madrid: Museo Nacional Centro de Arte Reina Sofia, 2001.
Waters, D. W. *Science and the Techniques of Navigation in the Renaissance*. London: Trustees of the National Maritime Museum, Maritime Monographs and Reports, No. 19, 1976.
Watson, Ruth. "The Heart of the Map: Material Projections in Art and Cartography." PhD Thesis, School of Art, Australian National University, Canberra, 2005.

Webb, Francis. "A Drum for Ben Boyd." In *Cap and Bells: the Poetry of Francis Webb*. Sydney: Angus & Robertson, 1991.

Whewell, William. "History of Inductive Sciences." In *William Whewell: Selected Writings on the History of Science*, edited by Y. Elkana. Chicago: University of Chicago Press, 1984.

———. *The Philosophy of the Inductive Sciences*. 2 vols. London: John W. Parker, 1867.

Whitaker, Albert K. *Plato's* Parmenides. Newburyport, Mass.: Focus Publishing, 1996.

Whiting, H. T. A., and D. W. Masterson, eds. *Readings in the Aesthetics of Sports*. London: Lepus Books, 1974.

Whitney, Charles. *Francis Bacon and Modernity*. New Haven, Conn.: Yale University Press, 1986.

Willard, Frances E. "How I Learned to Ride the Bicycle." In *Out of the Bleachers: Writings on Women and Sport*, edited by Stephanie L. Twin. New York: The Feminist Press, c.1979.

Winslow, C. E. A. *The Conquest of Epidemic Disease*. Princeton, N.J.: Princeton University Press, 1943.

Winter, Samuel Pratt. "The Voyage of the Argo." In *The Winter Cooke Papers*. Melbourne: La Trobe Library: WCP, 5, 2.4. Ms Collection 86647007.

Wood, Dennis. *The Power of Maps*. New York: Guilford, 1992.

Worgan, George. *Journal of a First Fleet Surgeon*. Sydney: Library Council of New South Wales and the Library of Australian History, 1978.

Yampolsky, M. "The Essential Bone Structure: Mimesis in Eisenstein." In *Eisenstein Rediscovered*, edited by I. Christie and R. Taylor. London: Routledge, 1993.

# INDEX

Entries in **boldface type** refer to illustrations

Aborigines, Australian: bark paintings, 110; graphic design, 110; tracks, 33, 149, 160. *See also* Papunya Tula painting movement
Adelaide. *See* Carter, Paul and *Tracks*
Aesop, 168
Agamben, Giorgio, 45, 98, 251
Alberti, Leon Battista, 88
allegory. *See* Carter, Paul and *Solution*
anacoluthon. *See* Carter, Paul and Ruark Lewis, *Relay*
Anmatyerre people. *See* Papunya Tula painting movement
Antico di Porcia, Count Gian, 44
Apelles, 82, 88–89, 90
Appelbaum, David, 62
Arakawa, Shusaku and Madeline Gins, 13, 15n.8, 269–270
archetypes. *See* Bardon, Geoffrey
architecture, and chemistry, 3–4, 197. *See also* Fox Talbot, Henry
arête. *See* Carter, Paul and Ruark Lewis, *Relay*
Argo principle. *See* Carter, Paul and *Solution*
Aristotle, 59, 76n.26, 91, 96
Arrernte people. *See* Papunya Tula painting movement
Asterisk principle. *See* Carter, Paul and *Solution*
axiomatics. *See* dark writing, problematics

Bacchylides, 208, 222–224
Bachmann, Ingeborg, 276–277
Bacon, Francis, 22, 23

Badiou, Alain, 229
Balint, Michael, 70
Barbari, Jacopo di, 172n.39
Bardon, Geoffrey, 9, 10, 103–134 passim, 263; archetype, 105, 113–118, **115**, 127, 130; comic strip, 116, **117**; documentation of paintings, 126, 127–130; dotting, 120–123; Dreamings classifications, 129–130; finish, 125; Haast's Bluff mural, 130; hapticity, 105, 108, **119**, 123, 130; hieroglyph, 105, 108, 118–124, 130, 210; movement image, 115–118, 123–125; performance, 126–127; *The Richer Hours* (film), 130
Barthes, Roland, 185, 186
Barton, John Hack, 144, **145**
Bataille, Georges, 266
Bates, Donald. *See* Lab architecture studio
Baudelaire, Charles, 246
Beautemps-Beaupré, Charles de, 51
Benjamin, Walter, 98, 225n.15, 246, 254–255, 256
Benson, Bruce Ellis, 275
Bentham, Jeremy, 30
Berger, John, 247, 272–273
Berkeley, Bishop George, 62, 254
Bertin, Jacques, 46n.24
Bloch, Ernst, 167, 231, 238
Boccioni, Umberto, 262, 278n.14
Boucher, François, 3–5, 197, **plate 1**
Boullée, Etienne Louis, 231
Bowra, Sir Maurice, 221
Boyle, Robert, 197
Brady, Joseph, 188
Brodsky-Lacour, Claudia, 80–81, 195, 261

Browne, Sir Thomas, 225n.19
Bruno, Giordano, 92–93

Cadava, Eduardo, 354–255
Caillois, Roger, 256n.10
Cameron, Julia, **247**
Carr, David, 85
Carter, Paul: *The Lie of the Land*, 13, 83, 91, 104, 112, 140; *Repressed Spaces*, 201n.56, 238; *The Road to Botany Bay*, 13, 26, 32, 83
Carter, Paul and Ruark Lewis, *Relay*, 12, 13, 204, 214; *anacoluthon*, 213, 215; *arête*, 221; *charis*, 208, 209, 216, 217, 221; colour, 219–220; Death and, 220–222; diver, 224, **plate 20**; Fig Grove, **205**, 213; graffiti clusters, 208, 210, **plates 14, 15**; Hargreaves and Associates, 204, 208, 219, 220, 223; *kairos*, 204, 216, 219; monograms, 210–212, **211**; poetic composition, 212–219, **plate 13**; *scriptio continua*, 207–208, 215, 224n.4; secreted words, 222–223; tiers, blue, **plate 19**; tiers, green, 218, 219, **plate 18**; tiers, red, 214–215, 217, **plates 12, 16**; tiers, yellow, 215, **plate 17**; typography, 206–208, 210–212, 217–218
Carter, Paul and *Solution*, 11, 173–198 passim, 198n.2, 203, 229; allegory, 195–196; Argo principle, 181, 183–185, 186–187, 189, 191, 222; Asterisk principle, 187, 189; colloidal systems, 177–182, 199n.23, **plate 11**; ground pattern design, 189–194; harbour definition, 176; the humid, 174–175, 188, **193**; Melbourne's Docklands, 172–177, **176**, 180, 183, 186, 187–188, **188**, **190**, **plate 10**; storyboard, 182–183; Victoria Harbour (*see* Carter, Paul and *Solution*, Melbourne's Docklands)
Carter, Paul and *Tracks*, 11, 152–159, **153, 154, 155, 158**; Adelaide, 141–142, **141, 145, 148**, 150–152, 203, 229, **plates 8, 9**; North Terrace, 141–147, **142, 144**, 169n.4. *See also* ichnography; Light, William
cartography. *See* geography, maps and mapping
Cetina, Knorr, 267
characterology. *See* dark writing
*charis*. *See* Carter, Paul and Ruark Lewis, *Relay*
chemistry. *See* architecture
Chladni, Ernst, 261
*chora*, 96–98

*chronos*, 216
Clark, Justine, 82
Coastlines. *See* geography
Cobb-Stevens, Richard, 90
Coleridge, Samuel Taylor, 241
colloidal systems. *See* Carter, Paul and *Solution*
Coode, Sir John, 174, 188, **190**
Cook, James, 24, 56
Corbin, Alain, 71
Cottom, Daniel, 65
Cuthbert, Betty, 211, 216

Dalyell, J. G., 49, 70
dapple, 1. *See also* Fox Talbot, Henry
dark writing, 1–4, 4–8, 195–196, 204, 221–222, 228–256 passim, 265; body, 228, 232–233; characterology, 233–234, 237, 248; danger, 253; design, 275, 277; graphology, 233; handwriting, 235–237; materiality, 230–231; movement, 229, 232, 274–276; painting, 232; photologos, 253–254; problematics, 229–230; rhythm, 271–273, 274–276; time, 273; underwriting, 232
Darwin, Charles, 30
Darwin, Erasmus, 261
Davidson, Peter. *See* Lab architecture studio
Da Viterbo, Egidio, 93
Dawes, William, **37**
Defoe, Daniel, 69
Deleuze, Gilles, 229, 230, 231, 254
De Nerval, Gérard, 246
De Man, Paul, 195–196
De Quincey, Thomas, 161–162, 171n.32, 179, 180, 203, 273
Derrida, Jacques, 91, 140, 234–235, 251
Descartes, René, 23, 38, 80–81, 88, 195, 261, 277–278
Deutsche, Rosalind, 183, 192
Dingo, Ernie, 221
Diver, The. *See* Tomb of the Diver
Docklands, Melbourne. *See* Carter, Paul and *Solution*
drawing, xv, 272–273
Drummond, Henry, 105
Durkheim, Emile, 263
D'Urville, Dumont, 56

Edney, Matthew H., 56
eido-kinetic intuition. *See* movement

Eisenstein, Sergei, 182, 263–264
Eliot, T. S., 19
Eora/Dharawal people, 220
Etkind, Alexander, 264
Etruscan tomb painting, 248–252, **plate 21**
Everett, D. H., 177
Eyre, E. J., 55–56, 75n.15

Fechner, Gustav Theodor, 132
Feininger, Lyonel, 262
Fig Grove, Homebush Bay. *See* Carter, Paul and Ruark Lewis, *Relay*
Flinders, Matthew, 25, **26**, 51
Flintoff-King, Debbie, 215
Forrest, Thomas, **60**, 72
Forster, J. R., 20, 21–22, 29, 70, 72
Fox Talbot, Henry, 12, 238–245, 248, 253; ancient scripts, 243, 245; architecture, 244–245; dapple, 241, 242; exposure time, 245–246; negative-positive method, 243; *The Pencil of Nature*, 241–242, 248; printing, 244; sciagraphy, 239–241, **239**, **240**, 243, **244**, **249**, **250**
Fraser, Dawn, 210, 219
Freud, Sigmund, 29, 132, 133, 233, 238
Friis, Fred, 106, 112, 130
Fry, Roger, 247

Gabo, Naum, 262
Gadamer, Hans-Georg, 91–92, 95, 96, 101n.59
Gaimard, Joseph, 69–70
Gall, Francis Joseph, 234
Ganascia, Jean-Gabriel, 81
Garug people, 220
Gasché, Rodolphe, 179, 257n.13
Gay, Peter, 23
Genet, Jean, 179–180
geography: Australian exploration, 33, 34, 35; coastlines, 49–74 passim, **52**, **53**; environmental unconscious, 38–39, 43; figurative (*see* geography, symbols); inductive reasoning, 36–38, 41–43, 53–55, 57; maps and mapping, 17–21, **18**, 26–27, **26**, 34–35, **34**, **37**, **52**, **53**, 74n.7, 75n.17, 150, 265–266; mental geography, 32, 35, 36; myth of, 28–35, 43; place names, 24–25, 34, 46, 57, 61, 62; quarantine, 65–68, **66**; rhythmic geography, 275–276; shipwrecks, 69–71; similitudes (*see* geography, symbols); space, 17; spatial history, 35, 84; spiritualism, 65; surveying, 54–57; symbols, 21, 24, 37–38, 43, 51–53. *See also* dark writing; movement
geology. *See* Hutton, James
Giacometti, Alberto, 179–180, 238
Gibson, J. J., 58
Gill, Edmund, 177, 188
Gillen, F. J., 263
Gins, Madeline. *See* Arakawa, Shusuka and Madeline Gins
Giotto, 88, 90
Goetsch, James, 44–45
Goodman, Nelson, 81, 274
Gosse, Philip, 60, 76n.29
Gould, Shane, 210, 217
graffiti cluster. *See* Carter, Paul and Ruark Lewis, *Relay*
Grant, James, **52**, **53**
graphology. *See* dark writing
Grosz, Elizabeth, 82, 95, 162
Guattari, Felix, 254

Hailes, Nathaniel, 147–149
Hall, Sir James, **42**
hapticity. *See* Bardon, Geoffrey
Hargreaves and Associates. *See* Carter, Paul and Ruark Lewis, *Relay*
Harley, J. B., 17
Harpur, Charles, 49
Hartley, Jesse, 229–230
Hartmann, Eduard von, 38
Heraclitus, 267
Herschel, Sir John Frederick, **247**
Hesiod, 146
hieroglyph. *See* Bardon, Geoffrey
Hillman, James, 133
Hogarth, William, 82–83, 88, 261
Hölderlin, Friedrich, 272
Holmes, Richard, 246–247, 252
Honey Ant Dreaming mural. *See* Papunya Tula painting movement
Hopkins, Gerard Manley, 1, 260, 280n.52
Horace (Quintus Horatius Flaccus), 214
Hosking, J. B. O., 188
Houel, Jean, 65–66, **66**
Humid. *See* Carter, Paul and *Solution*
Husserl, Edmund, 9, 11, 13, 84–88, 90, 91, 94, 95, 97, 140, 141–142, 143, 185, 260, 263

Hutton, James, 36, 38–43, **40**, **41**, **42**, 44, 93, 156, 234, 247

ichnography, **158**, 164–169
Ingleton, Geoffrey C., 51
Ingraham, Catherine, 51, 80
Innes, Bob, 129
Irigaray, Luce, 266
Isidore of Seville, 187

Jacob, Christian, 265
Jason (Greek hero), 222
Jefferies, Richard, 180–182

Kafka, Franz, 12, 16, 35, 86, 94, 204, 246, 254, 272
*kairos*. *See* Carter, Paul and Ruark Lewis, *Relay*
Kandinsky, Wassily, 108, 111
Kant, Immanuel, 2
Kaurna people (Adelaide Plains), 160
Kellogg, Rhoda, 107, 109
Khlebnikov, Velimir, 224n.5
Kierkegaard, Søren, 174–175, 233, 234, 245, 254
Kiesler, Frederick, 275–276
kinesthetic space. *See* movement
King, Phillip Parker, **53**, 55, 59, 64, 70, 74
Kingston, G. S., 147, **148**
Klages, Ludwig, 237, 238
Klee, Paul, 79, 94, 108, 160, 210, 266
Krauss, Rosalyn, 184, 185
Krell, David Farrell, 87, 90, 260, 261, 266
Kristeva, Julia, 226n.26
Kusbit, Donald, 185

Lab architecture studio, 260–261, 264–265
Lack, John, 174
Lacoue-Labarthe, Philippe, 206, 272
Lambert, Gregg, 231
Lapicque, Charles, 162, **163**
Latour, Bruno, 14, 19, 20, 144, 266, 267
La Trobe, Charles Joseph, 183
Leatherbarrow, David, 146, 149
Le Doeuff, Michèle, 32
Ledoux, Claude Nicholas, 231
Leibniz, Gottfried Wilhelm, 32
Levinas, Emmanuel, 162–163, 196, 202n.72
Lewis, Ruark. *See* Carter, Paul and Ruark Lewis, *Relay*
Libeskind, Daniel, 238

Light, William, 11, 140, **141**, 143, 147, 149
line, 14, 15, 37, 108–109, 260–278 passim; architectural, 80–81; coastline, 79–99 passim; deductive, 81–82, 261; inductive, 81–83, 261–262; linings, 266; in Modernism, 262–264; postlinear, 260–261; rhythm, 271
Lingis, Alphonso, 85
Lodoli, Carlo, 44
Lowenfeld, Viktor, 107–108, 109
Lungkata, Shorty. *See* Tjungurrayi, Shorty Lungkata
Luritja people. *See* Papunya Tula painting movement
Lynn, Greg, 164
Lyotard, Jean-François, 182, 195

Mach, Ernst, 3
Mallarmé, Stéphan, 213
Man, Paul de, 195–196
Mann, Thomas, 233, 257n.16
maps and mapping. *See* geography
Marion, Jean-Luc, 2
Marquand, David, 194
Marvin, Francis Sydney, 16
Merleau-Ponty, Maurice, 87–88, 90–91, 160, 196, 202n.68, 266
*methexis*, 13, 91–92, 133
Mill, John Stuart, 246
Miller, Mitchell, 98
*Miller Atlas*. *See* Jacob, Christian
Millikan, Robert Andrews, 178
*mimesis*. *See methexis*
Miró, Joan, 111
Mitchell, W. J. T., xiii
Moholy-Nagy, László, 228
Moles, Abraham, 230–231
monograms. *See* Carter, Paul and Ruark Lewis, *Relay*
Montgomery, Keith, 40–41
Montgomery, Peter, 212
Morgan, Charles, 12, 235–237, 238, 246, 253
Morrison, John, 173, 181
movement: eido-kinetic intuition, 15, 267–271; geography, 19, 43, 68, 84, 229; kinesthetic space, 86, 87, 88, 91; movement form, 133, 144–146, 160–164, 192, 203–204; movement image (*see* Bardon, Geoffrey); movement space (*see* Thrift, Nigel);

passage, 266–267; repression of, 16–21, 229, 234–235. *See also* dark writing; geography
Mukherjee, Jasmine, 192
Munn, Nancy, 156
Musil, Robert, 271
Myers, Fred, 118

Nadar, Felix, 246
Namatjira, Keith, 114
Nancy, Jean-Luc, 194, 217
Nerval, Gérard de, 246
Nicholas of Cusa, 92
Nietzsche, Frederic, 169
Nunn, Glynis, 216
Nyala, Hannah, 166–167, 169

O'Brien, Lewis, 140, 161, 168–169
*Oedipus at Colonus*. *See* Sophocles
Olalquiaga, Celeste, 19
Olympics, Sydney (2000). *See* Carter, Paul and Ruark Lewis, *Relay*
Orban, Desiderius, 106, 107, 108, 110, 178
Ostwald, Wilhelm, 177
Ovid (Publius Ovidius Naso), 72–73

Palinurus (Aeneas' helmsman), 21, 22, 29
Panofsky, Erwin, 167–168, 221
Papunya Tula painting movement, 103–134 passim; Anmatyerre people, 104; Arrernte people, 104, 263; Honey Ant Dreaming mural, 112–115, 131–132, 218, **plates 2, 6, 7**; Luritja people, 104; omni-directionality of paintings, 127; painting names, 128; Pintupi people, 104, 109, 117, 125, 131, 132, 212; Tingari Ancestors, 133; *tjukurrpa*, 129; Warlpiri people, 104. *See also* Bardon, Geoffrey
Parkinson, Sydney, 58–59
Parmenides, 4, 92, 93, 95–96, 162, 255
passage. *See* movement
Paton, Reverend John, 71–72
Paul, Saint, 98, 105, 217
Paxton, Steve, 274
periautography. *See* Vico, Giambattista
Péron, François, 181
Pevsner, Antoine, 262
photography, 254–255
Piaget, Jean, 267
Picasso, Pablo, 108

Pindar, 208–210, 212, 213–214, 216, 224
Pintupi people. *See* Papunya Tula painting movement
Pitjantjatjara people, 210
Plato: *The Gorgias*, 250–251; *The Parmenides* (*see* Parmenides); *The Timaeus*, 96–97
Playfair, John, 38, 39, 41, 43, 44, 57–58, 156, 234
Playfair, William, 261
Pliny the Elder, 82, 89, 90, 91, 265
Plotinus, 100n.36
Poe, Edgar Allan, 222
Protogenes, 82, 88–89, 90, 198
Pythagoras, 248

Quarantine. *See* geography

Rafael, Vicente, 244
Raggett, Obed, 107, 110, 112, 113, 117
Rang, Florens Christian, 256
Read, Herbert, 106
*Relay*. *See* Carter, Paul and Ruark Lewis, *Relay*
rhythm/*rhuthmos*, 14, 15, 232, 236. *See also* dark writing; geography; line
Ricoeur, Paul, 24, 27, 28
Rizal, José, 244
Roberts, Russell, 250, 258n.40
Rorschach, Hermann, 234
Rousseau, Jean-Jacques, 68–69
Rowse, Tim, 131
Ruskin, John, 35, 261, 262

Sallis, John, 97, 164
Sartre, Jean-Paul, 246
Sayers, Dorothy, 168, 172n.52
Schweitzer, Charles, 246
*sciagraphy*. *See* Fox Talbot, Henry
Semple, Ellen, 17
Seneca (Lucius Annaeus Seneca), 222
Serres, Michel, 20–21, 27, 28, 29, 231
Smith, Bernard, 105
Smith, Daniel, 229
Smith, Kenneth, 230
*Solution*. *See* Carter, Paul and *Solution*
Sophocles, 223
spatial history. *See* geography
Spencer, Baldwin, 263
Stewart, Balfour, 65
Stokes, John Lort, 54–55, 61, 62, 63–65, **64**, 73

storyboard. *See* Carter, Paul and *Solution*
Strehlow, T. G. H., 105

Tait, Peter Guthrie, 65
Tarawa, Charlie. *See* Tjungurrayi, Charlie Tarawa
Tench, Watkin, 68
Theseus (Greek mythological hero), 223–224
Thompson, D'Arcy Wentworth, 157, 178–179, 194, 198n.19
Thrift, Nigel, 14, 19, 267, 268, 271
Thucydides, 72
Tingari ancestors. *See* Papunya Tula painting movement
Tjakamarra, Anatjari No. III, 118
Tjakamarra, Long Jack Phillipus, 113
Tjakamarra, Old Mick, 113, 118, **119**, 131
Tjampitjinpa, Kaapa, 114, 131
Tjampitjinpa, Old Walter, 113, 114, 118, **119**, 125, 131, **plate 3**
Tjampitjinpa, Ronnie, 127
Tjangala, Uta Uta, **114**, 120
Tjapaltjarri, Bill Stockman, 113
Tjapaltjarri, Clifford Possum, 114
Tjapaltjarri, Mick Namerari, 113
Tjapaltjarri, Tim Leura, 114, 120, 125, 130
Tjapangati, Old Bert, 131
Tjapangati, Old Tom Onion, 131
Tjapangati, Old Tutuma, 114
Tjapangati, Tim Payungka, 113
*tjukurrpa*. *See* Papunya Tula painting movement
Tjungurrayi, Charlie Tarawa (Tjaruru), 113, 114, 128
Tjungurrayi, Shorty Lungkata, 118
Tjungurrayi, Yala Yala Gibbs, 113, **plate 5**
Tjupurrula, Johnny Warrangkula, 109, 112, 114, 118, 120, **121**, 130, **plate 4**
Toba (Aboriginal child, Papunya School, 1971), 111
Tomb of the Diver (Paestum/Pesto), 224, 233, 252–253, 255–256, **plates 22, 23.** *See also* Carter, Paul and Ruark Lewis, *Relay*; Etruscan tomb paintings
*Tracks*. *See* Carter, Paul
tracks, 37. *See also* Aborigines, Australian; ichnography
Turnbull, Robert, 97
Tymieniecka, Anna-Teresa, 87

Ungaretti, Giuseppe, 22

Vancouver, George, 57, 63, 75n.20
Vasari, Giorgio, 88, 169
Vattimo, Gianni, 169, 268
Verene, Donald, 23, 28, 43, 196, 230
Vertov, Dziga, 269
Vico, Giambattista, 16, 22–24, 25–28, 38, 83, 169, 185, 191; periautography, 44–45, 235, 247
Victoria Harbour. *See* Carter, Paul and *Solution*
Vidler, Anthony, 231, 256n.10
Virgil (Publius Vergilius Maro), 21, 22, 72
Virilio, Paul, 273
Viterbo, Egidio da, 93
Vitruvius (Marcus Vitruvius Pollio), 164, 165
Von Guerard, Eugene, **144**

Wagner, Roy, 156
Wallace, Alfred Russel, 59–60, 76nn.27, 28
Webb, Francis, 276
Weir, Ian. *See* Smith, Kenneth
Western Desert painting movement. *See* Papunya Tula painting movement
Whewell, William, 30–31, **31**, 32, 35, 261
Whitaker, Keith, 95–96
Willard, Frances, 215
Woiwurrung people, 174

Yampolsky, Mikhail, 263
Yanyuwa people, 61
Yee, Chiang, 107, 108, 120
Yirrkala Bark Petition, 17, **18**
Yolngu people, 171n.29

**ABOUT THE AUTHOR**

PAUL CARTER is professorial research fellow in the Faculty of Architecture, Building, and Planning at the University of Melbourne, Australia. He is the author of thirteen books, including the award-winning *The Road to Botany Bay* (1987).

Production Notes for Carter | DARK WRITING

Interior design by Leslie Fitch in Scala, with display type in Berthold Akzidenz Grotesk.

Composition by Copperline Book Services, Inc.

Printing and binding by Sheridan Books, Inc.

Printed on 60# Accent Opaque Opaque, 500 ppi